PROFESSIONAL GUIDE TO FILMMAKING

Bradford Schmidt

Brandon Thompson

Foreword by Nicholas Woodman, founder of GoPro

PEACHPIT PRESS

GOPRO: PROFESSIONAL GUIDE TO FILMMAKING

Bradford Schmidt and Brandon Thompson

PEACHPIT PRESS
Find us on the Web at www.peachpit.com

To report errors, please send a note to errata@peachpit.com
Peachpit Press is a division of Pearson Education
Copyright © 2015 by Bradford Schmidt and Brandon Thompson

Senior Editor: Karyn Johnson
Senior Production Editor: Tracey Croom
Developmental Editor: Corbin Collins
Copyeditor: Kelly Kordes Anton
Proofreader: Scout Festa
Cover Design: Aren Straiger
Cover Photos: Kelly Slater (front), Caleb Farro (back)
Interior Design: Mimi Heft
Compositor: Kim Scott, Bumpy Design
Indexer: Valerie Perry

ISBN-13: 978-0-321-93416-1
ISBN-10: 0-321-93416-4

9 8 7 6 5 4

Printed and bound in the United States of America

GoPro®

PROFESSIONAL GUIDE TO FILMMAKING

Bradford Schmidt
Brandon Thompson

Acknowledgments

In finding media for this book, we benefited from the knowledge and curation of the social and creative teams at GoPro, and we would like to thank them—specifically, Jensen Granger, Mattias Sullivan, Pilar Woodman, and Sean Custer. We would especially like to thank Jensen Granger for his Photoshop expertise. He and Sean Custer also provided the burst photo stitches featured in this book. We also thank Karyn Johnson at Peachpit for shepherding us through this whole process, and Mimi Heft and Nancy Aldrich-Ruenzel for their everlasting patience. We'd also like to thank Jordan Miller, Caroline Emerson, and Anna Hoff for not going insane as we took over their couch every weekend for two years to work on this project. Further, we owe a debt of gratitude to GoPro's legal team, Sharon Zezima and Simon Seidler. A final GoPro thanks goes to a few individuals who helped develop this book: Kim Lantz, Justin Wilkenfeld, Paul Osborne, Paul Crandell, and Nick Woodman.

And, of course, much of our work at GoPro would not have been possible without the ceaseless adventuring and creative endeavors of GoPro users, those athletes, photographers, filmmakers, adventurers, and enthusiasts who have used the product to capture many of the beautiful moments you see throughout these pages. They have all freely contributed their images to this book, and for that we are grateful.

Finally, we dedicate this book to all of the production artists and producers who make up GoPro's in-house media production team, GoPro Original Productions. Creating art takes time and patience. This book is a tribute to these artists' labor, love, and frequent nights spent sleeping under the desk—all in the pursuit of their passions.

Jason Moran / Majuro, Marshall Islands Chesty Photo/.5sec

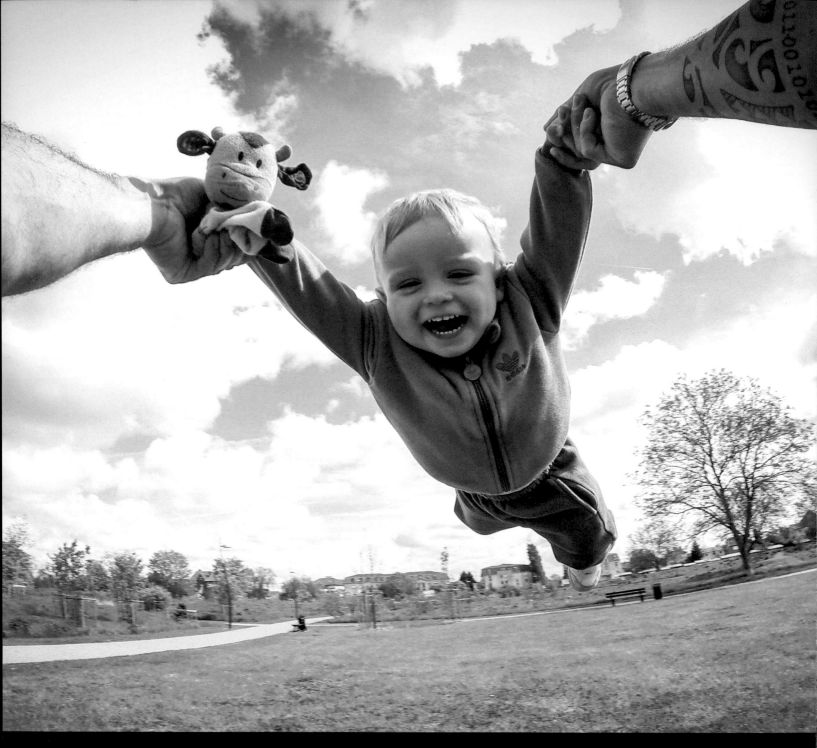

Table of Contents

Bradford Schmidt / Hollow Trees, Mentawai Islands, Infrared 35mm, 2002

Nicholas Louw / South Africa · Chesty · Photo/.5sec

2 Mounts 45

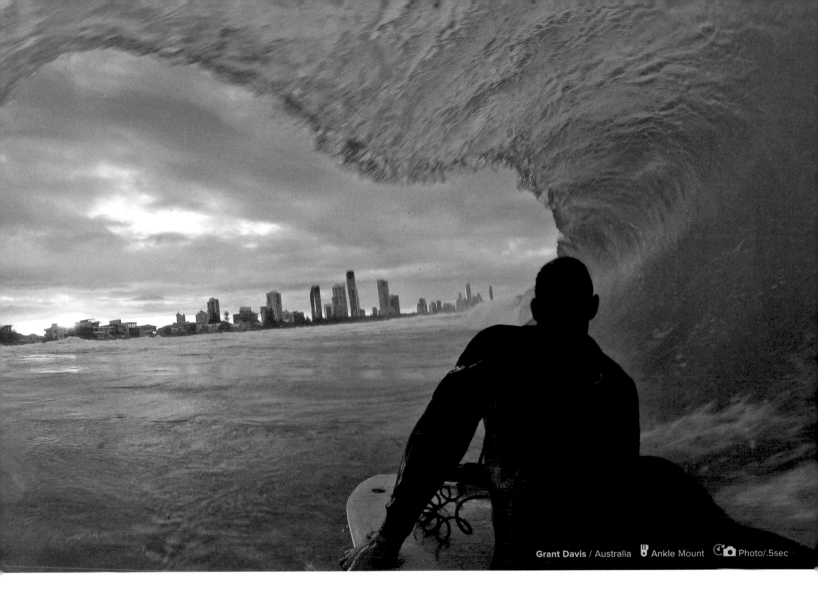

Grant Davis / Australia 🖐 Ankle Mount 📷 Photo/.5sec

3 Angles by Activity 98

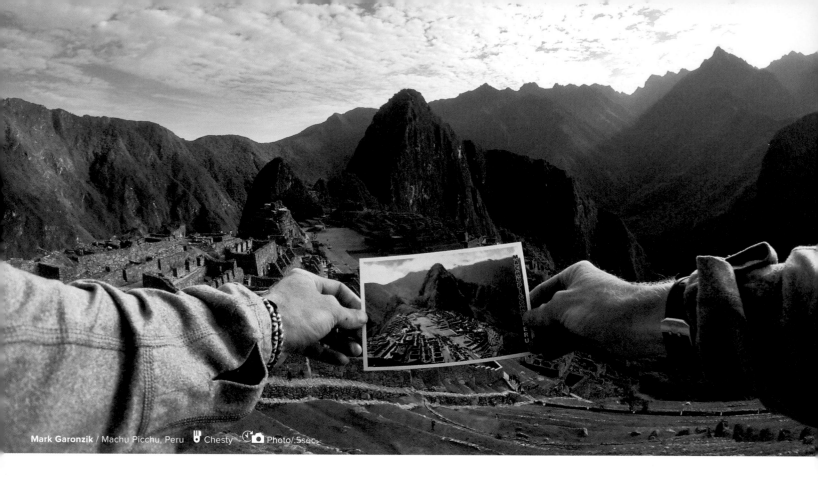

Mark Garonzik / Machu Picchu, Peru ♍ Chesty 📷 Photo/.5sec.

4 Capturing a Story 128

5 Art of Editing 178

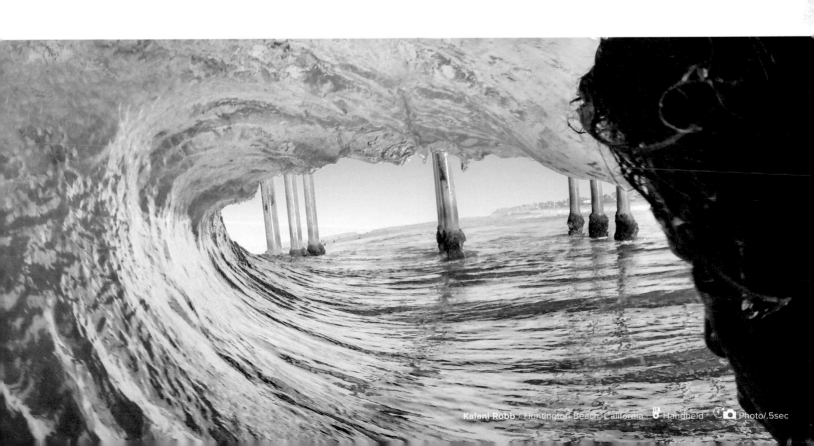

Kalani Robb / Huntington Beach, California Handheld Photo/.5sec

6 Story Analysis 232

Yara Khakbaz / San Francisco, California Polecam Photo/.5sec

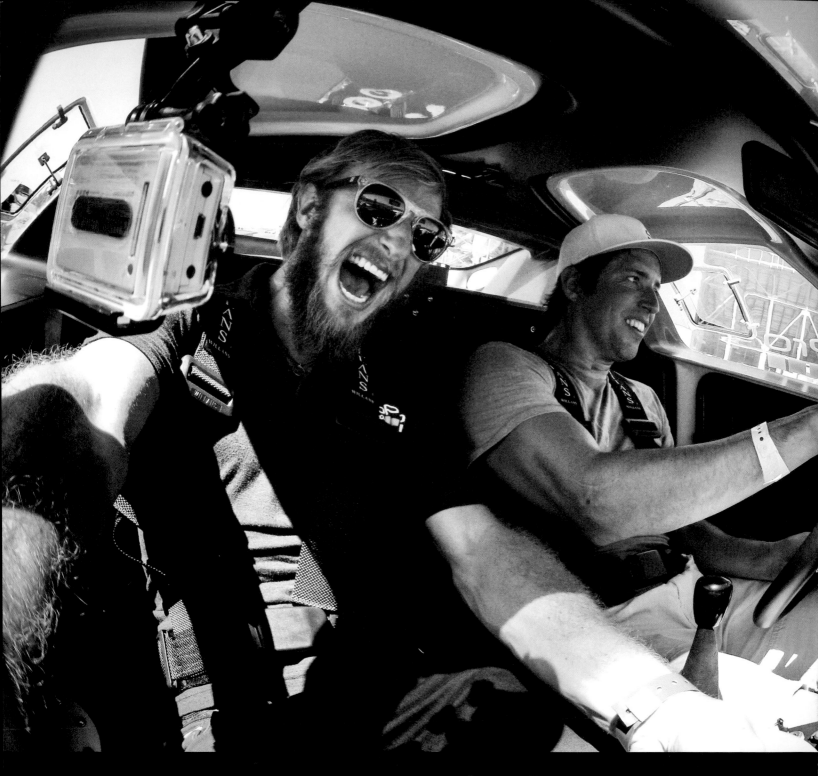

Bradford Schmidt, Nicholas Woodman / Sonoma Raceway, California Handheld Photo/.5sec

Foreword

Since founding GoPro in 2002 and witnessing the incredible events that followed, I've come to believe our personal interests and passions act as roadmaps for our lives. Passion is often what motivates us to get off the couch and start moving in a certain direction. The direction we choose, over time, becomes our life. Consider this and you'll appreciate the events that brought me together with this book's author and the founding member of GoPro's media production team, Bradford Schmidt.

In 2002, I was out of work and had no idea what to do with the rest of my life. With hopes of finding inspiration on the road, I planned a five-month surf trip around Australia and Indonesia to pursue my obsession with surfing. The irony is that I had my inspiration for GoPro, initially a simple wrist camera for surfers, before I even left for my trip. By the time I met Bradford four months later aboard an overnight ferry to the Mentawai Islands in Indonesia, I was already testing an early GoPro prototype. Bradford and I had both followed our passions to that point in space and time and it was there, on that boat, that we formed a friendship that would one day lead to great things.

In the years that followed, I established GoPro as a small but growing business and Bradford followed his passion for filmmaking to UCLA film school. During that period I met Bradford's childhood friend, Brandon Thompson, and each year I would send the two of them prototypes of GoPro's soon-to-be-released camera for them to test on their adventures. Always honest, they generally weren't too impressed until 2009 when I sent them an early sample of the HD HERO, GoPro's first HD camera. I vividly remember Bradford calling me up, excitely telling me just what I'd told him the day before: "This camera is going to change everything."

Shortly thereafter, I convinced Bradford to leave the lure of Hollywood to establish what would become GoPro's in-house media production department, GoPro Original Productions. Brandon soon joined and a magic momentum set in. Although a far cry from what it is today, our media production team started with a spark that would help it become what is now arguably the most innovative and creative group of short-form content creators in the world. That spark was Bradford, himself.

Today, Bradford, Brandon, and I work together with GoPro's nearly 900 employees to enable others around the world to self-document and share their interests and experiences like never before. GoPro has become a global movement of visual expression thanks in large part to the inspiring content Bradford and his team have produced over the years. This book is an invaluable window into their creative thinking and summarizes years of experience and insight. Hopefully it serves as a spark for you just as the authors have for GoPro.

Don't forget to follow your passions. They just might lead you to you.

Nicholas Woodman,
Founder and CEO of GoPro

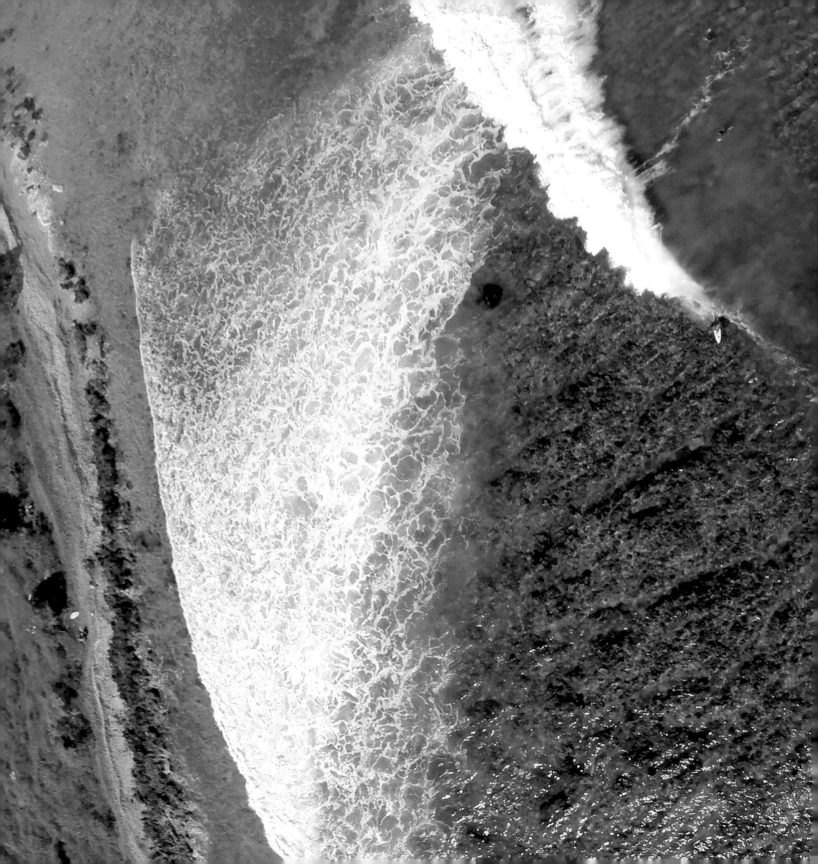

Preface

AS STORYTELLERS AND MEMBERS OF **GoPro's** media production department, we feel blessed to have been able to contribute to a dynamic company and watch GoPro grow from a tiny startup to the leading international brand that it is today. This book is an attempt to sum up everything we have learned about capturing and editing GoPro content during that time. This is the book we wish we'd had five years ago, when we first started making videos for GoPro. We've taken special care to make the contents applicable to all GoPro users, whether you are a seasoned professional filmmaker or a stoked amateur who has pulled the camera out of the box for the very first time.

The videos featured in this book are direct examples of what is being discussed in the text, and we highly recommend that you watch them as you flip through the pages. There are several ways to access these videos:

- Go to www.peachpit.com/GoProBook, where you will find a hyperlink list of all the videos in this book, organized by order of appearance and chapter.

- Scan the QR codes provided in the video bar using a smartphone or tablet equipped with a QR app.

- Use YouTube or Google to search for the video's title.

- Enter the URL link directly into the address bar of a web browser.

- In the e-book version of this book, you can just tap the link.

With each video, we have tried to give credit to the principal GoPro production artists involved in its creation. This isn't always easy. Crew members and editors often help direct productions, and directors often work with editors in the editing room. Everyone wears many different hats, so we have tried to credit everyone in their primary role to avoid redundancy. Of course, many other un-named individuals are involved in these projects. We appreciate all the time, efforts, and patience of everyone involved in our collaborative style of filmmaking.

Anthony Walsh / Tahiti Drone Photo/.5sec

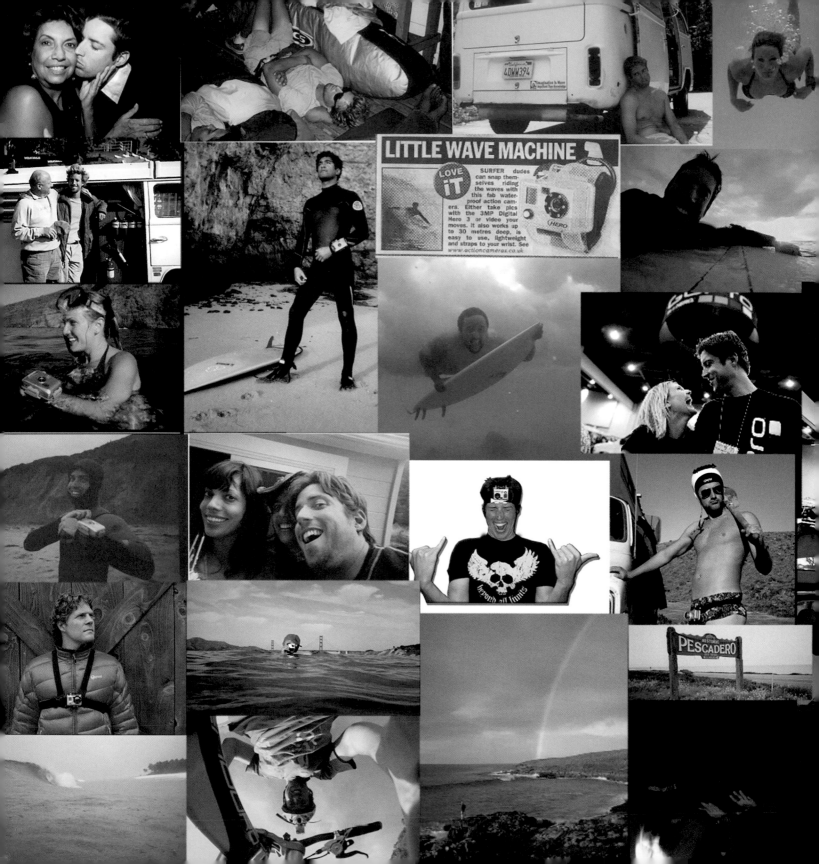

LITTLE WAVE MACHINE

SURFER dudes can snap themselves riding the waves with this fab waterproof action camera. Either take pics with the 3MP Digital Hero 3 or video your moves. It also works up to 30 metres deep, is easy to use, lightweight and straps to your wrist. See www.actioncameras.co.uk

LOVE iT

HERO

PESCADERO

INTRODUCTION

History of GoPro

As recalled by Bradford Schmidt

IT WAS 2002. I WAS back home after three years of traveling, holding in my hands dozens of 35mm photographs still warm from the printing machine at my local pharmacy. My brother was there, thumbing through the photos with me. I hoped these pictures might be enough to convince him to return with me to a magical set of remote islands that were being whispered about in the surfing community—the Mentawais. Although it had been a surf trip, any pictures of myself actually surfing were conspicuously absent. I had traveled alone, so all the shots were limited to perfect waves without a surfer in sight, taken from the beach before I paddled out. The photos felt strangely empty, considering the euphoria I'd experienced riding those waves.

The results were going to be different the next time, however I scraped together enough funds for another round-the-world ticket and bought an expensive waterproof 35mm camera. Several months later, my brother and I stepped onto the wooden planks of an old ferry leaving from Padang, Sumatra, for the far-flung Mentawai Islands. On the back deck of the ferry, where we strung our hammocks and surfboards, lay a fair-skinned, blonde-haired woman taking a nap. Strange. This was a locals' ferry... typically no Westerners. Then from the depths of a cargo hold filled with fluttering chickens and bleating goats came a distinct laugh, warm and booming. A wild-haired Nicholas Woodman was charming the captain of the ferry with his broken Bhasa and salty grin.

On the overnight ferry, we learned that Nick had graduated from the University of California, San Diego with a major in visual arts, though he had no interest in a normal job. He wanted to be an entrepreneur. He'd started a company called FunBug during the dotcom era, but it had gone bust after a couple of years. Reeling from that failure, he decided to spend his personal savings on an extended surf trip to stretch his mind and gather inspiration for his next venture. Nick also came prepared to document his love for surfing. He'd combined a surf leash, a series of O-rings, and a disposable waterproof camera—the first GoPro prototype.

Over the next two months, my brother, Nick, his girlfriend Jill (now his wife), and I became tight companions, traveling together from wave to wave and island to island. Nick and I connected through our mutual love of photography and our desire to get the shot. We surfed many sessions experimenting with his prototype wrist camera, dreaming of the possibilities of where such an idea could go.

After that trip, I continued on to Africa and traveled for several more years while Nick returned to California to start GoPro. All the while, Nick was busy patenting the wrist strap design and trying to get his company off the ground. Originally, his vision was to develop a wrist strap that was interchangeable with any disposable camera and license the idea to a larger company. But that process proved to be too slow and difficult and Nick determined there was more opportunity in developing his own camera specifically designed for his wrist strap invention.

By 2004, I was living in San Diego working as a surf instructor. One day, I got a call from Nick asking me to help him set up his booth at the local surf industry trade show. Nick and Jill drove down and picked me up in their VW bus. We set up a quaint little booth complete with faux Roman pillars Nick borrowed from his parents and large Kinko's printouts of GoPro's first product: a waterproof wrist camera named HERO. There we were, a tiny little idea surrounded by the titans of the surf industry. As we parted ways after the trade show, Nick handed me a HERO camera to use on my next adventure, working on boats in the Caribbean and surfing in Mexico.

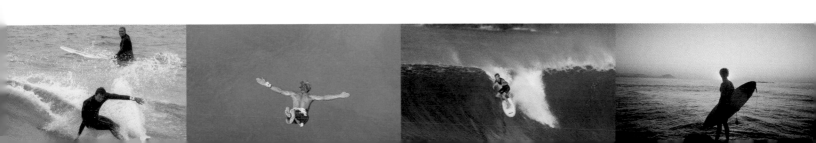

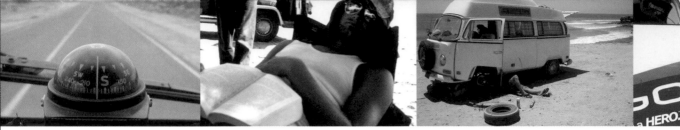

A year later, I returned to California. Jill picked me up in San Francisco and drove me down to Pescadero where their 1971 yellow VW bus named "Lily" waited for me. I was to buy it and live in it while attending film school. Woodman had been developing the first digital version of his HERO camera. Operating on one AAA battery, it could record 10 seconds of low-res video at 240p, somewhere around 20 frames per second, with no audio. He was ecstatic about the possibilities... a tiny video camera the size of a matchbox! Having been entrusted with one of his new prototype cameras, I drove away in my new bus and picked up my childhood friends Brandon Thompson and "Big Metal" Todd Henry and headed south to Baja. Most of our product testing took place around Scorpion Bay. It was there that we recorded the first ever GoPro follow-cam shots and the 1971 VW bus became known as "The Chupacabra."

In 2007, I was still at UCLA studying filmmaking when Nick released his second generation digital wrist camera, the Digital HERO 3. It captured three-megapixel photos, and was a quite innovative for its time. By then, GoPro was doing well enough that Nick could afford to attend race driving school, another one of his passions. During school, Nick had the idea to strap his digital wrist camera to the roll bar of his car to record video of himself driving on the track. As soon as Nick stepped back and saw his wrist camera mounted in this new way, a lightbulb turned on and Nick suddenly realized that GoPro could be much more than just a wrist camera company.

Digital HERO Soul Arch

"Big Metal" Todd Henry tries out his soul arch at an ultra-secret surf spot in Baja that is definitely not Scorpion Bay. Shot on the Digital HERO in 2006.

https://vimeo.
com/109760084

Filmer: Bradford Schmidt
Editor: Brandon Thompson

That summer I was headed back down to Baja again with my friend Brandon, and before we left a box arrived from Nick. It contained a few of his Digital HERO 3 cameras, several prototype water-housings, a bunch of adhesive-backed, 3D-printed mounts for attaching the cameras to surfboards, a vented helmet strap, and most importantly, experimental wide-angle lens adapters. Brandon and I used duct tape to attach the lens adapters to the waterhousings and used surf wax to waterproof the lens elements. Somehow, the adapters worked well enough and Brandon and I were inspired to shoot the first (and perhaps the silliest) GoPro story: "The Last, Greatest Epic Spot."

In the Fall of 2008, Nick gave me a call to say there was no need to duct tape and surf wax seal the wide angle lens adapters anymore. He wanted to fly me to Bali for a week and even pay me. I just needed to bring home tropical barrel shots with the first ever wide angle GoPro: the Digital HERO 5 Wide.

The Last, Greatest Epic Spot

A couple of friends, a VW Kombi, and an end-of-the-world south swell all come together in GoPro's first story piece. Shot on the Digital HERO 3 in 2007.

Filmers: Bradford Schmidt, Austin Schmidt, Brandon Thompson, Cameron Barsanti
Editors: Bradford Schmidt, Brandon Thompson

https://vimeo.com/
109965533

Weeks later, I walked straight off the plane from Bali to another ASR tradeshow in San Diego to deliver the golden shots. But this time, I didn't find a small booth with faux Roman pillars. GoPro had several big-screen TVs, a motorcycle, a race car, and a sports car in a big open space next to the titan surf companies. Alongside Nick and Jill were Neil Dana, Ruben Ducheyne, Vince Geluso, Damon Jones, and Justin Wilkenfeld. All were friends of Nick's who had helped grow GoPro over the past few years. Nick had hired his college friends on the theory that working with friends made work feel less like work. Not a bad theory, as it turns out.

At that tradeshow, a USC ski crew convinced Justin to sponsor them with two new wide-angle GoPros. That winter, future Senior Production Artist Abe Kislevitz and the USC ski crew would make a ski video like nothing we'd ever seen before.

USC Ski & Snowboard Video of the Week

One weekend, two cameras, one ski team. EPIC. Shot on the Digital HERO5 Wide.

http://youtu.be/
nDMJYyrynNA

Filmers: Abe Kislevitz, Chris Farro, Caleb Farro, Matt Cook
Filmer: Abe Kislevitz

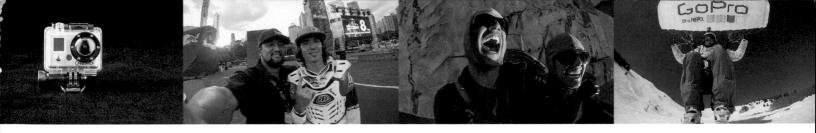

A year later, in August 2009, a little cardboard box arrived at my doorstep. It was actually Brandon's doorstep—I had only just graduated from film school, was unemployed, and was sleeping on his couch. Inside the box was a prototype GoPro HD HERO... 1080p. I was expecting it as Nick had called me the day before to tell me he was sending me his latest and greatest camera. "This is going to change everything," he'd said. Up until that point GoPro felt more or less like a cool hobby idea my good friend had come up with. I picked up the camera and walked outside to shoot some sample footage in the parking lot. Once I came back in and watched the footage on my computer, I started freaking out and called Nick:

"Nick! This camera is going change everything," I yelled.

"Dude, I know! That's what I was telling you!" Nick shouted back.

"So what do you think?" he then asked. "Do you want to move up here full-time and start a YouTube channel for GoPro?"

"Yes, my friend. Yes."

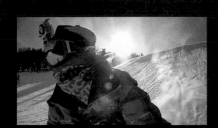

GoPro 2010 Highlights: You in HD

We shot 100% of this video with the HD HERO® camera.

Filers: GoPro Media & Athletes
Editors: Bradford Schmidt, Abe Kislevitz, Brandon Thompson

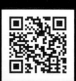

http://www.youtube.com/
watch?v=yo3M6EB8kmk

It seems only a short time, but a lot has happened since then.

It's often said that success can have strange effects on people, especially between friends. There is a fear that the essence of the friendship and the purpose of the things you work so hard to achieve will be lost. Such has not been the case at GoPro. It's still a company of friends—only there are more of us. Nick's desire to bring his friends together on a shared quest has made GoPro a family. Everyone cares about each other as much as we care about the company.

Success hasn't changed who we are, and for that I am so grateful. Jill's laughter today is as infectious as the first time I heard it on the Sumatran seas. Nick's voice retains that resonating warmth, and that curious sparkle in his eye has only gotten brighter with time.

NASDAQ, New York City

By the start of 2014, GoPro had become the No. 1 brand channel on YouTube.
On June 26th, 2014, GoPro became a publicly traded company.
The IPO valued GoPro at several billion dollars.

GoPro Primer

GOPRO'S CREATOR, NICHOLAS WOODMAN, DESCRIBES a GoPro as a *proactive* capture device, which differentiates itself from *reactive* capture devices such as smartphones. A proactive capture device encourages users to think about what they are doing and how they are going to capture it beforehand. Although many books out there show you how to use a traditional camera, this is the first book demonstrating how to tap the true potential of your GoPro to capture immersive and engaging content from an unlimited range of perspectives.

GoPro is marketed as a professional quality yet easy-to-use consumer camera. You can take it out of the box, mount it, and press a button. Generally speaking, you'll have a good chance of achieving great results due to the GoPro's simplicity and performance. And while leaving the camera in its default settings is fine in most cases, you'll be missing out on all the versatility this powerful tool has to offer. We believe that understanding the GoPro's full capabilities is the first step to consistently capturing powerful content.

Gunnar Jeannette / Daytona International Speedway Helmet 1080p30/Photo/5sec

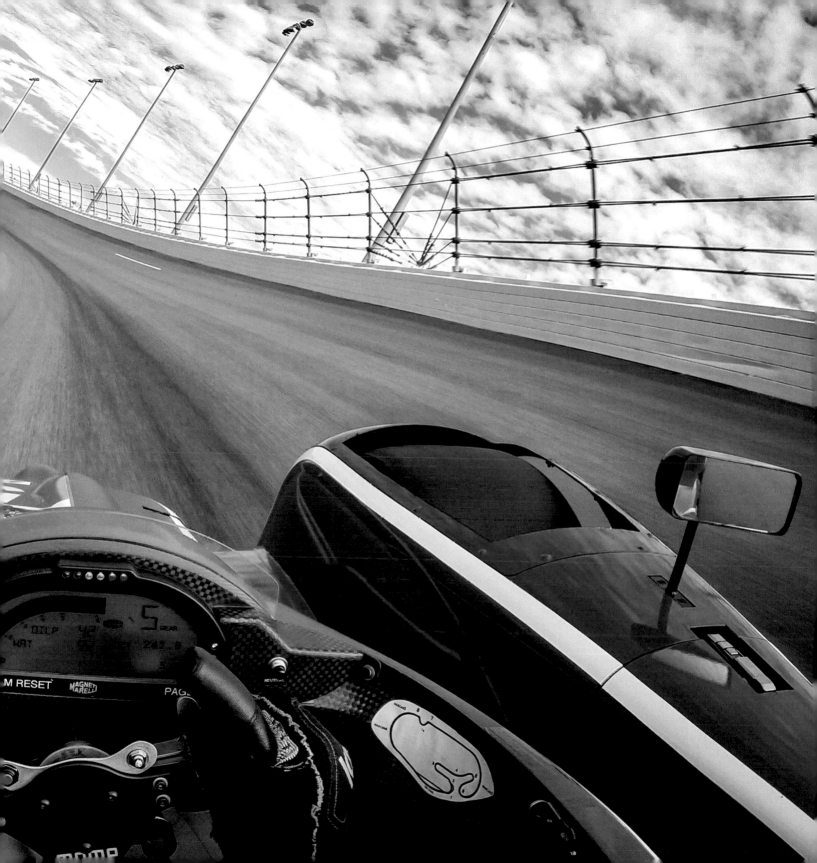

Basic Definitions

The world of digital photography and video features plenty of jargon, and it can be intimidating if you're just getting started. The basics aren't too complicated, however. To best understand your GoPro, you should have a handle on a few concepts: resolution, aspect ratio, field of view and frame rate. In the following section, we define these terms and also touch on the basics of image processing with respect to video quality for more advanced users.

Resolution

The resolution of a digital image refers to the size of the image as measured in picture elements, or *pixels*. More pixels equals bigger image equals higher image quality. Photo and video resolutions are measured differently.

Photo resolution is typically measured in millions of pixels, or *megapixels* (MP). For example, the highest resolution photo possible from the GoPro HERO4 Black Edition is 4000 pixels wide by 3000 pixels high: 4000 × 3000 = 12,000,000 pixels, or 12 MP.

Video resolution is usually measured by width and height, often using only the height for short-hand. Video with dimensions of 1920 pixels wide by 1080 pixels high can be called 1920 × 1080, or shortened using the vertical dimension alone, to 1080, or in the GoPro's case, 1080p (the *p* stands for *progressive* and describes how the image sensor records video information). For wide-screen resolutions over 1080p, the shortened form is expressed using the width instead. Video shot in 2.7K has dimensions of 2704 pixels wide by 1520 pixels high, and can be referred to as 2704×1520, or simply 2.7K.

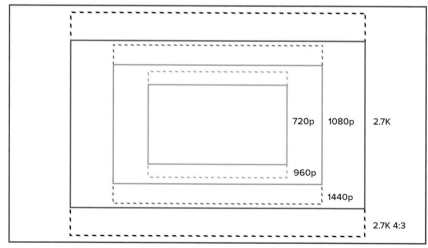

Aspect Ratio

Aspect ratio is the ratio between the width and the height of an image. A GoPro primarily captures video in two aspect ratios: 4:3 and 16:9. The 4:3 ratio produces a taller squarish frame, the standard ratio for older televisions and computer monitors. The 16:9 ratio produces a wider and more rectangular frame, the traditional widescreen ratio that is the shape of many modern HD TVs and laptop displays.

The number of pixels in the width and height are usually reduced to their simplest terms. 1920:1440 contains large numbers that are hard to visualize. The reduced ratio of 4:3 is the same thing and it's easier to wrap our minds around. 4:3 tells us that for every 4 pixels of frame width, there are 3 pixels of height—in real-world terms, the frame is squarish, just a bit wider than it is tall.

GoPro's media production team often captures video in 4:3 aspect ratio because point-of-view angles from locations such as the helmet or chest require a taller frame to capture all the action. Head strap, helmet, chest, and surfboard mounts...pretty much any body or gear-mounted shot benefits from a 4:3 resolution. Fixed perspective shots involving less rapid direction changes, such as those from a vehicle or tripod, are inherently more stable and are thus prime candidates for widescreen, 16:9 resolutions.

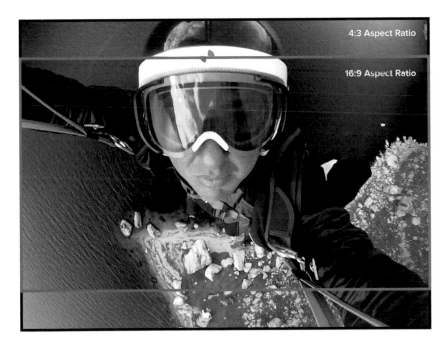

Marshall Miller / Norway　Gnarwhal　960p30

SuperView

Displaying 4:3 video is an issue nowadays because virtually all video players use widescreen ratios like 16:9. Displaying 4:3 in widescreen yields black bars on each side of the screen. In a number of GoPro's early videos, you will see these characteristic black bars. In those days, we didn't really know what to do with the 4:3 aspect ratio except to leave it, or zoom in and crop out the black bars. Later in editing we learned how to dynamically stretch 4:3 footage while retaining the proportions in the center of the frame. The next logical step was to do this in-camera, and thus SuperView was born.

SuperVIew is currently available in 4K, 2.7K, 1080p, and 720p. It can be a great option for those who want to avoid the manual process of cropping or stretching their 4:3 footage and it is best suited for body-worn and gear-mounted scenarios when you want to capture the maximum view angle for the most immersive and stable footage. For advanced users seeking ultimate creative control we recommend experimenting with cropping or stretching footage yourself (see the "Cropping and Stretching" section in Chapter 5). There is an advantage to the HERO4 Black's 4K SuperView, however, in that GoPro's 4K resolution doesn't have a 4:3 aspect ratio equivalent. If you are editing on a 4K timeline, 4K24 SuperView is the highest resolution option for POV footage, though it is only available in 24 fps.

Field of View

Field of view, abbreviated as FOV, refers to the extent of the visible world that the camera's lens is capable of capturing, as measured in degrees. Traditionally, rounder, shorter lenses capture more of the world and are thus said to be "wide," while longer, flatter lenses capture less of the world and are "narrow." The GoPro has an ultrawide lens that, while shooting in the default Wide mode, can capture 170 degrees of the world in front of it.

While a traditional camera's FOV is changed by switching between lenses, the GoPro's field of view can be varied electronically. It does this by sampling smaller areas of the image sensor. The GoPro's Wide, Medium, and Narrow modes have FOVs of 170, 127, and 90 degrees, respectively. Because the purpose of 4:3 resolutions is to offer the maximum possible FOV, only 16:9 resolutions

offer optional Medium and Narrow FOVs. The narrower FOV causes all objects in the frame to appear closer. It also produces less lens distortion around the periphery of the frame and simulates the long lens look of a more traditional camera.

- Wide (170 degrees) = 14 mm Focal Length

- Medium (127 degrees) = 21 mm Focal Length

- Narrow (90 degrees) = 28 mm Focal Length

Medium FOV is best used for static and stable mounted shots, such as a tripod or steadicam. We use Medium for interviews and wide shots because faces and horizons appear less distorted. Narrow FOV is used for specific shots, typically when you have restricted access or where close camera placement is impossible.

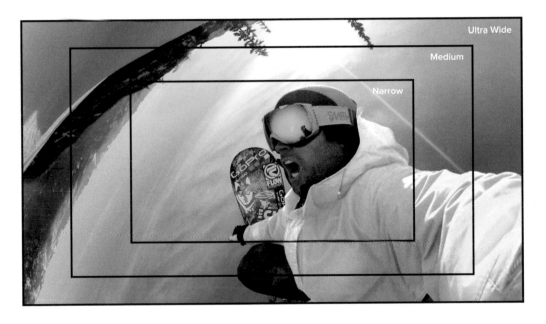

Mike Basich / Tahoe, California ⚷ Handheld 📷 Photo/.5sec

Frame Rate

Video is essentially a series of pictures, often called *frames*, captured at a high rate of speed. The speed at which these frames are captured is known as frame rate, and it is measured in frames per second (fps). The standard frame rates used for television in the world today are 30 fps in the United States, and 25 fps in parts of Europe, Asia, and elsewhere. The GoPro is capable of capturing video at both 30 and 25 fps, as well as many other frame rates.

It's important to differentiate between capture frame rate and playback frame rate. While a video may be captured at 60 fps, you can later play that footage back at any speed you choose. Playing it back at 60 fps gives the video normal speed—because the action is played back at the same speed it was captured. Playing the same video back at a lower speed such as 30 fps results in slow motion. Playback at a higher speed such as 120 fps results in fast motion.

Another important thing to note is that video's frame rate directly affects exposure time. Lower frame rates allow more time for light to register on the sensor for each frame, which is useful for low light. High frame rates, on the other hand, are best suited for bright sunlight.

For simplicity, GoPro users often combine both resolution and frame rate when talking about the camera's video modes. Shooting 1080p resolution at a 60 fps frame rate can be abbreviated as shooting 1080p60.

30 fps

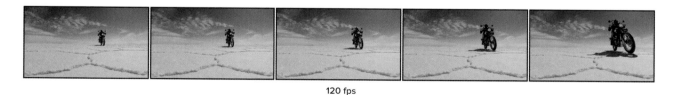

120 fps

Kyle Camerer, Joseph Johnson / Bolivia Static 720p120

Suggested Modes for Maximum Quality

In general, as sensors for digital cameras gain higher resolution and video mode options get more numerous, a balance must be found between the frame rate, number of pixels, the FOV, and what the processor can handle. To allow for certain combinations of resolutions and frame rates that might otherwise be challenging for the processor to compute, a digital camera's firmware may use different methods of lowering the pixel count that is being read off the sensor at any one time. These methods of reducing pixel count are referred to as 'binning' and 'skipping' as opposed to 'native,' which is the term used when all of the sensor's pixels are being read from the sensor.

Native capture yields the highest image quality. With native, one or more pixels in the image sensor correspond to a single pixel in the output image. Binning and skipping allow for higher frame rates by combining pixels in order to reduce the load on the processor. Cropping is another technique that allows for higher frame rates as the camera reads a smaller "cropped" portion of the image sensor's pixel area. Cropping is also often used to produce a smaller FOV.

A camera's processing power matters because it ultimately affects the amount of data that gets read and utilized from the sensor. Generally speaking, more data means better image quality. Keeping maximum image quality in mind, our media department's resident image quality guru Abe Kislevitz has compiled a list of recommended modes for the HERO4 Black:

- **4K30:** For static or very stable mounted shots (non-POV) that DON'T require slow motion.

- **2.7K48 Wide and Medium:** For non-POV shots that DO require slow motion.

- **1080p120 Narrow:** For non-POV shots that require super slow motion.
 1080p120 Wide is also good but has a bit more aliasing.

- **2.7K 4:3:** For body or gear-mounted shots (POV) that DON'T require slow motion.

- **1440p60:** For POV shots that DO require slow motion.
 1440p80 is also good but has a bit more aliasing.

- **960p120:** For POV shots that require SUPER slow motion.

Photo Modes

In 2010, world champion longboarder Harley Ingleby paddled out at a break in New South Wales, Australia. Attached to the nose of his board was his 5 megapixel HD HERO. As a set rolled in, Ingleby pressed the shutter button and began recording in time-lapse photo mode, automatically capturing a photo every 2 seconds. He swung his board around, caught a wave, and pulled into his first barrel of the day. As GoPro-luck would have it, one of the photos captured on this wave became the cover shot of *Australian Longboarding* magazine. Ingleby later told us this was the first time he'd ever tried shooting time-lapse photos with his GoPro. Until then, he'd only captured video.

Since then, GoPro has continued to push the photo-capture limits of its cameras. The HERO4 Black can capture 12 megapixel photos at time-lapse rates of a photo every 0.5 seconds and burst photos at speeds up to 30 photos per second. The HERO4 added photo-specific Protune settings (much like those of video) and powerful new Night Photo and Night-Lapse modes, which feature adjustable long exposure times from 2 to 30 seconds. These improvements, combined with the rising popularity of photo sharing platforms such as Facebook and Instagram, have made GoPro the tool of choice for self-capturing immersive and engaging photos.

As a side note, Ingleby's cover shot was monumental for another reason. Nick Woodman had grown up reading surfing magazines and was enamored by the lure of the "cover shot." When he first started GoPro, he dreamed of the day when one of his cameras would capture a cover shot for one of his customers. Eight years later, Ingleby's cover, GoPro's first, brought tears to his eyes.

Harley Ingleby / New South Wales, Australia 🔱 Surf Mount 📷 Photo/2sec

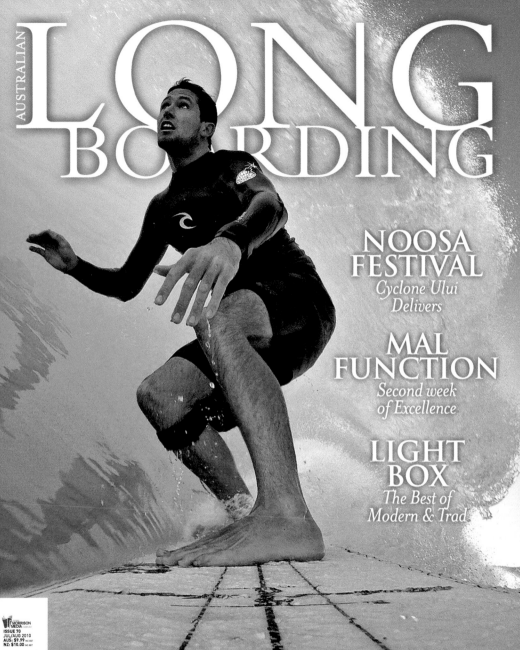

AUSTRALIAN
LONG BOARDING

NOOSA FESTIVAL
*Cyclone Ului
Delivers*

MAL FUNCTION
*Second week
of Excellence*

LIGHT BOX
*The Best of
Modern & Trad*

MORRISON MEDIA
ISSUE 70
JUL/AUG 2010
AUS: $9.99 INC GST
NZ: $10.00 INC GST
04

ISSN 1442-6759

9 771442 675002

BOARDROOM
Backyard Bunk House

PERCEPTIONS
Inscrutable Chinese Tale

STATE WRAPS
Grassroots News Australia-wide

LIFESTYLE
Byron Bay, Wheels, Planet, and more

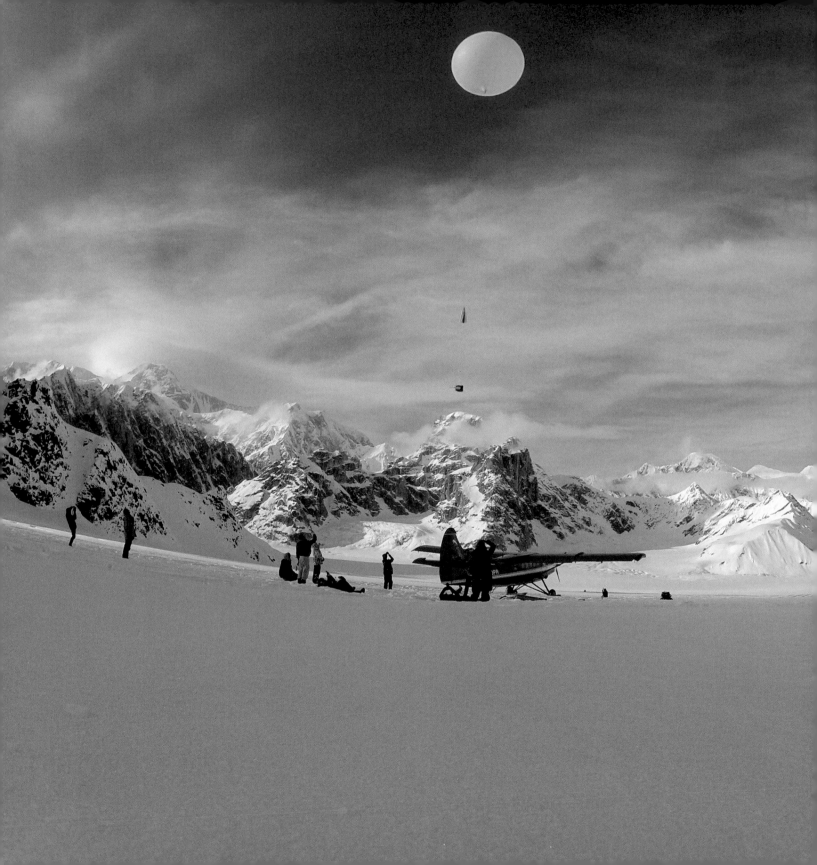

Time-Lapse Photos

Resolution	Photo Rates
12, 7, 5 MP	.5, 1, 2, 5, 10, 30, 60 second intervals

Time-lapse photo mode and video are two of the camera's most frequently used functions. The traditional definition of time-lapse is a series of photos combined to create a moving image on a video timeline. It gives an otherwise unseen view of time—sunsets, clouds zooming by, or plants growing. Time-lapses are useful in storytelling because they can introduce an environment, add variety to a montage, or control a video's pacing. Chapter 5 discusses such functions in more depth.

GoPro has expanded the role of time-lapse photo capture to also include the capturing of high quality, never-before-seen photos of intense action. This was a simple solution to the user's inability to press a shutter button while being upside-down or spinning in mid-air. Shooting half-second photos has become the most popular use of the GoPro time-lapse function, and many of the photos in this book were captured this way.

Shorter interval time-lapses have some trade-offs. In order to accomplish .5 and 1 second time-lapses, the processor must compress the images more. Less exposure time occurs per photo as well. In bright sunlight, you won't notice a difference, but in clouds, shade, or low light, this setting is less ideal. The 2, 5, 10, 30, and 60 second modes have ample time for exposure, and the images will be less compressed.

With the HERO4 came new photo-specific Protune settings which include white balance, color profile, ISO limit, sharpening, and exposure compensation (see the upcoming section, "Protune," for more details). During the day, you'll generally get the best results by leaving all of these settings in AUTO mode. If you are inclined to experiment, photo white balance should only be changed for a specific reason, such as while shooting night photos or time-lapses (we cover these in the next section). We recommend using GoPro Color for your color profile, unless you are a color grading professional. ISO limit performs similarly to video, but is limited to 800 on the high end. The lower the ISO, the less grain will appear in your image. Set on auto during the day, the camera will hover around 100 ISO. However, night-lapses are a different case. We always set sharpening at low for more control while editing and coloring our photos. For the most part, we recommend setting the exposure compensation to 0, but it can be advantageous to set compensation to -.5 to keep highlights from blowing out.

Jordan Miller / Alaska ⚑ Tripod 📷 Photo/2sec

Kevin Custer / San Francisco Tripod 20sec Exposure, ISO 400

Night-Lapse Photos

Exposure Settings	ISO Limit
Auto, 2, 5, 10, 15, 20, 30 seconds	.100, 200, 400, 800

GoPro's night-lapse function was introduced with the release of the HERO4. During the day, a photo will typically expose between 1/60th and 1/8000th of a second. The night-lapse feature allows the camera to expose from 2 to 30 seconds, thus allowing more light to enter the camera's image sensor. Night-lapse is perhaps the most complex GoPro capture mode as it requires some forethought and a few nights of trial and error to perfect.

The Auto setting has a wide variety of uses. If there is ample light such as from a city, cars, or street lights, the Auto setting can be a good choice. It will automatically adjust for exposure up to 2 seconds. Freeway driving, cityscapes, and campfires work well in this mode. Auto setting is also ideal for day-to-night transition time-lapses such as sunrises and sunsets, both of which require a broader exposure range than the standard GoPro time-lapse provides.

Exposure settings beyond Auto require more consideration. The manually selected 2- and 5-second exposure times are great for cityscapes, thunderstorms, fireworks, and light painting. 10-to-20-second exposures work well for full moon landscapes and rural settings. With these longer exposures, try lowering the ISO in Protune for less grain (but also less light). 30-second exposures with an 800 ISO will yield the best star-lapses. For the brightest stars, try pointing the camera away from the moon's trajectory across the night sky, as the moon in the frame will over-power the stars' twinkling. However, the sliver of a moon can also give spectacular exposure to foreground landscape elements and give perspective to the stars travelling across the night sky.

Keep in mind the HERO4's new Protune settings for photos when capturing at night. White Balance and ISO settings will differ for every situation. A good rule of thumb is: 5500K works for a neutral setting, while a higher ISO will give a brighter image but also more noise. We almost always test out a few night photos and check to see if all the settings are correct before leaving the camera overnight. We recommend keeping the Interval setting to continuous, unless for a specific reason.

It's wise to make sure your HERO4 is safe and protected during a night-lapse. If it's a 30-second exposure, you'll most certainly leave it and go to bed. Try using a durable external battery with USB plug to keep your camera powered all night long. GoPro's Battery BacPacs are great in a pinch, but only last for a few hours. Generally speaking, a frame mount is ideal because the heat of the camera will keep dew from forming on the lens. If there is rain or possible weather, however, try using a skeleton housing and a zip-lock bag for your external USB battery.

Burst Photos

Resolution	Photo Rates
12, 7, 5 MP	30 photos per 1 or 2 or 3 seconds
	10 photos per 1 or 2 seconds
	5 or 3 photos per 1 second

A time-lapse photo every half second is good for blanket photo coverage through an entire run or session. But sometimes even a half-second interval doesn't capture the exact frame you want. Looking through a half-second photo stream, you'll inevitably find those moments where the camera *almost* captured the perfect shot. Even with video, when looking frame by frame, you will always spot that one frame that makes you say to yourself, "If only THAT were a photo!"

Burst Photo Mode was designed just for this kind of situation. Burst captures 30 full resolution photos per second. Burst also features settings for capturing 30 photos over 2 or 3 seconds, giving a little bit of margin for error when pressing the shutter button as you leap off a cliff or attempt to photograph your friend's incredible feat... or folly.

To achieve really precise burst photo timing, try using GoPro's Smart Remote or App. The handheld Smart Remote allows the user to precisely trigger the camera right before the action happens while the GoPro App does the same if you're able to have a smartphone or tablet accessible while filming.

The compression and file sizes of burst photos are similar to those of .5 and 1 second time-lapses. However, the exposure is set only once at the very first frame, and remains the same throughout the next 29 photos.

Pedro Grimaldi Garcia / Newquay, England Static Burst

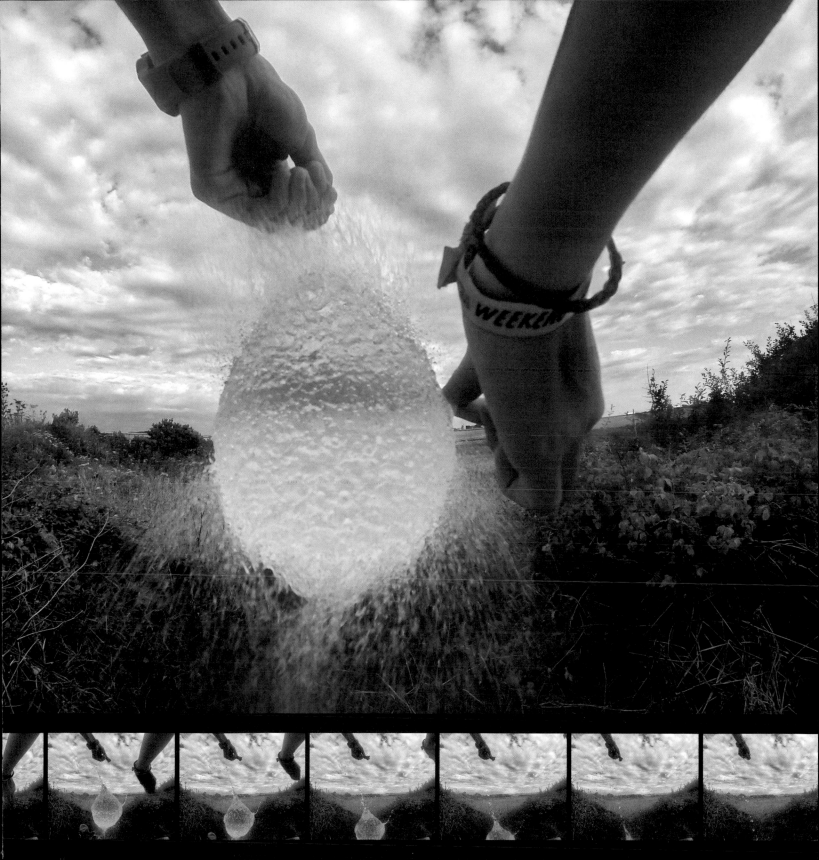

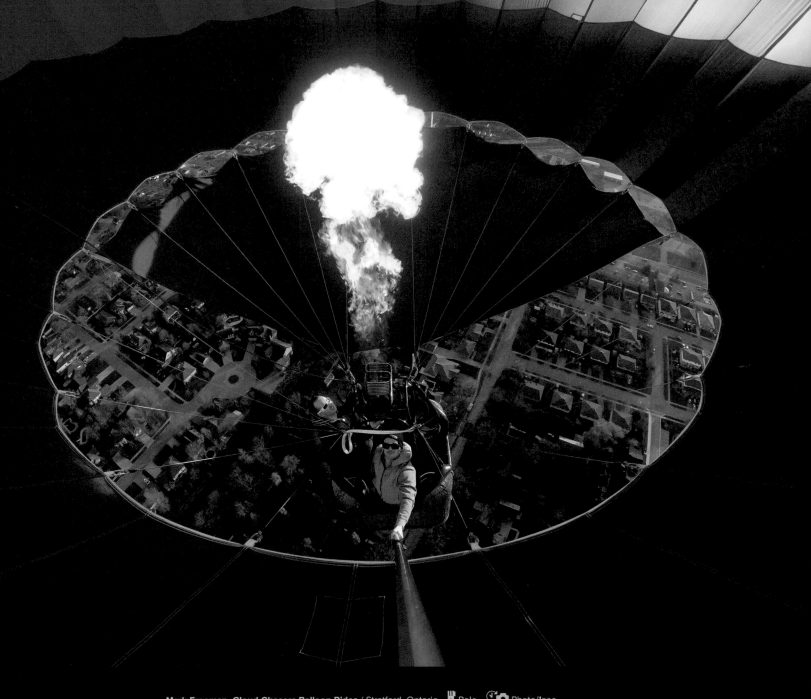

Mark Freeman, Cloud Chasers Balloon Rides / Stratford, Ontario ⛳ Pole 📷 Photo/1sec

Video Modes

1080p120. 2.7K48. 1440p80. 4K30, and so on. Why does GoPro offer so many different video settings, anyway? One reason is the need for multiple aspect ratios: the GoPro's 16:9 and 4:3 video modes are designed to capture so many different activities from so many different perspectives. Another has to do with the realities of image processing limitations and the trade-off between resolution and frame rate. Higher resolutions limit the number of frames per second a camera can capture. So when ultra high resolution and detail are the goal, then a slower frame rate may be required. When super slow motion is your aim, then a higher frame rate takes precedence and you may need to shoot in a slightly lower resolution. 2.7K48 is a great example of a resolution and frame rate that effectively balances both sides of the equation.

This is all well and good. But it doesn't answer the question most GoPro users will inevitably face, which is: "What mode should I shoot in?" The good news is that the answer to this question matters less than you might think.

In the fall of 2012, GoPro released the HERO3, which surpassed most consumer cameras in both maximum resolution and frame rates—a testament to our engineering team's capabilities. In January, we needed a 30-second commercial to air during the Super Bowl, the most widely viewed forum for advertising in the world. It was the perfect opportunity to showcase a video shot on the newly released, 1080p60 capable HERO3. Yet, what video did we choose? Dubstep Baby, a customer video shot in the sub-premium 720p60 resolution on our first generation HD HERO camera. Why?

Because content is king. At the end of the day, the actual content being captured is more important than the resolution or frame rate it is captured in. So if you're feeling anxious about whether or not the mode you're using is correct, don't worry. Throughout this book we aim to help you learn without getting bogged down by the numbers. As long as you're passionate and focused on creating great content, the technical knowledge will come naturally with experience.

Super Bowl 2013 Dubstep Baby Commercial

Baby Charlie Ray goes for a tour of the house in GoPro's commercial for Game Day! Shot on the HD HERO in 2012.

Filmer: Jeff Wick
Editor: Kyle Camerer

https://www.youtube.com/watch?v=3luc-03ZJuU

720p

Resolution	Aspect Ratio	Frame Rate	FOV
1280×720 pixels	16:9	30, 60, 120 fps	Ultra Wide, Medium, Narrow

Introduced in November 2009, the original HD HERO was capable of capturing both 1080p30 and 720p60 video. While 1080p30 was impressive, 720p60 really showed the world what a GoPro could do. Prior to this, point of view (POV) action footage was typically filmed through a narrower FOV lens at 30 fps. You might see a shaky POV shot cut into your favorite 1980s- or 1990s-era ski or skateboard movie, for instance. But such shaky footage induced nausea in the viewer, and was considered unwatchable by general audiences for more than a few seconds. 720p60 was our golden mode during the first two years of the HD HERO, from late 2009 to late 2011. This changed with the HD HERO2 as 960p48 became the standard for mounted POV. In the Fall of 2012, we introduced HERO3 which boasted both 1080p60 and 720p120. 720p120 is still a great choice for complex high action activities, such as Kalani Chapman's End of the Road barrel at Teahupo'o, filmed on the HERO3 and featured below. Note the considerable difference in speed to a similar shot he captured at Cloudbreak, which was filmed in 720p60 on the HD HERO2 (also featured below). While most people would usually use 4:3 aspect ratio modes for mounted shots like these, in both cases Chapman chose to forgo the extra coverage for a higher frame rate.

End of the Road with Kalani Chapman

Kalani Chapman snags a clean, 12–15 foot drainer at Teahupo'o in Tahiti. Shot in 720p120 on the HERO3 in 2013.

https://www.youtube.com/watch?v=7xtxVNCbtZ4

Filmers: Kalani Chapman, Pete Hodgson
Editor: Davis Paul

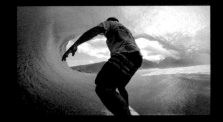

Endless Cloudbreak Barrel with Kalani Chapman

Kalani Chapman shows us what riding an endless wave feels like at Cloudbreak in Tavarua, Fiji. Shot in 720p60 on the HD HERO2 in 2012.

https://www.youtube.com/watch?v=wJ7thHYw-PM

Filmers: Kalani Chapman, Pete Hodgson
Editor: Jordan Miller

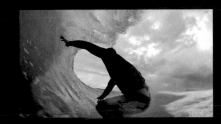

960p

Resolution	Aspect Ratio	Frame Rate	FOV
1280×960 pixels	4:3	60, 120 fps	Ultra Wide

960p is an innovative 4:3 resolution that GoPro introduced in the first HD HERO. Designed to provide 25% more vertical viewing area than 16:9 resolutions, such as 720p and 1080p, 960p makes it easier to capture your knees and skis AND the horizon while skiing, or the handlebars and front fender of your bike AND the track ahead while racing motocross. The result is a much more immersive and stable viewing experience that better mimics your natural vision. An added sense of stability comes from having less relative motion in the scene relative to the viewing area of the scene. Just consider the difference in stability between a video shot with a hand-held telephoto lens versus one shot with an ultra-wide GoPro lens. Every bit of motion is far less noticeable and distracting when the relative FOV is larger.

960p was the go-to mode for the media department and was responsible for nearly all mounted footage prior to the release of HERO3. Today, the HERO4's 1440p gives the same taller aspect ratio as 960p but with twice the resolution, and so is much preferred. The primary reason to use 960p now is for the 120 fps super slowmo.

Professional motocross and stunt rider Ronnie Renner filmed the first ever motocross video to make it to the GoPro Channel on YouTube. This was before we knew about dynamic stretching and SuperView, so black bars are present on either side of the frame. The beauty and effectiveness of 960p are perfectly illustrated as the horizon, Ronnie's hands, handlebars, and front fender are always in the frame.

Ronnie Renner at the MX Track

Ronnie Renner on an early morning practice session at Pala Raceway. Shot in 960p30 on the HD HERO in 2009, Ronnie shows how the 4:3 aspect ratio captures both horizon and handlebars.

Filmer: Ronnie Renner
Editor: Bradford Schmidt

https://www.youtube.com/watch?v=VIzJBrFXmal

1080p

Resolution	Aspect Ratio	Frame Rate	FOV
1920×1080 pixels	16:9	24, 30, 48, 60, 90, 120 fps	Ultra Wide, Medium, Narrow

Back in 2009, watching full 1080p from atop a race car flying over the track at 150 mph on a large HDTV was a hypnotic and near-religious experience. It was the kind of content viewing experience that made believers out of thousands of customers visiting our booth at GoPro trade shows. The original HD HERO featured 1080p30 which, unlike 720p, was considered "true" HD and gave GoPro industry cred as a fully high definition camera. Due to sensor limitations, the HD HERO's 1080p had a restricted FOV (127 degrees), which meant it was primarily used for static shots or when the camera would be mounted to more stable objects or devices like a race car. To find wider use thoughout all of our productions, 1080p had to wait several years for the wider FOV that came with the HD HERO2 and the higher frame rates that came with the HERO3. Notice the difference in quality between Nick Woodman's "Formula Car Clip," filmed on the original HD HERO in 2009, and his later HERO3 video, "Grand Prix of Sonoma." The HERO3 delivered 1080p with the largest selection of frame rates and FOVs, and thus it became our go-to resolution for everything except mounted POV, which required the taller 4:3 frame. With the HERO3+ in 2013, came a new 1080p mode: 1080-S or SuperView.

Formula Car Clip

The best part about developing cameras at GoPro is the R&D. Here, GoPro CEO Nicholas Woodman starts from the back of the pack to test out GoPro's HD HERO camera in 1080p back in 2009.

https://www.youtube.com/watch?v=OI7x706ODVM

Filmer: Nick Woodman
Editor: Bradford Schmidt

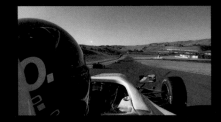

Grand Prix of Sonoma 2013 Celebration

Celebrate the Grand Prix of Sonoma with GoPro CEO Nicholas Woodman and the rest of the GoPro family. Shot in 1080p60 Wide on the HERO3 in 2013.

Director: James Kirkham Producer: Jaci Pastore Editor: Patrick Barrett

https://www.youtube.com/watch?v=k3GRBkf2YBU

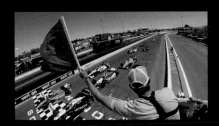

1440p

Resolution	Aspect Ratio	Frame Rate	FOV
1920×1440 pixels	4:3	24, 30, 48, 60, 80 fps	Ultra Wide

1440p was the higher resolution evolution of 960p, with the same 4:3 aspect ratio and frame rates now reaching 80 fps with the HERO4 Black. 1440p adds 180 extra pixels to the top and 180 to the bottom of the traditional 1080p frame, delivering a 25% taller FOV. Like 960p, 1440p is best used for mounted POV shots.

Kelly McGarry's mountain bike run at Red Bull Rampage—GoPro's first un-edited, or "uncut," viral video to top 20 million views—is a great example of how 1440p can help capture a legendary moment. The increased vertical resolution of the screen creates context by showing the horizon and Kelly's bike, and by prefacing the approaching course features in the distance. This extra context keeps the audience from becoming disoriented through the jolts, shakes, and flips of Kelly's epic run. The extra frames from 48 fps give us just enough slow motion through Kelly's backflip to appreciate what's happening. A higher frame rate could have been useful for even slower motion, but due to the cloud cover, 48 fps was the wisest choice for the best exposure. It's also good to note that 1440p frame rates beyond 30fps require more image processing. Our media team generally uses 1440p60 for the best combination of slow motion and image quality.

1440p is downscaled to fit on a 1080p timeline, which most editors are still editing on today. The imminent popularity of 4K, both on Ultra HD televisions and on the Internet, will change all that. For now, modes like 1440p, 2.7K, or 4K that go beyond high definition give the user more options in post-production. Anything that requires image enlargement, such as graphics work or motion stabilization, benefits from the extra pixels. An editor can also use the additional resolution to choose their own frame by pushing in and cropping.

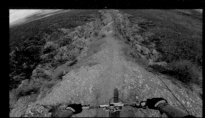

Backflip Over 72' Canyon

Kelly McGarry flips a 72 foot canyon gap at Red Bull Rampage 2013 to earn a second place finish. Shot in 1440p48 on the HERO3, Kelly's run shows the benefit of having a few extra frames to show down the right moment.

Filmer: Kelly McGarry
Editor: Nate Lee

https://www.youtube.com/watch?v=x76VEPXYaI0

2.7K

Resolution	Aspect Ratio	Frame Rate	FOV
2704×1520 pixels	16:9	24, 30, 48 fps	Ultra Wide, Medium

With the release of the HERO4 camera, 2.7K48 mode has become the new 1080p60 in GoPro's media department. Each frame of 2.7K video is essentially a 4 MP photo. It has over 30 percent more resolution with nearly the same frame rate as 1080p60 for slow motion. Sometimes we'll even switch to GoPro's PAL setting at 2.7K50 for an extra 2 fps.

2.7K includes two FOV options: Ultra Wide and Medium. 2.7K Medium is extremely useful and replaces 1080p Medium for most interviews, establishing wides and environmental static shots. The Ultra Wide FOV is great for shooting on vehicles, wide shots, and aerial footage. The short film "Koh Yao Noi" by Philip Bloom provides a perfect example. Composed entirely of 2.7K drone footage, the film was edited on a 1080p timeline. The extra resolution of the 2.7K footage gave Philip plenty of leeway to crop frames and stabilize any shaky drone shots while still retaining full 1080p HD resolution in the final edit.

Koh Yao Noi, a Film by Philip Bloom

Philip Bloom took a holiday in Thailand with his drone and shot this short film entirely in 2.7K. Be sure to watch full screen in the highest resolution! Shot on the HERO3+ in 2014.

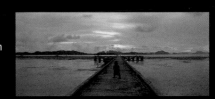

Filmer: Philip Bloom

2.7K 4:3

Resolution	Aspect Ratio	Frame Rate	FOV
2704×2028 pixels	4:3	30 fps	Ultra Wide

2.7K 4:3 is GoPro's most powerful 4:3 resolution and frame rate combo for POV or body-mounted shots that don't require slow motion. The higher resolution and lower frame rate make 2.7K 4:3 a go-to for shoots where low light is an issue. Filming low light music performances is a perfect example of when 2.7K 4:3 shines. And if you are trying to retain a professional 4K video with POV footage at 30 fps, then 2.7K 4:3 will upscale nicely into a 4K timeline.

"Golden Eagle POV Flight in 2.7K" is a prime example of how well 4:3 aspect ratio video captures body-mounted POV. In this case, the subject is an animal, but the same principles apply. The taller video gives more space on the top of the frame to capture the horizon, and more space on the bottom for the eagle's head, thus orienting the viewer's perspective. Another good resolution and frame rate to consider for this shot might have been 1440p60, which would have allowed the editor to slow down the flight of the eagle, although the ultra high resolution is certainly stunning.

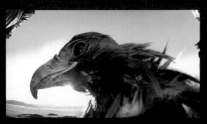

Golden Eagle POV Flight in 2.7K

David De Vleeschauwer and Debbie Pappyn travel to Mongolia to capture the point of view of a golden eagle as he soars over the Altai Mountains. Shot in 2.7K30 on the HERO3+ in 2014.

Filmers: David De Vleeschauwer, Debbie Pappyn
Editor: Nick Mitzenmacher

https://www.youtube.com/watch?v=mNtZBcEN6jg

4K

Resolution	Aspect Ratio	Frame Rate	FOV
3840×2160 pixels	16:9	24, 30 fps	Ultra Wide

4K, also called Ultra HD, is the future brought to reality by the HERO4 Black. The HERO3 aimed for 4K at 24 fps but fell just short because of processor limitations. The HERO3's 4K15 was only a promise of what was to come.

The HERO4's launch video marked the first time GoPro released a video in full 4K resolution—currently the highest resolution supported by YouTube and other online video distribution sites. At 4K, the video contains over 8 million pixels per frame with each still representing the equivalent of an 8.3 megapixel photo. And although that kind of data may be a stretch for current internet bandwidths and compression technology, the time is coming when 4K will replace 1080p as the online viewing resolution of choice.

4K televisions are becoming more affordable. For exhibiting your work on 4K screens or in theaters, the HERO4 Black's 4K30 mode is the best possible option; however, there's still reason to shoot in Ultra HD even if you are editing on a 1080p timeline. The additional video information also helps preserve quality through transcoding, resizing, and compression in the post-production workflow. And just as with 1440p or 2.7K, the higher resolution will give you leeway in choosing the perfect frame for shots in your video.

For professionals seeking to work exclusively in 4K on a 24 fps timeline, 4K24 SuperView takes advantage of the camera's entire sensor. It pulls the image from a taller 4:3 aspect ratio and dynamically stretches it into a 16:9 frame.

https://www.youtube.com/watch?v=wTcNtgA6gHs

GoPro HERO4: The Adventure of Life in 4K

The HERO4 reel takes us on adventures all over the world: an active volcano, Japan's neon streets, a wild mustang refuge, an iceberg climbing expedition, the world's biggest dance party, and a whale rescue mission.

Directors: Nicholas Woodman, Bradford Schmidt, Jordan Miller, Abe Kislevitz
Producer: Cort Muller Crew: GoPro Media
Editors: Sam "The General" Lazarus, Ryan Truettner

WVGA

Resolution	Aspect Ratio	Frame Rate	FOV
848×480 pixels	16:9	240 fps	Ultra Wide

WVGA is the wide-screen equivalent of the standard VGA resolution. An unfortunate side effect of the ever-increasing HD resolutions in cameras is that standard definition WVGA only continues to look more outdated. The advent of 15-second video for Instagram, however, has made GoPro's WVGAp240 a popular mode.

WVGA's real advantage is the 240 fps frame rate. The super slow motion is fun to play with and portends the day when HD will have similar frame rates. If image quality is your main concern but you still want wicked-fast frame rates, stick with the HERO4 Black and 1080p120. Motion interpolation software, such as GoPro Studio's Flux, can make 120 or even 60 fps footage look far slower than WVGA slowed from 240 to 30 fps. If implemented skillfully, the results can look nearly seamless. Certain shots, however, will still only be possible with frame rates of 240 and beyond.

In the featured video, filmmaker Jeremiah Warren shows an innovative use of this mode by extending a GoPro from a ceiling fan twirling in the trees as he set off fireworks below. The video is so striking you'd swear he was using a *Matrix*-style multicamera array to freeze time. It's interesting to note that Jeremiah tried shooting the scene in 720p120, but the effect was not the same.

Fireworks Showdown with Jeremiah Warren

Jeremiah Warren builds his own bullet-time rig and blasts off some fireworks. Shot in WVGA at 240fps on the HERO3 in 2013.

Filmer: Jeremiah Warren
Editor: Taylor Turner

https://www.youtube.com/watch?v=5a9Ubf59U1E

Protune

Modes Available	Average Bitrate
All	60 Mb/s

Protune was first introduced as a HERO2 firmware update to enhance video quality and give GoPro's professional users more power over image correction during post-production. Protune drastically increased video bit rates, added a flat color space with higher dynamic range for more latitude in post-production, and unlocked 24 fps frame rates for all modes so GoPro footage could be transferred easily to film and television industry timelines. An additional HERO3+ firmware update added selectible features such as GoPro Color, White Balance, ISO Limit, Sharpening, and Exposure, giving you more control over the camera than ever.

We recommend always using Protune. The higher data rate greatly reduces compression artifacting and increases image quality. The difference can be seen in the two featured frame grabs from HD HERO2 Protune test footage. Here, the camera has been shaken to induce compression artifacts and the images have been scaled up. The Protune footage does a much better job handling high motion.

Flat Color has a neutral, milky look and initially appears unflattering compared with normal GoPro images. When color corrected, however, Flat Color will give more definition in the shadows and highlights. A general rule to follow with color and sharpening is to let the camera do whatever you aren't comfortable doing yourself in post-production. Time can also be an issue. GoPro's media team will often use GoPro Color and in-camera sharpening when working events such as the X Games, where fast turnarounds on videos are required.

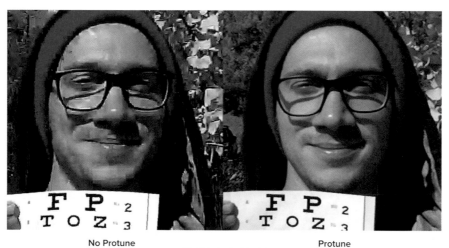

No Protune Protune

HD HERO2 1080p30
at 300% scale

Auto White Balance

- **Auto (default):** Unless under specific shooting conditions, this is always recommended.
- **3000K:** Looks the coolest. This setting is best for incandescent lighting indoors or sunrise and sunset outdoors.
- **5500K:** Looks neutral. This is best for outdoor settings during the day.
- **6500K:** Looks the warmest. This is best for shooting indoors with cool fluoresecent white light.
- **Native or RAW:** This is considered native. It is a direct sensor readout without any color correction and works best for a controlled, heavy post-production workflow.

Color

- **GoPro Color (default):** GoPro's in-camera color settings for a natural look.
- **Flat:** A flat color profile for professionals seeking the most control in post-production.

ISO Limit

- **6400 (default):** Brighter video in low light, increased image noise, especially in the blacks.
- **1600:** Moderately bright video in low light, moderate image noise.
- **400:** Darker video in low light, reduced image noise.

Sharpness

- **High (default):** Ultra-sharp video. This is the same level of sharpness as applied when the camera is not in Protune.
- **Medium:** Moderately sharp video.
- **Low:** Softest sharpening.

Exposure

Ranges in values from −2.0 to +2.0, in .5 step increments. The default setting is 0. This setting works within the limits of the ISO setting to adjust image exposure. Use under complex lighting conditions, such as when the camera is inside a vehicle, to keep the world outside the windshield from overexposing.

GoPro Studio

The 3D blockbuster *Avatar* renewed a massive 3D craze in the film and camera industry. We began developing the first GoPro 3D system in preparation for GoPro's first NAB trade show in April 2010. After capturing a variety of "jam sync" 3D footage (the firmware for frame sync was not yet developed), we tried a variety of available 3D software and, through trial and error, we found the best program to be Cineform. At 5 a.m. on the opening day at NAB, we were still editing the 3D reel on the trade show floor. As we'd hoped, the audience was astounded at the quality and ability of this tiny inexpensive GoPro camera to capture high quality 3D footage—at a fraction of the price of anything else available at the time.

Serendipitously, Cineform owners David Newman and David Taylor introduced themselves at the GoPro booth, delighted that we had used their software and made such a large splash at the trade show. Months later, our firmware engineers cracked the code for frame sync between two GoPros. We became convinced that collaborating with Cineform was the best solution in order to build an editing software for our upcoming 3D HERO System. This collaboration turned into a merging of GoPro and Cineform, and GoPro Studio, our desktop editing application, was born.

What began as a program for syncing and muxing stereoscopic video soon grew to include other features to aid in the GoPro post-production workflow: transcoding into the GoPro Cineform Codec, time-lapse processing, image correction, fisheye adjustment control, and eventually template video editing. More recent updates give users the ability to view HiLight tags on the timeline to quickly find their best moments, as well as Flux motion interpolation for super slow motion and speed changes.

A cool feature of GoPro Studio is that it's nondestructive: any changes made to a clip inside Studio do not need to be rendered. Instead, they are stored alongside the clip as metadata. The computer then uses this metadata to reinterpret the video when you play it back. Essentially, Studio works in parallel with your editing program. While a clip is on the timeline, you can open it up in GoPro Studio and adjust any changes you made previously or remove them entirely.

From the genesis of Studio to where it's headed in the future, perhaps, the most interesting part about GoPro is that it's not just a camera company anymore. It's becoming an end-to-end content creation company, and isn't that why we all got excited about GoPro in the first place? It's for the content!

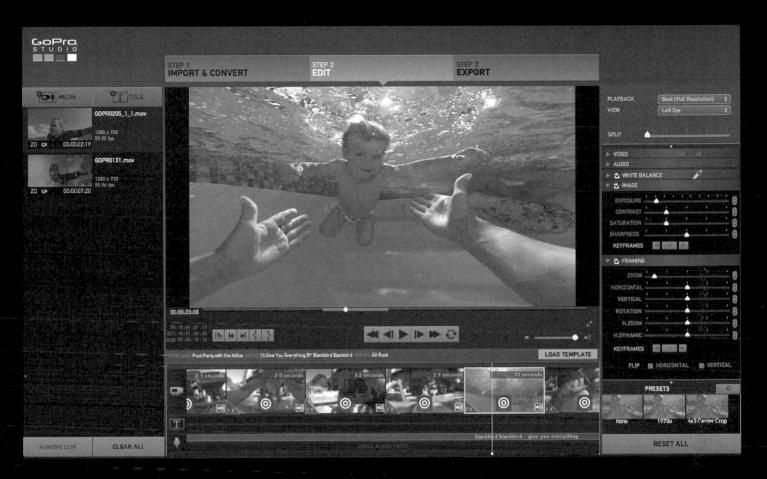

Nicholas Woodman and son / Los Altos, California Mouth Mount 1440p48

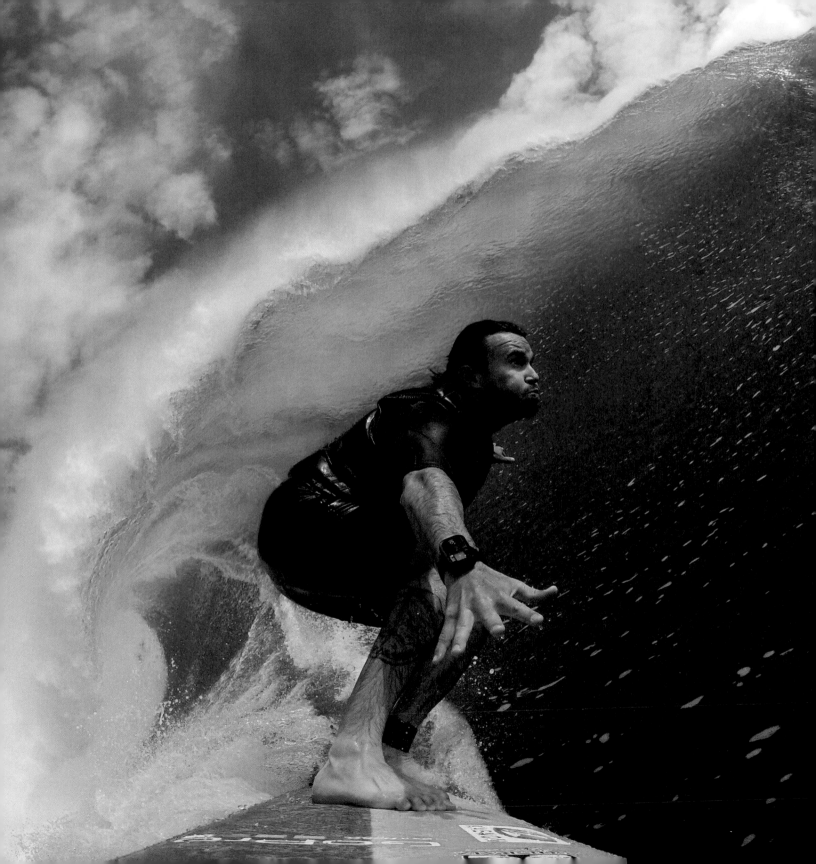

Wi-Fi

Modes Available	Range	Operation Frequency
All	600 feet	2.4 GHZ

First introduced as a modular BacPac accessory for the HD HERO2 (similar to the LCD and Battery BacPac), Wi-Fi is now integrated into all GoPros except for the entry level HERO. Wi-Fi gives the user power to take full control of his or her GoPro using either GoPro's Smart Remote or the GoPro App when using a smartphone or tablet. A number of tutorials on www.gopro.com give step-by-step instructions on the setup and pairing of Wi-Fi between your control devices and your GoPro. Chapter 7 discusses download and sharing features within the GoPro App.

The durable, waterproof Smart Remote can control up to 50 GoPros simultaneously at a maximum range of approximately 600 feet. And as mentioned, the Smart Remote is extremely handy for triggering video and photo capture when your GoPro is out of reach.

The GoPro App has become an essential tool on all GoPro media productions due to its ability to turn your smartphone or tablet into a live preview screen and remote control ability. Pressing record remotely, switching in between photo and video, or choosing between FOVs and resolutions is a welcome convenience for our productions to work quickly and efficiently. The GoPro App also makes it easy to wirelessly play back your footage on your smartphone, which can be valuable for immediately checking to see if you nailed the shot or if you need to reshoot. Once you've got the shot, you can quickly copy that photo or video over to your smartphone or tablet to share it without needing to connect to a computer.

Jamie Sterling / Fiji Surfboard Mount Burst

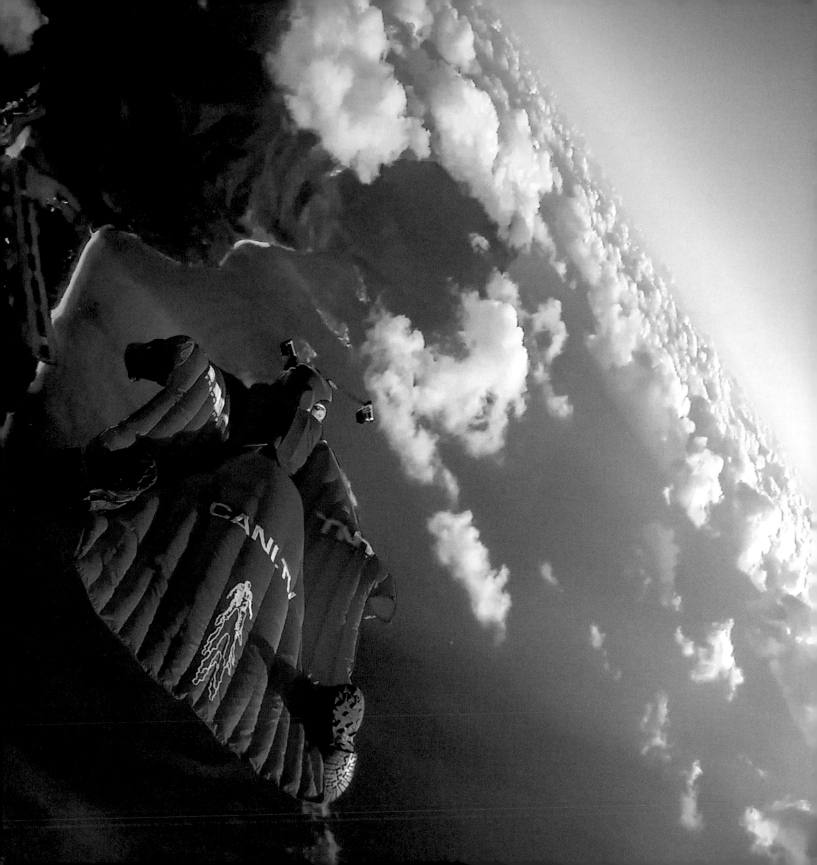

Mounts

GOPRO IS ARGUABLY THE WORLD'S MOST VERSATILE camera thanks in large part to its mountability. As the range of available mounts and accessories grows, so does the potential of the camera. Each year we see mounting breakthroughs and innovations that lead to never-before-seen shots. These shots inspire GoPro's own product design efforts as well as those of third-party manufacturers and garage shop inventors. The growing ecosystem of GoPro-compatible mounts and accessories continues to position GoPro as one of the most capable filmmaking tools of all time.

The first section of this chapter covers many of GoPro's mounts and accessories. The second section delves into experimental mounts developed by our media team and others over the years. The third section explores some of filmmaking's more traditional tools and how you can use them in combination with the GoPro. The final section covers the pioneering field of multicamera capture.

Jeb Corliss, Luigi Cani / Lord Howe Marine Park, Australia Hand Mount 2.7K30

GoPro Mounts

We think of GoPro's broad range of mounts as an enabler to your creativity, a starting point for you to experiment and discover new perspectives of your world. And while each mount has an intended use, the beauty is that they can be repurposed and used in any number of ways. The vented helmet strap can be used to cinch a GoPro around a tree. The Chesty can be double-wrapped around a ski boot. The head strap can be worn like a belt or a Speedo. We'll mention a few fun variations we've discovered, but for every one of our ideas our creative users have come up with dozens more. And that's what's so incredible about GoPro!

Wrist Camera: The Beginning

Nick Woodman prototyped the first GoPro wrist camera while preparing for a surf trip to Australia and Indonesia. His vision was that surfers should be able to wear a camera and photograph one another while surfing. GoPro's first product, the 35mm film-based HERO camera, launched on September 15th, 2004, in San Diego, California at the Action Sports Retailer trade show. The rest, as they say… is history.

Woodman's original wrist strap design was GoPro's only mount until late 2007. It wasn't until Nick strapped an early digital GoPro wrist camera to the roll bar of a racecar that he realized how enabling a GoPro mounting system would be. Several years and dozens of subsequent mounts later, Nick's original wrist camera design remains a viable solution for capturing active, on-the-go footage.

Wrist Strap Marketing Video – 2005

A young Nick Woodman bikes, kayaks, surfs, and hikes, all while getting the shot with his GoPro HERO Wrist Camera.

https://vimeo.com/
109965584

Director: Stephen Baumer Editors: Stephen Baumer, Evan Arnold
Producer and Music: Nicholas Woodman

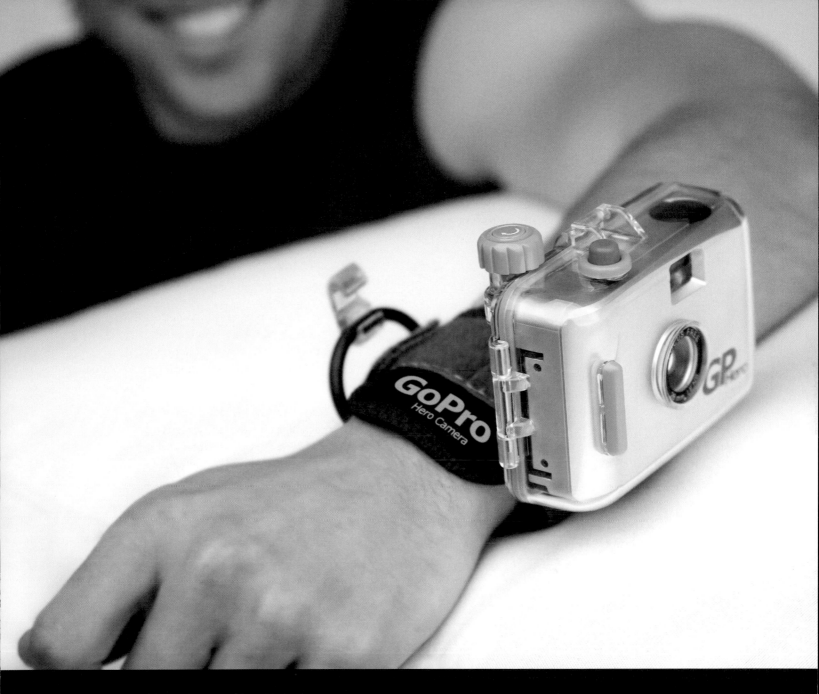

Nicholas Woodman / Sausalito, California

Head Strap

The human head is an ideal camera-mounting location for multiple reasons. The near eye-level view simulates the human perspective and gives a viewer the immersive sensation of seeing another's point of view. The head is also the most stable part of the body. It acts like a natural shock absorber—the legs, arms, and spine absorb the spins, jolts, and shakes of athletic activity.

For most activities, the straps should be tightened to the point of slight discomfort—otherwise, the camera will shake. We almost always use the head strap in conjunction with the lightweight Frame mount—the lighter camera will be less likely to fall off. For style points, take the top strap off and wear it under a beanie, hat, or bandana. We constantly film with the head strap during productions—it's a good way to capture behind-the-scenes footage.

A similar lower profile mount is the QuickClip. It's useful for putting on a backwards baseball cap, but isn't as stable for rigorous activity. We also clip the mount upside-down to the front pocket of a collared shirt for a Chesty-like perspective without all the straps, though it is less stable.

Adjusting the head strap camera angle is key. A common mistake is pointing the GoPro straight forward, resulting in video that is framed too high. The camera should be tilted slightly downward so a line can be drawn from the center of the lens to the ground six to ten feet in front of it. Once you have the correct angle, hand-tighten the thumbscrew and then use a Phillips screwdriver to crank down on it so the camera won't move.

A 4:3 aspect ratio video mode such as 2.7K 4:3, 1440p or 960p works well with the head strap. The extra resolution covers the ground and filmer's body and helps to anchor the eye through chaotic action.

Crystal Ball Street Performer

Portuguese street performer Luis Reis demonstrates his amazing contact juggling skills. Shot on the HERO3+ in 2014.

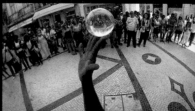

http://www.youtube.com/
watch?v=KFBRqTpNjU8

Filmer: Luis Reis
Editor: Matthew Suggett

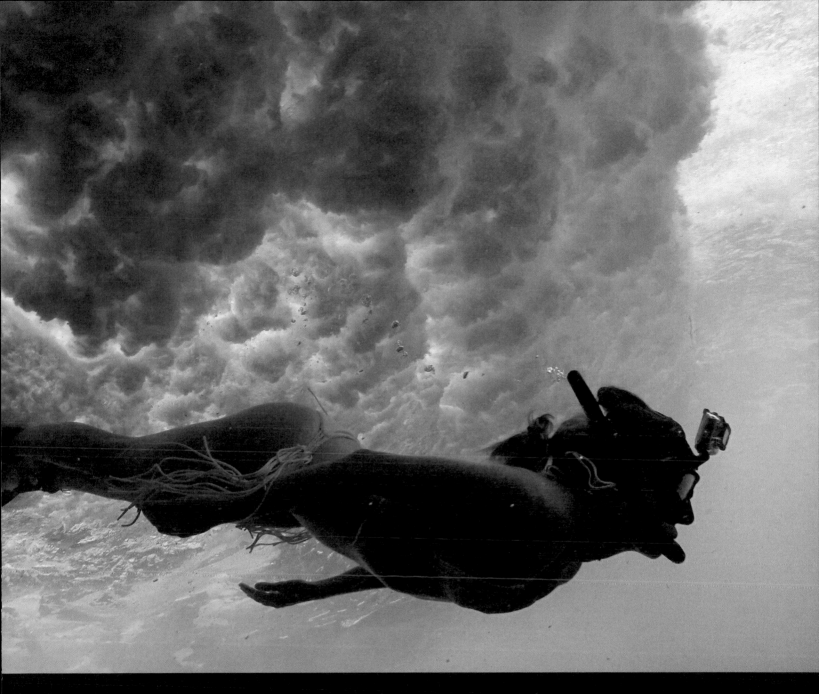

Kirk Krack, Ashleigh Baird / Tonga ☍ Norbert ⏱📷 Photo/.5sec

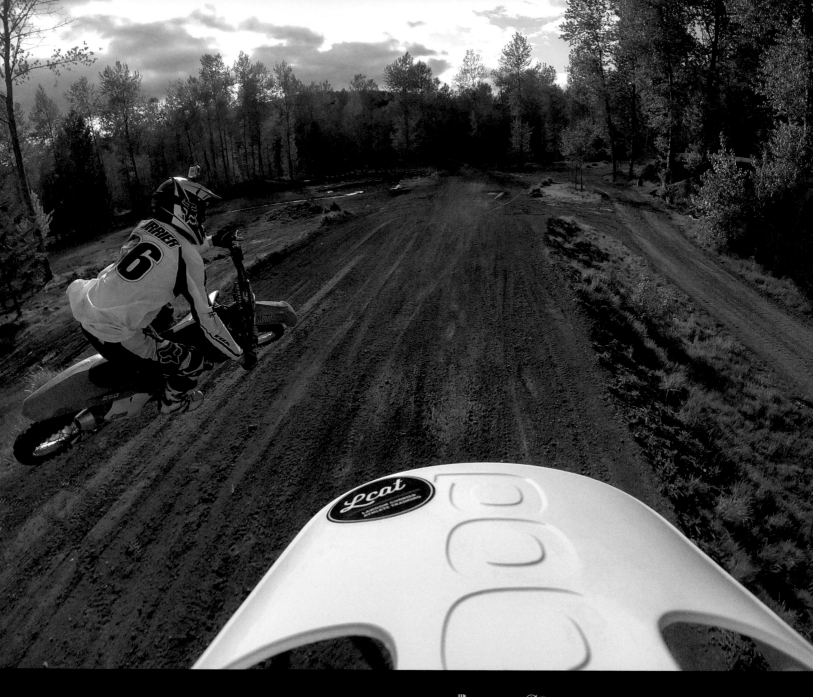

Kris "Jaymo" Jamieson, Landon Currier / Brush Prairie, Washington 🍴 Top Helmet 📷 Photo/.5sec

Helmet

The helmet camera offers an essential POV for incredible human feats. It can put the viewer straight into the perspective of jumping off a cliff or over a canyon, for example. The power of the mount lies in its ease of use and unobtrusiveness: users simply click in the camera, turn it on, and then forget about it.

The top-mounted camera should be balanced at the apex of the helmet. The camera can be pointed forward for standard POV, or backward for an interesting rear perspective or a following friend. A popular variation is to place the camera on the frontmost surface of the helmet, just above the forehead. This makes for a lower profile appearance. In combination with The Frame mount, the entire setup is featherweight and barely noticeable. Make sure to use the protective lens accessory. A helmet's rigid surface is perfect for placing the camera at any angle you wish, so a multitude of variations are possible. As a rule, all but the flattest of helmets will use a curved sticky. Skip ahead to the "Adhesive Mount" section for tips on getting a good bond.

As with the head strap, it's easy to frame too high. Tilt the camera slightly downward so that a line is projected from the center of the lens to the ground about six to ten feet in front of it. In general, you should frame your shot so the helmet is in view and recognizable (occupying somewhere between a lower sixth and third of the screen). The fixed foreground helps orient the viewer. GoPro App preview or an LCD BacPac are convenient for perfecting your angle. Once you've got the correct angle, tighten the thumb screw with a screwdriver. A helmet-mounted shot will only be as steady as the helmet itself. A tight-fitting helmet and snug chin strap go a long way toward making sure your footage isn't shaky.

For video modes, a 4:3 aspect ratio mode such as 2.7K 4:3, 1440p or 960p works best with the helmet to capture as much of the ground, limbs, and horizon as possible.

**Crankworx Whistler –
Mike Montgomery's Slopestyle Run**

Mike Montgomery's seamless second place run at the 2010 Crankworx Whistler. Shot in 960p30 on the HD HERO.

Filmer: Mike Montgomery
Editor: Abe Kislevitz

https://www.youtube.com/watch?v=OrbSRLildOk

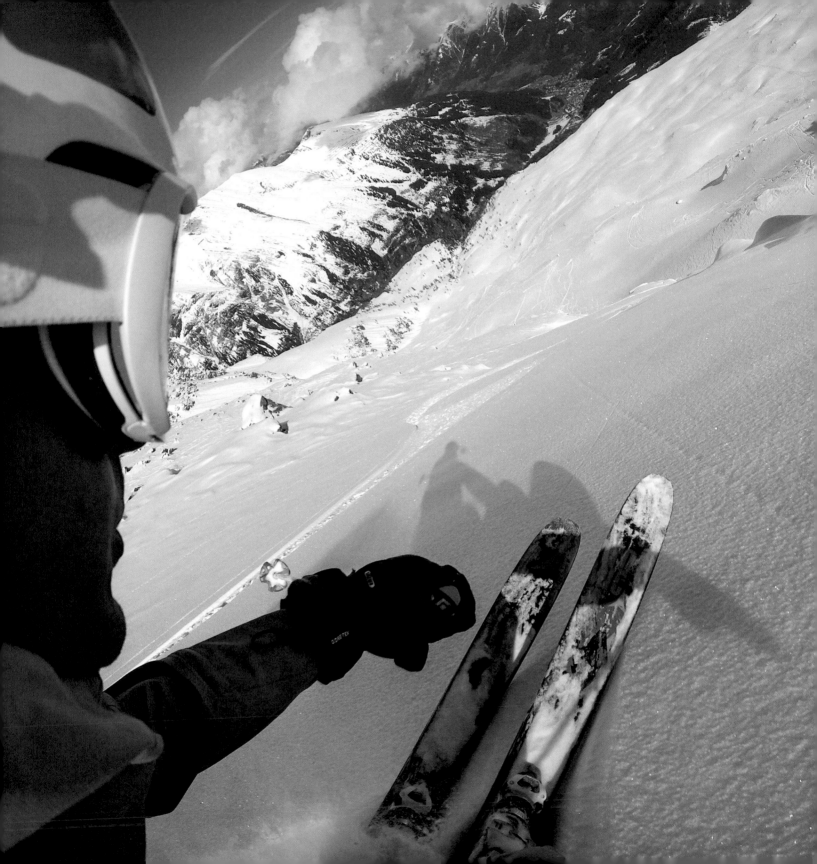

Sidemount

Another staple helmet angle is the sidemount, which can offer a better view but is less frequently used. The sidemount requires a pivoting extension arm accessory to rotate the camera 90 degrees. This angle captures more of the subject's arms, legs, and body, as well as the ground, and can give a better overall sense of interaction within a photo or video space than the traditional top-mounted helmet camera.

The camera's fixed focus starts to go soft about a foot or so from the lens. To counteract this, mount it as far out laterally as possible to keep the helmet from becoming a distracting blur. Configure the pivot arm so the long arm is horizontal and the short arm is vertical. We usually shoot with the camera upside-down on the helmet's right side so the lens is farthest away from the helmet surface. For shaky activities, it's best to mount the camera upside-down, as this is the most stable configuration. It also helps to use the white rubber quick-release plug to dampen any vibration.

A common mistake is framing too much of the helmet in the shot. It should take up less than a third of the frame. It's best to use Wi-Fi preview or an LCD BacPac to perfect your framing. A good rule of thumb is to point the camera forward and then swivel it away from the helmet a degree or two to place it in the right position.

A taller 4:3 aspect ratio such as 2.7K 4:3, 1440p or 960p with the extra top-to-bottom resolution is essential for the side helmet orientation, to capture as much of the arms, legs, and body as possible.

Christoph Oberschneider / Gastein, Austria Side Helmet Photo/2sec

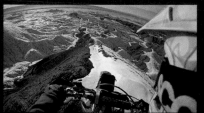

Moto Snowy Ridgeline

Chris McMahan threads a snowy ridge in Grand Junction, Colorado.
Shot in 960p30 on the HD HERO in 2012.

Filmer: Chris McMahan
Editor: Tina Marchman

https://www.youtube.com/
watch?v=EvUK3Pkmpqg

Chesty

The Chesty is a unique angle made possible by the GoPro's matchbox design. Such a view would be impossible with a lipstick-style POV camera. A Chesty perspective can sometimes feel more real and immersive than a helmet or head strap, which may seem too high or removed. A properly rigged Chesty best captures the combined motion of a subject's hands, arms, and legs. It's a great mount to buckle on and then forget about while filming everyday activities or interactions. GoPro also makes a smaller size for kids. The mount can also be used on large animals such as dogs, or even lions (although GoPro now makes a specific dog mount called Fetch).

The Chesty's harness should be tight, almost to the point of discomfort, to keep the camera from shifting. If you're not performing a rigorous activity with lots of gear, sometimes the straps can be unsightly. We often put them under a button-up shirt or a jacket so only the camera shows. In the midst of action, the camera lens can be easily smudged or dirtied. Be sure to check it every so often and keep it clean.

For most activities, the camera should be angled straight out when mounted on the Chesty. Mountain biking, road cycling, and motocross, however, are exceptions because the rider leans forward, making the camera point to the ground. In this case, flip the camera and J-Hook buckle upside-down, lean over the handlebars in a natural position, and tilt the camera 45 degrees so it's aimed roughly parallel to the ground. You can also wear the Chesty backwards for filming friends who are following behind you.

Chesty footage and 4:3 video modes such as 2.7K 4:3, 1440p or 960p are synonymous. The camera's close proximity to the body means the frame will be tight on the action and sometimes obstructed by limbs or athletic gear. The extra resolution on the top and bottom anchors the perspective and keeps the audience from becoming too disoriented.

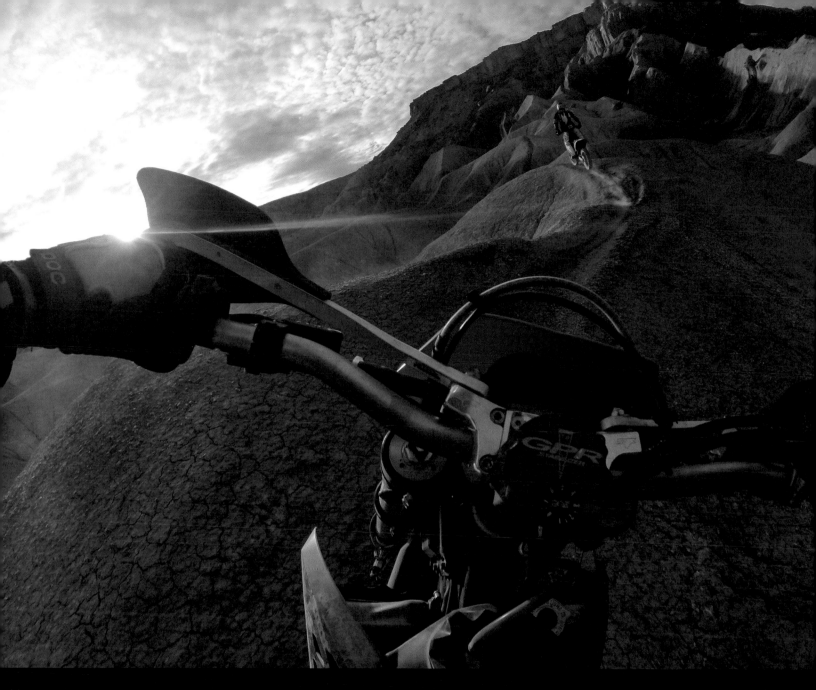

Neil Amonson / Utah Chesty Photo/2sec

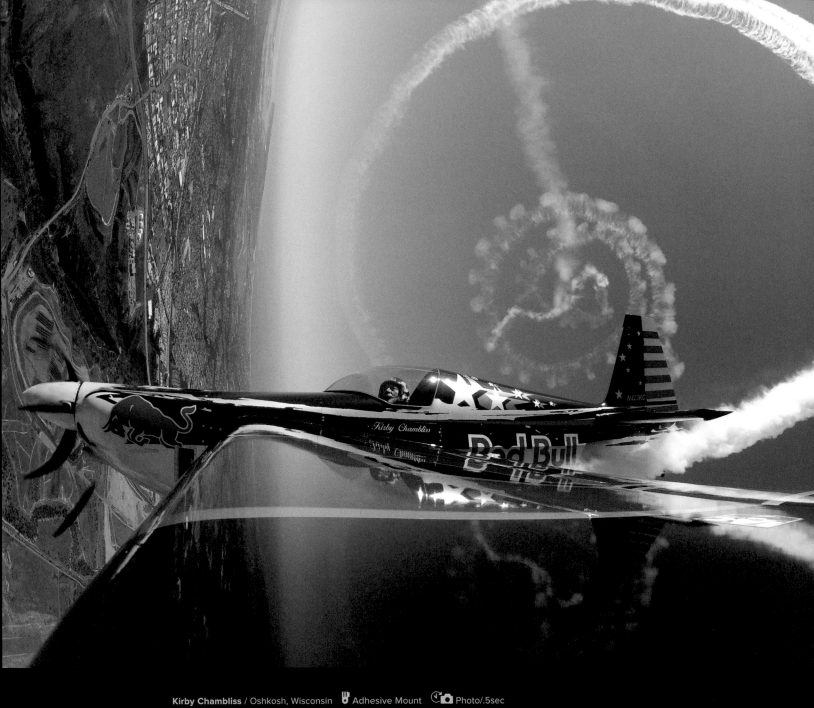

Kirby Chambliss / Oshkosh, Wisconsin Adhesive Mount Photo/.5sec

Adhesive Mount

"Are you sure that thing is gonna hold?"

Everyone is skeptical...at first. But combining a 5 oz. camera with 3M adhesive will capture a view from just about anywhere. Photographers have used the sticky mount in some pretty improbable places—including attached to the body of deep sea submersibles and on the wingtip of a cork-screwing airplane undergoing serious g-forces. With adhesive mounts, any flat, smooth location can serve as a potential camera mount. The secret is in the application.

The proper application starts with cleaning the intended surface. Use wax remover or acetone for surfboards, an appropriate cleaner/degreaser for other surfaces. Buff the surface with paper towel or cloth to make sure it is dry with no residue. The surface should be at room temperature. If the surface is cold and dewy, the camera and mount will be gone. Mark the intended location with a pencil. Leave the red plastic on the sticky and heat it with a lighter until the plastic begins to shrink and bubble. Carefully remove the plastic and immediately apply pressure to the adhesive mount on the cleaned location. We recommend you allow the mount to sit overnight before using, when possible.

Even when applied perfectly, extremely cold temperatures can freeze an adhesive mount and cause it to fall off. We've attached cameras with stickies under weather balloons going into the stratosphere. When we recovered the balloons, all the stickies had fallen off. In those extremes, it is wise to use a tripod mount or screw the adhesive into place.

The GoPro Removable Instrument Mount is a new technology variation on the adhesive mount. The Removable Instrument Mount solves the problem of the normal 3M sticky material potentially harming or leaving residue on valuable finishes, such as on a guitar.

When mounted to a helmet, person, or instrument, use 2.7K 4:3, 1440p or 960p video modes. On anything else, we tend to use 16:9 modes such as 4K, 2.7K or 1080p120, especially for slow motion. If you're getting a lot of foreground element from the mounting surface, try switching to a Medium FOV or tilting the camera up so the surface doesn't dominate your frame.

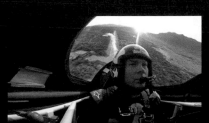

Kirby Chambliss Epic Flight

Two-time Red Bull Air Race World Champion Kirby Chambliss takes us on an epic flight over the beautiful landscapes of Arizona. Shot on the HD HERO2 in 2011.

Director: Zak Shelhamer Producer: Yara Khakbaz
Crew: Patrick Barrett, Wes Nobles Editor: Brandon Thompson

https://www.youtube.com/watch?v=mO0FmzRW96o

Suction Cup

As one of GoPro's first mounts, the suction cup has experienced a number of design iterations throughout the years. The most recent version is stiffer and has a flatter profile and comes with several arm options for different camera orientations and higher or lower profiles.

When properly applied to a flat surface, the suction cup can handle speeds of more than 100 miles per hour. The farther the camera is away from the suction cup, the less stable it becomes at higher speeds. Make sure the surface is clean of dirt and debris. The hold of the suction is only as good as the seal the soft plastic makes with the surface. You can test the hold by pulling on it.

The suction cup is a great all-purpose mount with applications beyond its traditional use in auto sports. Like the adhesive mount, the suction cup mount transforms any flat surface into an unexpected perspective. We always bring one on our productions because you never know when it might be useful. Used creatively, a suction cup essentially becomes a versatile tripod that fits in your pocket. Put it on the window of a subway or train for great travel shots and moving time-lapses. Attach it to swinging or sliding surfaces such as doors or windows for on-the-go tracking and dolly shots. Know your surfaces, however. It's easy to get ambitious and place the suction cup on a surface that looks fine, but is actually porous. Twenty minutes later, the camera falls off.

Generally speaking, the suction cup works best with 16:9 modes such as 4K or 2.7K48, if you are looking for slow motion. The Wi-Fi App preview and LCD touchscreen are both great for quickly deciding between modes and FOVs. Try the various arms for rotating the camera to level the horizon and find that perfect shot composition.

Chris Forsberg Wins Round 1 at Formula Drift Long Beach

Chris Forsberg and Kenny Moen in Round 1 of the Formula Drift 2014 Pro Championship. Shot on the HERO3+ in 2014.

Filmers: James Kirkham, Hart Houston, Nate Lewis
Editor: Brian Town

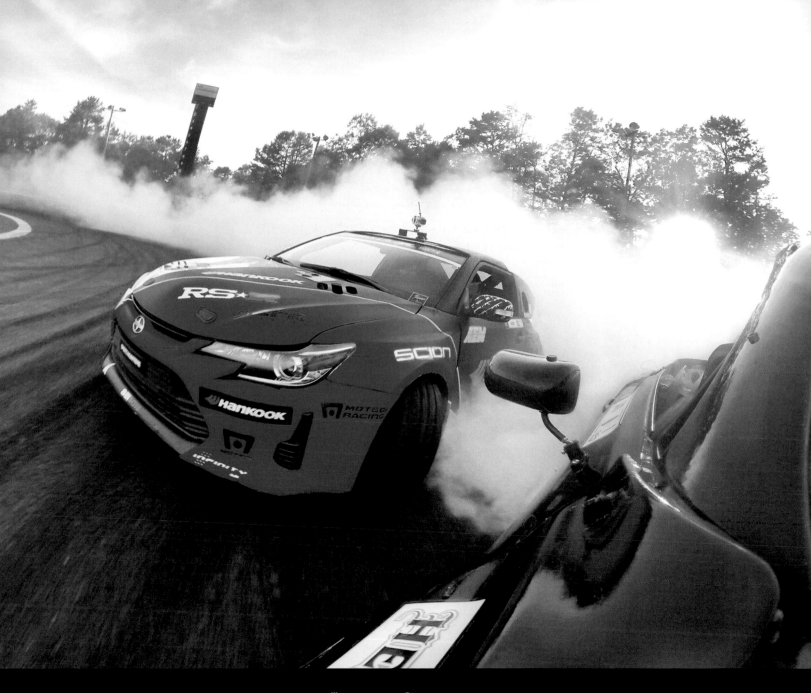

Daigo Saito / Wall Speedway, New Jersey Suction Cup Photo/.5sec

Handlebar/Seatpost Mount

Originally called the Ride Hero, GoPro's Handlebar/Seatpost Mount offers unexpected applications beyond its original intention. The mount was first designed to clamp onto the seatpost or handlebars of a bike. The current mount fits from .7- to 1.5-inch tubing, with narrower diameters from .43 to .7 inches possible when using the rubber gasket. A tour through the GoPro universe on YouTube shows this mount attaching a camera to all kinds of objects: spatulas, paddles, pens, and more. One of the most popular uses of a handlebar mount is attaching the GoPro to the end of a pole, especially a ski pole. You can then use the pole as a kind of filmer's extension for getting closer to the action, or for reverse POV shots with the camera pointed back at the user, as in Chris Garside's "Snowboarding with the Pole Cam Mount."

Handlebar mounting requires a pivoting extension arm to spin the camera 90 degrees to the front or back. On anything but a smooth paved road, handlebar footage can be shaky. GoPro recommends using the rubber gaskets to help reduce slippage and vibration. This mount is used most often on the seatpost (check out Andrew Taylor's TV commercial featured here) and other parts of the bike frame, such as the front fork, chain stays, or down tube. Depending on tube width, a roll bar mount may be more applicable.

The handlebar mount, as with all body- and gear-centric mounts, excels with the taller resolution of 2.7K 4:3, 1440p60 or 960p120 modes. If you're using an outward-facing polecam for following your friends, shoot in a 16:9 aspect ratio. The following section discusses this technique in more detail.

Aaron Chase / Queenstown, New Zealand Chesty Photo/.5sec

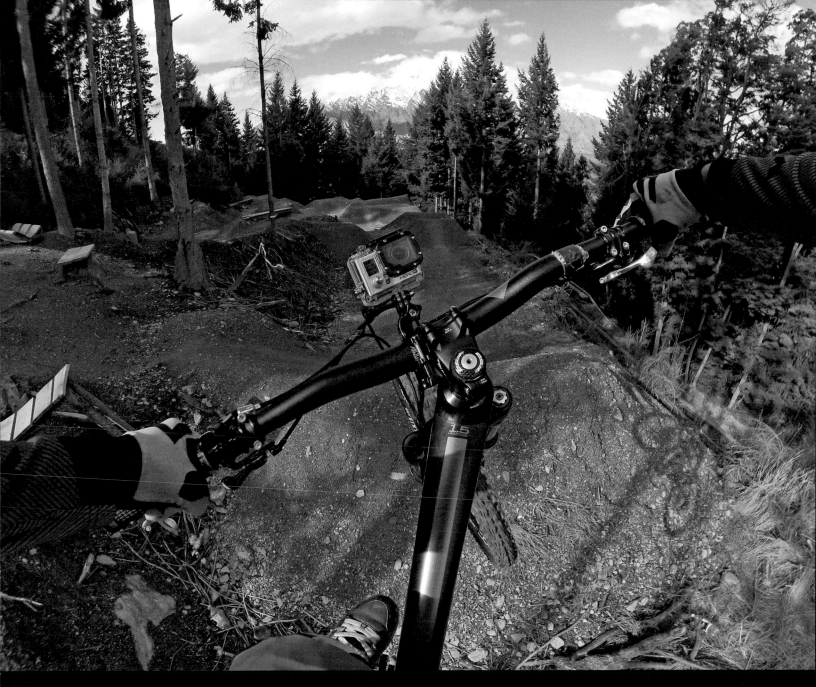

Freestyle Biking with Andrew Taylor
– TV Commercial – You in HD

This was one of GoPro's first commercials to air on national TV.
Shot in 720p60 on the HD HERO in 2010.

Filmer: Andrew Taylor
Editor: Brandon Thompson

https://www.youtube.com/
watch?v=yaFG5wCgk9c

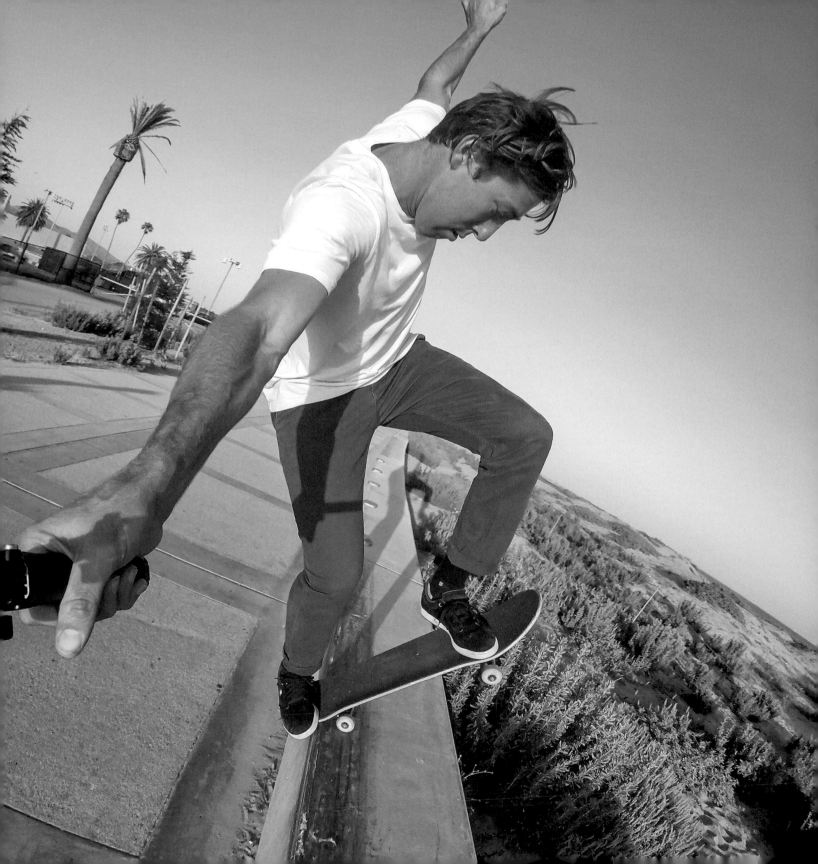

3-Way Extension Arm

Ah, the selfie.

GoPro's ethos has always been about the photographer/filmer participating in the activity. When GoPro incorporated an ultra-wide lens, this ethos went even deeper, enabling the creators to turn the camera around and document themselves. While holding the camera with a hand works well, the human arm isn't quite long enough to capture the entire environment and context on a GoPro. Getting the camera just a few more inches past arm's length makes all the difference. After years of research and prototypes, GoPro finally released the 3-Way extension arm in 2014. The 3-Way is compact, carries a small tripod, and unfolds as a traditional straight pole or a curved one.

For reverse POV, you can curve the 3-Way to frame out the armature while still including feet and the ground. Aiming the lens at belly button height rather than at one's face ensures that the entire body is in frame. We typically shoot 4:3 aspect ratio modes like 1440p or 960p.

For non-POV or follow-cam, there are many options. You can use the 3-Way, a ski pole with the handlebar mount, or something longer, such as an extension pole by RPS Studio. Filming with long polecams puts the audience right in the midst of the action without risking injury to ourselves.

Follow-cams have become a ski and snowboard filming staple. Filming with the polecam is a subtle science. We teach people to be loose with their knees and wield the pole with their fingertips to minimize camera shake. Your knees and elbows should absorb any vibration as you move. Polecams are also great for putting the camera in low or high positions for unique perspectives.

As mentioned, POV footage is best in 4:3 aspect ratios such as 2.7K 4:3, 1440p60 or 960p120. Non-POV or follow-cam works best in a widescreen 16:9 aspect ratio. 2.7K48 is a good high resolution option, while 1080p120 should be used if super slow motion is a must.

Mikey Taylor / Southern California 3-Way Extension Arm Burst

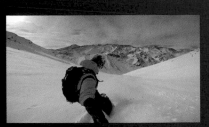

Travis Rice Chilean Powder Run

Travis Rice gets tracks on an epic powder day in a remote section of the Andes Mountains. Shot on the HERO3+ in 2013.

Filmer: Travis Rice
Editor: Kyle Camerer

https://www.youtube.com/watch?v=zKsotFHiqEw

Roll Bar Mount

The roll bar mount works for just about anything: poles, helicopters, boats, bumpers, trees, and, of course, roll bars. It is a larger version of a handlebar mount, and is capable of mounting poles from 1.4 to 2.5 inches. This is another versatile mount that makes a great addition to any shooting kit.

Good mounting requires you to carefully choose a mounting location, since certain parts of cars and motorcycles vibrate more than others. Generally, the closer a camera is mounted to the frame of a vehicle, the less it will shake. We sometimes use duct or gaff tape under the roll bar mount to further dampen vibration. Too much vibration causes rolling shutter, a warbling, Jello-like image distortion that occurs when objects in the frame move faster than the camera's sensor can scan. One of the most effective ways to reduce rolling shutter is to increase the frame rate. This decreases each frame's exposure time and thus reduces rolling shutter distortion.

Extensions, especially pivoting extension arms, are good for rotating or orienting the camera for the desired frame, though using more than one increases vibration. The photo of Byce Menzies featured here was taken from a roll bar mount on the central A-pillar.

Vehicle-mounted shots are relatively stable and work well with the GoPro 16:9 video modes. Use 4K at 30 fps for its crisp resolution, or 2.7K48 for the higher frame rate, if rolling shutter is a problem.

The Baja 1000 with Bryce Menzies

Baja 500 champion and GoPro athlete Bryce Menzies returns to the wash in 2012 to pursue his first Baja 1000 victory. Shot on the HERO3 in 2012.

https://www.youtube.com/watch?v=ydM9tO7B6cw

Director & Editor: James Kirkham Producer: Jaci Pastore
Crew: Patrick Barrett, Nate Lewis, David Sullivan, Justin Shreeve, Rod Rojas

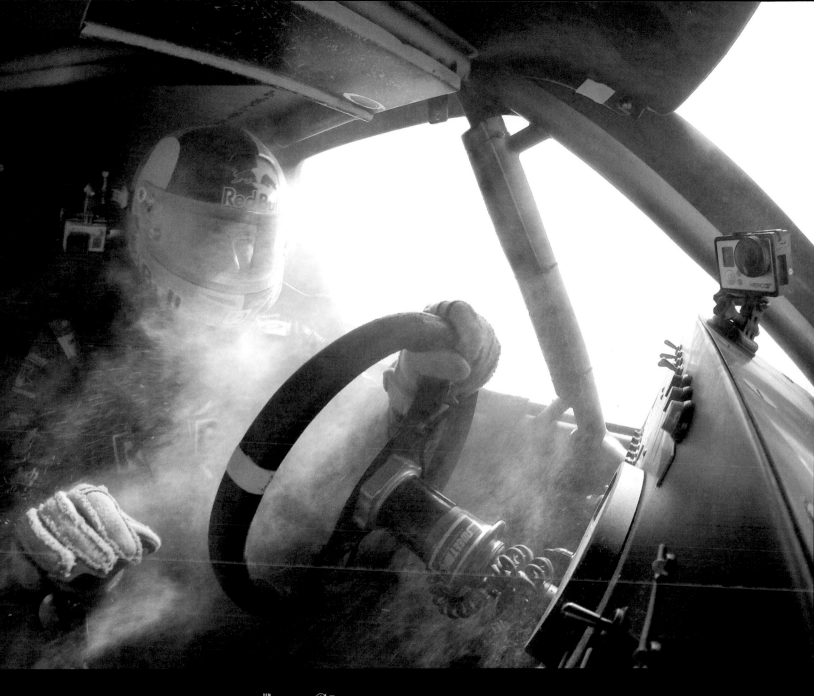

Bryce Menzies / Nevada Roll Bar Photo/.5sec

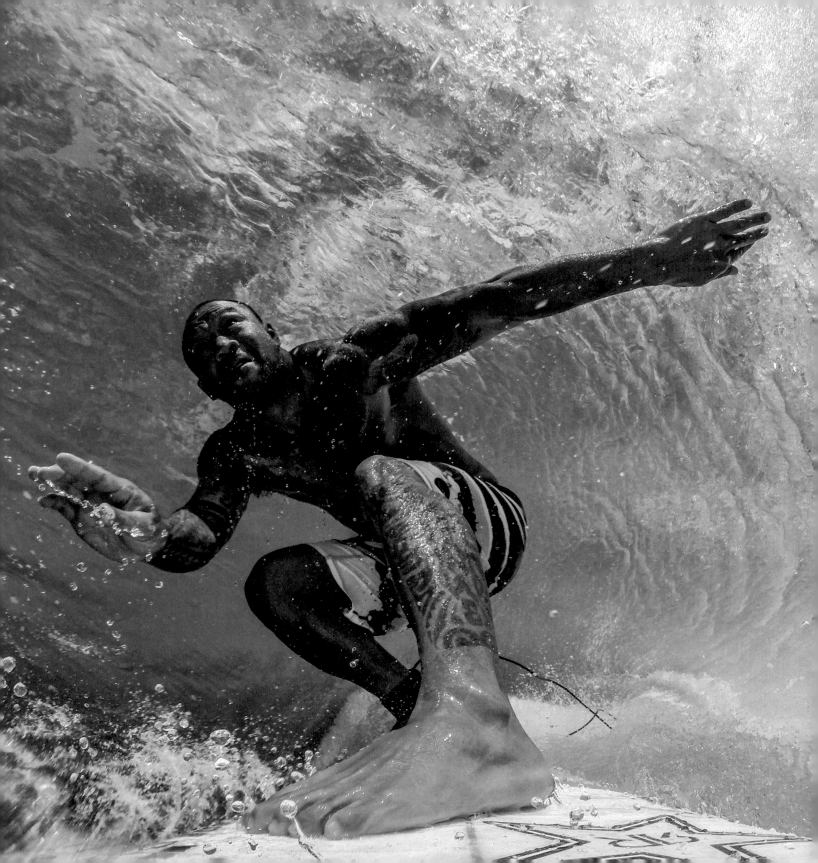

Surfboard Mount

GoPro was born as a wrist camera meant to allow one surfer to film another surfer. The surfboard mount was the logical evolution, enabling surfers to turn the camera around and for the first time film themselves. Older versions of the mount featured a larger adhesive pad, but over time we discovered the extra surface area didn't contribute significantly to the reliability of the mount. We learned early on that water hitting the back of the camera causes the surfboard mount's quick-release buckle to eject, which is why the white rubber plug is essential. The mount comes with a camera leash for peace of mind, although we usually forgo these in favor of the floaty backdoor instead. Proper application of the surfboard mount gives you the best chance of protecting your camera in a heavy wipeout (see the "Adhesive Mount" section for how to apply these mounts). GoPro also recently released the Bodyboard Mount, similar to the surf mount except that it installs like a bodyboard leash plug.

Generally, the camera mount should be placed as far forward on the board as possible, and the camera should be swiveled back as far as it will go (roughly 45 degrees). The standard setup centers the camera over the stringer and pointing back down the board. Another option if you are surfing only rights or only lefts is to apply the mount a few inches toward the inside rail, rotating the camera back towards the stringer to capture less of the walled face of the wave and more of the falling lip, which looks great in slow motion.

A properly framed surfboard shot shows just enough of the board and feet to create context, while reserving the rest of the space for the surfer and wave. Use the GoPro App to find the perfect frame. Surfboard-mounted shots work best in 1440p60 or 960p120 modes, because slow motion is essential with surfing. On short boards especially, every extra pixel of vertical resolution is needed to capture the board, surfer, and wave.

Sunny Garcia / Oahu, Hawaii 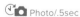 Surfboard Mount Photo/.5sec

Banzai Pipeline

As the first ripping swell of the season hits Pipeline, Jamie Sterling, Sion Milosky, and Mikey Bruneau pull into some massive pits using the surf mount. Shot in 720p60 on the HD HERO in 2010.

Filmers: Jamie Sterling, Sion Milosky, Mikey Bruneau
Editor: Bradford Schmidt

https://www.youtube.com/watch?v=JyB9LjP4COI

Jaws Mount

Jaws—a clamp with an adjustable gooseneck—is one of the most widely used tools in our media team's inventory. It's an invaluable mount for filming anything that isn't moving too fast. The clamp is surprisingly strong and can be attached to just about anything from .25 to 2 inches in diameter. A GoPro can be mounted directly to the clamp or extended using the adjustable gooseneck. Using the gooseneck offers the advantage of allowing you to twist the camera and choose your frame. We often use Jaws for environmentals, time-lapses, static wides, and spontaneous moments because it's quick and easy to attach.

Filming music shows how versatile Jaws can be. Musical instruments are obviously played close to the body, so the camera needs to be extended out to capture both the instrument and player in context. Jaws provides an easily maneuverable extension for drum stands, music stands, the head of a guitar (use extra padding for delicate woods and finishes), and just about anywhere else you can think of. The interior rubber strap can tighten and hold onto a diameter as small as a pencil.

The Jaws mount generally uses 16:9 aspect ratio modes such as 4K or 2.7K48. For instrument mounting, sometimes we use a 4:3 mode such as 2.7K 4:3 or 1440p if the taller frame reveals more of the instrument, musician's face, or surrounding crowd. Frame rate as always depend on the light conditions. If you are filming in low light, such as a music venue or bar, make sure to set the frame rate to 24 or 30 fps. Lower frame rates increase the exposure time for each frame and make for better quality in darker conditions.

Black Lips Stage Dive at SXSW

Cole Alexander, king of the stage and the universe, takes you on a ride to the grimy depths of the pit. Shot on the HERO3+ in 2014.

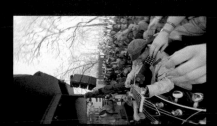

Tripod Mount

GoPro's three-prong mounting system is designed for durability, versatility, and safety. Most other companies don't use GoPro's mounting system, however. The tripod mount makes the camera compatible with any standard 1/4inch, 20-thread screw used by industry-standard tripods and other camera accessories. GoPro further improved on this by releasing the Mic Stand Mount, which incorporates the 1/4 inch, 20-thread screw under a GoPro quick-release buckle. The mount can stay attached to the thread screw while easily taking the camera on and off via the quick-release buckle.

The variety of tripods and accessories for cameras in general is staggering. We use a number of different compact tripods, some with fluid heads for panning wides or static shots. Tripod mounts are essential for mounting to these and other tools such as poles, jibs, and extensions.

The video example "A Freakin' Huge Explosion" takes advantage of a tripod mount to capture a close-up static shot where it would be too dangerous for the filmer to stand.

4K, 2.7K48, or 1080p120 modes are popular options for tripod shooting. The inherent stability means you can take advantage of narrower FOV settings: 2.7K Medium or 1080p Narrow. Otherwise, shoot 4K for the high resolution, or 1080p120 if ultra slow motion is needed.

Bradford Schmidt, Jordan Miller / Oahu, Hawaii Norbert Photo/2sec

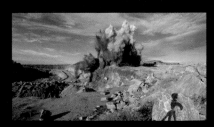

A Freakin' Huge Explosion

Check out this freakin' HUGE explosion!
Shot on the HERO3+ in 2014.

Filmer: Jason Astill
Editor: Sam "The General" Lazarus

http://www.youtube.com/
watch?v=3lPo_GHfab0

The Handler and Norbert

In the early days of GoPro, it was common to see members of GoPro's media team running around events with disconnected bicycle handlebars looking fairly ridiculous. Handlebar mounts can attach multiple GoPros to a set of bicycle handlebars along with a shotgun mic. This allowed team members to capture simultaneous video, photos, and high-quality audio. The Handler is GoPro's floating handheld grip mount and is ideal for most users when shooting with a single camera. For more than one camera, we tend to use a Norbert.

K-Tek introduced us to the Norbert mount at NAB in 2011, and it served as a better, more compact solution than bicycle handlebars. The Norbert is a square frame with grips and multiple 1/4-inch, 20-thread screws and hot shoe mounts. While the 1/4-inch, 20-thread screws can be used in combination with the GoPro tripod mount, we find it easier to mount cameras onto the Norbert using adhesive mounts. More cameras can be mounted onto the Norbert this way, and the cameras can be quickly snapped out via the quick-release buckles. The hot shoe mounts on top are made for mounting a mini-shotgun microphone just out of frame. The 1/4-inch, 20-thread screws or 5/8-inch, 11-thread screws work with LED lights or any other camera accessories.

Over the past few years, small drones have begun using miniature gimbals. Gimbals have other applications as well. For example, we have rigged Norberts with three axis gimbals to smooth out handheld footage. This requires more effort, but the shots are well worth it.

For the best coverage, especially with unrepeatable moments, GoPro's media teams often mount three cameras to a Norbert: two shooting video at 2.7K48 and 4K, and one shooting photos in .5 second time-lapse mode. Depending on the rarity of what you are capturing (such as the mythic 90-foot blue whale shown here), it's nice to set one video in wide FOV and one in Medium FOV just in case. For interviews, one of the video cameras can be switched to a narrower FOV mode, usually 2.7K Medium, for a tighter frame on the subject.

Bradford Schmidt, Kirk Krack / Mexico Norbert Photo/.5sec

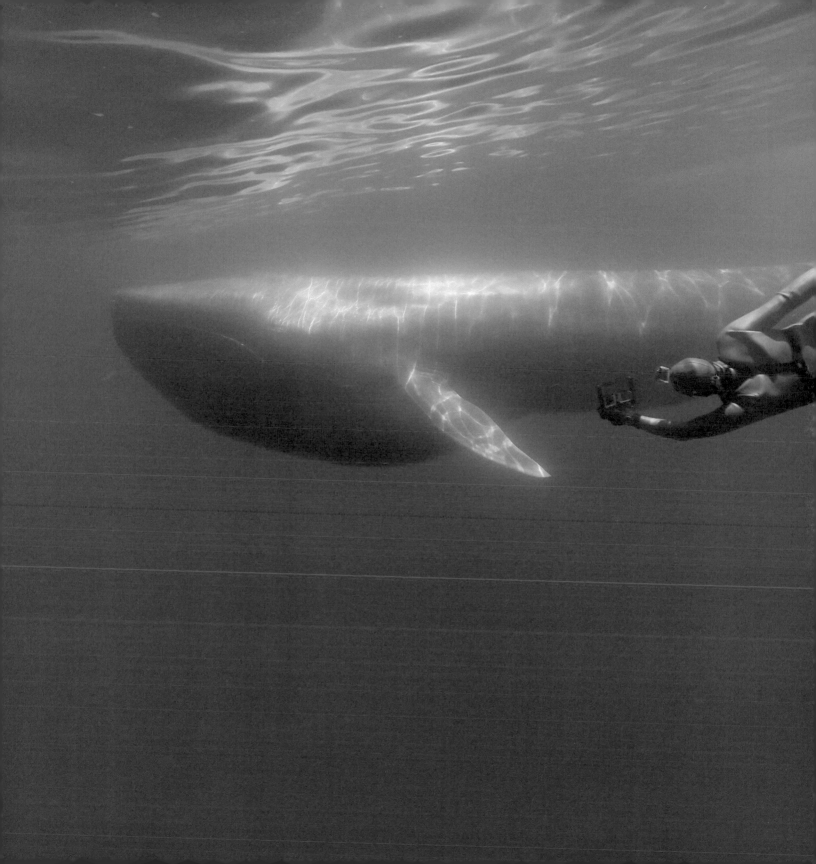

Experimental Mounts

The most beautiful aspect of GoPro is that its versatility is only limited by your imagination. We on GoPro's media team continually learn from watching what other people do and then we try to expand upon their ideas. We push the camera until it breaks—and after it does, we find another way. Each mount described in this section was created by asking the question: "What if...?"

Gnarwhal

Aerial maestro and GoPro Bomb Squad member Neil Amonson first introduced us to the gnarwhal when Amonson threw himself off a cliff in Norway. His "bobblehead," centered comically in the frame, caused us all to laugh. Over time, the mount took on the name gnarwhal (pronounced "nar-wall"), a combination of the ubiquitous action sports noun *gnar*, and the elusive horned whale of the Northern Seas, the *narwhal*.

The gnarwhal offers an intense view of the subject's face, capturing reactions and emotions like a traditional closeup. If framed well, the athlete's entire body is in view, along with the surrounding environment. The longer the gnarwhal, the more natural the face and environment will feel. Like any other perspective, however, it can be overdone, so use in moderation. Safety is another factor that should be considered when using this mount.

We keep a number of gnarwhals on hand for our productions. We've had custom aluminum ones fabricated, although these days you can buy them on Amazon. You can make short gnarwhals with a couple of extensions, although these tend to foreshorten the face quite a bit. Sometimes, we use additional extensions to drop the camera down so it points directly into the eyes. The angle is less cartoonish than looking down the eyebrows.

Use an LCD BacPac or Wi-Fi-enabled smartphone to compose the shot so the gnarwhal mount is just barely out of the frame and cropping will be minimal in post. Typical to any POV, gnarwhals benefit from taller frames such as 2.7K4:3, 1440p60 or 960p120.

Base Jump Clip

Neil Amonson, one of GoPro's more nutball athletes, takes a swan dive in Norway. Yes, this is real... and yes, Neil is awesome. Shot in 960p30 on the HD HERO in 2009.

https://www.youtube.com/watch?v=jNkMhJNWaXo

Filmer: Neil Amonson
Editor: Bradford Schmidt

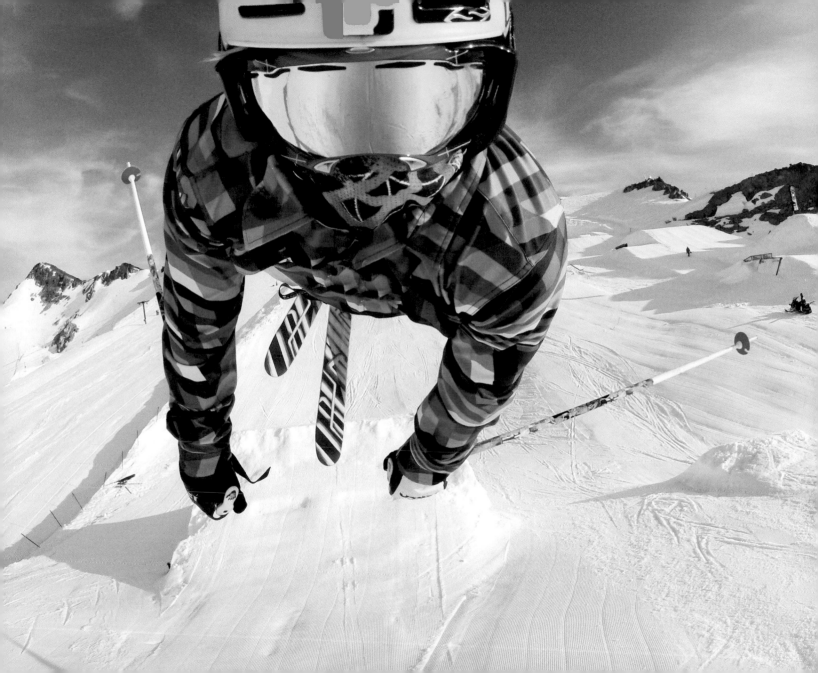

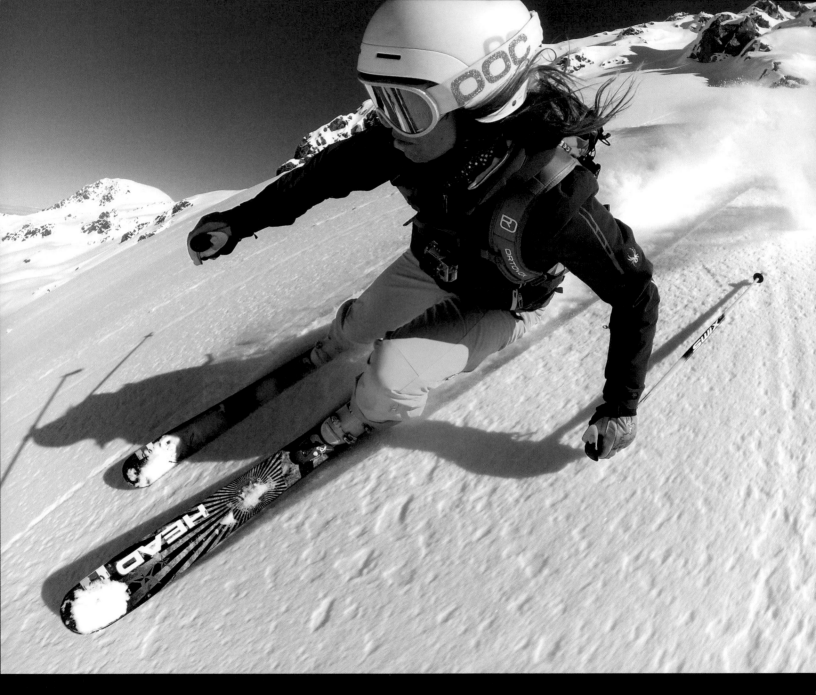

Julia Mancuso / Mount Cook, New Zealand Helmet Spinner Photo/.5sec

Spinner

Over time, the fixed position gnarwhal evolved into the dynamically rotating helmet spinner. Our first spinner was made by clamping a carbon fiber pole to a roller blade wheel mounted on top of a helmet. The Spinner made its official debut in GoPro's HERO3 reel, featured in shots with speed bikes, kayaks, skiers, and snowboarders. The majority of the audience scratched their heads, wondering, "How'd they do that?"

The typical helmet spinner requires a curved adhesive mount applied to the apex of the helmet. Any turn or tilt from the subject causes the camera to rotate around the helmet, capturing a seemingly impossible shot. We balance the rig with two cameras, achieving different rotational speeds by moving one of the cameras closer or farther away from center. For a more direct look into the subject's eyes, use a small downward extension at one end of the pole.

Use an LCD BacPac or Wi-Fi-enabled smartphone to compose the shot so the mount is just barely out of frame. Interestingly enough, the opposite camera will always be blocked by the helmet and face in the center. The only time the audience will be able to tell is in the shadows, as shown by Julia Mancuso's photo in this section.

You can build your own spinner or buy one from KillerShot, which makes a swivel mount that attaches directly to a GoPro quick-release buckle on top of a helmet. This mount also features convenient detachable carbon fiber poles for traveling. The idea of the spinner has various other applications, such as on auto vehicles or even underwater submarines.

Spinners usually benefit from taller frames and should use modes like 1440p60 or 960p120. High frame rates should be used, as this is a very dynamic perspective that can disorient the audience if it isn't slowed down. We typically shoot one camera in video and the other in .5 second time-lapse mode.

Art of the Double Cork with Bobby Brown TV Commercial

Bobby Brown puts a unique "spin" on the standard double cork. Shot in 960p100 on the HERO3 in 2013.

Filmer: Bobby Brown
Editor: Zak Shelhamer

https://www.youtube.com/watch?v=8Ykv2i_VyKU

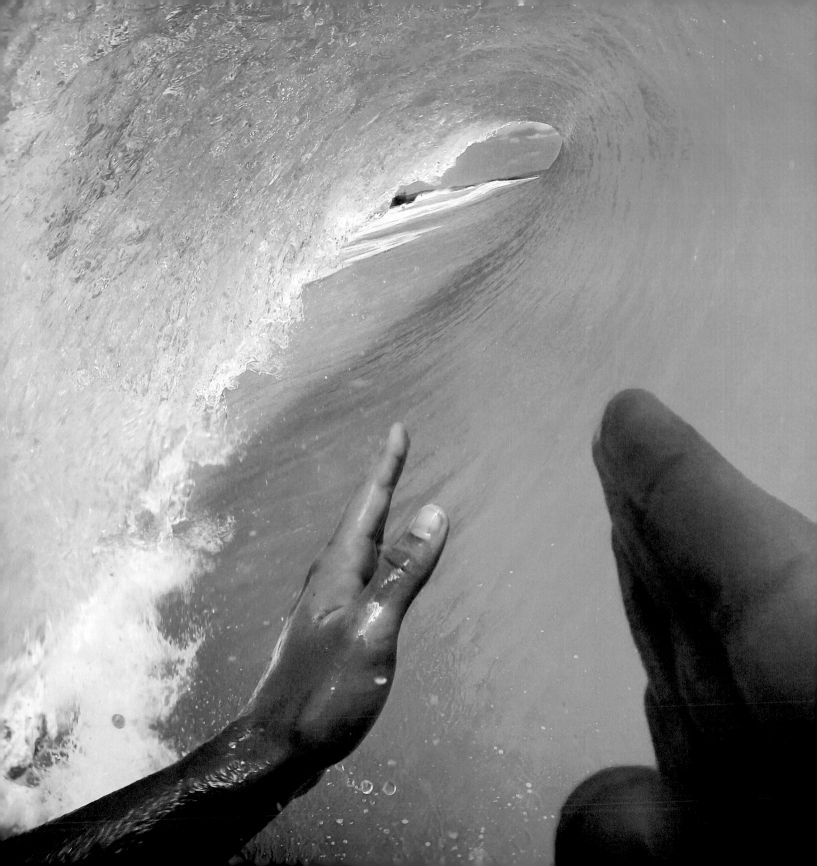

Mouth Mount

In hindsight, we wish we'd have thought of the mouth mount as soon as we took the camera off the wrist. During the HD HERO2 launch shoot in Bali, Mikala Jones would bite down on the floaty back, grab the camera once he dropped into the wave, and hold it behind his head. He felt helmets were awkward and head straps too floppy. We looked at the head strap's plastic front piece and realized if you put that in your mouth upside-down against your chin....

Revelation.

The mouth mount. Something that can be stashed in your pocket on the paddle out and during lulls. This is a versatile mount for direct POV (such as in Alex Smith's featured photo), handheld over-the-shoulder POV, or a follow-cam behind another surfer. All three are refreshing perspectives, more immersive than the typical long lens surf shot from the beach.

Over time, we noticed that a helmet or head strap always looked a little above the world. The 8 inches from the top of the forehead to the bottom of the chin actually makes a large difference in perspective. In the case of Carter Beauford's video featured here, it's 8 inches closer to the arms, hands, sticks, and drums. The mouth mount is more immersive than the head strap and more stable and responsive to the head's movements than the Chesty.

To build a mouth mount, remove the plastic front piece from the head strap. Wrap a thin piece of foam with electrical tape around the plastic. Be careful to pad correctly so that you protect your teeth. Bite down on the padding so that the camera is oriented upside-down with the floaty back resting against the chin. This mount can be potentially dangerous so use with care.

Angle is very important for the mouth mount. Tilt the camera slightly down toward the chin so the lens points a few degrees below the horizon. A fun trick with the mouth mount is to flip it around and point it directly down at your feet. This was originally devised for skating and has naturally transferred to other activities involving footwork. As with all POV, the mouth mount is best shot in 2.7K 4:3, 1440p60, or 960p120 for super slow motion.

Alex Smith / Oahu, Hawaii Mouth Mount Photo/.5sec

Dave Matthews Band's Carter Beauford Drum Solo

Legendary drummer Carter Beauford of Dave Matthews Band rips a drum solo in the studio like you've never seen before. Shot in 960p30 on the HD HERO2 in 2012.

Filmer: Carter Beauford
Editor: Tyler Johnson

https://www.youtube.com/watch?v=M9Pb6PF8LXA

Appendage Mounts

Different sports demand different perspectives. We first saw the ankle mount used to capture unique shots in human flight. The angle showed both the athlete's body and where he was headed, which made it especially useful for skydiving and basejumping. Depending on the activity, cameras fixed off appendages are fairly experimental but can offer unique perspectives and cutaway shots in editing. Slowed down with a high frame rate, they have the potential to be incredible moments, as in the Bungee Jumping TV commercial featured here. The final climactic moment was shot with a 6-inch extension from two vented helmet straps cinched around the calf. The shot is unusable for all but 2 seconds of freefall; however, at 60 fps, those 2 seconds were all that were needed to capture the emotion and perspective of the moment.

As far as construction, we have continually experimented with Velcro, straps, shinguards, and extensions coming off all appendages—some successful and some not. Foot mounts can be as simple as tucking a j-hook accessory underneath shoelaces, or as elaborate as David Bengtsson's photo here, which was captured from a custommade shinguard extension. Ankle and thigh mounts generally look best with the camera pointing up the side of the leg, keeping the lens as far from the leg as possible. The extra distance gives a better view of the environment and reduces foreshortening of the body. A few inches can go a long way toward capturing a more engaging and immersive shot.

When framing these types of mounts, be careful that the foreground (shoe, ankle, leg, thigh) doesn't dominate the frame. Use the foreground for orientation, but dedicate the majority of the frame to the subject and surrounding environment. Because these shots tend to be shaky, they can benefit from taller frames and higher frame rates. We recommend either 1440p60 or 960p120 for the extra frame rate to reduce shakiness, and the extra resolution to reduce disorientation and allow precise cropping or stretching in editing.

David Bengtsson, Saalbach Hinterglemm / Austria Leg Extension Photo/2sec

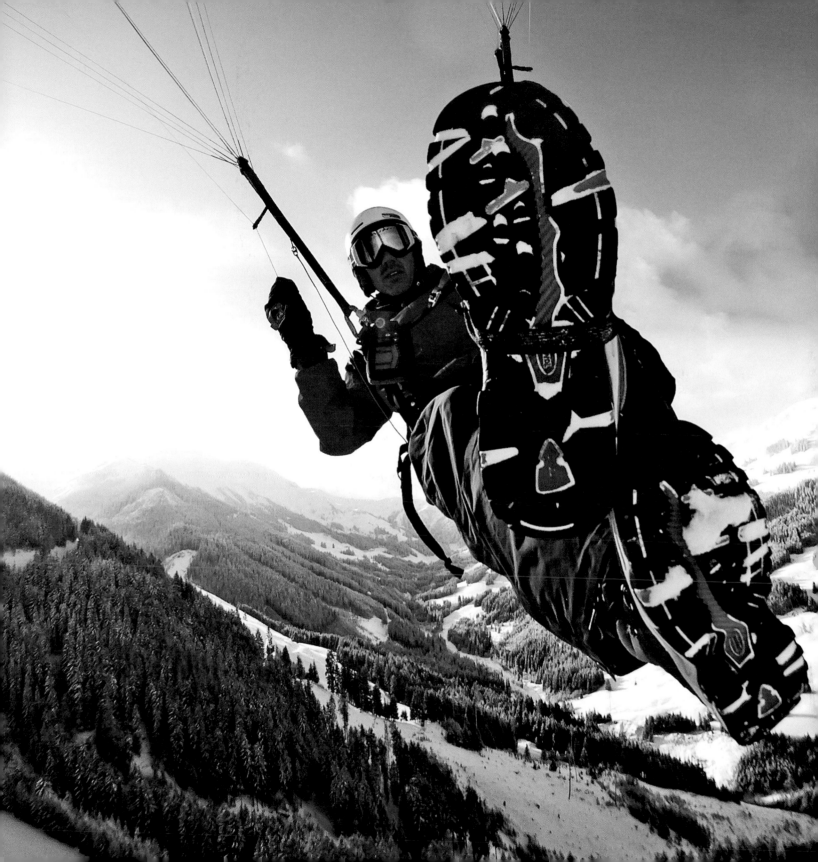

Backpack Mount

We have stubbornly chased after the over-the-shoulder perspective since the HD HERO. We had visions of a surfer wearing a backpack-mounted camera inside a barreling wave. The shot evaded us for years due to frame rate limitations and prototypes that were ripped apart in heavy surf. But something unexpected happened for the HERO3 launch shoot in Tahiti. Anthony Walsh donned a new rugged version of the backpack mount (built by our R&D specialist, Travis Pynn) on a fun-sized day at Teahupo'o and got knocked off his feet a couple of times. As the session progressed, Walsh figured out how to brace himself properly if the camera happened to get caught by the lip of the wave. Unbeknownst to us, he had captured magic. The footage would later blow the minds of all those present, including Kelly Slater, who exclaimed, "That's the most f*cked up shot I've ever seen. Can I give that backpack thing a try?" The shot realized something first glimpsed in *Morning of the Earth*—the internal anatomy of a barreling wave.

The backpack mount design went through three or four different iterations over the years. The version Walsh wore was a robust windsurfing harness. It was drilled and mounted with a carbon fiber baseplate supporting an extendable RPS pole, with two reinforcing extensions clamped to the pole for further support.

Around the time of the HERO3 release, a company called Sail Systems Video developed a backpack mount of their own: a similar windsurf harness, and a more popular, less rugged version that works for everything else. The human midsection is naturally stable and makes for good mounting. The best part is that the mount's arm is adjustable so you can place the camera in any position. We bring several of these backpack mounts on most of our shoots, and they are incredibly useful for all kinds of activities.

You can adjust the backpack mount for other perspectives besides over-the-shoulder. Inverting the arm or turning the entire apparatus around to the belly unlocks a whole new set of angles, some of which are shown here. Most configurations will use a 4:3 aspect ratio mode such as 2.7K 4:3, 1440p60 or 960p120.

Anthony Walsh Tahiti — TV Commercial

Anthony Walsh gives us a uniquely beautiful view of the inside lip of a wave. This video was captured with a backpack mount. Shot in 960p100 on the HERO3 in 2012.

https://www.youtube.com/watch?v=GbEEWIOWUZ0

Filmer: Anthony Walsh
Editor: Jordan Miller

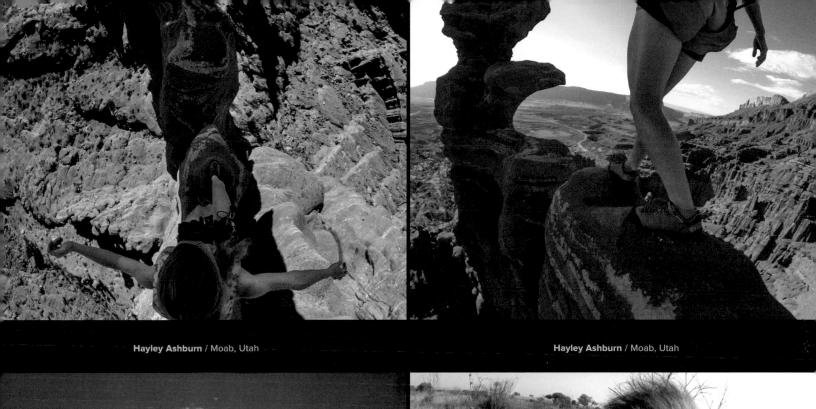

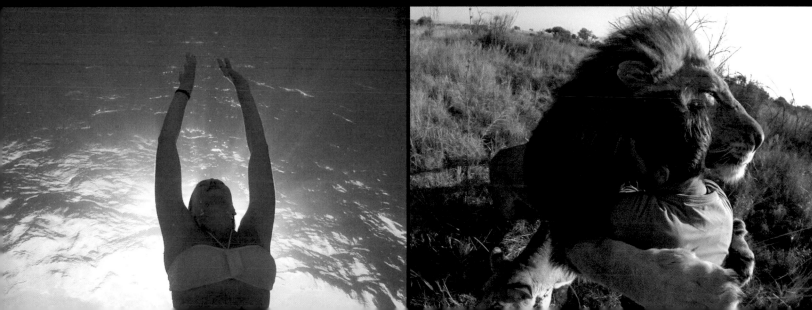

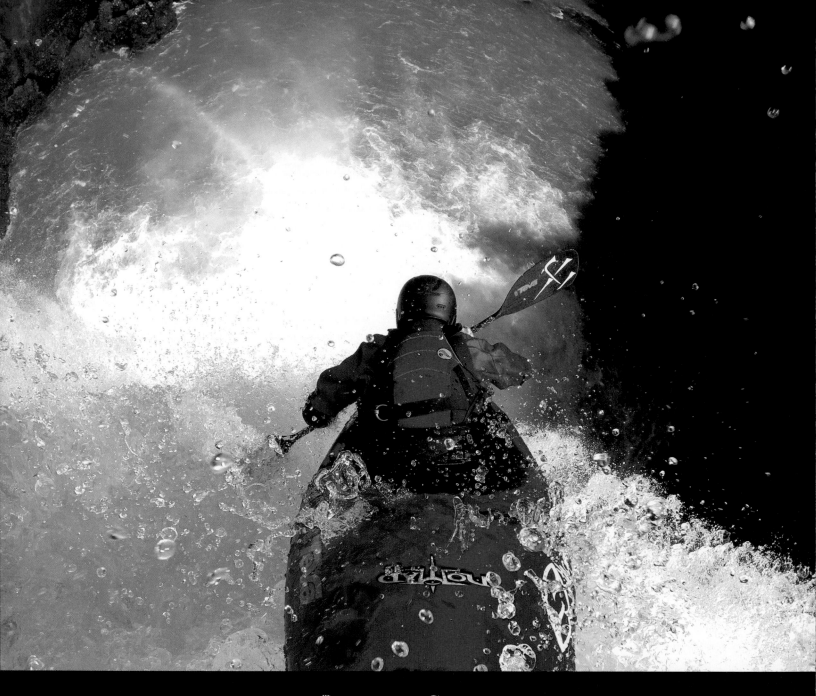

Rush Sturges / Tomata Falls, Mexico 🖐 Kayak Tail Extension 📷 Photo/.5sec

Extensions

One of the challenges of mounting the GoPro to larger objects is projecting the camera out far enough to define the object and give context within its surroundings. In the featured photo from Rush Sturges, mounting the camera directly to the tail would have made the kayak an abstract red blob in the foreground. As with the 3-Way extension arm, sometimes bringing the camera out a few inches can make a world of difference.

Building an extension varies according to the application. Generally speaking, triangulation equals stability. We often use a long telescoping pole such as the RPS supported by two smaller extensions. We drill holes in the ends of the poles and extensions, then use screws or zipties to attach the poles to our standard quick-release buckles, which click into adhesive mounts affixed to the desired surface. The entire apparatus forms something like an elongated pyramid. The triangulation helps fight vibration and movement. When mounting for auto sports, it's important to place the adhesive mounts closest to the frame of the vehicle where vibration is minimal.

An extension mounted to the back of a vehicle provides great coverage, showing not only the vehicle but the road ahead. Like the backpack, the extension can be flipped around for a frontal view by mounting off the nose. We have used these nose mounts on everything from Ken Block's car in Russia to deep sea submersibles. A kayak mount like Rush's is constructed with a piece of 1-inch steel tubing going through a flange bolted into the kayak body itself. Oahu photographer Pete Hodgson has used a similar technique for surfing, using steel or carbon fiber poles glassed into the back of surfboards. Fixed mounts like these are good for going over waterfalls or in heavy surf, but take extreme care. In an accident, you want the entire apparatus to break away instead of remain rigid, which is why we often use adhesive mounts.

Use the LCD BacPac or Wi-Fi App to carefully choose your frame before securing all screws and quick-release buckles. Extensions go well with either a 4:3 or 16:9 aspect ratio, depending on your framing and the need for high frame rates.

Dane Jackson's 60-foot Waterfall Drop

Dane Jackson drops the 60-foot La Tomata waterfall in central Veracruz, Mexico. Shot on the HERO3+ in 2014.

Filmer: Dane Jackson
Editor: Justin Whiting

https://www.youtube.com/
watch?v=IwsC0zHCdz8

Filmmaker Toys

The GoPro excels at more than just capturing POV footage. You can take the camera off body and vehicle mounts, and use it in conjunction with traditional filmmaking tools such as drones, steadi-cams, jibs, sliders, and more to capture dynamic wide shots. These shots are especially useful for providing coverage and establishing continuity of time and space on the editing timeline.

Aerial Photography

Drones have brought aerial photography to the masses. An affordable quadcopter and gimbal coupled with a GoPro allows you to get high-quality cinematography that normally would cost a hundred times more, all packed into a bag the size of your average carry-on.

You can learn the basics of flying a drone in a single day. There are a number of tutorials and information to be found online, and it's well worth investing the time if you are serious about aerial filmmaking. Most of the people in our media department now know how to fly drones, and we use them on most major productions.

Shakiness can be an issue with aerial video. Shooting 48 to 60 fps will allow for smoother footage through slow motion. A drone's three-axis gimbals go a long way toward stabilizing the camera, but try using Adobe's Warp Stabilizer to smooth out any shakes in your footage. Filming in 4K or 2.7K will ensure enough resolution for any cropping applied by stabilization. A Medium FOV can help if you are catching the copter's blades or landing gear in the periphery of the frame. A narrower FOV also has the added benefit of bringing a subject closer.

Ice Caves

Fly into Juneau, Alaska, and descend into the beauty of Mendenhall Glacier. Shot on the HERO3+ in 2014.

https://www.youtube.com/watch?v=0JWK-EDVOV0

Filmer: Christopher Carson
Editor: Rafael August

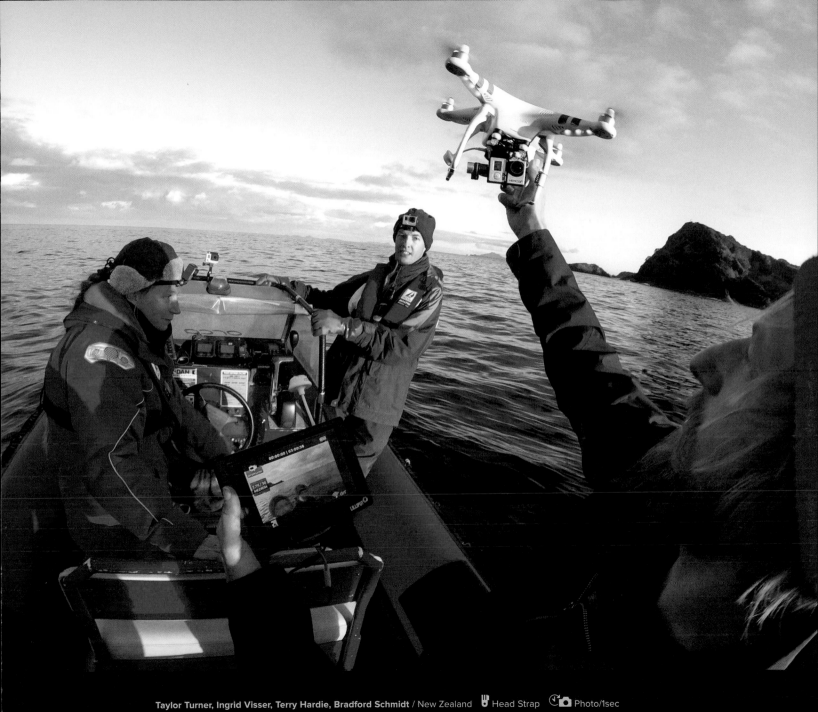

Taylor Turner, Ingrid Visser, Terry Hardie, Bradford Schmidt / New Zealand · Head Strap · Photo/1sec

Steadicams and Gimbals

Steadicam has been revolutionary in photography since the mid-1970s. Larger film cameras required a complicated body harness with spring-loaded arms for stabilization. Today's smaller, lighter cameras can achieve the same results with an entirely handheld rig. A number of different companies make them today. Most designs use a combination of weights to increase the camera's rotational inertia, thereby decreasing its tendency to shake or rotate while moving. Steadicams can be expensive and bulky, especially for a GoPro. Three-axis gimbals, like those used in drones, have recently become a popular, cheaper alternative.

The most dynamic steadicam or gimbal shots include foreground, midground, and background elements, with the camera weaving smoothly between close objects in frame—the closer, the better. We sometimes use them for interviews when sitting in one place feels stifling and one-dimensional. These "walk-and-talks" can help the interviewee feel more comfortable and make an interview more dynamic. We almost always shoot 16:9 video when using steadicams or gimbals. Filming in 4K or 2.7K48 allows for extra resolution if additional motion stabilization is required in post-production.

Sliders and Jibs

Sliders and jibs add cinematic movement to an otherwise static frame. Traditionally, Kessler makes some of the best sliders and jibs on the market, although they are built for heavier cameras than the GoPro. We mount multiple cameras on the baseplate: one in 2.7K Medium or 1080p Narrow FOV, and one shooting Ultra Wide, usually 4K. For interviews, the narrower FOVs distort the face less and feel more intimate, while the wide FOV captures the whole environment. We almost always use 16:9 video when filming with sliders or jibs.

Slider shots require some forethought. A good slider shot is composed with foreground, midground, and background elements so the audience really feels the change in perspective as the camera moves. You can also spin the slider 90 degrees with the camera facing forward for smooth push-ins or pull-backs. Combined with extensions, this technique can be especially useful for reveals, such as the 4-foot slider used in the opening and closing shots of Our Orangutan Brethren (see "Short Feature" in Chapter 6). Another variation is to hold the entire slider vertical for ascents or descents; we've done this a number of times to reveal a subject either above or below water.

Motorized sliders can be pricey. If you're on a budget, GoPro Studio software director David Newman has adapted a small toy train and track with a step-down motor that easily mounts a GoPro for slider-like shots and time-lapses. They are available for sale online. Jibs can be large and pricey as well. Aviator makes compact and lightweight jibs that you can pair with most standard tripods.

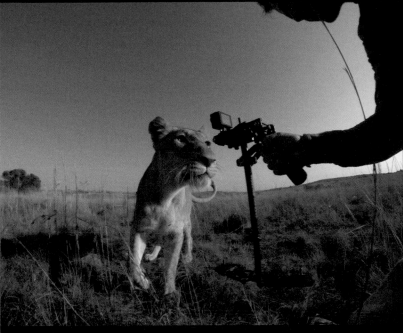

Kevin Richardson / Pretoria, South Africa

Marshall Miller, Bradford Schmidt / Moab, Utah

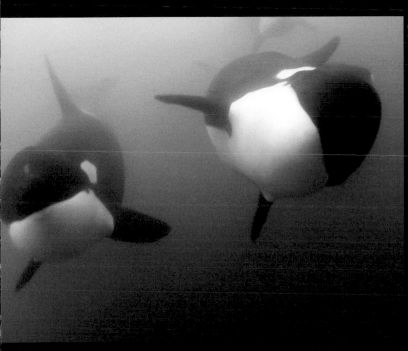

Ingrid Visser / New Zealand

Bradford Schmidt, Kevin Richardson / Pretoria, South Africa

Tow Cams

We first discovered the tow cam when watching a viral video posted by Mark Peters, a fisherman from Santa Cruz. Peters had built a torpedo-like tube with a GoPro to tow from the back of his boat. When coming home from fishing one day, he spotted a few dolphins playing in his boat's wake. He dropped his invention in the water and captured surreal footage that many would later claim was fake. It wasn't.

We became good friends with Peters, and he let us borrow his setup for filming whales in Tonga. It has since become indispensable for all our underwater wildlife shoots. A number of companies now make similar units. Torpedos with stabilizing fins tend to keep the camera steadier as it is towed through the water.

Aerial towing is another testament to the ingenuity of GoPro's users. For paragliding, speedflying, or paramotoring, a thin cord coming off the flyer's body or canopy pulls a small camera-mounted tube with stabilizing fins. The tube and camera trail along behind the flyer and capture a unique follow-cam shot. The results, as seen in the paramotoring video here, can be breathtaking. A quick search online finds a number of companies, such as WingmanCam, that manufacture these devices.

Both 16:9 and 4:3 aspect ratio modes can be used with tow cams, depending on the application. We recommend shooting at least 60 fps, however, to fully enjoy the floating sensation.

3rd Person Paramotor

Ever since Christopher Pine was a kid, he wanted to fly. Everything changed once he found paramotoring. Shot on the HD HERO in 2012.

https://www.youtube.com/
watch?v=y-MoBAtC1KY

Filmer: Christopher Pine
Editor: Tyler Johnson

Swimming with Dolphins — Santa Cruz, CA

Mark Peters and friends encounter an unexpected surprise while albacore fishing off the coast of Santa Cruz, California: Pacific White Sided Dolphins playfully hitch a ride behind their fishing boat. Shot on the HD HERO2 in 2012.

https://www.youtube.com/
watch?v=LStXdttFj_o

Filmer: Mark Peters
Editor: Annemarie Hennes

Sound

When people think about a camera, they only think of the visual aspect. For most camera manufacturers, sound is an afterthought. But sound can be just as important and impactful. In filmmaking, sound is half the story. The first GoPro Digital HERO's ten-second video recordings didn't even capture sound. Three years later, the HD HERO's sound profile was developed by Nicholas Woodman himself, who spent hours testing with his electric motorcycle and racecar. Woodman tuned the audio to capture the roaring engine while decreasing wind noise at high speeds. We've come a long way since then. The HERO4 has twice the dynamic range compared to the HERO3+. The Frame mount gives the camera's internal microphone better exposure to natural sound. Still, for capturing low-decibel noises or the subtle tones of the human voice, nothing beats a dedicated mic. To accommodate this need, GoPro sells a USB adapter for an 1/8-inch audio jack.

Lavaliers and Shotguns

Using The Frame mount the HERO3 and HERO4's audio quality is amazing. But a lavalier can make it really crisp when recording interviews and other activities in which genuine reactions from people will help build the story. We tend to use a long lav plugged into a camera specifically dedicated for audio. This camera is then tucked into the subject's pocket or jacket, becoming an audio recording device that can go unnoticed.

Countless lavaliers are on the market, and they range in price. We use a lavalier from Countryman that features an 1/8-inch plug that goes into our 3.5mm USB adapter. It's waterproof, durable, and not too expensive. Run the lavalier underneath the shirt and clip or tape the microphone at the collar, making sure it won't rub against the clothing during movement. Remember that even a little bit of wind will blow out an uncovered microphone, ruining the audio. Cover the lavalier with foam or fur to help reduce wind noise.

Shotgun microphones are specifically designed for directional audio capture. Internal camera microphones or lavaliers are omni-directional and don't compare for isolating targeted voices. Typically, the longer the shotgun the more directional the capture. The trick is to have one strong enough to reach a subject 6 feet away, but also physically short enough not to be seen in the GoPro's wide lens. We've found the Shure VP83 and the Rode Micro Shotgun pair nicely with the camera using the Norbert. Most shotgun mics have a setting to limit the wind, but it is essential to cover the shotgun with good foam or fur to eliminate the chance of spoiling the hard-earned audio. Be sure also to check the connections between the camera, adapter, and microphone. Shotguns usually require separate batteries. Make sure the batteries are fresh and the microphone is turned on, otherwise you risk losing all audio as the GoPro's internal audio is disabled when an external mic is plugged into the USB.

Multi-Camera

GoPro has fueled interest in creative multicamera solutions. Our early developments in GoPro 3D served as a primer for an expanded experimentation in multi-camera applications. If two cameras can be in frame-sync together, why not 10? Why not 50? GoPro 3D, array, and spherical technologies all require camera sync. Sync can be achieved in two ways: *true frame sync* or *jam sync*. True frame sync means all cameras are in exact sync in-camera when capturing each frame. Jam sync means each camera records independently and will thus be a little off from frame to frame, requiring manual syncing in post-production.

Dual and 3D

GoPro's Dual HERO System frame-syncs two regular GoPro cameras together with a cable and combines them in a dual-housing. You can use the system to take photos and video simultaneously, or for capturing stereoscopic 3D images. 3D takes advantage of the human brain's natural ability to perceive depth from two different viewpoints. Just as each of your eyes sees a slightly different perspective of the world, each camera in a 3D rig captures video at a slightly different angle. The difference between these observed angles is known as *parallax*. The greater the parallax, the closer an object is percieved to be by the brain.

3D video is truly realized only upon playback, when the right and left images are presented simultaneously to their corresponding eyes. The viewer wears special glasses so that the left-side image is viewable only by the left eye, and the right-side image by the right eye. The brain does the rest of the work. The photo featured here, shot by renowned shark photographer Andy Casagrande, requires red and cyan glasses to view.

How much the two images overlap, or converge, is what simulates depth in a 3D image. To process 3D images, use GoPro Studio to overlay the two images and adjust their convergence in a process known as *muxing*. The basic steps for muxing images are pretty straightforward. Use the color correction tools to adjust the images so they have similar exposure and color tone. Then, adjust the convergence, positioning the images so that the objects in the foreground overlap perfectly. In most cases, this is all you need to do. GoPro offers a number of 3D tutorials on gopro.com to walk users through the whole 3D workflow.

GoPro 3D: Highlight Reel 2011

Professional 3D made easy: Combine, capture, and create.
Shot on the HD HERO in 2011.

https://www.youtube.com/
watch?v=CDQ3rmEeKN8

Filmers: GoPro Media
Editor: Jordan Miller

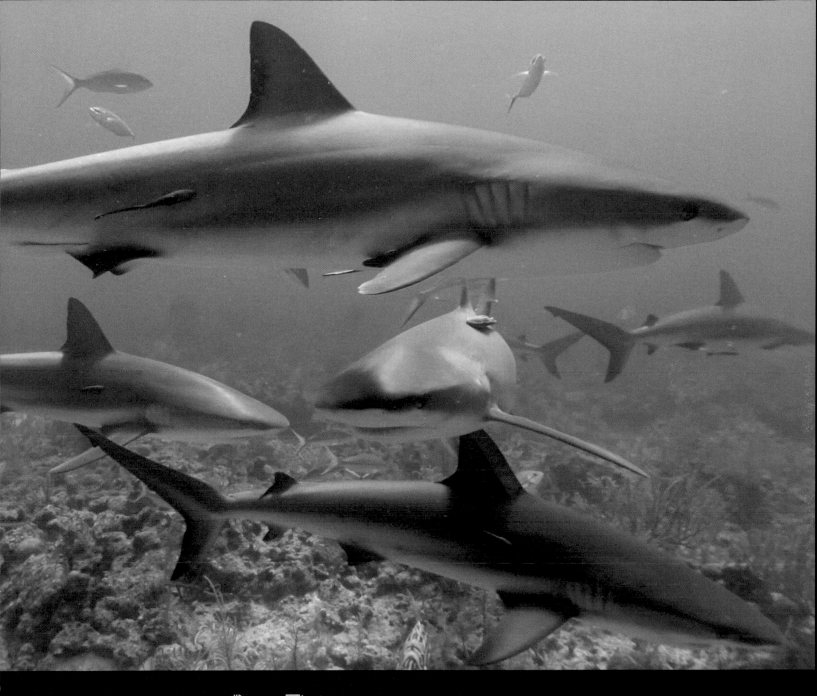

Array

"The GoPro array allows you to experience the world in four dimensions: the three dimensions of space, and the dimension of time... blending these together creates a unique and powerful perspective."

 —Tim Macmillan

In the early 1980s, Tim Macmillan was studying fine arts at University College, London. Macmillan placed a 35mm film strip into a plank of wood with tiny pinholes drilled at the center of each frame. He had all of his classmates jump in the air at the same time, while simultaneously exposing every frame on the filmstrip. Then he turned the strip of film into a loop and projected it. Tim had invented the first camera array for freezing objects in time while moving through space! Two decades later, the Wachowskis popularized the same technique in *The Matrix*.

An array consists of three or more synchronized cameras grouped together and recording simultaneously. There are many types of arrays, but the most well known today is the linear or arc. In a linear array, cameras are placed as close together as possible along a mounting bar. After capture, each video is stacked in order on a separate layer in the editing timeline. The editor starts at one end of the array and displays a frame from each camera, moving down the line. This creates virtual camera movement, in which the subject is normally frozen. If the subject moves during the virtual pan, it is called *phased* movement. This is done by letting each camera advance a single frame at a time, and only works with high frame rates such as 120 fps or more.

We almost always use motion interpolation software like GoPro Studio's Flux to slow down the array pan and allow the audience to take it in. We also use Warp Stabilizer to help smooth out any minute differences from camera to camera.

It is possible to build and jam sync your own array. GoPro production artist Tyler Johnson did just this with 24 GoPros in the video featured here. Jam syncing works best with scenes that don't have a lot of motion, but be prepared to spend time in After Effects cleaning things up. If the scene has a lot of motion in it, then true frame sync is a must.

Fire Breathing with a 24 GoPro Array

GoPro's own Tyler Johnson built his own array with 24 GoPros and teamed up with GoPro Music Supervisor/Fire Breather David Kelley to capture an epic moment that bends time and space. Shot on the HERO3 in 2013.

https://www.youtube.com/watch?v=3z_nYJoH6js

Filmers: Tyler Johnson, David Kelley
Editor: Tyler Johnson

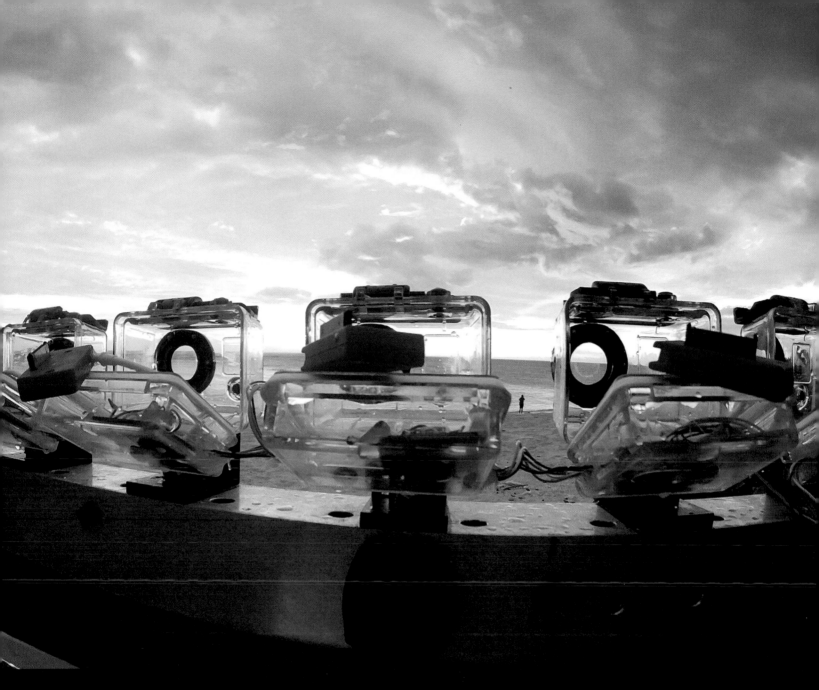

Bradford Schmidt / Fiji · Toy Train · Photo/2sec

Spherical

Whereas a conventional GoPro in Ultra Wide FOV setting captures 170 degrees of the world, spherical video captures the entire 360 degrees. A spherical rig of GoPros uses anywhere from four to fourteen cameras, arranged on a ball and facing outward. Cameras on opposite sides of the rig are positioned relative to each other so that lines projected through all the lenses converge on a single nodal point at the center of the rig.

Once captured, the separate videos must be combined into a single image. The individual video files from each camera are synced, stitched together, and displayed. There are different programs for stitching and editing spherical video—PTgui, Videostitch, and Kolor, for example. The final stitched spherical image will have a very high resolution, so a powerful computer is recommended.

Spherical arrays have many variations and methods of display. As a standard, most spherical players today accept videos with equirectangular projection, which preserves vertical lines in an image while keeping the horizon straight. The featured image of Mikala Jones is an equirectangular image stitched from six GoPros on a spherical rig.

There are many ways to interact with a spherical image. Most use a virtual camera with a limited FOV to map part of the image onto a traditional video screen. The user can then rotate the virtual camera with a variety of devices: a headset such as Occulus Rift, a smartphone with a spherical app, or by simply clicking and dragging the video screen with a mouse. Another unique way is to project the spherical content on to the inside of a dome. Like a conventional star dome or planetarium, this allows the user to stand inside and watch as the video experience unfolds around them.

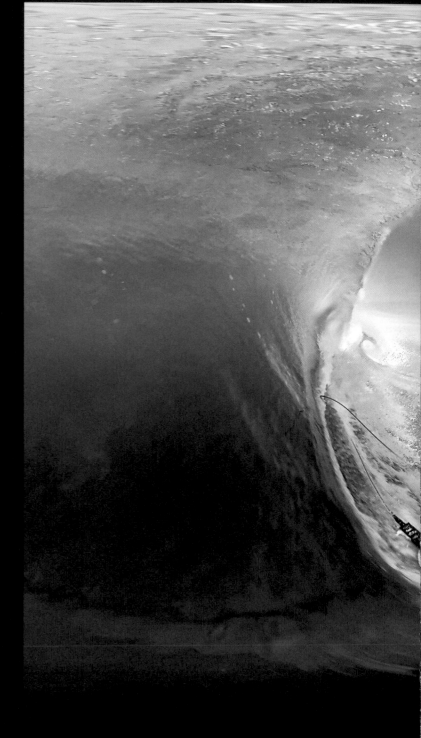

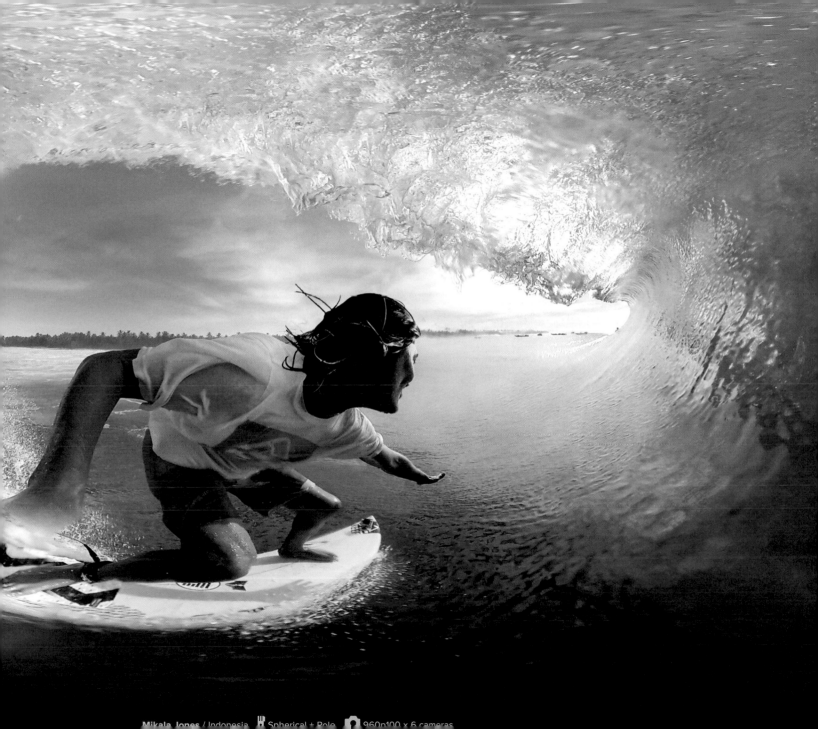

Angles by Activity

THIS CHAPTER PROVIDES A QUICK reference guide for filming with a GoPro. Each section covers the best mount setups and corresponding camera modes for capturing a specific activity. We've also included useful tips for getting the best shots and videos that show many of the featured angles in action.

In recommending camera modes, we take into account the many factors involved in capturing each activity. All the modes listed help you achieve the best coverage with the highest possible frame rate and resolution in bright, sunny conditions. If you're shooting in low light or very cloudy conditions, consider lowering the frame rate to increase exposure time. Also, consider how the footage will be edited. You may not need the highest resolution, such as **4K**, if you're only going to use the footage for a standard-definition Instagram video on mobile devices. As always, use 4:3 aspect ratio modes for body-mounted or gear-mounted angles and stick with 16:9 modes for wide or vehicle-mounted shots.

The GoPro camera presents an ocean of possible applications. The list of mounting options grows every day as users discover new ways to capture their favorite activities. With a little creativity, you can adapt an innovative angle for one activity to fit another activity. This is how GoPro has been so successful in capturing such a wide spectrum of human endeavors. The angles presented in this chapter are a starting point—we encourage you to invent your own perspectives.

Ryan and Bia Atkins / Maui, Hawaii Handheld Photo/.5sec

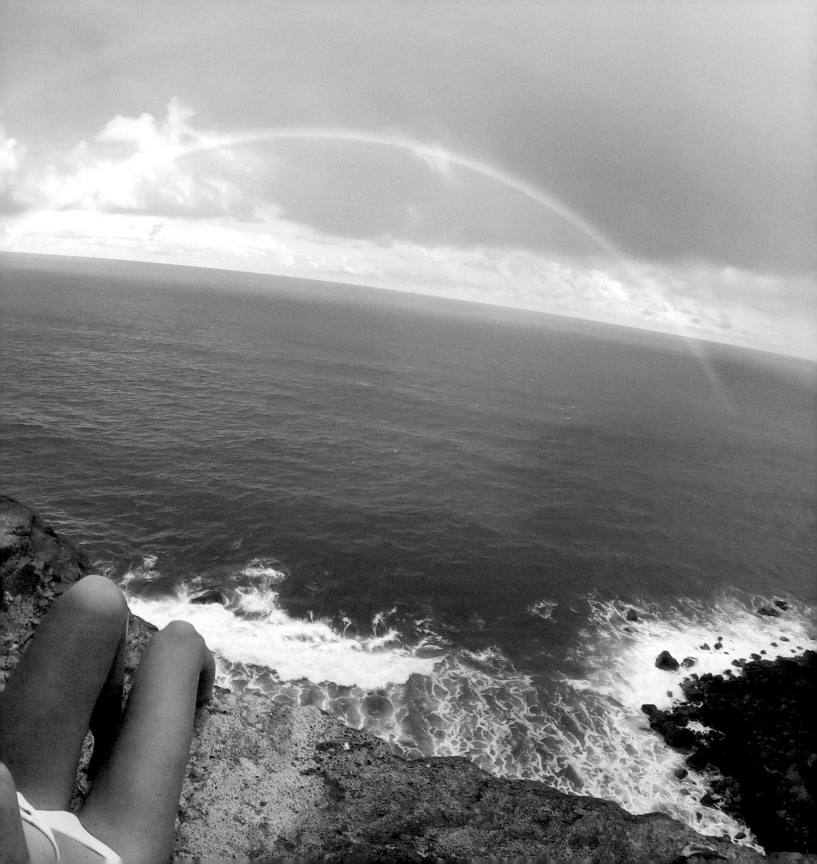

Surf

We recommend filming high frame rates while surfing because the action happens so fast. Slow motion extends the surfing experience on screen and it also makes the water look awesome. For gear, use floaty backs in case the surf mount pops off and antifogs to keep your shots clean. Remember to frequently lick the lens to keep it free of water drops.

The surfboard mount, mouth mount, and handheld shots are basic angles that create a foundation for surf video editing. One of our favorite angles is the follow-cam. You can best achieve these shots with the mouth mount. While filming follow-cam, concentrate on camera work rather than surfing. Surf with a smooth gliding motion, absorb all the shock with your knees, and don't take your eyes off the other surfer.

Advanced surfers can try more difficult, experimental setups such as the 3-Way extension arm, the Handler, backpack, and the tail pole to capture unique angles. The 3-Way can put the camera farther away from the subject, which makes a huge difference. We tape padding around the middle of the 3-Way so we can hold it between our teeth while paddling and then grab it after dropping in. You can achieve deeper barrel shots by holding it behind you, or you can capture spectacular carves, cutbacks, and airs by holding it in front.

Endless Barrels — GoPro of the Winter 2013–14

Filmers: GoPro of the Winter Contestants
Editor: Taylor Turner
Camera: HERO3+, 2014

https://www.youtube.com/watch?v=gm7eT0MGt2Y

Handheld / 960p120 / Jamie O'Brien

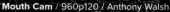
Follow-Cam / 960p120 / Anthony Walsh, Laird Hamilton

Surf Mount / 960p120 / Marlon Gerber **Longboard Extension** / 960p120 / Kelia Moniz **Mouth Cam** / 960p120 / Anthony Walsh

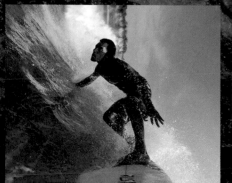

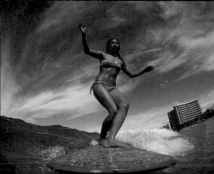

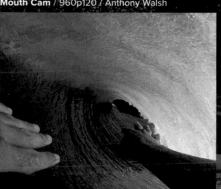

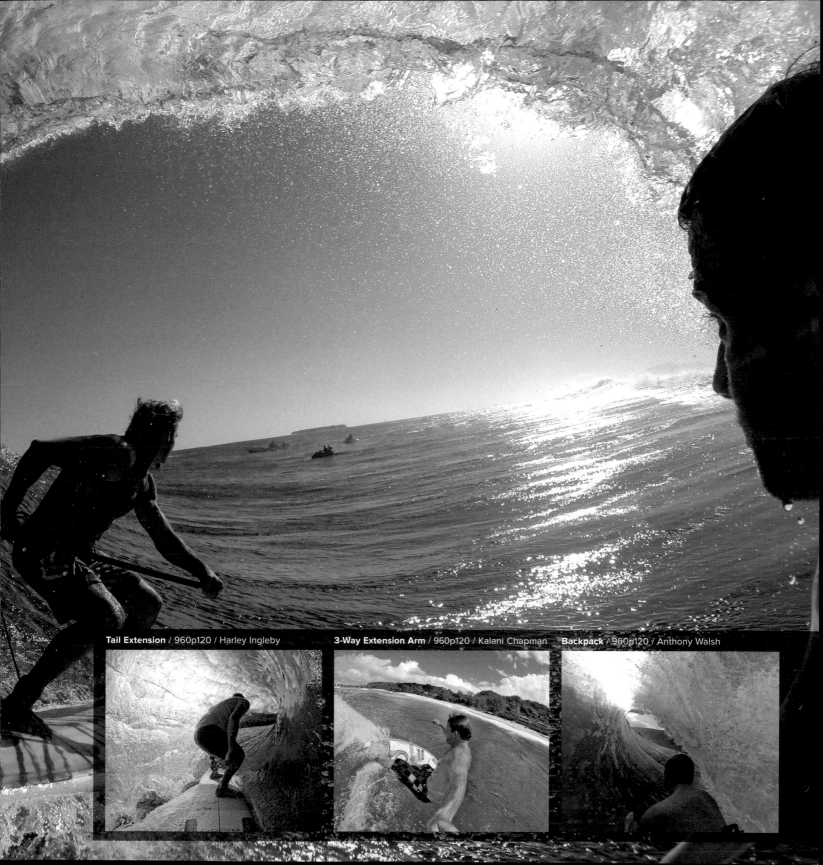

Tail Extension / 960p120 / Harley Ingleby **3-Way Extension Arm** / 960p120 / Kalani Chapman **Backpack** / 960p120 / Anthony Walsh

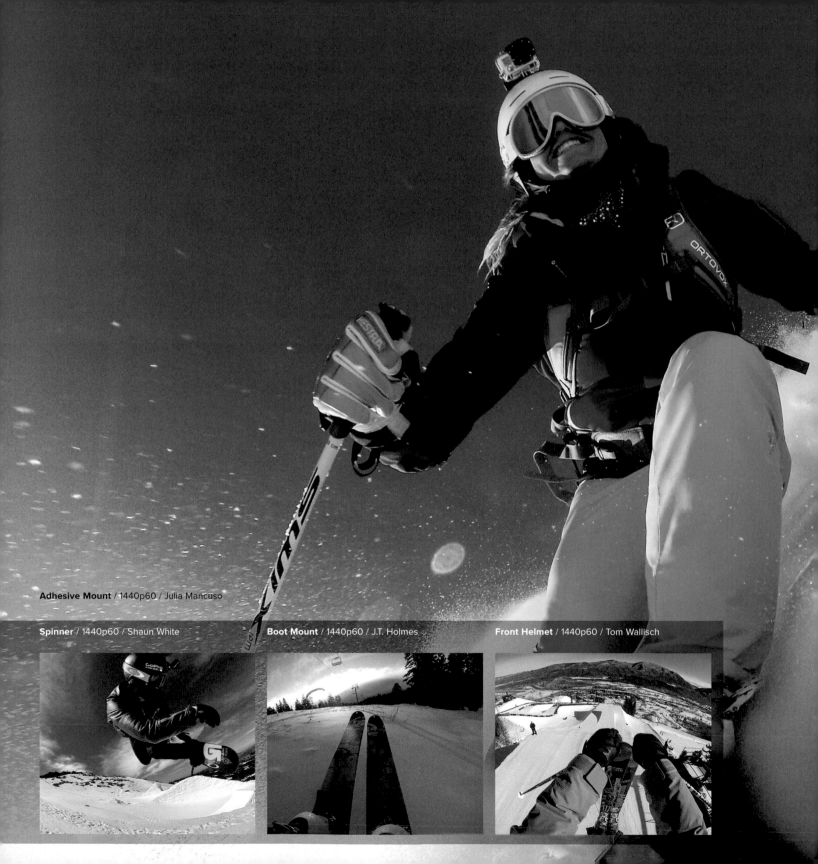

Adhesive Mount / 1440p60 / Julia Mancuso

Spinner / 1440p60 / Shaun White **Boot Mount** / 1440p60 / J.T. Holmes **Front Helmet** / 1440p60 / Tom Wallisch

Snow

GoPro is now ubiquitous at just about every ski area in the world. If you mount the camera properly, skiing and snowboarding footage is usually smooth and stable. Generally speaking, you can use a Frame mount on a helmet because snow rarely sprays overhead and it offers the best audio. For anything below the helmet, use a waterproof housing and antifogs, or use a skeleton backdoor.

Various mounts work for shooting skiing and snowboarding. Top-mounted helmet cameras are unobtrusive and offer total coverage. A popular option is using a Frame-mounted camera on the front of the helmet. Mounting to the side of the helmet is another option. The Chesty offers the most immersive perspective, although you will need to strap it down tight. Be careful when applying adhesive mounts directly to skis and snowboards because they tend to pop off in freezing temperatures.

Although POV is the foundation of any edit, you can accomplish dynamic follow-cam no matter your skill level. Use the handlebar/seatpost mount's included thick gasket to attach the camera to the skinny end of a ski pole for filming your friends or turn it around to film yourself. Use a screwdriver to tighten any knobs so the cameras don't pivot in the middle of the run. Keep the ski pole light on your fingertips and concentrate on keeping your wrist from rotating to prevent jittery shots.

Chesty / 1440p60 / Chris Davenport

Let Me Take You to the Mountain

Director: Abe Kislevitz
Producer: Yara Khakbaz
Crew: Caleb Farro, Trenton Pasic
Editor: Kyle Camerer
Camera: HERO3+, 2013

https://www.youtube.com/watch?v=C-y70ZO5zE0

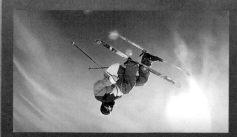

Follow-Cam / 1080p120 / Abe Kislevitz, Matt Cook

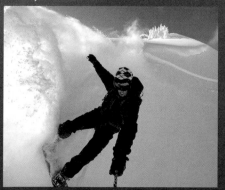

Handlebar Ski Pole / 1440p60 / Kris "Jaymo" Jamieson

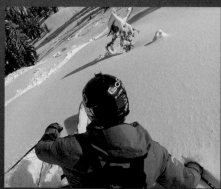

Backpack / 1440p60 / J.T. Holmes

Auto

Automotive vehicles offer nearly endless mounting locations along the body, windows, and interior. For any interior shots, use a Frame mount for the best audio. Depending on weather and road conditions, a housing with a skeleton backdoor is recommended to keep the camera protected from mud, gravel, and the elements, as well as giving ventilation to keep the lens from fogging. It's important to attach the camera as close to the structural frame of the vehicle as possible to keep the footage stable at high speeds.

Be sure to clean the surface of your vehicle before applying a suction cup mount or adhesive mounts. Use a screwdriver to tighten down any knobs or extensions to keep the cameras from shaking due to engine vibration or high speeds. Extensions off the vehicle offer really unique perspectives but can be shaky, so we recommend mounting with care and filming at high frame rates. A rotating mount made by Vector lets you capture especially unique shots from the roof of a drifting car.

When mounting inside a dark vehicle, you can take advantage of one of the most practical uses of the GoPro's adjustable exposure setting. Drop the exposure to −2 to keep the highlights outside the windows from blowing out. Auto sports are almost always filmed in a high resolution, 16:9 mode such as 4K 30 (except during specific situations such as shaky extension mounts or filming in slow motion).

Longest Jump Story

Director and Editor: James Kirkham
Producer: Jaci Pastore
Crew: Seamus Makim, Hart Houston, Nate Lewis
Camera: HERO3+, 2014

https://www.youtube.com/watch?v=HWOANXNGrZc

Roll Bar / 2.7K48 / Guerlain Chicherit

Over the Shoulder / 4K30 / Nobuhiro "Monster" Tajima

Front Extension / 960p120 / Ken Block

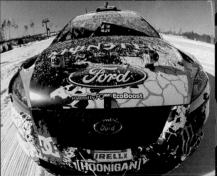

Suction Cup / 1440p60 / Vaughn Gittin Jr.

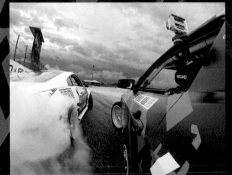

Low Bumper / 4K30 / Nicholas Woodman

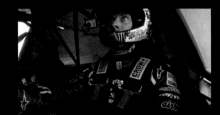

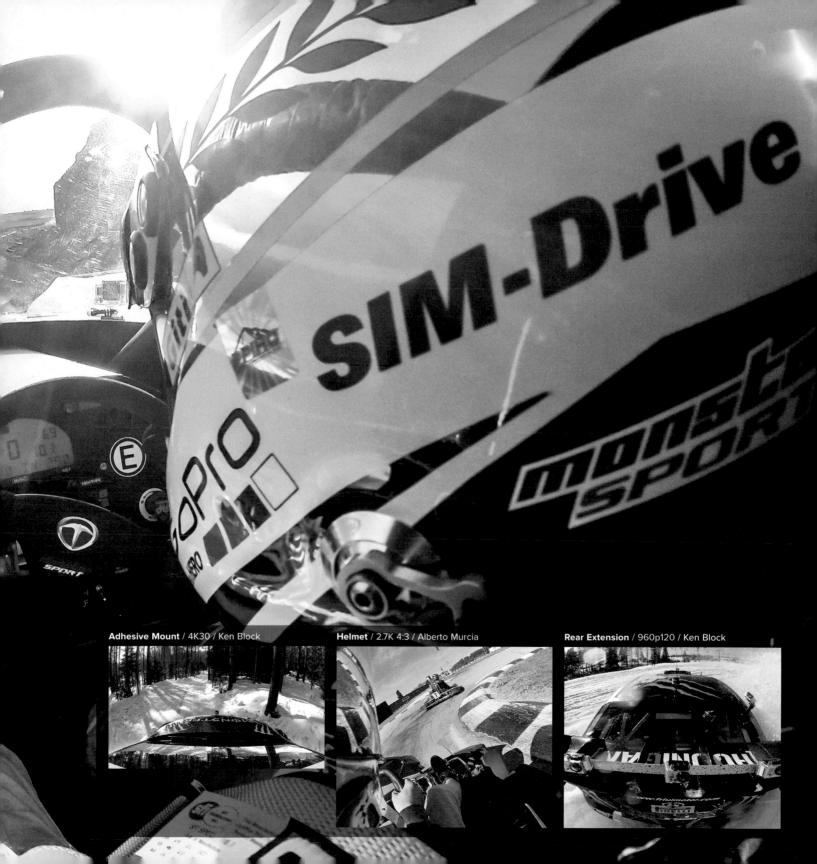

Adhesive Mount / 4K30 / Ken Block

Helmet / 2.7K 4:3 / Alberto Murcia

Rear Extension / 960p120 / Ken Block

Bike

Biking offers many variables and invites experimentation. If you're going for speed, film at higher resolutions with lower frame rates. For jumps and free riding, use as high a frame rate as possible to slow down critical moments in the air or on the trail. A Frame mount with a protective lens provides the best audio, but in inclement weather or muddy conditions, use a housing with a skeleton backdoor to protect your camera from the elements.

Helmet-mounted perspectives are a staple for biking, and they do a decent job of capturing the forearms and handlebars. The Chesty mount is the most immersive angle, but your GoPro must be mounted upside-down and tilted up 45 degrees to capture the horizon and approaching terrain as you lean forward over the handlebars.

Gnarwhals, spinners, and bike frame mounts offer unique perspectives. They also tend to be shaky, so be sure to use high frame rates so you can slow down the footage in editing. If the bike's tubing is too thick for the standard handlebar mount, try a roll bar mount.

Post Office Bike Jam 2011

Filmers: Travis Pynn,
Annemarie Hennes, Mario Callejas
Editor: Jordan Miller
Camera: HD HERO, 2011

https://www.youtube.com/
watch?v=dt2swkr_KmY

Seatpost Mount / 1440p60 / Jeff Herbertson

Chesty / 1440p60 / Gee Atherton

Gnarwhal / 1440p60 / Aaron Chase **Top Helmet** / 1440p60 / Kris "Jaymo" Jamieson **Side Helmet** / 2.7K 4:3 / Aaron Chase

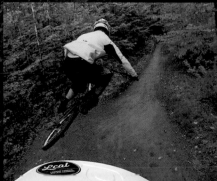

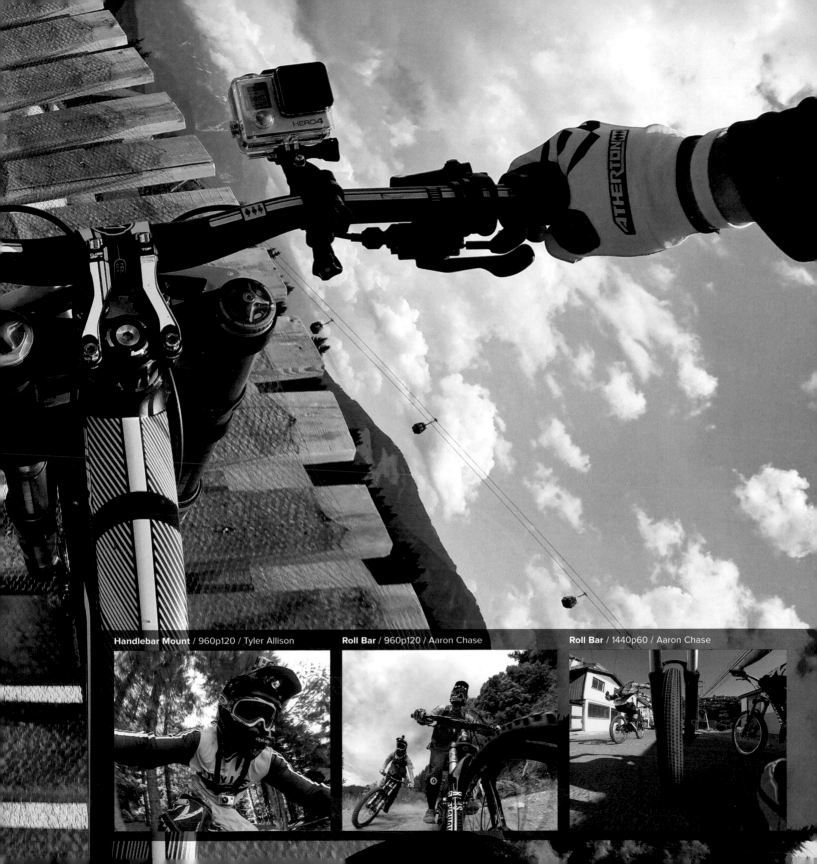

Handlebar Mount / 960p120 / Tyler Allison

Roll Bar / 960p120 / Aaron Chase

Roll Bar / 1440p60 / Aaron Chase

Human Flight

BASE jumpers, skydivers, speed flyers, hang gliders, and wingsuit flyers were early adopters of GoPro, and they developed a multitude of angles and filming techniques. Extensions yield amazing shots, but should be used with extreme caution.

Human flight is obviously dangerous and it requires careful filming. Self-capture and POV form the essential foundation for any human flight video, with follow-cam reserved for the most advanced flyers. Neil Amonson introduced us to the gnarwhal while BASE jumping, and it now applies to almost every activity. A Chesty strung low beneath the parachute chest strap and pointed up toward the chin offers a great perspective. An innovative back-of-hand mount fits like a glove and provides a convenient option for self-capture.

The ankle/leg mount is one of the more unique human flight angles, but it can be the shakiest. The human flight follow-cam is a dangerous art form, and many professionals utilize a precisely aligned eye monocle to achieve perfect framing. Medium and Narrow FOVs are more ideal to capture an even closer perspective of the subject. Hang gliders and speed flyers also tow torpedo-like devices behind them for follow-cam shots.

Close Encounters – Proximity Flying with Jokke Sommer

Filmer: Jokke Sommer
Editor: Nate Lee
Camera: HD HERO, 2012

https://www.youtube.com/watch?v=bwMaqfwlER8

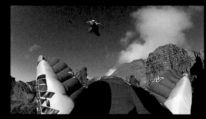

Helmet Reverse / 1440p60 / Jokke Sommer

Follow-Cam / 2.7K48 Medium / Jeb Corliss, Luigi Cani

Chesty / 1440p60 / Marshall Miller

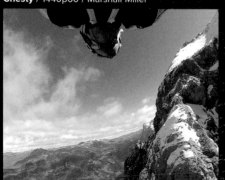

Gnarwhal / 1440p60 / Marshall Miller

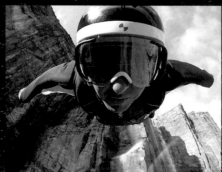

Hand Mount / 1440p60 / Jeb Corliss, Luigi Cani

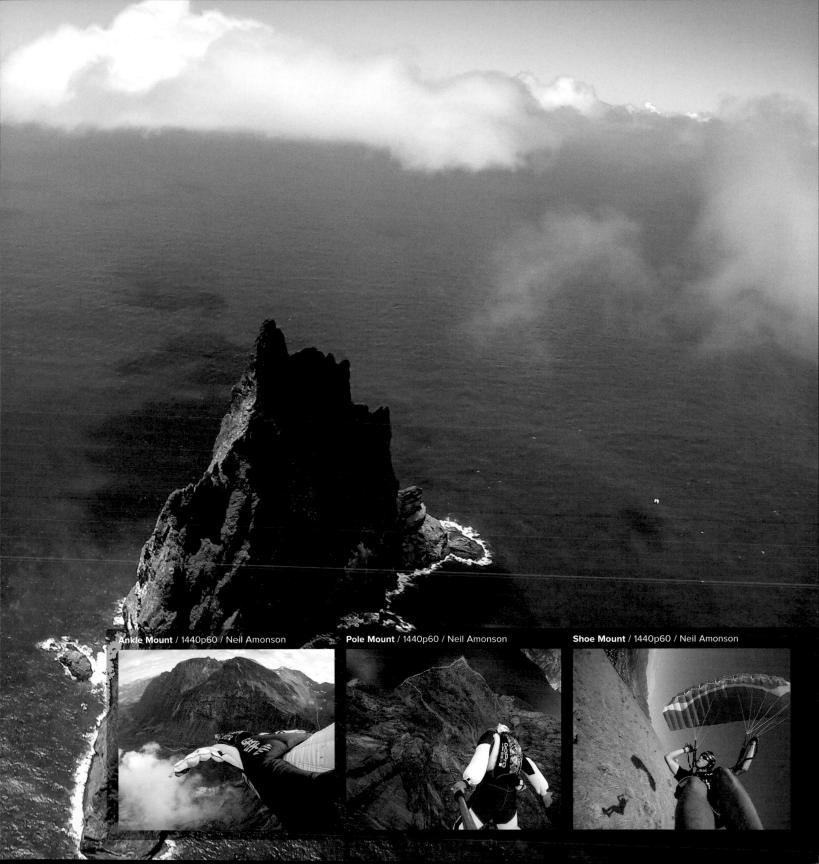

Ankle Mount / 1440p60 / Neil Amonson

Pole Mount / 1440p60 / Neil Amonson

Shoe Mount / 1440p60 / Neil Amonson

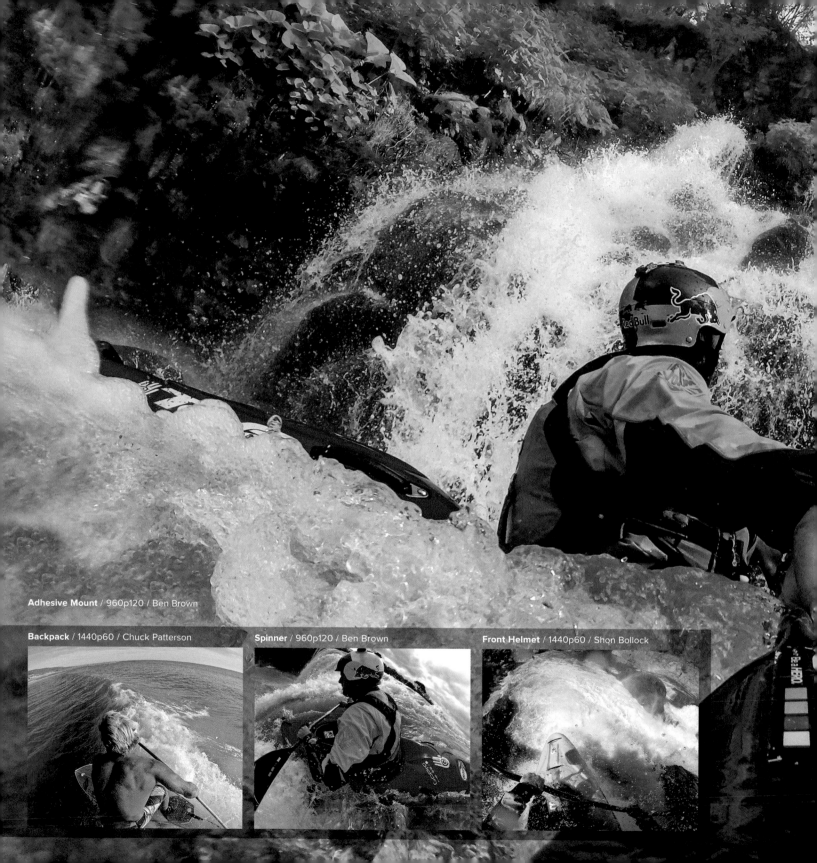

Adhesive Mount / 960p120 / Ben Brown

Backpack / 1440p60 / Chuck Patterson

Spinner / 960p120 / Ben Brown

Front Helmet / 1440p60 / Shon Bollock

Paddle

Kayaking and stand up paddling (SUP) offer a number of very inventive mounting techniques for documenting activities that are otherwise difficult to capture. A paddle essentially puts a pole-mount in your hands already, which is great for obtaining shots of yourself within your environment. The water and intensity of the action necessitate high frame rates.

On a paddle, using a roll bar mount out of the way of your hands is very simple and effective. Helmet mounts and mouth mounts provide stable and quintessenial POV angles. To give context to the user within the shot, use a surf mount for your SUP or a handlebar mount on the front or rear handle of your kayak. Once you capture these angles, though, you'll immediately want to push the camera out even more and elevate it with an extension for a better perspective.

Pole extensions off the front and back are particularly unique and stunning angles, but are typically unsafe and suitable only for experts. As with anything in water, we recommend using waterproof housings with antifog strips inside and floaty backdoors attached. Try licking the lens often or pretreating the lens with Rain-X to keep waterdrops from ruining the shot.

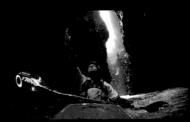

Front Extension / 960p120 / Ben Brown

Kayak New Zealand

Director: Jordan Miller
Producer: Yara Khakbaz
Crew: Bradford Schmidt, Nicholas Lubsen, Sam Lazarus
Editor: Wes Nobles
Camera: HERO3, 2012

https://www.youtube.com/watch?v=yLUxzgdeD78

Side Helmet / 1440p60 / Ben Brown

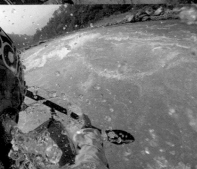

Roll Bar / 1440p60 / Mike Coots

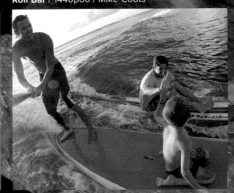

Rear Extension / 960p120 / Rafael Ortiz

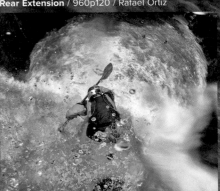

Motorcycle

Choosing a frame rate for motorcycle footage depends on the application. If you're filming speed-bikes on streets or highways, you probably won't need slow motion. Motocross, jumping, or free-riding in the desert, on the other hand, definitely benefit from slow motion, especially for trick sequences. Using a Frame mount with a protective lens is ideal for capturing sound. However, in muddy or wet conditions, use a waterproof housing.

Front, side, and reverse helmet mounts offer the most stable and versatile angles for motorcycle sports. The Chesty gives the quintessential immersive perspective, but it needs to be cinched down tight to keep the camera from shaking.

A helmet spinner offers a phenomenal angle but must be used with extreme caution by experts only as they can be very dangerous to the rider. Asymmetric positioning of the camera allows the mount to spin and gives the audience a full view. Try mounts on the motorcycle body, backpacks, or a 3-Way extension arm for more interesting perspectives. However, engine vibration and high speeds are the enemy. With these, as well as with the spinner, high frame rates are essential to ensure usable footage.

Highest Road in the World

Director and Editor: James Kirkham
Producer: Yara Khakbaz
Crew: Alex Chacon, Zak Shelhamer
Camera: HERO3+, 2013

https://www.youtube.com/watch?v=DwV-lm0kGqg

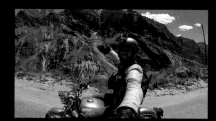

3-Way / 1440p60 / Alex Chacon

Gnarwhal / 1440p60 / Francisco Garza Andonie

Side Helmet / 2.7K 4:3 / Ronnie Renner **Spinner** / 960p120 / Ronnie Renner **Chesty** / 2.7K 4:3 / James Kirkham

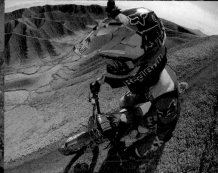
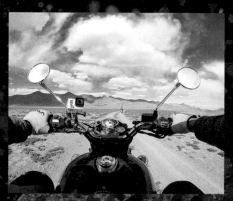

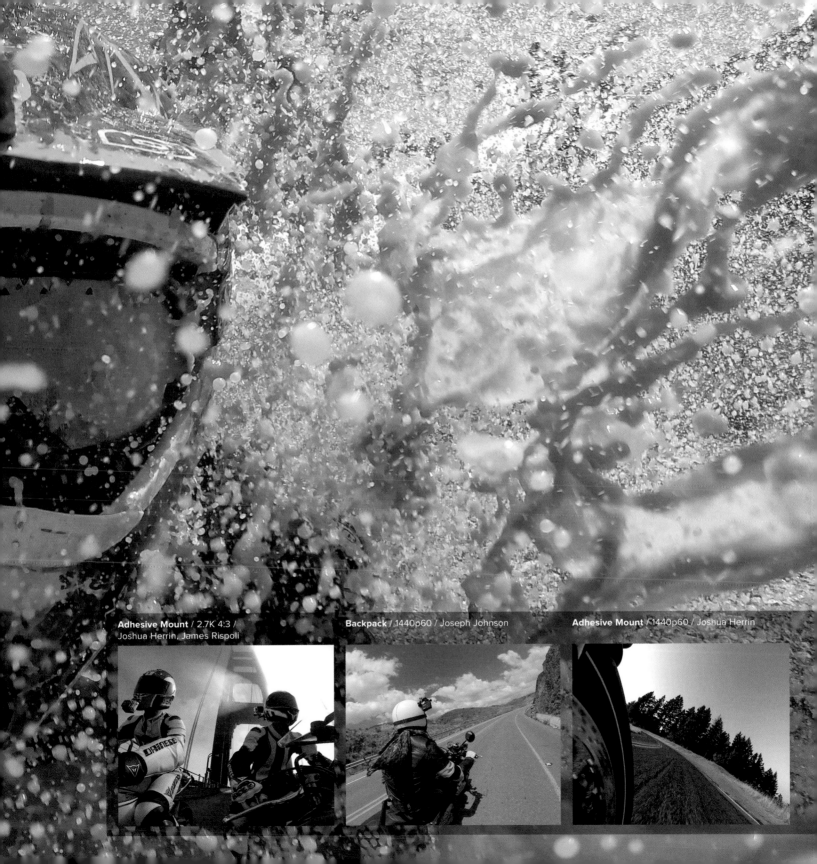

Adhesive Mount / 2.7K 4:3 /
Joshua Herrin, James Rispoli

Backpack / 1440p60 / Joseph Johnson

Adhesive Mount / 1440p60 / Joshua Herrin

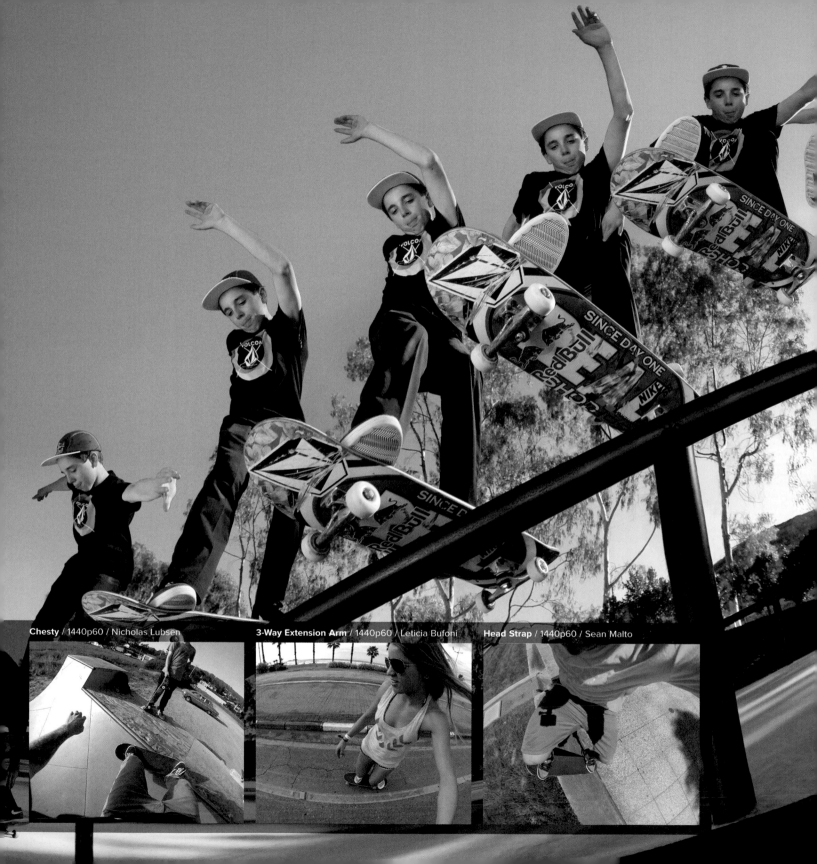

Chesty / 1440p60 / Nicholas Lubsen **3-Way Extension Arm** / 1440p60 / Leticia Bufoni **Head Strap** / 1440p60 / Sean Malto

Skate

To film skateboarding, we usually use a Frame mount because a more exposed camera captures better audio. Just take care of your camera and be sure to use the protective lens that comes with it.

Follow-cam is essential with skateboarding. We use a weighted handheld rig to capture stable follow-cam because it provides a foundational layer for the editing timeline that you can inter-cut with POV and other interesting angles. The board cam is an easy angle to set up. Place the bare camera down on the deck in front of the rear truck and use a few strips of gaff or duct tape to secure it. Use a protective lens to keep the camera from getting scratched. When filming with POV angles from mounts such as the head strap, Chesty, or speedo cam, point the camera down at the skater's feet to capture the footwork.

More experimental mounts (such as the shoe cam, 3-Way extension arm, or backpack) can be shaky, so we recommend using higher frame rates. Lowering the 3-Way so the camera is on the level of the board is a good perspective for flip tricks and footwork. A backpack setup offers a unique angle, especially if it's elevated over the head with an extension.

**Skateboarding
Bucky Lasek's
Backyard Bowl**

Filmers: Bradford Schmidt, Justin Wilkenfeld
Editor: Jordan Miller
Camera: HD HERO, 2011

https://www.youtube.com/watch?v=3qh8OFVCBwU

Adhesive Mount / 2.7K48 / Bucky Lasek

Tripod / 2.7K48 / Jensen Granger, Alex Midler

Follow-Cam / 2.7K48 / Tyler Johnson

Head Strap Speedo / 960p120 / Ryan Sheckler

Shoe Mount / 960p120 / Nicholas Lubsen

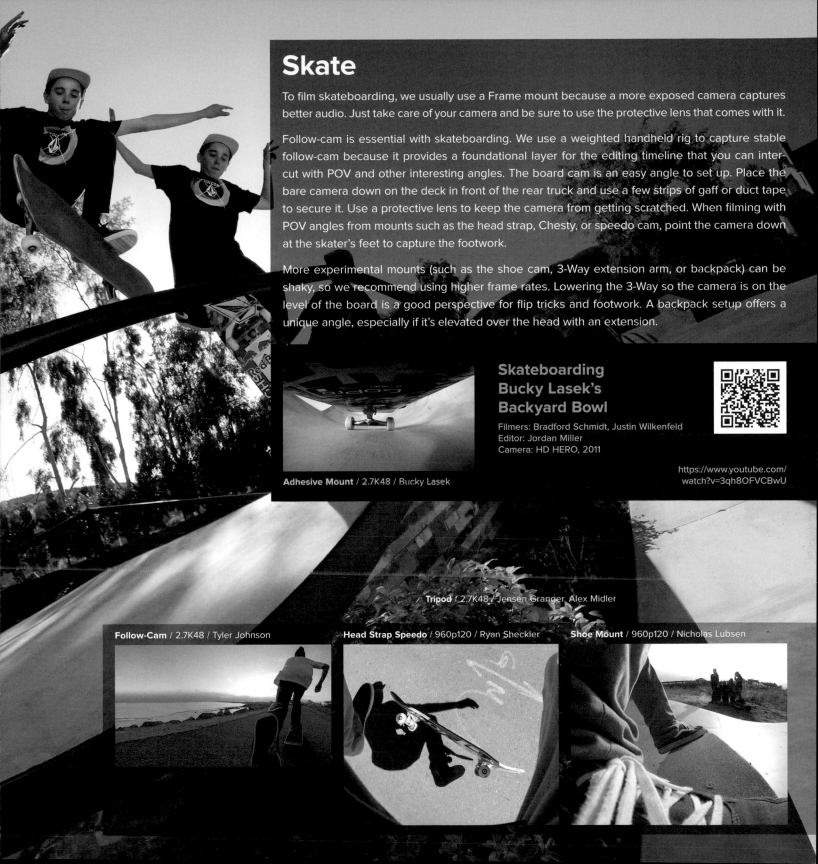

Underwater

The best underwater filming occurs from the surface to about 30 feet deep—beyond that, major color correction is needed to produce decent color. Antifog strips are essential. The more robust GoPro Dive Housing is recommended at depths of more than 90 feet. When shooting underwater, you'll notice that water magnifies your video and makes objects appear closer. For accurate framing while mounting, you can simulate the magnification effect using an LCD screen with a Medium FOV at the surface, then switch back to Wide before you dive underwater.

Head straps, mask mounts (Octomask offers a built-in mount), and the 3-Way extension arm offer terrific angles for capturing underwater activity. For smooth filming and total coverage, we use a weighted Norbert with three cameras: one in Medium 2.7K48 FOV (with an LCD BacPac), one in 4K30 Wide FOV, and one shooting .5 second time-lapse. Super slow motion is probably not necessary, depending on the activity, so we tend to shoot as high a resolution as possible while still retaining 48 to 60 fps in case a little slow motion is needed.

Extensions from the weight belt, backpacks, and leg mounts provide unique angles because the diver is usually horizontal. You can reverse the backpack mount to capture a frontal view or invert it with the camera facing up the torso to capture the diver and the wider environment.

Shark Riders

Director: Bradford Schmidt
Producer: Yara Khakbaz, Whitney McGraw
Crew: Travis Pynn,
Andy and Emma Casagrande
Editor: Brandon Thompson
Camera: HD HERO2, 2012

https://www.youtube.com/
watch?v=ucivXRBrP_0

Inverted Backpack / 1440p60 / Mark Healey

Norbert / 2.7K48 Medium / Andy Casagrande, Mark Healey

Head Strap / 1440p60 / Mark Healey

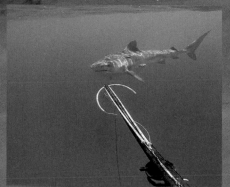

Backpack / 1440p60 / Mark Healey

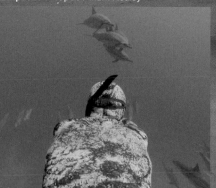

3-Way Extension Arm / 1440p60 / Ashleigh Baird

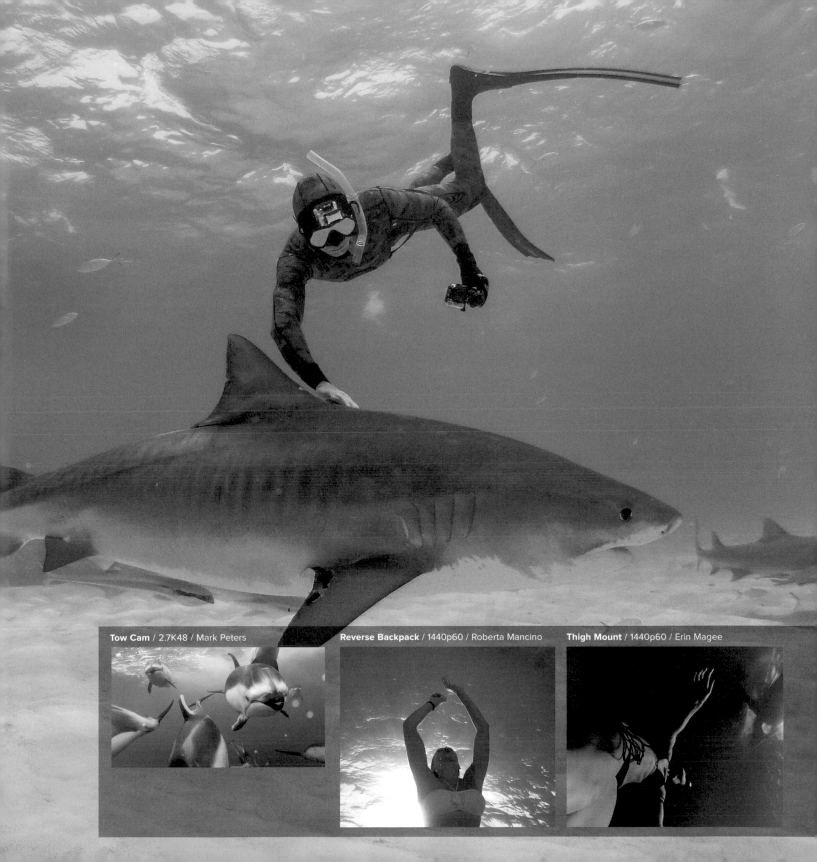

Tow Cam / 2.7K48 / Mark Peters

Reverse Backpack / 1440p60 / Roberta Mancino

Thigh Mount / 1440p60 / Erin Magee

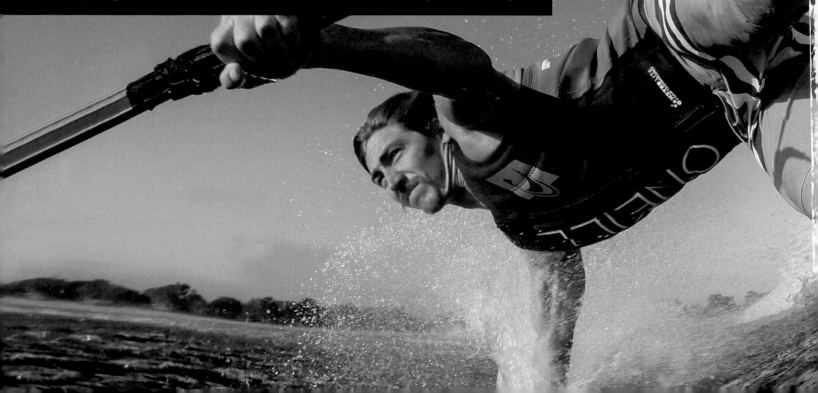

Wake and Wind

As a general rule, anything involving water at speed looks better with slow motion. We recommend using higher frame rates to capture wake and wind activities. As with all watersports, use a floaty backdoor to protect your camera and antifogs to keep the lens clear. Prepare the lens with Rain-X or lick the lens and dunk it periodically to keep water drops from forming.

Head, mouth, and chest-mounted angles are staples that make a great foundation for editing. Board or equipment-mounted angles tend to shake at high speeds, so use higher frame rates when the sun is shining. The rope tow mount and kite mount are very unique angles specific to these activities because they allow you to adjust the distance from the subject. Note that these can be unstable, so high frame rates are essential.

Collin Harrington has captured some of the best footage we've seen in this category. He films follow-cam with a long pole from the back of a Jet Ski while following another wakeboarder. The closer the better. The shot captures the entire scene with the athlete and the boat.

Melissa Marquardt: Friends, Puppies, and Wakeboarding

Filmers: Wes Nobles, Kyle Camerer
Editor: Phillip Rogna
Camera: HERO3, 2012

https://www.youtube.com/watch?v=udylO1Fiqjk

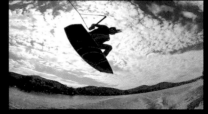

Follow-Cam / 1080p120 / Melissa Marquardt

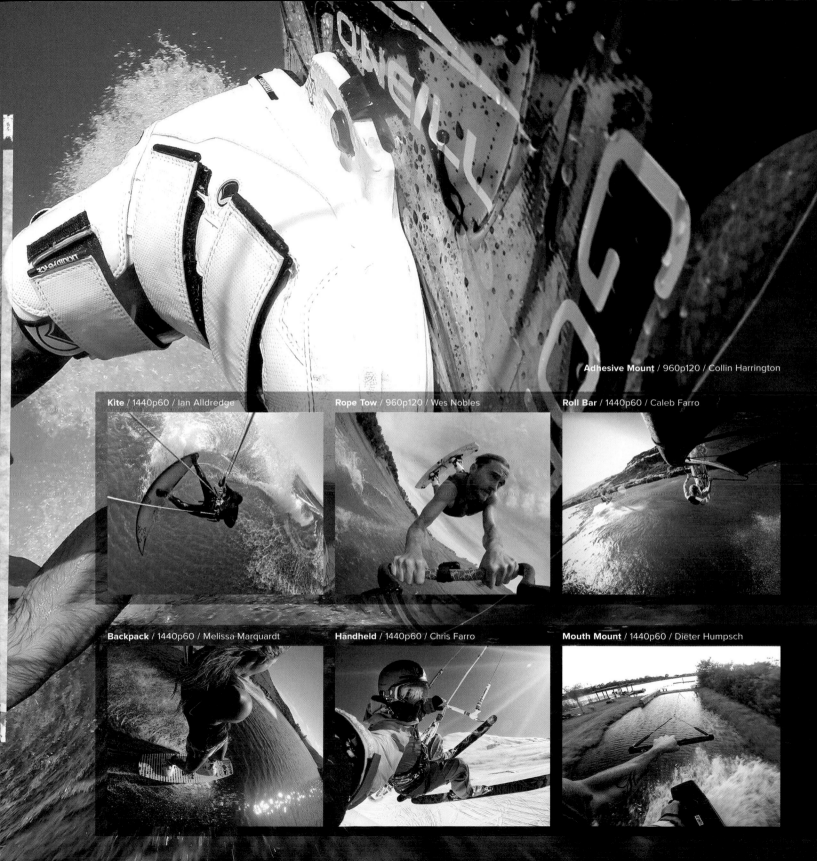

Adhesive Mount / 960p120 / Collin Harrington

Kite / 1440p60 / Ian Alldredge

Rope Tow / 960p120 / Wes Nobles

Roll Bar / 1440p60 / Caleb Farro

Backpack / 1440p60 / Melissa Marquardt

Handheld / 1440p60 / Chris Farro

Mouth Mount / 1440p60 / Dieter Humpsch

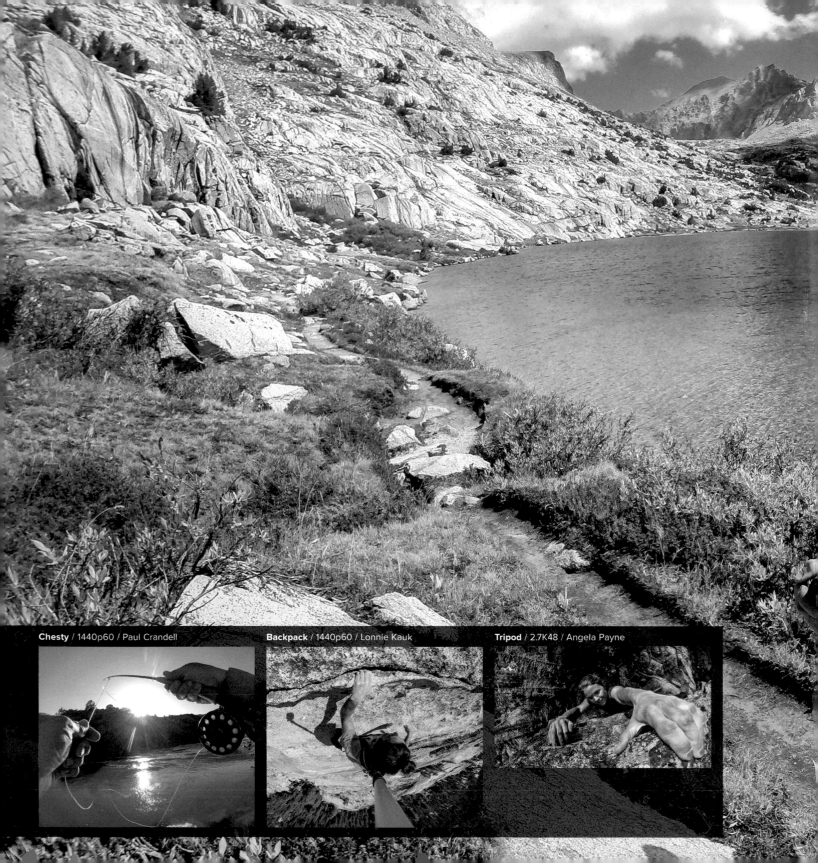

Chesty / 1440p60 / Paul Crandell **Backpack** / 1440p60 / Lonnie Kauk **Tripod** / 2.7K48 / Angela Payne

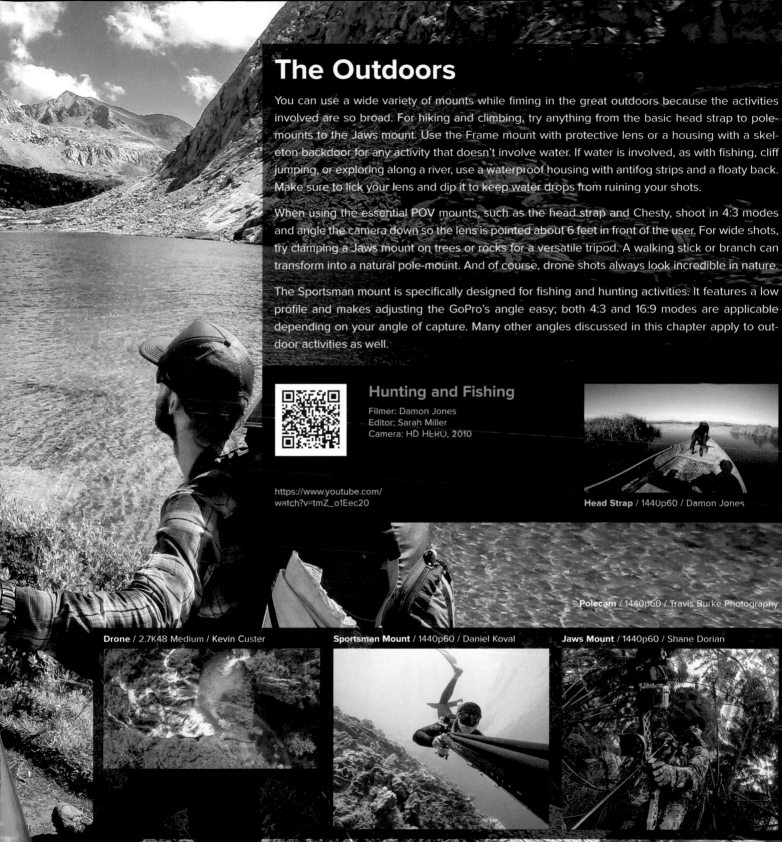

The Outdoors

You can use a wide variety of mounts while fiming in the great outdoors because the activities involved are so broad. For hiking and climbing, try anything from the basic head strap to pole-mounts to the Jaws mount. Use the Frame mount with protective lens or a housing with a skeleton backdoor for any activity that doesn't involve water. If water is involved, as with fishing, cliff jumping, or exploring along a river, use a waterproof housing with antifog strips and a floaty back. Make sure to lick your lens and dip it to keep water drops from ruining your shots.

When using the essential POV mounts, such as the head strap and Chesty, shoot in 4:3 modes and angle the camera down so the lens is pointed about 6 feet in front of the user. For wide shots, try clamping a Jaws mount on trees or rocks for a versatile tripod. A walking stick or branch can transform into a natural pole-mount. And of course, drone shots always look incredible in nature.

The Sportsman mount is specifically designed for fishing and hunting activities. It features a low profile and makes adjusting the GoPro's angle easy; both 4:3 and 16:9 modes are applicable depending on your angle of capture. Many other angles discussed in this chapter apply to outdoor activities as well.

Hunting and Fishing

Filmer: Damon Jones
Editor: Sarah Miller
Camera: HD HERO, 2010

https://www.youtube.com/
watch?v=tmZ_o1Eec20

Head Strap / 1440p60 / Damon Jones

Polecam / 1440p60 / Travis Burke Photography

Drone / 2.7K48 Medium / Kevin Custer

Sportsman Mount / 1440p60 / Daniel Koval

Jaws Mount / 1440p60 / Shane Dorian

Music

Although the GoPro was originally designed for well-lit outdoor activities, its range of use has expanded since the introduction of The Frame mount and the HERO4's improved audio recording and low-light performance. Music is typically filmed in low-light environments, so we recommend frame rates of 24 or 30 fps with a Protune ISO setting of 400. GoPro makes a 3.5mm mic jack to USB adapter for recording high fidelity audio from an external mic directly into the camera. If your goal is to record audio from multiple instruments or a band, however, we recommend using a professional audio recording setup.

The mic stand mount captures a static wide shot for the foundation of any musical performance edit. Most instruments are played fairly close to the musician, so any kind of extension yields a better contextual shot. The Jaws mount's adjustable neck makes it indispensable for instrument mounting. However, if you are playing music with lots of fast movement and need a more rigid extension, try linking together several twist 90 accessories and tightening them with a screwdriver for a more rigid setup. A large or elongated instrument, such as a flute or trombone, can also work with the handlebar mount in unique ways. Mounting to any moving part of the instrument yields a dynamic shot.

For any POV or instrument mount close to the musician, use a 4:3 resolution such as 2.7K 4:3. Wide shots, extensions, and instrument mounts that are farther from the musician are all candidates for a 16:9 aspect ratio with higher resolution such as 4K or 2.7K Medium for less distortion.

Radiation City at the Cathedral of Junk

Director: Jordan Miller
Producer: Jaci Pastore
Crew: Evan Arnold
Editor: Gabriel Noguez
Camera: HERO3, 2013

https://www.youtube.com/watch?v=E8cAKU_wAAs

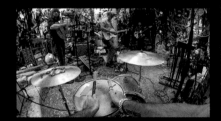

Chesty / 2.7K 4:3 / Radiation City

Jaws Mount / 2.7K 4:3 / Danny Fernandez

Head Strap / 2.7K 4:3 / Thomas Himes

Handlebar Mount / 4K30 / David Finlayson

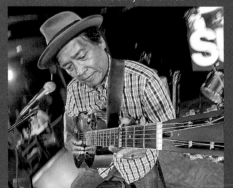

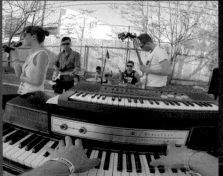

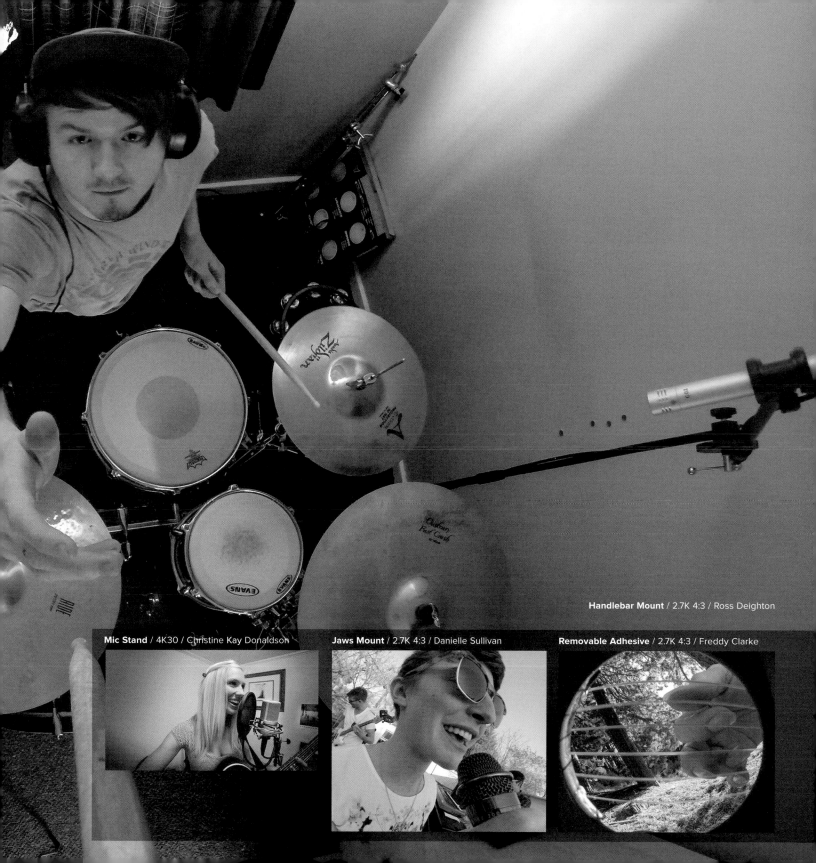

Handlebar Mount / 2.7K 4:3 / Ross Deighton

Mic Stand / 4K30 / Christine Kay Donaldson

Jaws Mount / 2.7K 4:3 / Danielle Sullivan

Removable Adhesive / 2.7K 4:3 / Freddy Clarke

Sports

The introduction of GoPro to team sports is relatively new. Sports that use helmets, such as football, lacrosse, and hockey benefit from the helmet as a natural mounting place for stable POV footage. While the running, sprinting, skating, and quick changes in direction produce an inherent jostle in the footage, when used correctly in editing such motion can add energy to a video. For soccer and basketball, which do not require helmets, head straps are the next best thing. Typically, we use Frame mounts with protective lenses for the lightest camera setup possible. Whether using a helmet or cinched-down head strap, cameras should be well secured to keep shake to a minimum.

Helmet-cams, head straps, and Chesty mounts are almost always in a 4:3 mode with the camera aimed a few degrees farther down to capture the arms, legs, and ball. More experimental mounts such as the gnarwhal, spinner, or stick mounts offer very stunning cinematic shots but are obviously not as practical or safe in actual high-impact game situations.

Why Play Basketball?

Director and Editor: Davis Paul
Producer: Whitney McGraw
Camera: HERO3+, 2014

https://www.youtube.com/
watch?v=Bq8gBGx0XTc

Jaws Mount / 2.7K48 / Davis Paul

Head Strap / 1440p60 / Bradley Allain

Tripod / 1440p60 / Davis Paul

Chesty / 1440p60 / Jordan Reasy

Side Helmet / 1440p60 / Dwayne Lawson

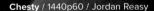

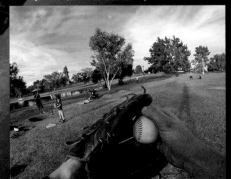

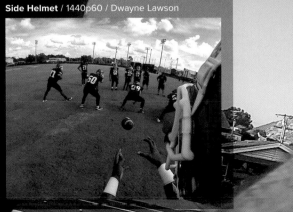

Adhesive Mount / 960p120 / Jensen & Tim Granger **3-Way Extension Arm** / 960p120 / Davis Paul **Head Strap** / 1440p60 / Soweto Kids

Animal

While Fetch is GoPro's first official animal mount, our insatiable curiosity for animal POV has been with us from the beginning. With animals, the key is to make the camera as light and secure as possible as it will be going on an unpredictable wild ride! Because of this, we typically use a waterproof housing and antifog strips with the camera set to a 4:3 aspect ratio mode and a high frame rate for slow motion.

For many animals, a good mounting location tends to be behind the shoulders in the middle of the back looking over the head. This usually requires a harness of some kind. For birds, we have fashioned custom foam padding with nonabrasive string or tubing. For dogs, you can use the Fetch mount or in some cases a Chesty with the straps tightened all the way down. The Fetch harness also has a camera mount that rests on the dog's chest, pointing forward.

You can also find versatile uses for a handlebar/seatpost mount with animals. We've used one to attach a GoPro to a stick for playing with a dog, or even orangutans. The lens tends to get dirty quickly, so try using another GoPro on the other end of the stick for a better chance of getting the shot.

Meg Lion Hunt

Filmer: Kevin Richardson
Editor: Sam "The General" Lazarus
Camera: HERO3+, 2013

https://www.youtube.com/
watch?v=MthhQ8rUzT8

Chesty / 960p120 / Kevin Richardson, Meg

Pole Mount / 2.7K48 / Kevin Richardson

Handlebar / 960p120 / Jordan Miller, Willy

Bird Harness / 960p120 / Walter Neser

Handlebar / 960p120 / Travis Pynn, Chicken

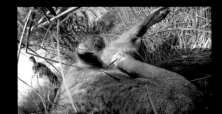

Fetch / 960p120 / Zak Shelhamer, Violet

Fin Clamp / 1440p60 / Bradford Schmidt

Horse Chesty / 1440p60 / Trenton Pasic

Capturing a Story

EVERY TIME YOU PRESS RECORD on your GoPro during an experience, you are capturing a story. Every time you play that recording for someone, you are sharing the story. What makes GoPro so powerful is this: That is *your* story you are sharing.

GoPro is a proactive capture device that allows the filmmaker to experience a moment he or she is passionate about, self-document that moment, and then relive and share that moment as a story with others. A GoPro complements an experience rather than getting in between the filmmaker and the experience itself. In this way, filmmaking with a GoPro differs from traditional methods.

There is a saying in film: A story is told three times. Once in writing. Once in production. Once in editing. This idea can be applied to GoPro filmmaking. Initially, a story begins in your head when you come up with the idea and plan it out, usually by writing it down. When you are shooting, the story morphs and is adapted according to the situation. In editing, the story becomes more precise. With each telling, the story gets better. You eliminate the bad ideas and add better ones.

This chapter and the next walk through each stage of the filmmaking process. This chapter covers the first two stages, planning and production, as well as some theory and lessons we've learned in our own filmmaking journey. The final stage, editing, is covered in Chapter 5.

Bradford Schmidt, Kirk Krack / Tonga Norbert Photo/.5sec

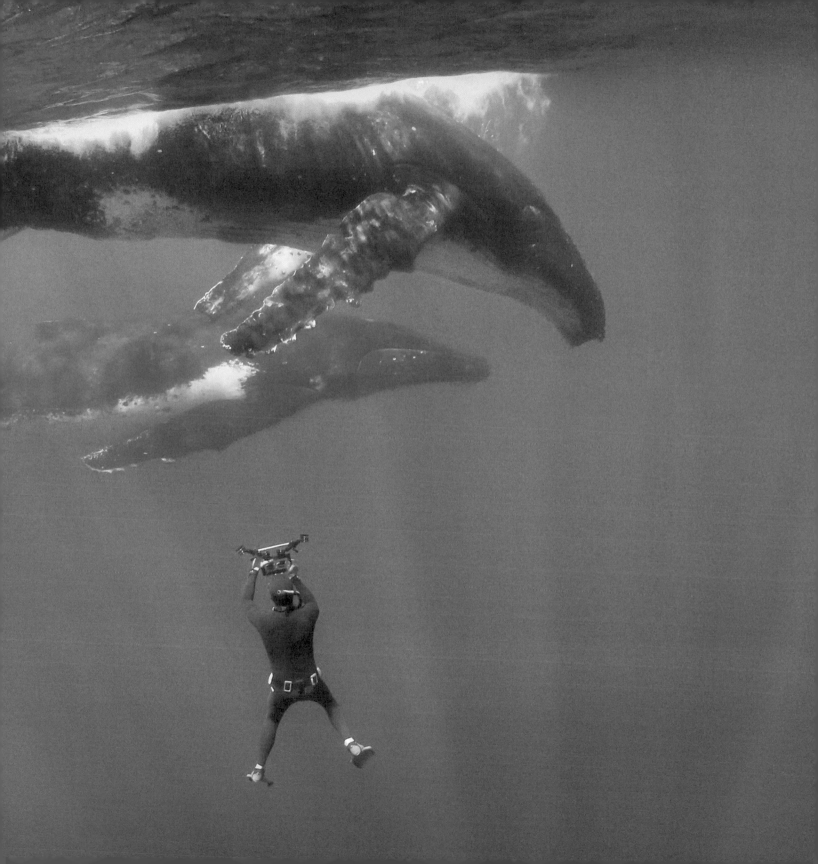

Neil Amonson / Mexico Head Strap Photo/.5sec

Preparation

Good filmmakers understand the *direction* of the story and the structure from start to finish, while adapting along the way. This requires planning. Sloppy filmmakers just shoot everything and expect to make sense of it later in the edit. You can always cobble something together in editing, but it's painful and less elegant. When a story is truly directed from the beginning, it can become far more powerful.

Story Research and Planning

If you want to create a story, the first question you should ask yourself is this: What am I passionate about? What do I want to experience? Maybe you just built a bike jump with your buddy in your backyard. Maybe you always wanted to go to Peru. Maybe you saw a photo of an albino whale off the Great Barrier Reef and you want to swim with it. Finding that passion is the starting point. Proper research and planning can set up the experience to become a great story.

Once you have the idea, explore YouTube and Google to gain knowledge and understanding of the locations and characters. Look at photos and Facebook pages. Research every website on the topic you can find. Listen to interviews of characters you're interested in—they can provide a sense of depth in your story. Make phone calls or Skype with potential subjects who live in the area or have previously traveled there. Consider logistics: permits, visas, immunizations, weather, and safety. How much time is required to properly experience what you are passionate about—allowing for complications and improvisation?

And then there are aesthetics. In traditional cinema, entire departments handle art direction, costumes, and the like. An audience will quickly judge your characters as authentic and believable or not based on appearance. Spend time figuring out the colors, clothing, and gear—and how they interact with the setting—to make an image sing. If you're diving underwater, for example, a solid black wetsuit and hood have zero expression and personality. If the gear you want to use is involved or expensive, contact the companies directly to see if they will send or sponsor equipment. This can be one of the most enjoyable parts of the pre-production stage, and it helps your mind start visualizing creative ideas for the film. This visualization can propel you into the stage of writing or sketching the story's scenarios.

Most importantly, consider what that ultimate moment of your story will be. The moment that will be so amazing you can close your eyes and practically feel it. Because that moment will be the climax—the most important building block of your story.

Neil Amonson / Mexico Head Strap Photo/.5sec

Story Building Blocks

Story building blocks are the basic foundation on which your story can be built. When preparing for a production, we always plan on capturing the following general building blocks:

- **Introduce the environment and characters.** Including yourself. Who are we and where are we?

- **Capture the climactic moment.** This is what you came here to do and the reason the audience will watch your story. Plan coverage for that moment.

- **Document the resolution.** This is an easy one to forget. Whether it's victory or failure, capture it all.

The climactic moment is almost always planned, because it's the whole reason you are telling the story. On an average story shoot, we plan for five days minimum—one day for scouting, three days for filming, and one day as a buffer for the weather. The sooner you can capture the climactic moment, the better. You can spend the remaining days covering the other building blocks.

In preparation, figuring out the climax to aim for and communicating it to everyone beforehand gets you most of the way to success with fewer surprises. When creating the climax, the filmmaker must set up the right scenarios in which genuine and authentic actions occur. Even in traditional scripted filmmaking, the best directors are not the ones who tell actors to stand here and say this exact line. Rather, they try to create a scenario in which characters feel and act naturally. The same principles apply with documentaries or with GoPro filmmaking.

The best climactic scenarios involve a character who overcomes an obstacle. When telling a GoPro story, the obstacle is often inherent to the experience. For example, let's say you were about to go paragliding with a hawk today, *but* it's windy and dangerous and the guide doesn't speak your language. Capitalize on these *buts* and document them. With experience, you will learn to adapt your story during production whenever a sudden obstacle might create tension that builds toward the climax.

So, now that you've figured out *what* you're going to shoot, you need to think about *how* you're going to shoot it.

Kirk Krack / Tonga Norbert Photo/.5sec

Camera Gear

When assembling gear for a shoot, most of the filmmakers at GoPro (called production artists) begin by making a list of everything they could possibly need for any situation. With GoPro, the temptation is always strong to be an absolute gear hound. Spread all the gear on the floor and look at the empty bag. Then, ask yourself, "Am I *really* going to use this?" Envision the weight of it all on your shoulders—while carrying it through the airport, loading it into cars, unpacking all the bags, repacking it for early morning wake-ups, reorganizing it late at night after a long day. Sometimes, too much gear will paralyze you. It takes a few productions to understand that it's not what you might use, but what you are *likely* to use. If you can narrow down to the essentials, then you'll have room to throw in a couple of curveball gear ideas for that one shot you've always wanted to get.

Novice production artists will spend half the morning looking over gear and debating what they'll use during the day—meanwhile, the beautiful dawn light is disappearing and your character is sipping coffee, ready to share something poignant while looking out the window at a mountain of fresh powder. All you really needed was a rolling camera. The steadicam that takes an hour to balance might give you a cinematic move, but it won't bring back the genuine moment you missed, and that could have been the heart of your story.

It's wise to carry a camera, LCD BacPac, and two charged batteries in your pocket on a shoot at all times. Also remember to pack a few mounting extension arms and keep them handy while shooting. These small parts can be useful for mounting to anything and tweaking the camera's angle. Finally, don't forget audio gear. Sound is extremely important. Consider whether a waterproof backdoor, skeleton backdoor, or The Frame is the best sound-related accessory for the job. As good as the HERO4's audio capabilities are, if you've got an interview and there's any wind, an external mic may be the way to go.

Audio Gear

Proper audio gear is essential. Absolutely essential. Good sound is like the air you breathe—you don't notice it until it's bad. Depending on how loud the surrounding environment is, the HERO4 has surprisingly good audio when used with a head strap, helmet, a Chesty with The Frame mount. For interviews in a quiet environment, you can often get away with using the camera's internal audio. However, to guarantee great audio, we always use a lavalier or shotgun mic just in case. We usually stash in the backpack a set of lavaliers for each main character or a shotgun mic in case something unexpected begins to happen.

Currently, the our media production teams use a Countryman waterproof lavalier with an 1/8-inch plug that connects into a USB adapter. It's decently priced and durable, and it provides great sound when clipped or taped onto a lapel/shirt. In conjunction with a Chesty mount, you can simultaneously capture great audio and POV video during an active interview. If the Chesty mount is not aesthetically pleasing in the shot, simply dedicate the camera to audio. Place the unit in the subject's pocket and press record. It'll capture audio for two hours, at which point you can swap the battery if it goes dead.

Always use foam or fur to help with wind noise on the lav mic. K-Tek, creator of the Norbert, also sells great small furs for lavs. It's wise to back up your interview audio with a shotgun mic, if possible. A number of good short shotgun mics with 1/8-inch plugs are available. Rode makes a great shotgun called the VideoMic Pro, but its rubber shock mounts don't hold up well to rugged use. For something more durable, Shure makes a great short shotgun mic called the VP83.

If using a dedicated audio camera or multiple cameras during an Interview, you may need to sync the sound together in a dedicated sequence on your editing timeline. You can do this manually by lining up the waveforms or by using programs such as PluralEyes. If you are recording music professionally, it goes without saying that it's best to use dedicated audio recording equipment, rather than camera audio or a lavalier, and then sync that audio with the video on the timeline.

What's in Your Pack?

Here are the essentials that we as GoPro filmmakers carry in our backpack on any given production:

- [] 4 to 6 cameras in waterproof cases with quick-release (QR) buckles
- [] 4 Frame mounts with protective lens covers and QR buckles
- [] 1 LCD BacPac with backdoor
- [] 1 Battery BacPac with backdoor
- [] 1 Smart Remote and charger
- [] 10 Adhesive Mounts (curved, flat, and surf)
- [] 1 grab bag of mounts (quick-release buckles, J-hooks, extension arms, etc.)
- [] 1 Chesty (chest harness)
- [] 1 head strap
- [] 1 mouth mount (experimental)
- [] 2 gnarwhal long extensions with screws
- [] 1 Handler grip mount
- [] 1 handlebar/seatpost mount
- [] 1 roll bar mount
- [] 1 Jaws mount
- [] 1 3-Way Extension Arm
- [] 2 tripod mounts
- [] 1 RPS pole
- [] 1 medium JOBY GorillaPod
- [] 1 charger for 2 batteries with cables
- [] 4 extra batteries
- [] 4 micro SD cards with readers
- [] 2 anti-fog packs
- [] 2 GoPro Floaty Backdoors
- [] 1 laptop (15-inch)
- [] 2 mini hard drives (1 TB each)
- [] 1 Norbert
- [] 2 mic adapters (3.5mm)
- [] 2 lavalier mics
- [] 1 shotgun mic

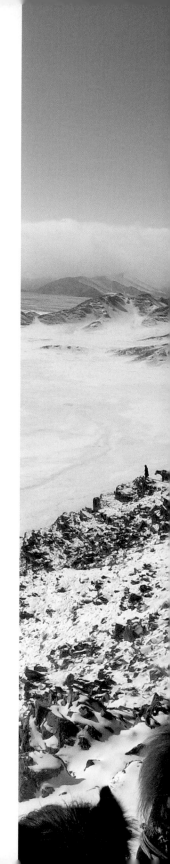

Production

Telling a story with GoPro is an art unto itself. In our media department, we refer to individuals with this skill as production artists. Production artists are like independent directors. While shooting on a production, they must be conscious of camera placement, coverage, sound, light, recording interviews, logging and reviewing footage each day... all while being aware of the story as it evolves around them.

Trapping as Coverage

Nathan Myers, editor for *Surfing* magazine, first coined the term *trapper* for how we shoot with the GoPro. During the Bali shoot for the HD HERO2 launch video, Myers observed two of us methodically strapping and sticking multiple GoPros to four surfers, pressing record, and heading out. Two hours later, we all came back in, reviewed the footage, tweaked the setups, and repeated the process. Session after session after session. Myers observed that this was a fundamental difference in content creation. We weren't chasing shots. We were *trapping* them. We set up the scenario and waited for the moment to come to us.

Limitation can be the best motivation for creativity when you are forced to invent new ways to get the shots you need to tell the story. As an example, before GoPro, skiing was mainly filmed with a long lens to capture the skier in context with the surroundings. With GoPro, that isn't an option. The solution is to put a GoPro on the end of a ski pole and go off the jump *with* the skier. The inventive follow-cam shot is more engaging, and all because of a limitation. This concept applies to most activities and is a big part of how GoPro has created a whole new method of filming.

In classic cinema, *coverage* is defined as the use of multiple camera setups and shots to comprise or "cover" an entire scene. Traditionally, there is one shot called a master, which is a wide shot covering the entire scene from entrance to exit. And although you can shoot an entire scene in one shot, this doesn't leave room for changes in the edit. In editing, having more coverage allows flexibility for continuous cutting of an action from one perspective to another, letting the audience digest a moment or scene from multiple perspectives to achieve maximum impact.

Lauren McGough / Mongolia Handheld Photo/.5sec

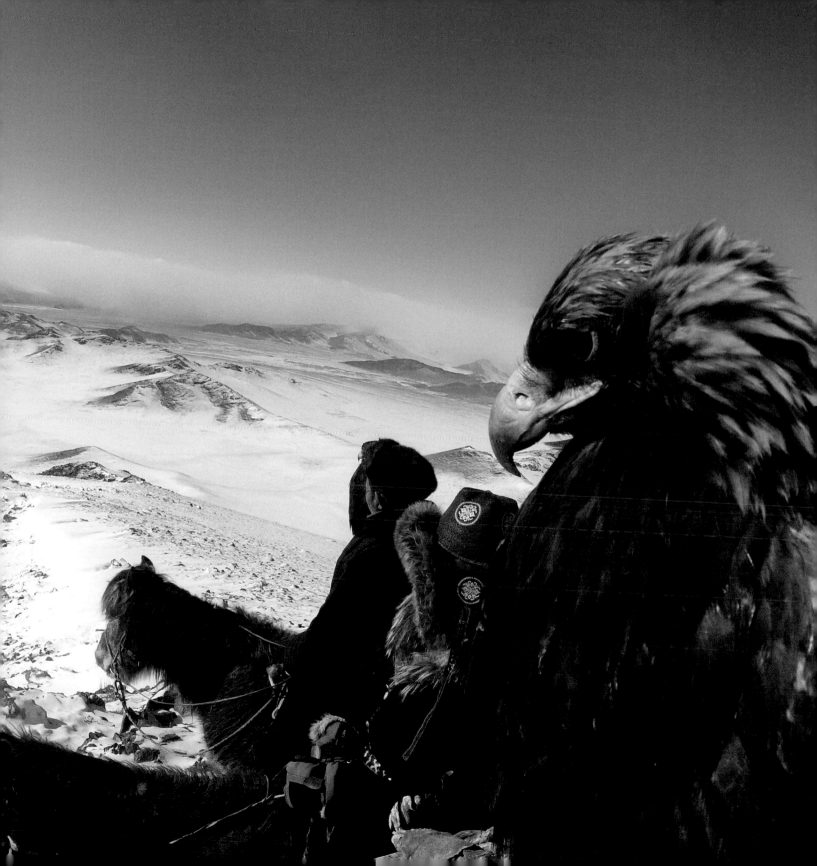

Shot Classification

When planning for coverage, it's important to understand the different types of shots, what they are capable of capturing, and how they will be used in editing. We use five traditional cinema terms to classify GoPro shots:

Wide shot: The primary focus of a wide shot is the setting and then the character(s) within it. This is standard and typically static. The wide shot is used as reference for the rest of the coverage. For GoPro, a wide means the camera is not usually attached to the character. The tiny camera also allows the filmmaker to transform a static wide to a dynamic moving wide. Steadicams, poles, handheld gyros, or drones are the best tools for this. We typically shoot both a drone and a follow-cam for coverage, usually running the scenario twice so the shots are clean. Statics still have their place for establishing, pacing, and beauty. In the climactic moment, however, a dynamic moving master can be incredibly impactful.

Full shot: The primary focus of a full shot is the character's full body interacting with the setting. This is achieved by mounting the camera several feet away from any part of the body via equipment or a long extension such as a pole, spinner, surfboard, or ski tip.

Medium close-up shot: As the camera moves closer, the primary focus of a medium close-up shot begins to shift from the setting and character's body to the face. Sometimes, only half the body is seen and can feel larger than the setting itself. To achieve these, mount the camera either onto or very close to the body using mounts such as the 3-Way extension arm, Handler grip mount, spinners, or backpack mounts. These are some of the most popular GoPro shots.

Close-up shot: The focus of a close-up shot is solely on the character's face while the setting fades into the periphery. The character's emotion feels larger than life as it takes over the entire screen. Use mounts such as the gnarwhal or handheld.

POV shot: With a POV shot, the audience is experiencing everything from the subject's perspective. The inclusion of hands, arms, and legs within the shot gives the best orientation and sense of immersion. Use mounts such as the head strap, helmet, or Chesty. While POV shots are obviously a staple for GoPro, in traditional coverage they were considered a specialty shot and used only on specific occasions.

John Jackson / The Andes, Chile

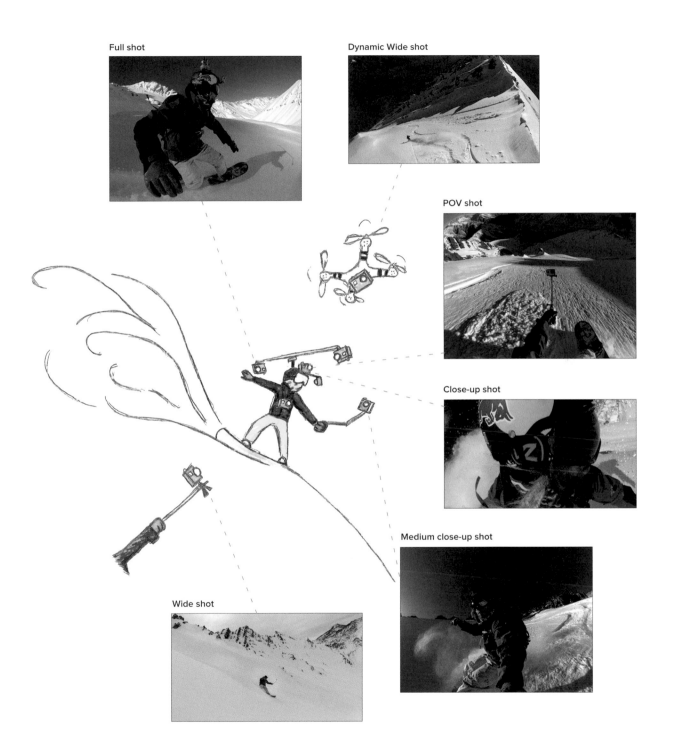

Full shot

Dynamic Wide shot

POV shot

Close-up shot

Medium close-up shot

Wide shot

Primaries and Secondaries

Traditionally, directors use storyboards and shot lists to plan their shots. At GoPro, we generally don't storyboard each sequential shot. If it helps you, however, then by all means do it. We often draw camera and mount setup diagrams for important scenes. Whether a character or vehicle, draw a stick figure with GoPro cameras and all the potential mounting options. Share the drawings with the characters beforehand so that everyone is prepared. This will eliminate surprises and misunderstandings while filming.

We generally shoot what are called primaries and secondaries. *Primaries* are shot first, especially when the scenario is new and unknown, and they usually consist of wide shots and POV coverage. The primaries provide the essential angles you need—so even if everything else goes wrong, you have these to fall back on when creating the video. *Secondary* setups involve backpacks, poles, armatures, and gnarwhals—generally, things you don't want to see on the character within the wide shot. The secondary setups are typically our most inventive and experimental mountings, producing unique angles you've never seen.

Well in advance, the filmmaker and character should decide what POV mount is as natural a part of the character's ensemble as a shirt or a hat would be. Seeing the POV camera in the wide shot is generally fine, and can lend a sense of realism as if the characters are filming everything themselves without any kind of "film crew." Primaries are usually from head- or chest-mounted cameras. This uncomplicated approach keeps the characters from being distracted as they experience the scenario for the first time. The filmmaker can then watch the action in order to educate himself or herself on where the secondaries should be. Once you've thoroughly nailed your wides and primaries, move on to your secondary setups—the money shots. Secondary setups can be awkward, distracting, and sometimes complicated for the character to use, so be willing to adapt and improvise. Often, we'll repeat our primary angles while filming secondaries, just for additional footage.

As an example, while shooting in the Bahamas for the HD HERO2 Dive Housing launch, we needed to capture a climactic scene where two characters rode a tiger shark together. The primary setup consisted of Mark Healey and Roberta Mancino's head-mounted GoPros and a single wide shot from cameraman Andy Casagrande. We introduced the secondary setup on the last day, and included a pole mount attached to Healey's waist and a leg mount on Roberta's jet boots. The wide shot and POV head-mounted GoPros were great and would've made a solid scene, but Healey's secondary mount intimately captured both athletes simultaneously connecting with the shark and put the magic into the climactic scene.

Before embarking on an adventure, always ask yourself, "What's my next unique shot?" We always aim for one new type of shot every production, something we haven't seen or tried before. Sometimes it works, sometimes it doesn't, but it forces an artist to be progressive and continually improve.

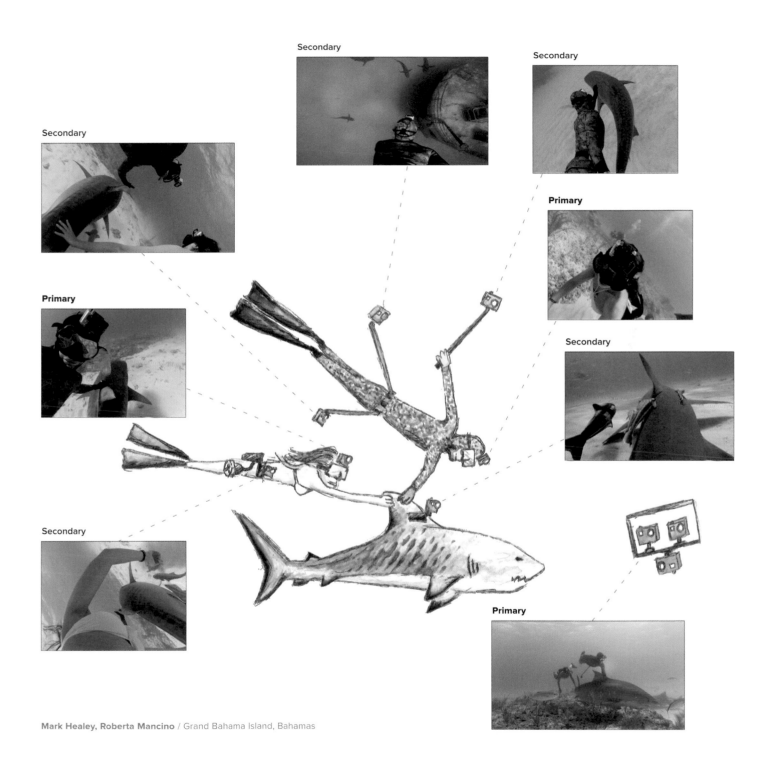

Secondary

Secondary

Secondary

Secondary

Primary

Secondary

Primary

Secondary

Primary

Mark Healey, Roberta Mancino / Grand Bahama Island, Bahamas

Light

Light plays a crucial role in capturing impactful footage as well as emotion for your story. On productions, we often schedule a specific afternoon or even full day to scout each location and understand what is best for lighting. As in all outdoor photography, dawn and dusk are the most ideal conditions. In the HD3+ shoot "Moab Towers and Magic Backpacks," the light greatly complicated production planning and execution. We scheduled four days to film the multi-pitch climb up the Fisher towers and then a BASE jump off. This also included time for interviews and establishing shots. On the scout day, we surveyed the towers and divided the story into three building blocks. An Initial Ascent up the tower for the introduction, a Final Ascent up the twisting formation called Ancient Art (which leads to the climax), and a climactic BASE jump off with a floating resolution in the air.

Ancient Art rises nearly a thousand feet above the desert floor, facing west. Each section of the video took place on a different part of the tower and had different lighting requirements. The sandstone chimney that comprised the Initial Ascent only received light from 10 a.m. to noon. The best light for the Final Ascent occurred right after the sun peaked over the surrounding cliffs, at 8:30 a.m. The BASE jump was best filmed at dusk when the sunset illuminated the rock spires to a glowing red and filled the valley with magical light for the climactic beat. This meant that the athletes and crew had to be in position for all these crucial times. When factoring in the wind, weather, and other variables, each successfully filmed scene became something of a logistical miracle.

Capturing the climax was the most difficult of all. During the summer months, the sun drops quickly, limiting our magic hour to, at most, 20 minutes from 7:10 to 7:30 p.m. Wind was an X factor that could make or break the shoot. As the sun dips, the desert cools down, creating gusts and updrafts in the late afternoon. Anything over 10 mph is unsafe for jumping. So at 7:00 p.m., Ashburn and Miller had to be at the top of Ancient Art and poised to jump. The crew needed to be in place with all ten cameras rolling, both quadcopters ready to go, and all of us waiting for the wind to die down before the sun dipped below the horizon.

Why all this work and coordination for only several seconds of freefall? You've already committed the effort, time, and money to travel somewhere. This is the climax of the story—the magical moment the audience has been waiting for. Make the moment the most impactful it can be with the best possible light.

Moab Towers & Magic Backpacks

Hayley Ashburn and Marshall Miller ascend and leap from Ancient Art in the Fisher Towers in Moab, Utah. Shot on the HERO3+ in 2013.

http://www.youtube.com/
watch?v=fVcV9ltdZ8w

Director: Bradford Schmidt Producer: Yara Khakbaz
Crew: Mike Pfau Editor: Ryan Truettner

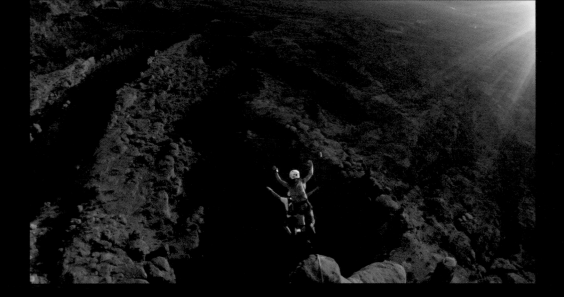

Colin Guinn Drone 1080p60 Medium

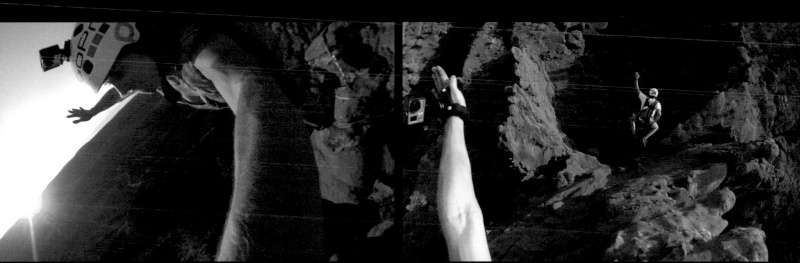

Low Light

GoPro was conceived with outdoor settings in mind. Our original HD HERO sensor was specifically designed for performance in bright sunlight, not for dark interior lighting. But GoPro's ability to capture in low light has increased by leaps and bounds since then, and the HERO4 Black leverages its new processor and updated Protune settings to deliver the most stunning low light performance, yet.

At GoPro, we always set the ISO or gain to 400 for video. This will cause the camera to crush the blacks regardless of the lighting conditions, keeping the processor from ramping the gain and creating image noise. The featured Tony Royster video is a great example of how an ISO setting of 400 can be used to create a dramatic scene. The interior lighting setup and projections were controlled with the understanding that this new ISO locking feature would be able to handle the surrounding dark curtains and allow them to fall into black without pumping up the gain and noise.

Frame rate affects footage quality in low light. In essence, the faster the frame rate, the less time each frame has to expose properly. At 24 or 30 fps, each frame has four times the ability to register light than at 120 fps. Shooting high frame rates during lower light or cloudy scenarios yields grainy and blurry images because the camera doesn't have enough time to expose each frame properly.

GoPro has also introduced an Auto Low Light mode for users who may not be as conscious of light levels and frame rates. In this mode, the camera detects if the light drops below an acceptable level and automatically slows down to 30 fps. For example, if you are recording at 1080p60 and happen to step indoors, the clip will drop to 30 fps to allow for better exposure. The Auto Low Light mode simply duplicates each frame to keep the clip at a constant 60 fps for playback. While this isn't ideal for editing, precious footage could be salvaged. However, we encourage you to always be aware of lighting conditions and be proactive in changing camera settings as conditions change, rather than using an automatic mode if your goal is the ultimate in image quality.

Edward Ma, Glitch Mob / Red Rocks Amphitheatre Adhesive Mount Photo/2sec

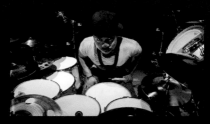

Tony Royster Jr. – Drummer's Odyssey

Tony Royster Jr. discovered his calling in life was to play the drums; he was 3 years old. By the time he was 11, he was a child prodigy. Shot on the HERO3+ in 2013.

Director: Jordan Miller
Editor: Gabriel Noguez
Producer: Jaci Pastore

https://www.youtube.com/watch?v=kOY7BeZCY-U

Directing the Interview

Everyone has a genuine story to tell. Good interviewing depends on the interviewer's ability to gain the subject's trust and help them deliver that story in an authentic way. The easiest way to accomplish this is to make the interview an engaging conversation instead of a question-and-answer session.

A typical GoPro interview setup combines a short shotgun on top of a Norbert with two cameras. Each camera is set to different FOVs, such as 4K Wide and 2.7K Medium. Medium FOV limits any facial distortion and feels more natural. Keeping an interview rig within close reach is good practice because interviews can happen naturally or as a reaction to a situation. Nothing sounds more genuine than the emotion of the moment.

When directing interviews, remember the following principles:

- Do your research beforehand. It's good to ask for explanations and clarity, but don't arrive clueless. An informed interviewer gains the subject's trust.

- Double-check audio levels and recording. Nothing is worse than doing the same interview twice due to technical issues.

- Turn off the blinking red light on the GoPro. It can be distracting and remind the subject they are being recorded, which makes them self-conscious.

- Keep the lens at eyeline. Too high or too low can be unflattering, unless it is a deliberate thematic choice.

- Don't ask questions that can be answered with a "yes" or "no."

- Tell your interviewee to reformulate your questions as the first part of the answer. This provides needed context to the answers in editing.

- Be conscious of keeping the subject's audio clean. Don't interrupt the end of his or her lines when conversing or asking the next question. For encouragement, offer a silent nod or smile.

- Be aware of voice quality, pacing, and energy. If the subject is speaking too fast, calm them down with deep breaths. Do physical exercise to get a flat or bored subject's heart beating. When someone is energized but speaking slowly, it adds weight to the words.

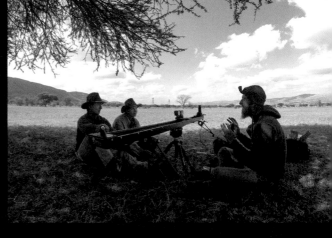

Jordan Miller, **Bradford Schmidt** / Sumatra, Indonesia

Sam Lazarus, **Bradford Schmidt, Kerri Wolter, Walter Neser** / South Africa

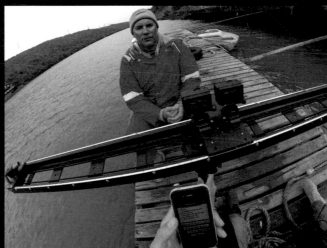

- Keep response questions clear and concise. Avoid direct address so subjects don't become self-conscious. For example: "Describe that moment" instead of "Tell me exactly what you were feeling." This subtly focuses the subject on the experience instead of the present interview with "you" and "me."

- Keep the GoPros rolling after the interview is "over." Subjects will relax when the perceived pressure of the interview has ended. Sometimes, you'll be chasing after a genuine quote and as soon as the interview is over, they casually deliver gold.

- Keep a notepad for reference. Make sure you have covered the five Ws: Who, What, Where, When, and Why.

Static Interviews

The classic "talking head" is a *static interview*. Static interviews are a necessity for large heavy cameras that require tripods and are difficult to move around. GoPro production artists try their best to stay away from static interviews, because they are traditional and lack energy. Technological advancement in our 5 oz. cameras easily allows for dynamic and active interviews. That being said, there is something about a beautifully composed portrait of a subject with a gorgeous background. If you are going to shoot a static, shoot it well. A very slight bit of movement from a slider with layered background elements will feel more dynamic. If you don't have a slider, try to make your static unique. The video example "Masters of Indo" places the main characters, Marlon Gerber and Varun Tanjung, on the ground, lying perpendicular to each other. An interview six inches off the ground is unusual.

The interview is part of your story, so use it to tell even more about the character or the theme. In "Masters of Indo," we were attracted to the tree during the shoot because it reminded us of what the story was about—a family tree, the inheritance of a surfing dynasty, handed down to each protégé descendant. In the middle of the interview, we asked the nephew, Varun, to go swing on the rope. This allowed the uncle, Marlon, to open up as he was otherwise guarded in his nephew's company. This also gave us the ability to break up the interview in editing by cutting between the two's POV cameras, which made the interview childlike and playful. It also offered a great visual metaphor for the story: Marlon is rooted in the family tree, looking up and forward in time at Varun, who now has the same choices (and perhaps fate) as Marlon once did.

The analysis may seem silly or too deep, but the thought the filmmaker puts into a story are the layers the audience may (or may not) read into. If the thought isn't put in to begin with, then the layers won't be there.

Active Interviews

Active interviews can open up a world of layered storytelling. Most people have a difficult time being themselves in front of a lens, especially if they are staring right at that lens. GoPro's size goes a long way in making the camera invisible to the subject. Distraction is the easiest way to help the subject forget the camera is present. Strap the cameras on, turn the blinking red lights off, press record, and walk around with your interview subjects. Let them show you around, interact with things and other people, and they will naturally begin to tell you a story from the past. Once it seems as if they've forgotten the cameras are even there, begin to engage in a deeper conversation.

The "World of Gavin Beschen," featured in Chapter 6, is an example of an active interview. Beschen is a naturally shy person, and placing a camera in his face wasn't going to create the right atmosphere. Strolling down to his home break and around his garden allowed him to relax. Paying attention to his words and asking open questions led to natural conversations about his passions in life—his family and daughter.

One of the most cinematic techniques for active interviews is using a steadicam or handheld gimbal. Floating around a character as they are in the midst of showing you the surroundings and what they are passionate about can be dynamic and inspiring. "Our Orangutan Brethren," featured later in this chapter, is a good example of an integrated steadicam interview. This is classically referred to as a "walk and talk," in which the subject is shot from the front and led by the filmmaker, who is walking backwards. In the final ascent leading up to the freedom of Suri the orangutan, we interviewed Peter Pratje as he brought the crew to the release site.

Walking backwards while filming can be tricky—it usually requires a spotter and decent path. It's important to be conscious of layering background elements when possible to help create a dynamic sense of movement. In this case, the jungle provides ample layering. Used properly, a technique like this can really emphasize a certain part of the story. Pratje's walk and talk gave the audience the feeling that the story was moving somewhere important, which it was: toward the final climax of Suri's release.

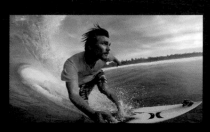

Masters of Indo

Marlon Gerber fosters his protégé nephew Varun Tanjung in the ways of Indonesian surfing. Varun has a choice, just as Marlon did. Shot on the HERO3+ in 2013.

Director: Bradford Schmidt Producer: Yara Khakbaz
Crew: Jordan Miller, Adam Instone Editor: Ryan Truettner

http://www.youtube.com/watch?v=_UUjJJQ02n0

Interview Theory

Of the five Ws—who, what, where, when, and why—the "why" is the real question you need answered, and it often serves as an underlying theme of the story. It's the question we as humans struggle with and try to answer our entire lives—and the audience is no exception. Nevertheless, the direct question, "Why do you do what you do?" is for a subject one of the hardest to answer. Just ask it of yourself. Your answer will probably seem vague, generic, and unsatisfying. Direct "why" questions typically yield indirect answers, but a series of indirect questions can reveal answers that even the subjects themselves are not fully aware of.

Getting to the root of the "why" question starts with earning the character's trust. Using good communication practices—such as looking the person in the eyes, showing respect, and not interrupting—all help do this. But trust really starts with people being able to identify with one another. The best interviews are those in which the interviewer-interviewee barrier breaks down. Make it a two-way conversation and not an investigation. Come prepared with a story about yourself that your subject can identify with. Maybe you're talking to a BASE jumper and you tell him about the time you were scared of heights as a child. Making yourself vulnerable compels them to open up as well. Subjects almost always reciprocate with a story of their own. Connection and empathy go a long way toward gaining trust.

You should be interacting and conversing with the subject(s) as much as possible during the first few days of the shoot. Continually ask yourself what makes them tick. Observe them and test them out with a few light inquiries to get a sense of who they are. Jot down notes and begin formulating a list of interview questions. It's good practice to have the subject begin an interview by stating his or her name, origin, and profession. Then have the subject describe the present situation and purpose. These are good warm-up questions and provide an informed baseline to work from later in the edit when context is needed. Once they are answered, however, it's best to spend all your time and energy with the most important question: why?

The questions you've prepared aren't set in stone. They are a guide. Always be willing to lead the interviewee along a different line of thought, or to challenge your subject. In the "Supercross New Year 2013" video, Ryan Villapoto is practiced and understated in his interviews. Both he and James Stewart have done plenty of them, so the process must be mechanical for them. During the interview Villapoto states, "I race motorcycles because I grew up doing it. It's the only thing I know. Now it's my job." The interviewer nods and moves on with another question. An opportunity was missed. He could have responded with, "So it used to be fun as a kid, and now it's just a job for money?" This kind of challenge could have transformed the mechanical Ryan into a passionate Ryan, defending why the sport is meaningful to him.

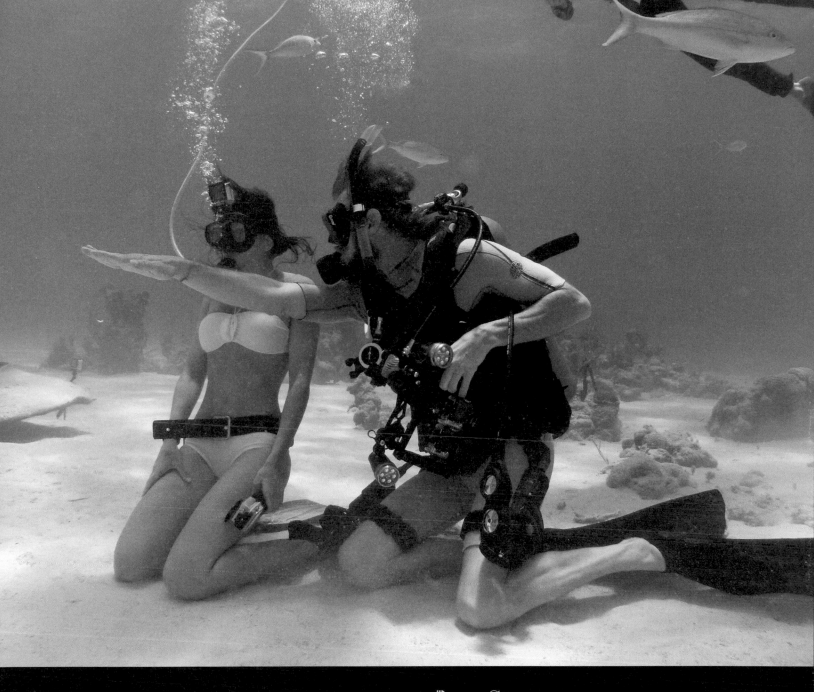

We all want to be understood, and that innate human need always shows itself in one way or another—tone, body language, analogies, and so on. We are subconsciously telegraphing others in order to be understood. Pay attention to the signals and they will dictate the course of the interview. Maybe the character is trying to express an issue or problem they have but won't directly say it. When you get to a trusted and deep space with your character, there may be awkward silence or pregnant pauses. Don't be the one to fill the silence—let them do it. The interviewer's job is to create a safe place and gain the trust needed for the subject to open up. Trust is earned, not given. And it is the filmmakers' responsibility in editing to use that trust wisely and be true to that character.

It's useful to prepare your list of guidance questions over the first few days of a shoot, arrange them with a few warmup questions, and then throw in a challenging one relating to the thematic "why." Progress the interview in overlapping circles with each new topic touching previous important ones. Continuously loop back and remind the subject of certain ideas or feelings they spoke of earlier. Natural repetition can help arrange sentences cohesively and concisely. As a filmmaker, you will notice the necessity of this in editing, when you have to cut down or rearrange voiceover.

This kind of progressive overlapping technique was used while filming in the Bahamas for the HD HERO2 Dive Housing product launch with Mark Healey and Roberta Mancino. Over the first few days, we noticed a few commonalities between the freediver and the skydiver, which helped us arrange our list of guidance questions. Both feared other humans more than wild animals. Both have issues with loss of control, but derive purpose and pleasure from situations in which nature has total control over their life. Both subjects shared an interesting thematic interplay of euphoria through fear and loss of control which manifested in their dreams. Each interview lasted two-and-a-half hours with many questions adapting to how each was responding to the fear. We have included the following list of guiding questions used while interviewing Mark Healey for "Director's Cut: Shark Riders" (indirect "why" questions are in bold).

Supercross New Year 2013

James Stewart and Ryan Villopoto are starting 2013 with style. Get a glimpse of each rider's philosophy and training ground as they prepare for the 2013 Supercross Season! Shot on the HERO3 in 2012.

https://www.youtube.com/watch?v=BoTha-S1leU

Producer: Jaci Pastore Filmers: Kyle Camerer, Will Posey
Editor: Matt Sanders

Interview Questions: Mark Healey

Can you state your name and where you're from?	(who)
What comes up first when you Google yourself?	(who: profession and origin)
Do you think of yourself as that person?	**(indirect why)**
How deep have you gone?	(what: his interest in freediving)
How do you train for that?	(go through breathing exercises to calm him)
What's the deepest you think you'll go?	**(indirect why: push him on his purpose and goals in life)**
What's your power animal?	(what: his interest in sharks and wildlife)
If reincarnated for all the things you've done, would it be the same animal?	**(indirect why: does he respond to anything spiritual? God?)**
Ever been bitten by a shark?	(when: tell us a story)
What's the scariest break you've ever surfed?	(when: his interest in surfing)
What's scarier: great white sharks, big wave hold-downs, or shallow water blackout?	(what)
Has there been a situation where you've felt out of control with sharks? With surfing?	(when)
Describe the feeling of being out of control underwater.	**(indirect why: fear)**
Where is the environment you like to control?	**(indirect why: he previously talked about interior mind control as self-control)**
Have you ever heard of lucid dreaming or had a lucid dream?	(when or who)
Are people or nature easier to predict?	**(indirect why: control)**
Do you have nightmares? Have you been eaten by a shark in a nightmare?	(share your own nightmare here to identify)
You watch and monitor shark behavior to sense danger. Do you monitor people in the same way? Is it different?	**(indirect why: control)**

Environmentals and Time-Lapses

Environmentals are shots that depict a story's location, often also showing the characters within it. They can be used as a video's opening, resolution, to bridge between story beats, or to convey the passage of time or journey. They can be either video or time-lapses typically shot during the spare moments on location. On the scouting day, always note where the sun rises and sets, and keep an eye out for any features or opportunities to shoot subjects that draw insightful elements into your story.

For video environmentals, set up foreground elements to give depth. If you can get the character in the shot, then all the better. We used this technique in "New York City...a Day in the Life," featured later in the chapter. We constructed a clothesline on top of a random NYC skyline apartment building, and Ryan Sheckler skated behind on the bridge multiple times while we faked wind by shaking the line. Small details make environmentals shine.

When it comes to time-lapses, there are two different types. One is an actual photo time-lapse shooting at a designated interval, and the other is a video time-lapse sped up. For video, we tend to shoot 4K30, in case something doesn't look natural when sped up. Windy trees, waves, or rivers can look jittery in a photo time-lapse, so having more frames to work with gives the editor more control. However, we use photo time-lapse mode for sunrise and sunset when good exposure and low light is needed or when shooting over extended periods of time. For extended time-lapses, we usually use a 64 GB memory card and a Battery BacPac or USB power.

Environmentals are best used to introduce and underscore themes in a video, as in "Remembering Sion Milosky." The opening time-lapse, captured with an egg timer, shows the abrupt appearance and departure of a silhouetted surfer. It's a nice introduction for a video about loss and the shortness of life. For the final shot, we see a small stream running out into the ocean waves. It's a peaceful shot, as if we are seeing Sion's spirit flow back to mother ocean, his home and resting place. This static environmental gives resolution to the story.

Remembering Sion Milosky

This video is GoPro's tribute to Sion Milosky: loving father, experienced waterman, and big wave charger. He will always be remembered. Shot on the HD HERO in 2010.

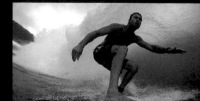

http://www.youtube.com/
watch?v=fn5_ivjLa_Y

Filmers: Bradford Schmidt, Jordan Miller
Editor: Brandon Thompson

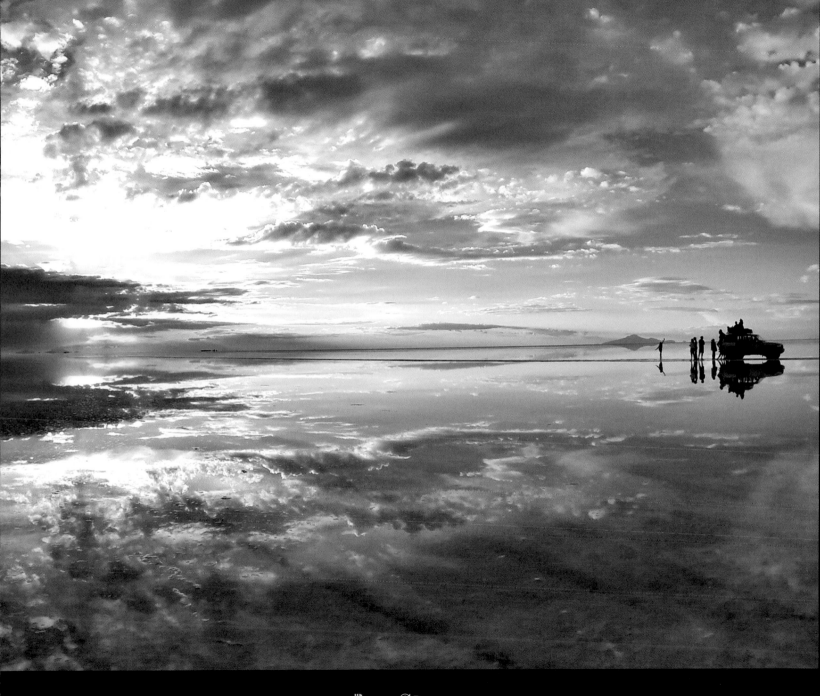

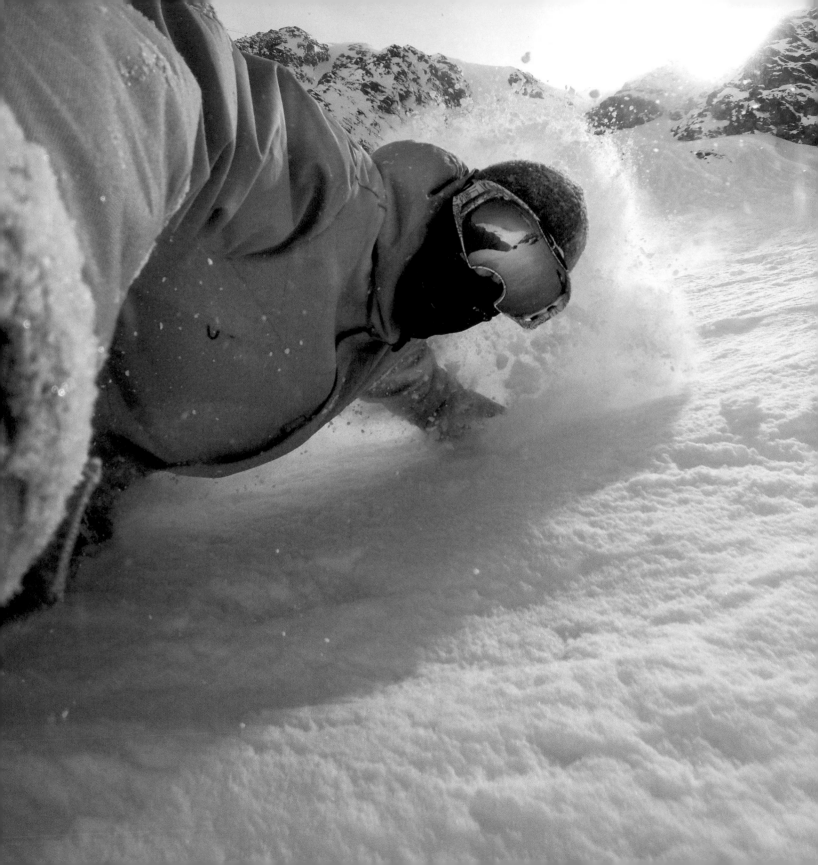

Photos

During production, we generally alternate between photo and video on certain mounts when the moment and lighting are right. Usually, the best photos are captured with secondary setups such as a 3-Way extension arm, backpack mount, or gnarwhal mount, which all do a good job of capturing the subject within his or her surroundings. These angles are very unique to GoPro and can tell a complete story in a single shot.

Time-lapse photos captured at 0.5 second intervals is the go-to photo mode for just about every production. There may be a thousand photos to sort through at the end of a session, but .5 second intervals will capture that quick moment of high action. It's good to remember, however, that in low-light or indoor situations, it's best to switch to photo every 2 second mode for the best exposure. (The Night-Lapse section in Chapter 1 gives additional information on shooting photos in low light.)

If the activity or action is calculated and brief, such as jumping off a waterfall, then burst is the photo capture mode of choice. Using the Smart Remote or GoPro App can achieve even more precise results when capturing a 30 photo burst over a 1-second period. One thing to keep in mind when timing a burst photo sequence is the 1-second delay that occurs from the remote or app to the camera it triggers. Sometimes, we use 30 photos every 2 or 3 seconds to ensure the moment is not missed.

When framing and mounting for photos, it's best to think differently from video. For example, turning the camera sideways for a vertical photo is usually more advantageous for self-capture. There is a tendency to point the camera at your face, but with such a wide lens, the upper half of the photo will consist of sky while the bottom half of the body will be cut off. It's best to aim the camera at your midsection or belly button to achieve proper framing for self-capture. When mounting a camera, stability and vibration are usually major concerns for usable video. However, in .5 sec or burst photo mode, shake or vibration usually don't matter. We ziptie long poles off vehicles, which bounce around. We even toss the camera high in the air for unique overhead aerial pictures. All you need for a good photo is great light and one split-second where it all comes together.

Cort Muller / Tignes, France ⚟ Handheld 📷 Photo/.5sec

Experimentation

Wait... they did that with a GoPro?

An ordinary GoPro can achieve extraordinary things. Seeing Felix Baumgartner take several GoPros up to the harsh, freezing environment of Earth's stratosphere in order to document his free fall from the edge of space was testament to how far a GoPro can go. We are continually astounded by the innovation and creativity we see from our users, professional and amateur alike. Their creative use of GoPro is inspiring and never-ending.

We've seen doctors adapt our 3D HERO System to capture a series of magnification mirrors to record 3D endoscopic surgery. Inventive astronomers have mounted GoPros to telescopes to capture pictures of the moon. Rocket scientists have inserted GoPros into a vacuum cryo-chamber to record and study plasma propulsion. Wildlife scientists use GoPros to document animal behavior at night with infrared lights. Biologists use macro lens adapters to place GoPros on feeders to record hummingbirds and insects. Oceanographic researchers combine footage from multiple GoPros to create animated 3D mapped environments of the sea floor. Because of GoPro's versatile and adaptable nature, the only real limitation is your imagination.

Take a moment and think about the story you are going to capture. Is there a unique way to film it that most people have never seen before? GoPros have the ability to go places where humans cannot. Be inventive and innovative in your filmmaking endeavors. Spend some time researching on YouTube and Google. There are all sorts of forums, websites, tutorials, and videos which explain a vast variety of interesting applications, adaptations, and uses for your GoPro that go far beyond what you normally see.

Bradford Schmidt / San Francisco, California ☘ GoPro + Macro ⏱📷 Photo/.5sec

Downloading and Review

Good organization of video footage starts on-site while the filmmaker is still shooting. When downloading all the footage at the end of the day, we tend to organize GoPro video files by character and by mount. All of Character A's helmet-cam for a given day goes into one folder, Character B's helmet-cam into another, and so forth. We then label the folders. You'll be thanking yourself later when you open up those neatly organized and labeled folders for selecting and editing. It's also imperative to back up the files on another hard drive on location. At GoPro, we actually back up our daily downloads twice.

For a production, one of the most critical and easily forgotten steps is footage review. This should take place each night when downloading the SD cards. A nightly review lets the filmmaker know what was actually captured and what was missed. Are there any character observations that should be brought up later in the interview? Is there an opening beat for the story? Is there an ending beat? Does the climactic beat even work? Did something go wrong? The review informs shooting decisions for the coming days and can even affect the direction of the story.

Most importantly, as a filmmaker you should use the review to identify what is working and what isn't. Make sure you are on your way to capturing all the building blocks that will later create a beginning, middle, and end to your story in editing. But it's also important not to be too attached to the building blocks you imagined. It may cause you to miss a genuine opportunity to improvise and capture something you didn't think of. The opening or ending of a film can surprise you in the midst of shooting, when something authentic happens with your character. You have to be open to improvisation and ready to let that magic happen.

Improvisation

Improvisation can save a story that is struggling, but it can also get the filmmaker into the most trouble, if solely relied upon. Good improvisers already have a masterful grasp of the tenets of filmmaking. They come prepared, and their experience and skill allow them to recognize when magic is happening and capture it. Novice filmmakers sometimes arrive unprepared and rely only on improvisation, where proper planning and effort would be more suited.

Since the beginning of GoPro, some production artists have consistently produced that certain magic; others have done so with far less consistency. Why? The successful artists are present in the moment. These are the artists in tune with their characters and aware of the potential possibilities at any given moment. A simple example of being in the moment was captured in "Roshambo— Red Bull Rampage 2012." After a frustrating, dusty day, production artist Trenton Pasic saw Chris Van Dine and Tyler McCaul walking up to the top of the Rampage course. Fortunately, he was prepared with two spare cameras in his pack. Sure, practice was over and the shooting day was done. But Trenton popped the two cameras on their helmets and began rolling. He ended up capturing a funny, natural moment between the two bikers and a great narrative flow that became a successful viral video for GoPro.

Another pillar of improvisation is understanding how to adapt or change direction when things go wrong, even when the climax is planned. This is often figured out during the downloading and review stage of a shoot. Improvising can keep a filmmaker from coming home empty-handed. We experienced this while shooting "Ken Block in Russia."

The production was supposed to be the first of an interwoven series for the release of our Wi-Fi BacPac in the Spring of 2012. Everything seemed to go wrong on this shoot. Wrong hotel locations, wrong firmware on prototype cameras, wrong weather... wrong climactic beat. We originally planned to have Block jump over a moving train as the climax for the story. On location, we quickly

Roshambo – Red Bull Rampage 2012

Chris Van Dine and Tyler McCaul take their first top to bottom runs
in practice at Red Bull Rampage 2012. Shot in 960p48 on the HD HERO2.

Filmer: Trenton Pasic
Editor: Trenton Pasic

https://www.youtube.com/
watch?v=C_h1Cgv4K2c

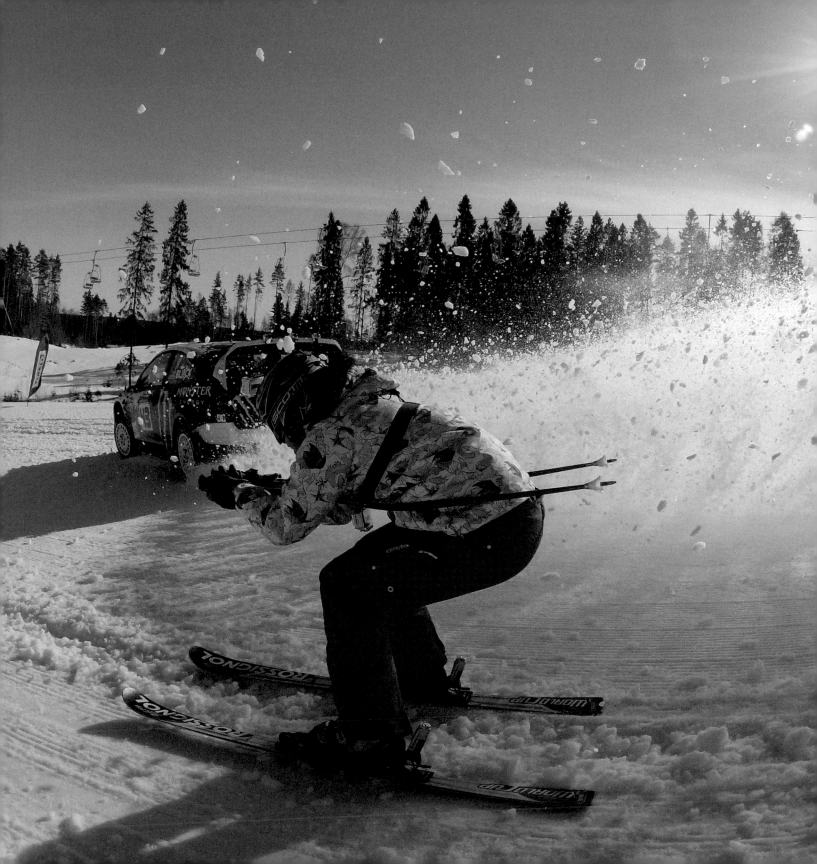

sobered up to the fact that the jump wasn't realistic. The next climax concept was to build a jump in the woods alongside the running train. The Russian crew spent all night building the jump, but the weather was too warm the next day. The jump didn't freeze properly and Block nearly ran into a tree at 50 mph. So that idea was scrapped.

Time was running out on the last day, and we still didn't have a climax or an ending. For our climactic beat we settled for Block destroying 30 GoPro cameras laid in an arc on the snow. But we knew we needed some kind of payoff to save this video from failure. We playfully matched a Russian skier against Block, who he blasts with a dramatic spray of snow. The rear bumper of his car had been torn off during that scene. Suddenly, we had an idea for a payoff. We improvised an ending where the Russian skier sees Block's car in the parking lot and kicks the bumper off as payback. Her revenge included the banter of the Italian mechanics, which made it even more humorous. It was our first improvised foray into GoPro comedy. And luckily it worked—the improvisation saved the video.

Some productions require improvisation, such as filming wildlife. When you have no control over the main characters, how you imagine the climax becomes more of a dice roll than a plan. Improvisation is key in understanding how to create optimal scenarios, predict behavior, and adapt to wildlife characters while still capturing a climactic beat for the story.

Bradford Schmidt, Ken Block / Russia Pole Photo/.5sec

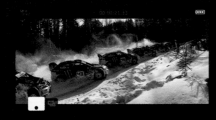

Ken Block in Russia

Ken Block is on a mission of destruction as he battles the elements, races rogue skiers, and tries to take out as many cameras as he can. Shot on the HD HERO2 in 2012.

Director: Bradford Schmidt Producer: Yara Khakbaz
Crew: Travis Pynn, Nicholas Lubsen, Rod Rojas
Editor: Jordan Miller, Davis Paul, Zak Shelhamer

https://www.youtube.com/
watch?v=EPr32OYuEmo

In 2012, the HERO3 was GoPro's first camera with a flat lens housing, thereby enabling extremely clear underwater footage for the first time from a stock GoPro. An underwater scene was a critical requirement for the launch video and we wanted to show the world something it hadn't seen before. There are only a few places where humans can legally dive with humpback whales. Tonga is one of them, with tropical water allowing more than 100 feet of visibility. We hired the best freediving coach in the world, Kirk Krack, and three professional freedivers: Ashleigh, Erin, and Mandy. The climactic moment was ambitious: three female characters in the same frame with enormous humpback whales.

Our outfitter in Tonga, Alistair, administered a dose of reality. Normally, the BBC or NatGeo would employ him for something like this with a shooting window of 20 or 30 days. We only had five.

Over the first few days, we followed the whales and learned a few interesting techniques. The animals have to welcome you into their space—you can't simply run at them. After you calmly swim parallel to them for a while, the whales grow curious and come closer and closer to you. We found out they were as curious about us as we were about them, but the approach had to be on their terms. We captured some beautiful shots, sometimes with one of the girls in the frame, but nothing magic. During review, we noticed one whale had come up underneath us with a big curious eye. One of us turned around and waved an arm. The whale turned and waved in response. Alistair explained that if the whale was curious enough, it would mimic you. That sparked a new idea for the climactic beat: capturing all three girls interacting and spinning with a whale in a single shot. Alistair's response was bleak: impossible.

On the second-to-last day, we improvised a new plan. At an opportune moment, Kirk would film a close follow behind the girls while Bradford would capture the wide and give the signal. In the late afternoon, it just happened. A large female was resting below the surface. The crew dove down parallel to the whale's eye level. The humpback and crew drifted closer and closer. The signal was given and the whale watched as the girls began to turn. As if on cue, the humpback turned and spun in sync with the freedivers. Our improvised plan had captured the impossible.

Bradford Schmidt, Ashleigh Baird, Erin Magee, Mandy Rae-Krack / Tonga Norbert Photo/.5sec

Whale Fantasia

Alan Watts, three sirens, and three humback whales dance together in a short film that will inspire you. Shot on the HERO3 in 2012 with freedivers Ashleigh Baird, Erin Magee, and Mandy Rae-Krack.

http://www.youtube.com/
watch?v=7Sv_Bv1H7BQ

Director: Bradford Schmidt Producer: Yara Khakbaz
Crew: Kirk Krack, Mike Pfau, Caleb Farro Editor: Brandon Thompson

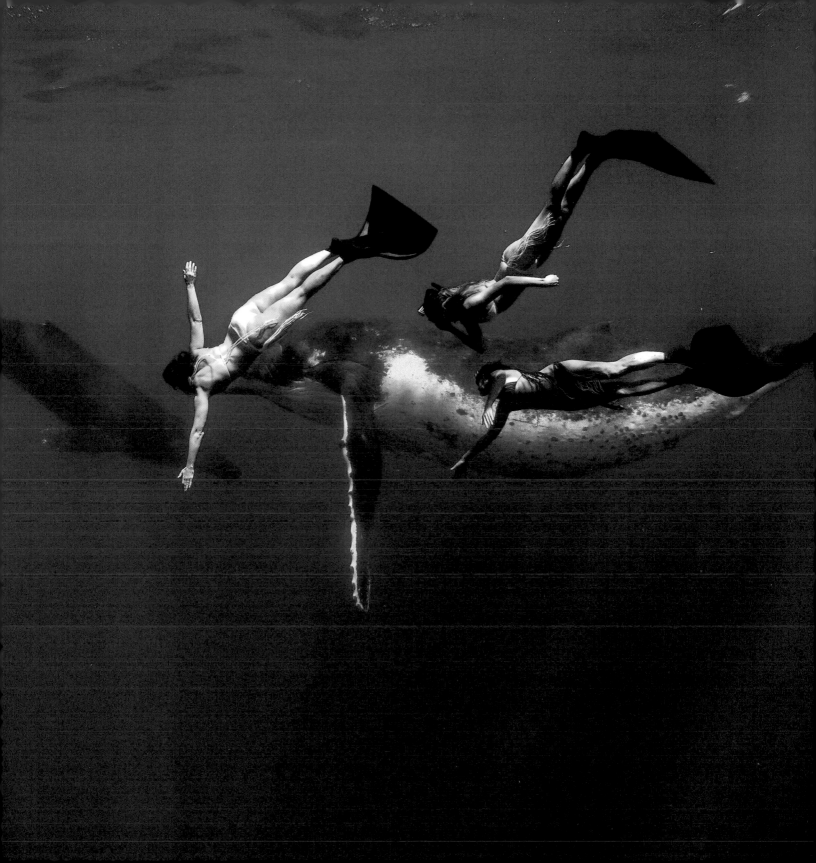

Biography of a Production

GoPro productions take many forms. We encounter various productions from a single camera shoot to a multiple crew production launch involving more than a hundred rolling cameras. Here we outline four distinct types of productions along the spectrum, from simple to complex.

One Man, One Camera

This video was the very first user-generated edit we ever published on the GoPro channel. One morning, Nick came into our Half Moon Bay office, where there were only 12 of us at the time. He was ecstatic about an edit he saw on YouTube...a customer was fulfilling the promise of GoPro! The video was well thought out and beautifully shot by a passionate kid, Brendan Schnurr, who didn't take himself too seriously. Schnurr was having fun with his one GoPro and he made an awesome piece in the middle of nowhere by himself, with a snowboard and a kite. We contacted him and asked if we could promote it on our channel and send him a camera to stoke him out. And he was stoked. This was the very beginning of what was to become the User Generated Content section of GoPro's media department.

This video is still one of our favorites and it epitomizes all that is GoPro. Brendan had all the elements to make up a short little story. He composed each shot with his single camera. He started with setting up establishing shots in the snow and an introductory close-up of the character—himself. Static wide shots are interspersed with POV shots from the Chesty mount and handheld. Great funny music and a climax or rather anti-climax that makes you laugh. This is the dream of GoPro realized and it's a beautiful thing. One man. One camera. And a whole lot of creativity.

 Brendan Schnurr / Keswick, Ontario Canopy 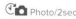 Photo/2sec

Snowkiting in the Backcountry

Shot in 720p60 on the HD HERO in 2009, Brendan Schnurr shows how to get creative with a single camera.

http://www.youtube.com/
watch?v=xr8N3IOP8X8

Filmer: Brendan Schnurr
Editor: Brendan Schnurr

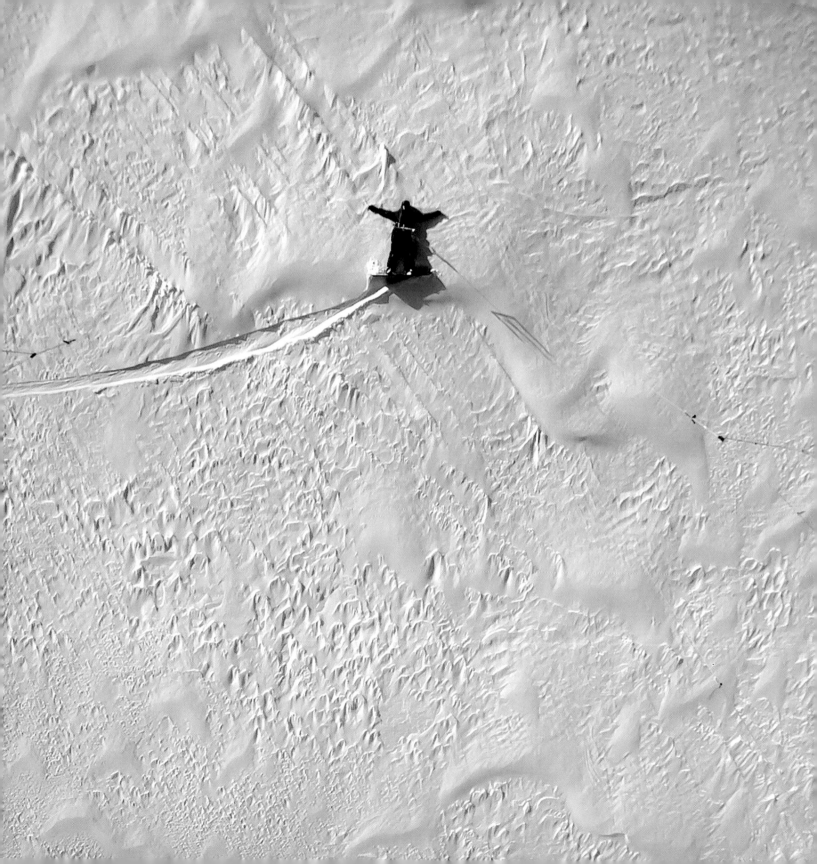

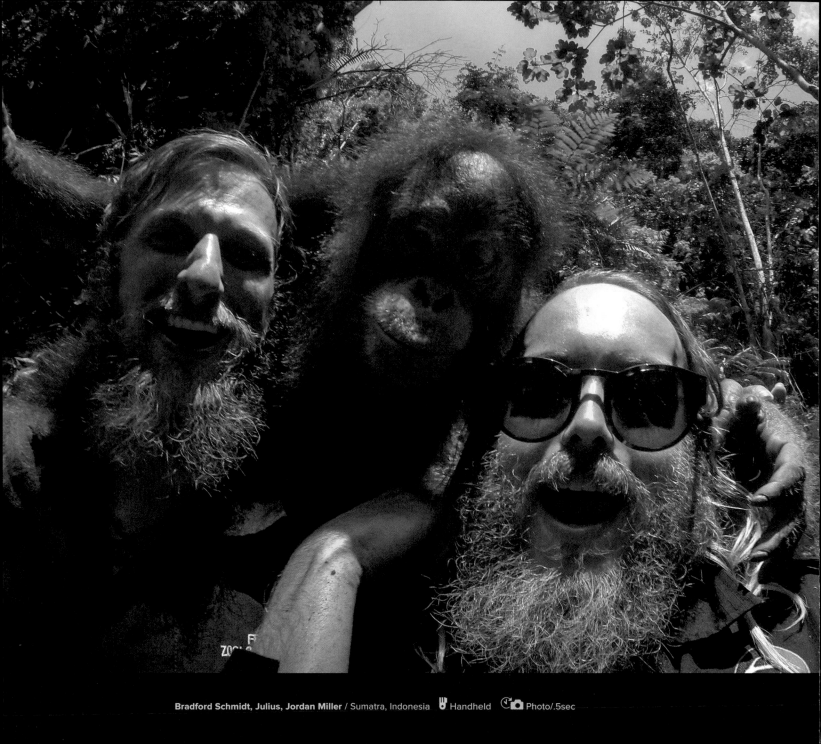

Bradford Schmidt, Julius, Jordan Miller / Sumatra, Indonesia　Handheld　Photo/.5sec

A Friend and Four Cameras

"Our Orangutan Brethren" was a production by two great friends, Brad Schmidt and Jordan Miller, who had tickets to Sumatra and wanted to hang out with orangutans. It's an example of how any passionate GoPro user and a buddy equipped with a couple of cameras can yield an incredible heartfelt story. This wasn't a large production, and it didn't require much money.

The idea began with a passion for the topic of endangered orangutans. Then came a lot of Google and YouTube research before finding the main character, Peter Pratje, and contacting the Frankfurt Zoological Society through its website. Next came several Skype calls with Pratje to collaborate on the potential building blocks for the story: training at the jungle school, the deforested waste-land, and most importantly, a plan to release a rehabilitated orangutan into the wild, which would naturally be our climax. Despite the necessity of improvisation with wildlife, we were prepared. We tried getting orangutan POV with Chesty mounts and handheld mirrors on the first day, but this failed. On the second day, we tried our handlebar mount on a wooden stick that had some strate-gically placed fruit drizzled with honey. The idea worked like a charm. We pretended to hide the stick, which made the apes desire it even more. They would snatch the camera stick away from us and carry it up into the trees and share the fruit with each other. This gave the story unique foot-age no one had ever seen before: orangutans filming themselves.

But just as some aspects necessitated improvisation, other aspects had to be deliberately planned in order for the story to convey specific ideas. The deforested wasteland needed to be personal to the orangutans, thus making it personal for the audience. We planned to film an orangutan on a dead tree, mourning the destroyed homeland. Pratje said orangutans would never climb a tree with no fruit, but we insisted. The single shot took four hours, but that moment became the emo-tional punch of the piece and served the exact purpose the story needed.

Any filmmaker could've made this story. We shot the entire thing with a handful of cameras and a couple of filmmaking toys: a drone, a Kessler Cineslider, a Glidecam, and a Sail System Backpack. Our audio gear included a lavalier mic and a shotgun mic. It was an uncomplicated shoot, simple and realistic for two friends, but it yielded one of the deepest stories we've ever told.

Our Orangutan Brethren

What we do for orangutans, we do for ourselves. Peter Pratje reveals how we, as individuals, can help prevent their imminent extinction. Shot on the HERO3+ in 2013.

Director: Bradford Schmidt Producer: Yara Khakbaz
Crew: Jordan Miller Editor: Mario Callejas

http://www.youtube.com/
watch?v=oir_PSJpbAA

Product Launch Production

"New York City...A Day in the Life" is a prime example of a GoPro professional production. We had a large crew consisting of five GoPro members, a local producer, a local scout, a professional skate filmer, and the professional skater, Ryan Sheckler. We had never filmed street skating, a big city or a marketing segment for a complicated product like the Wi-Fi BacPac and Remote before, which made this our most calculated production up to that time.

The concept was a skater's journey over the Manhattan Bridge to the Lower East Side skate park. Sheckler and his filmer, Erik Bragg, were to capture it all themselves with myriad GoPros and our new Wi-Fi products. The building blocks of the story were broken down into three major sections for the skater's "line" through the city. The introduction, on the Manhattan Bridge and the China-town stair set, would build to the climactic moment where Sheckler would kickflip over a taxicab before entering the skate park.

In order to prepare properly, we actually shot the entire film at each location with a local skater on our scout day. The Sun Seeker app uses a phone's GPS to project the sun's path while standing at a location. This allowed us to plot out the best time of day when the sun was peeking between tall skyscrapers to light up a location. After the initial scout day, we put a rough cut together that night to see what worked and what didn't. We realized we would need to depend heavily on graphics to communicate the features of our new Wi-Fi products.

The introduction and middle sections were fairly straightforward, but the finale was not. We arrived at the Lower East Side skate park four hours before sunset to prepare the scene and rig 30 static cameras around the taxicab, brick walls, curbs, and street. Once it was all done, we patiently waited until the light was best. Fending off the gathering crowd around the scene, keeping 30 cameras rolling on a city street, a dozen crew members choreographed, and a professional athlete landing a difficult trick was a feat unto itself. At the end of the day, the major lesson we took away from our professional product shoot in NYC was preparation and scouting saved our asses. But, of course, our job was only half done. The editing was going to be the hard part.

**New York City...A Day in the Life –
Starring Skate Legend Ryan Sheckler**

Ryan Sheckler takes a run from the Manhattan Bridge to the Lower East Side skate park. Shot on the HD HERO2 in 2012.

Director: Bradford Schmidt Producer: Yara Khakbaz
Crew: Zak Shelhamer, Nicholas Lubsen, Matt Lin, Sam Lazarus
Editors: Erik Bragg, Jordan Miller, Abe Kislevitz

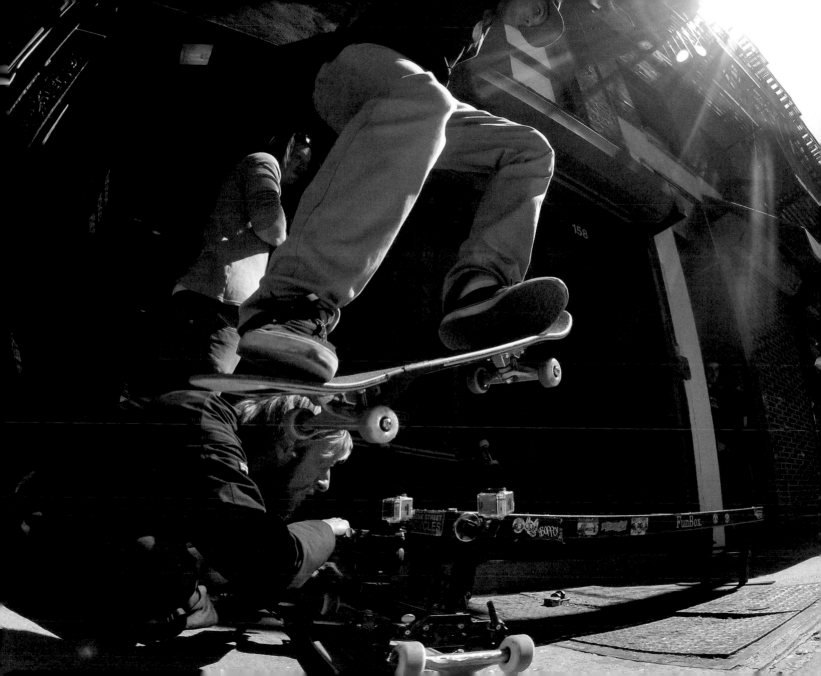

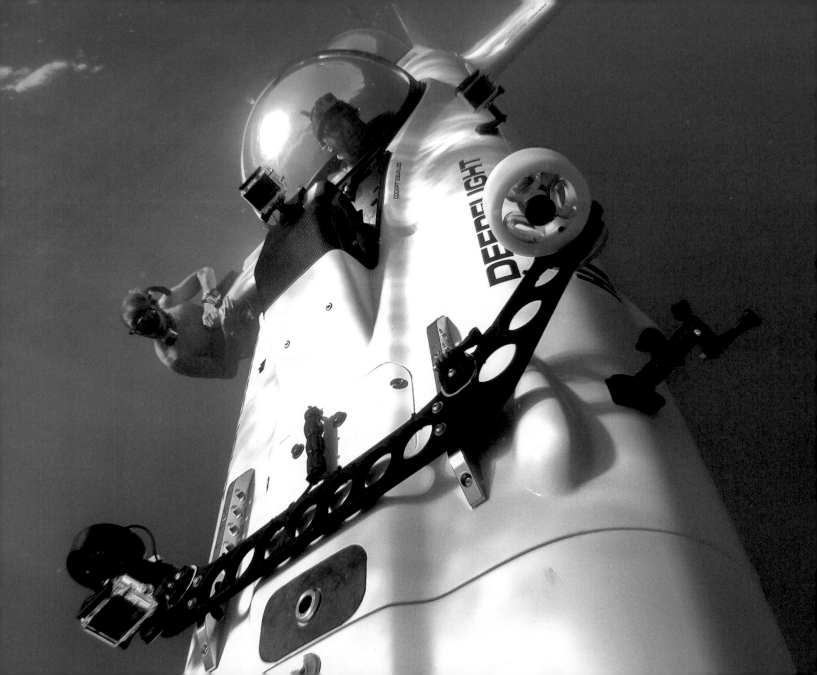

One Man, 30 Cameras

How has GoPro empowered the individual? "Deepflight Submersible - Searching for Whale Song" was filmed by one professional in a single day. It began when inventor Graham Hawkes invited Nick Woodman to test drive Graham's new submersible in Hawaii. For the story's building blocks, we planned (hopefully) for a whale encounter as the climax and a surface breach as the resolution. We drew mounting diagrams complete with a few wild ideas, including an elongated spinner mounted perpendicular to the vehicle's nose, like a propeller. Upon arrival, the first afternoon was spent preparing the submarine with sticky mounts and extensions using a camera and an LCD BacPac. Most of the cameras couldn't actually be placed on the submarine until it was floating in the water, so all the mounts had to be prepared beforehand. The extra few hours of preparation are essential so when the time comes, you simply press record and let the cameras do all the work.

In the morning, we found out Woodman wasn't able to pilot the submersible due to Coast Guard regulations. But we had Hawkes and his copilot Lee outfitted with red beanies, head straps, and lavalier mics in their submarine, all ready to be launched into the sea. All of the GoPros and mount setups were swum out to the floating sub and snapped into place in ten minutes. Hawkes was instructed to talk through everything while he was down at depth, explaining about the whales and the song and how he was recording them. His voice-over would be the spine of the story. The trapper had laid out all the GoPro traps and now had to trust that the magic of Hawkes's personality and the underwater dive would shine through to the 30 rolling cameras. Though whales were everywhere around us, and the hydrophones picked up whale song, Graham and Lee never visually encountered any underwater. We debated how to handle this in editing—an archive clip from the Tonga production gave a surreal moment of connection between Lee and a whale waving at each other. The climactic scene felt emotionally true to the story.

In this case, proper preparation, solid coverage, and understanding of the building blocks of the story made reconstructing that story on the timeline much easier. The filmmaker had a narrative flow in mind throughout the production, which allowed the editor to focus on making each beat impactful, rather than wasting time trying to conjure a structure out of thin air.

DeepFlight Submersible – Searching for Whale Song

Renowned submersible designer Graham Hawkes and copilot Lee Behel go on a surreal submersible adventure. Using their hydrophones, our intrepid explorers cruise the underwater valleys of Hawaii in an attempt to capture a whale song. Shot on the HERO3 in 2013.

Director: Bradford Schmidt Editor: Brandon Thompson

http://www.youtube.com/watch?v=xRsV_eUovKw

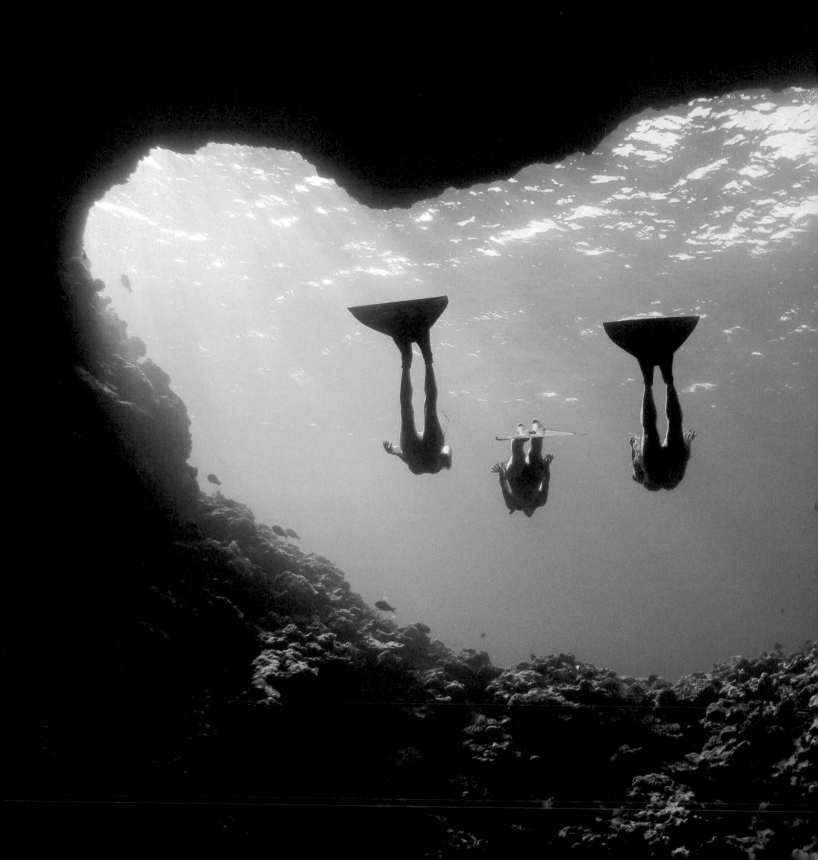

The best stories generally come from an artist who follows an idea throughout the shoot and goes into the editing phase with a map. You won't know everything that happened if you've shot with your GoPros properly, but you laid the best traps during the shoot with your coverage, and now it's time to find out if there are any golden surprises. Good filmmakers have a narrative flow in mind, which has been growing and adapting throughout production based on the story's building blocks. When they enter the editing stage, they write this down in what we call a "paper cut." Good footage is key. Editing is important, but remember: superb editing turns mediocre footage into mediocre footage edited superbly... which only yields a superbly mediocre video. Capture the content pool that will give you the ability to sculpt your masterpiece.

Your story will be as deep and as layered as the thought you put into it. That thought should occur during the shooting phase and the editing phase. Your well-thought-out details may seem trivial sometimes. But the audience will get out only what you put in, even if what they are getting isn't precisely what you intended...there is substance in it, and that is art.

Kirk Krack, Ashleigh Baird, Erin Magee, Mandy Rae-Krack / Tonga Norbert Photo/.5sec

Art of Editing

THE EDIT. THE THIRD AND final time a story is retold.

During this stage, the filmmaker discovers which shots worked, which didn't, and what surprises were caught along the way. Surprises are the best part of filming with GoPro because the camera is out of the filmmaker's hands, capturing unexpected moments and creating a life of its own. In editing, the filmmaker searches through gigabytes or even terabytes of footage for important moments, unexpected or not. The filmmaker then brings these moments to the forefront by carefully ordering them on an editing timeline so that a meaningful story emerges.

Editing is something of a silent art. Realized well, the editor's work is usually invisible. Editors must keep the audience immersed in the video experience at all times. They do this by sequencing story events, cutting unnecessary action, and maintaining continuity in time and space. This isn't to say that editing can't be a powerful form of expression. Images often imply deeper ideas or metaphors, and the human mind is naturally inclined to seek connection between images presented in sequence. A masterful editor understands this and juxtaposes imagery so those deeper ideas and metaphors are brought to light.

This chapter, like those preceding, contains references to GoPro's online videos. To become a good editor is to become aware of the art itself—to understand what motivates decisions and to judge both successes and failures. Although by no means perfect, these referenced videos highlight what we, as learned amateurs, consider to be the essentials of GoPro editing.

Andy "Godders" Godwin / Netheravon, England Top Helmet Photo/1sec

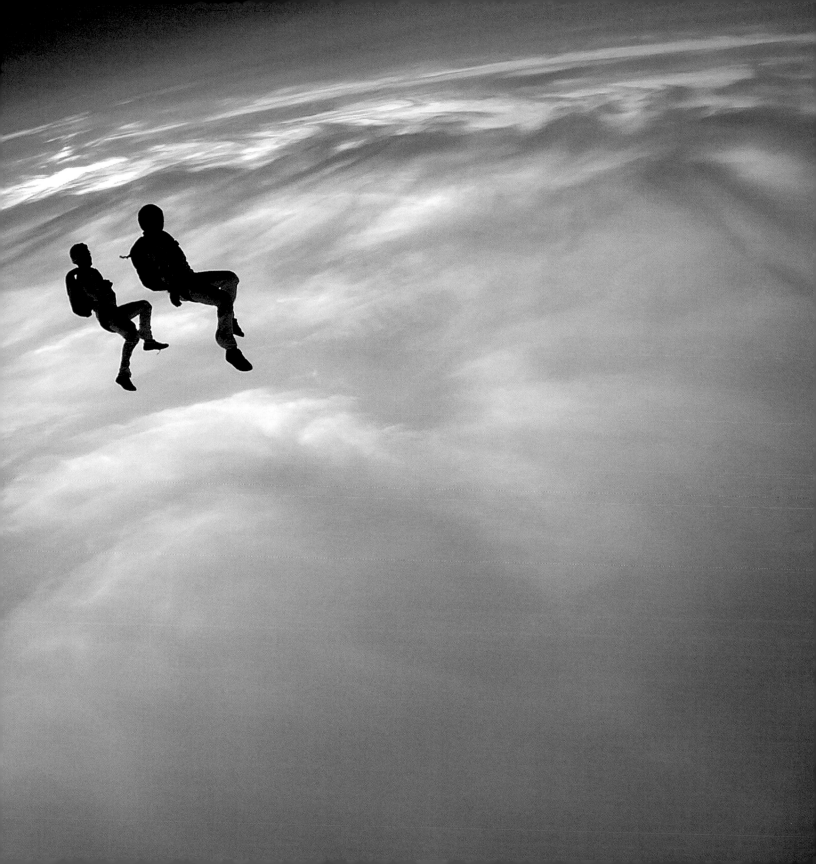

Getting Started

Technology changes rapidly, and the video industry is no exception. In this book, we decided to focus less on the specifics of any single editing platform and more on the nuts and bolts of editing theory. Unfortunately, running into difficulties with hardware/software is inevitable. The Internet is a vast, dynamic resource for tackling technical difficulties: Googling problems almost always leads to a blog or forum where other users have dealt with the same issue. Nevertheless, in this section we discuss a few technical considerations.

Gear

Editing can be expensive. Here are a few of the things you'll need:

- **Computer:** The more powerful your processor and graphics card, the less time you'll spend waiting around for video/graphics to render.

- **Editing software:** A number of quality editing platforms are available to you. Options include GoPro Studio, Adobe Premiere Pro, Apple Final Cut Pro, and Sony Vegas. Adobe After Effects and Apple Motion are good for graphics and text. At GoPro, we use GoPro Studio and Adobe Premiere Pro for editing and After Effects for graphics.

- **Transcoding software:** The high compression of GoPro's native video will cause some editing platforms to hiccup or lag. Use the free GoPro Studio to convert your MP4s into the GoPro Cineform codec, an editing codec that allows for a much smoother editing workflow.

- **External hard drive:** This is mandatory. This will give you a dedicated location to back up your raw video and store your projects. We recommend USB 3.0 or Thunderbolt compatibility if editing from an external hard drive.

- **Headphones/earbuds/speakers:** Unless you're editing for television or film, something low-dollar will probably work just fine. This will give you an idea of how the edit will sound from computer speakers or headphones, which are the primary listening devices for online video today.

Organization

Organizing a project before you've even begun will save you hours in editing. It also helps you find important files later and keeps you from accidentally deleting something imporant. We typically create a root folder with the name of the shoot or project and then place the following folders inside:

- **Exports:** Contains the exported finished product of your video, as well as any compressed versions for upload to the web.

- **GoPro Raw:** All the video files, straight from the camera in .mp4 format with the original GoPro file names (i.e. eGOPR0001), that you will be using for the edit. *Never delete your raws!*

- **Music:** Music files you might use for the edit.

- **Scratch:** Editing and visual effects programs usually require a space to store temporary data when rendering. Instruct the program to save those here.

- **Selects:** If you are transcoding, this folder will contain the best moments of footage, transcoded to the editing codec and renamed for clarity.

- **SFX:** Any sound effects files you will use.

- **VFX:** Project files, temporary files, and exports for any visual effects you will be doing in another program, such as Adobe After Effects.

Workflow Overview

So, all of your raw GoPro footage is loaded in the appropriate folder on your external hard drive. Now the temptation is to throw a few clips on the timeline and start cutting. It can't hurt, right? Just a cut here, a ripple there, add a little music, and you start to get excited. Before you know it, you're jump cutting an intro sequence up through the build just in time for the music to hit on an epic slowmo action cutting into a trick montage ramping into a match cut into a-ahahahHAHAA yes, yes, YE-...

Wait.

Don't fall into the trap of cutting before you have a plan. Or trying to force a story before understanding what story the footage is trying to tell. It's easy to become so focused on a single shot or sequence that, over time, you lose sight of a video's larger structure. In our media department, we have a special expression for this because it happens all the time, especially to us. We call it *getting lost in the woods*. You don't know what direction you are going because you can't see over the tops of the trees.

Over the years we've developed a workflow that helps editors avoid getting lost in the woods through proper planning and direction. We tend to break the editing process into five stages:

1. Selects

2. Paper cut

3. Rough cut

4. Second pass

5. Final pass

This flow isn't mandatory, and creative minds tend to go about this process in different ways. The workflow is a helpful tool, though. It is efficient and effective, producing results no matter your skill level or creative style.

David Bengtsson / Saalbach Hinterglemm, Austria 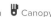 Canopy 📷 Photo/.5sec

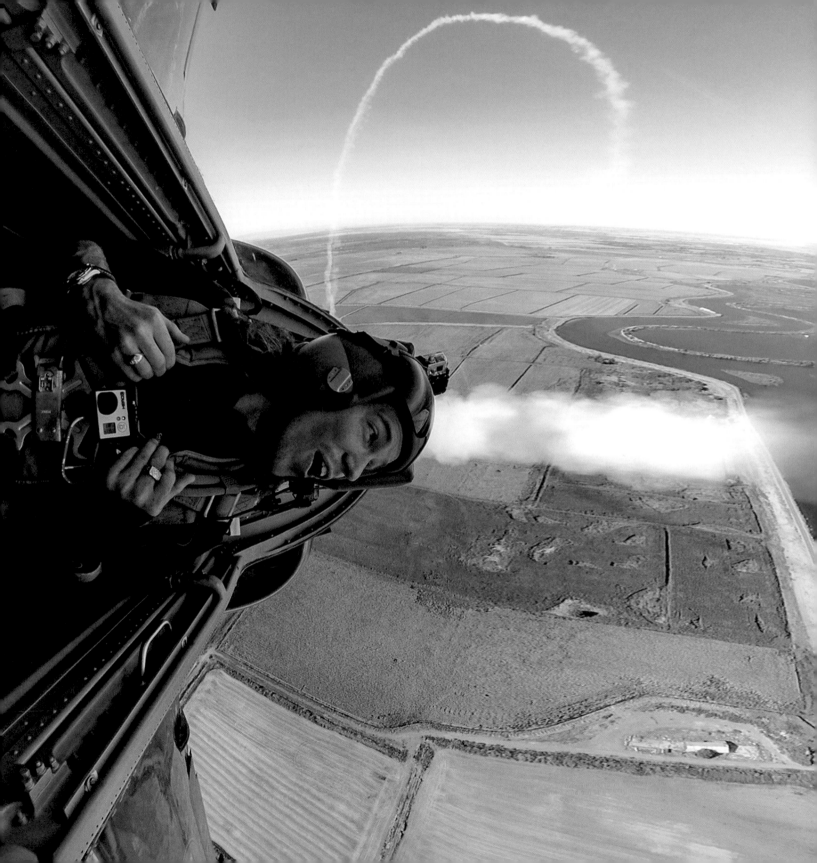

Selects

The first and arguably most important step of the editing flow is making *selects,* which are the best moments in your footage with all the unusable or uninteresting parts trimmed out. The selecting process is where the editor begins to understand the story being told by the footage. Upon completion, you should have every shot you need for the eventual finished edit. Selects are the building blocks of the story. In the paper cut stage, you will decide which building blocks best tell that story.

The selecting process is also the moment of truth when you find out the difference between what you think you shot and what you *actually* shot. A dead battery, wrong mode, poor framing, ruined audio...a lot can go wrong. But buried within the footage you will almost always find those beautiful moments where everything went right.

It's useful to categorize your selects according to function: action shots, establishing shots, interviews, transitions, time-lapses, and so on. Depending on the amount of footage and complexity of the edit, the selecting process can take anywhere from a few hours to days. In general, we select almost everything that is potentially usable. You don't want to end up going back to the raws later, just to find that one shot you missed. It's also useful to not trim your selects too tightly. Leaving an extra 3–5 seconds on the head and tail of each shot ensures flexibility on the timeline later.

Transcoding

GoPro video files are encoded using H.264, a video codec. H.264 compresses video file sizes for transfer onto memory cards. Some editing programs, however, cannot decode H.264 for real-time editing. GoPro Studio can transcode your footage into the intermediate Cineform codec that plays smoothly in editing, at the expense of larger file sizes. You can choose the best moments of your raw files, trim them, and transcode them to a new file with a new name.

If you are editing in a program such as Adobe Premiere Pro, transcoding is not necessary because the program can handle GoPro's H.264 compression. However, you should still go through the selecting process. Do this by creating timelines with appropriate names, setting in and out points in your footage, and dragging selected clips onto the corresponding timeline. For further clarity, rename the new clips or use markers.

Shaun White / California ⬆ Adhesive Mount 📷 Photo/.5sec

The Paper Cut

A *paper cut* is basically an outline of the most essential moments or beats in your story. This might consist of a half-dozen frame grabs accompanied by relevant notes on each beat with music and important quotes. A paper cut gives you a good starting place and keeps you from getting lost in the forest during the editing process—because it provides a roadmap and directions. A paper cut keeps you from falling victim to major holes and pitfalls.

Consider two editing scenarios:

In the first scenario, an editor was working on an auto race edit. The editor started cutting before knowing what the structure might be. For days he cut a beautiful introduction full of great titles and stylized color. Before the editor knew it, he had a six-minute video that was all intro...the race hadn't even started yet! For a short YouTube video, six minutes is a long time to wait for what you wanted to see.

As the project unfolded, it was painful for the editor to cut the introduction down after he'd spent so much time laboring over it. If he had completed a paper cut beforehand, he likely would have decided that the introduction need only be two minutes.

In an alternate scenario, another editor was tackling the "Jeb Corliss Flies Through Tianmen Cave" story. The footage featured two main events: Jeb's aborted jump and then his later successful flight through the cave. In the editor's paper cut, she noted plans to use the first half of Corliss's successful jump as the introduction. In a sense, this created tension by asking the question, "Is he going to make it?" She then introduced the characters and showed the aborted jump, before revisiting his successful jump in the second half.

Her instincts were good. Creating tension in the introduction hooks the audience. But the proposed structure felt long and circuitous. Looking at the paper cut, we quickly realized that the editor was manufacturing tension with a false opening when she didn't have to. The "Is he going to make it?" tension already existed in the aborted jump. So the manufactured opening got axed and the edit started with the aborted jump, setting up the theme of human perseverance: "You only fail if you give up." The paper cut saved days of what would have been a frustrating revision after the first rough cut.

Jeb Corliss Flies Through Tianmen Cave

Take a look behind the scenes as Jeb Corliss fufills his quest to make history. Corliss was the first person to fly through Heaven's Gate in Tianmen Mountain, China. Shot on the HD HERO2 in 2011.

https://www.youtube.com/
watch?v=2fAvbqQWRWo

Director: Jordan Miller Producer: Yara Khakbaz
Editor: Sarah Miller

Paper Cut: Jeb Corliss Tianmen Cave

 Opening Sequence: Jeb's failure: Start in Jeb's head-cam, on the helicopter with voiceover. Just raw audio with no music. He jumps and flies, heading for Heaven's Gate. He's going... going... and just when we think he's gonna make it he pulls his chute. Fail. Jeb frustrated at the bottom of the stairs.

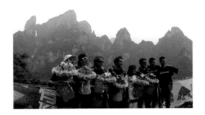 **Character Introduction:** Rewind. Freeze frames of Jeb and his crew, eating together, traveling, and jumping. Classic kung-fu music.

 Introduce the Obstacle: Jeb talks about the technical aspects of the jump. We travel up the mountain as Jeb says: "If you want to do something special, you have to work for it." They begin practice jumps to the somber/spooky music, "Ghostly Chatter" by Insightful. Douggs says, "I get more scared every time." Joby crashes. We feel the danger.

 Preparation for the Climax: Jeb prepares for his final jump. He explains that failure is a conscious choice to give up, that if you never give up then you will never fail. You are in the process of succeeding. We see flashbacks of his first failed jump. Then he steps off the helicopter. Tension builds. Music: "Diamond" by Lorn.

 Climax and Resolution: Jeb flies through the Cave. We see the people looking on in awe and wonder. Success! Jeb sums it up: "My time in this world is limited, but the things I can do are not."

Story

Humans are all different, and we go about life in very different ways. But at the core of our humanity lies a shared world of common emotion and experience. Exploring this world can give a video powerful meaning that communicates to more than just a small subset of people or a niche genre. It opens up the video to anyone who has shared in the emotion or experience portrayed onscreen.

Although GoPro was originally designed with the sports enthusiast in mind, sports are only a small facet of the overall human experience. We believe the reason our videos earn such a large viewership is because we try to tell a story with each one.

In filmmaking, stories usually involve a character who must overcome a problem. The story will have a beginning, middle, and end. These three stages unfold through *beats*: moments when an event, decision, or discovery moves the story's narrative forward, usually bringing the character closer to overcoming the problem.

GoPro videos and good stories complement each other. The camera inherently captures someone's perspective, so telling that person's story feels very natural. The video featured in this section, "Hovercraft Deer Rescue," exemplifies a simple POV story. James and his father encounter a pair of deer trapped on a frozen lake. The video could've just started with a head-cam of James already towing the deer, but the story is much more impactful when the editor takes time to set up the problem. In this case, the two men discuss what to do, search for the right tools, try to rig the deer, and so on. All this setup creates anticipation for the moment when the problem is overcome. This video is about more than deer or hovercrafts—it's about saving something or someone that is helpless. This situation has powerful emotions that come with it, and it's something that we all experience in life.

What's neat is that these ideas about story aren't anything new. Whether through pictures, signs, or spoken word, the tradition of storytelling has probably been around as long as humans themselves. The elements required to tell a good story are simple, universal, and timeless. Whether it's a tale around a fire, ancient Greek theater, thousand-page Russian novels, or a two-minute GoPro video on YouTube, the same unifying principles apply.

https://www.youtube.com/
watch?v=cgnceHH_p_I

Hovercraft Deer Rescue

James Kenison saw a Facebook post about some deer stuck out on the ice in the middle of Albert Lea Lake. He called his dad and they broke out the hovercraft. Shot on the HERO3 in 2013.

Filmer: James Kenison
Editor: Tina Marchman

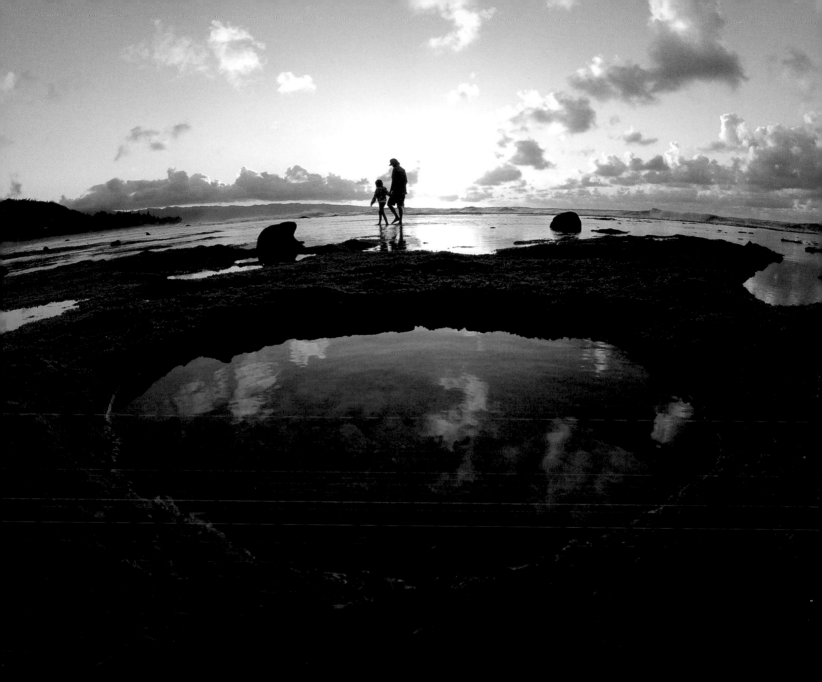

Dune Newhouse, Gavin and Marley Beschen / Oahu, Hawaii Handheld Single Shot

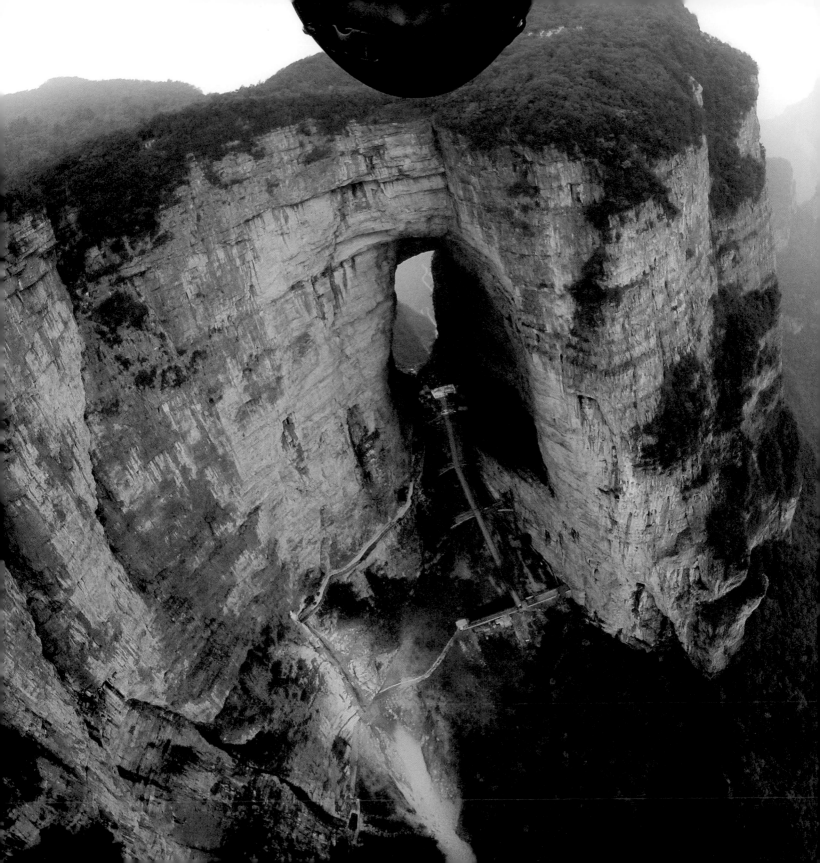

Characters and Conflict

We've all come across those people in life who make us laugh and say, "That person is a *character*!" They're interesting and usually likable. We want to spend time around them, to figure out what makes them tick. Obviously, these are the kinds of characters you want in a good video. And while such a video might be entertaining, it's not a story. Story happens when an interesting character is given a problem to solve or an obstacle to overcome.

As in life, actions are the true proof of someone's character inside a story. The best way for the audience to learn about characters is by watching them. This is where the problem comes in. Problems and obstacles require the character to take action. They create tension, leading the audience to question whether the character will overcome the obstacles or fail. It is this interplay between character, obstacle, and audience expectation that creates a dramatic story.

Classically, four kinds of problems exist in stories and they are usually framed as conflicts:

- **Human versus nature:** A human versus nature conflict is arguably the most common, whether it's a snowboarder taking on the mountain, a surfer pitted against the power of the ocean, or a BASE jumper defying gravity.

- **Human versus human:** Human versus human conflict is most notably seen in racing and competitions.

- **Human versus society:** Human versus society conflict often drives our conservation pieces, where we address problems created by larger human society.

- **Human versus self:** Human versus self conflict is a little more nuanced. Often, conflicts in the other three categories reveal internal conflicts inside the character. The human versus self conflict pits a character against some aspect of himself or herself that must be overcome. You can see a good example in the "Jeb Corliss and Roberta Mancino: Wingsuit Flyers" video featured here, as the athletes conquer their own fears in order to perform death-defying stunts.

Jeb Corliss / Tianmen Cave, China Chesty Photo/.5sec

Jeb Corliss and Roberta Mancino: Wingsuit Flyers

Jeb Corliss and Roberta Mancino share their perspective into the world of proximity wingsuit flying and base jumping. Watch to see onboard footage and personal interviews as they tell their stories of love and near death experiences. Shot on the HD HERO in 2010.

Filmer: Bradford Schmidt
Editor: Brandon Thompson

https://www.youtube.com/watch?v=LhmzmOwkRuM

Structure

With film, the viewer has an intrinsic desire to make connections from shot to shot, sequence to sequence, and beat to beat, thus deriving meaning from a story. Structure is the filmmaker's map, which outlines how and in what order important beats unfold so the viewer will feel the story's meaning in the most impactful way. The longer the story, the more intricate that structure needs to be to retain the audience's attention. But whether a 30-second TV commercial or a feature-length 90-minute film, all story structures must contain a beginning, middle, and end.

- **Beginning:** The character is introduced in the beginning of the edit.

- **Middle:** The character faces obstacles, which lead eventually to the greatest obstacle, or climax. Here, the character either overcomes or fails to overcome the greatest obstacle.

- **End:** The characters react to their success, or failure, in the end of the edit.

The beauty of this structure is that, even if you don't have a story with a defined conflict, concentrating on these stages will give a consistent, logical flow that viewers can instinctively grasp. As stories become longer, these stages are built from beats. *Beats* are those key moments you identify in the paper cut, when an event, decision, or discovery moves the story forward. If the structure is the roadmap, then beats are the waypoints. These beats are connected with supporting sequences to form the narrative of the story.

The featured "Pelican Learns to Fly" video is a great example of how structure builds a story. The beginning introduces the character of the abandoned pelican, as well as the obstacle: the pelican cannot fly. In the middle section, the pelican practices flying with a friendly human. The climax comes as the pelican takes off and soars over the water, conquering the obstacle. The end beat occurs later in the same shot, as the pelican comes back to where it started and lands safely. This simple, beautiful story is conveyed in a total of six shots. One of the interesting things about working with short format videos such as this, is it requires you to be concise: You only have a handful of shots to tell a story. And while you may find yourself wishing you had more, learning to embrace limitations like this will hone your sense of structure, and make you more creative as an artist.

Travis Burke Photography / The Wave, Grand Canyon Tripod Photo/.5sec

Pelican Learns to Fly

Abandoned by his flock, Bigbird the pelican stumbled ashore after a storm and was taken in by the staff of Greystoke Mahale in Tanzania. Shot on the HERO3+ in 2014.

Filmer: Brooke Garnett
Editor: Tina Marchman

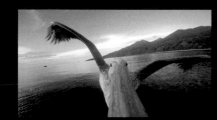

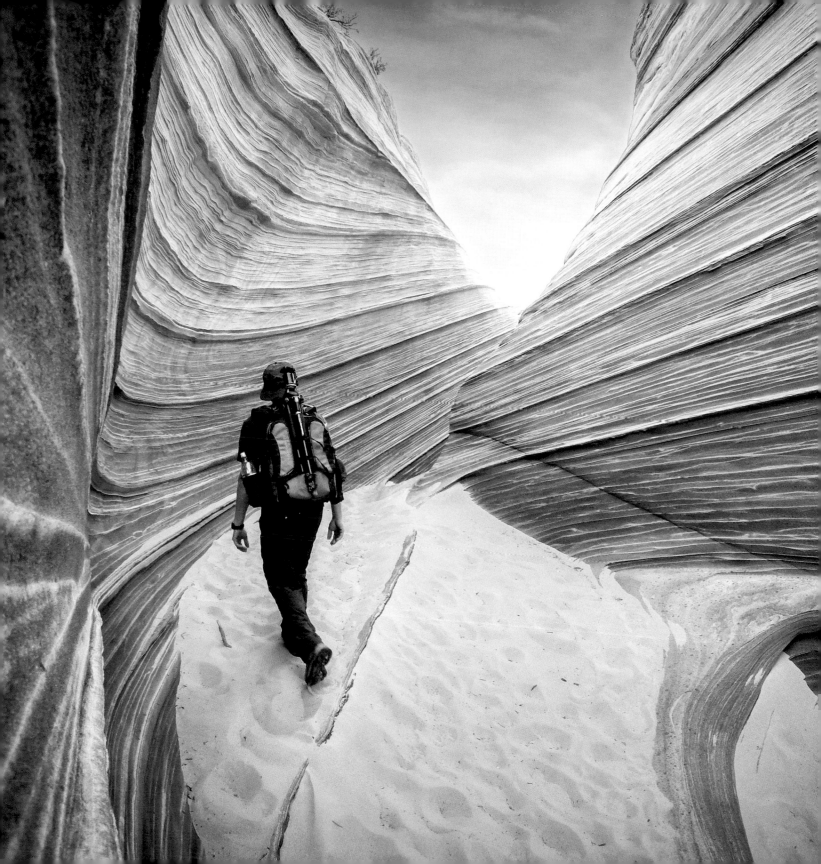

Music

Music can be a powerful tool for the editor, perhaps second only to the images themselves. Music taps straight into human emotion. Excitement, happiness, suspense, sadness, dread…there are no limits to the emotions a good song can impart to viewers. That said, you should only use music to enhance an emotion already inherent in the footage. As soon as music starts to dictate the emotion to the audience, without being motivated by the story, the editor has gone too far.

Finding the right music is a daunting task that requires significant time and effort. Because of this, we tend to gravitate toward our favorite songs—ones we've already heard, know, and love. This can be a mistake. It's hard to be objective when you're already attached to a song.

One of the lucky constraints we had in our early days at GoPro's media department was that there was no music budget, meaning that we couldn't edit to any song we wanted. So, we contacted less-well-known artists and negotiated trades for cameras. Limitations like these forced us to be selective, and spend time finding new music and making sure it fit the intended videos.

Today, we have a Music Supervision department dedicated to helping editors find music that speaks to the footage and procuring those songs from artists. The first question our music supervisor asks an editor is this: "Is music necessary?"

Silence can be just as powerful as Mozart. A pure, raw clip can be instantly immersive and demand audience attention, all the more so if the footage is unbelievable. The "Avalanche Cliff Jump with Matthias Giraud" video featured in this section captures the power of the video's own sound perfectly. The straight helmet-cam introduction leads us to believe we are watching a run-of-the-mill POV skiing video. Natural in-camera audio only reinforces the realism. The understatement of the intro and lack of music make Giraud's climactic moment all the more powerful. Music would only pull us out of the moment, telling us what to feel when the footage already does so—perfectly.

Avalanche Cliff Jump with Matthias Giraud

Skiiers Matthias Giraud and Stefan Laude try to outrun a massive avalanche in the French Alps. The only problem? Their escape route. Shot on the HD HERO in 2011.

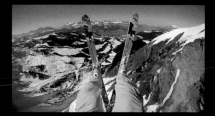

https://www.youtube.com/
watch?v=SwbP9WLX3fY

Filmers: Matthias Giraud, Stefan Laude
Editor: Abe Kislevitz

On the other hand, there are times when you find the perfect song. The mood and tempo go right with the images. The action feels electrified and energized by the music. It's as if the characters are dancing onscreen. The "Human Flight - TV Commercial" video showcases a perfect match of imagery and music. We acquired the 2011 TV commercial's content from the original creator, who had edited his own video and chosen music by Alex Khaskin. We experimented with other kinds music, but nothing came close to this original pairing, so it stayed.

"Las Vegas Grand Finale - Monster Energy Supercross 2011" is a classic example from GoPro's early action sports days. Weeks before shooting, we selected a track that embodied the madness of Vegas. We wanted to show the motocross world through the eyes (or helmet) of a champion. We borrowed Ryan Sipes's helmet and celebrated with it all weekend, forming a dream-like narrative that thumped along with the beat and brash lyrics of Wallpaper.

During this stage, it's important not to get bogged down trying to find the perfect song. Music selection is an ongoing process throughout the edit. You can move or delete songs entirely as the structure and story of an edit change. So just find something that has the right tone or feeling, and get ready to start cutting. In the second pass stage, we revisit music.

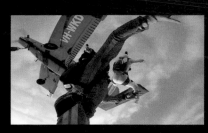

Human Flight – TV Commercial

Skydive with the Melbourne Skydive Centre in a one-of-a-kind heavenly descent currently airing on national TV. Shot on the HD HERO in 2011.

Filmers: Ossie Khan, Melbourne Skydive Centre
Editor: Jordan Miller

https://www.youtube.com/watch?v=swh_QwTZSk0

Las Vegas Grand Finale – Monster Energy Supercross 2011

What happens in Vegas gets recorded on GoPro and seen by millions. Once again, congrats to Ryan Sipes for winning the final shootout at Monster Energy Supercross 2011. Shot on the HD HERO in 2011.

Filmers: Bradford Schmidt, Travis Pynn, Kyle Camerer Editor: Jordan Miller

https://www.youtube.com/watch?v=qac-2TC3oDU

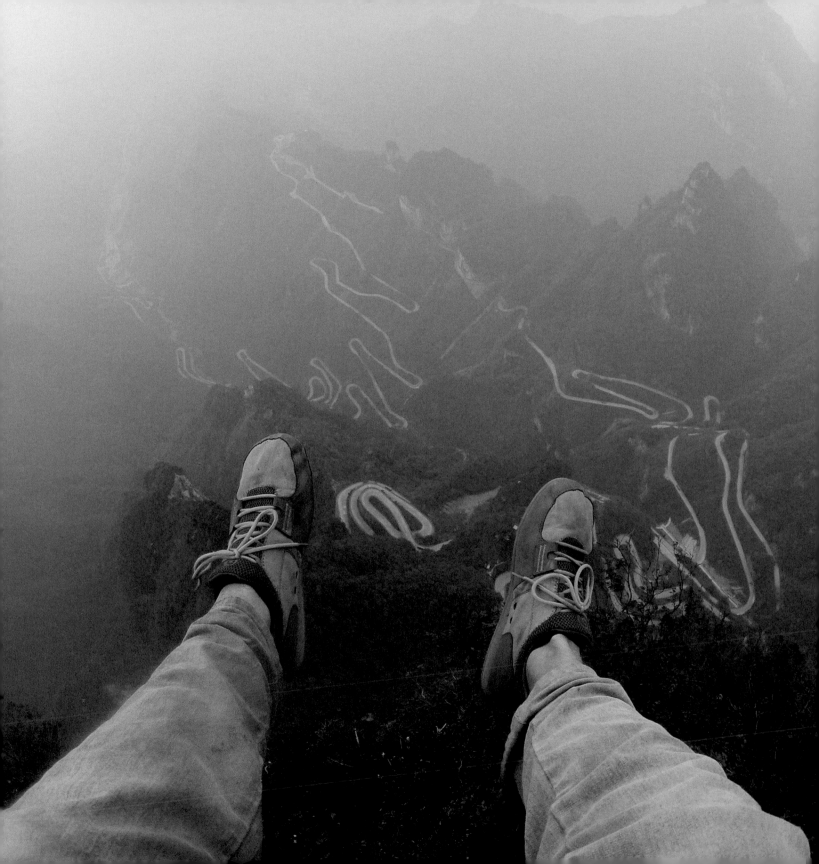

The Rough Cut

At last. You're ready to begin cutting. In the rough cut, the editor assembles sequences that connect the beats outlined in the paper cut. The rough cut stage focuses on the more mechanical facets of editing. This includes configuring the timeline, maintaining continuity, using different types of cuts, speed changes, time-lapses, and voiceover.

Just how you proceed is up to you. Different editors go about structuring their edits differently. Some start at the beginning and work sequentially. Others put together the climax sequence first, so they fully understand what they are building toward. Just get started and you'll naturally find the flow that works best.

Timeline Settings

Correctly configuring the timeline in your editing program is essential, and will ensure the highest possible image quality. The basic settings include:

- **Resolution:** While the GoPro shoots a number of different resolutions, you need to choose one for the timeline. Clips with the same resolution as the timeline's resolution will fit perfectly, while smaller resolutions will be scaled up and larger resolutions scaled down to best fit inside the timeline's player. A good rule of thumb is to set timeline resolution to the resolution of the intended playback device. If you are editing for web, 1920×1080 is a good choice for online video players such as YouTube and Vimeo. Since the HERO4 launch reel, we use a 4K timeline in Adobe Premiere, although this requires a top-of-the-line computer.

- **Frame rate/timebase:** Like resolution, frame rate should be set to the fps speed of the intended playback device. Set this to 29.97 fps if you are editing for web or for television broadcast in North America or parts of South America or Asia. Other options include 24, 23.98, and 25 fps (for European television broadcast or film).

- **Pixel aspect ratio:** This determines the shape of the pixels in the frame. GoPro shoots square pixels, so this should be set to Square.

- **Fields/field dominance:** This applies only to interlaced video, not to GoPro's progressive footage. This should be set to Off or No Fields.

- **Compressor/codec:** This tells the editing software how to decode the compression of your video files. If you've transcoded using GoPro Studio, set it to the GoPro Cineform 422 codec. If you're editing native video straight from the camera (such as in Premiere Pro), use the H.264 setting.

Jordan Miller / Tianmen, China Head Strap Photo/2sec

Continuity of Space and Time

The video experience is, in essence, a contract. Audience members agree to relinquish control over how they observe the world, in exchange for the video creator's deliverance of a coherent and meaningful experience. A good story ensures that a video will be meaningful. But how do you ensure the audience can make sense of what they are watching? *Continuity* describes the flowing, connected aspect of video. A single clip of a skier's helmet-cam is perfectly continuous. We stay in the same perspective from the top to the bottom of the mountain. The editor's primary tool, the cut, violates continuity. This isn't necessarily a bad thing. A sequence with many carefully made cuts can feel more real and continuous than a one-take shot. By introducing new perspectives, the editor can give the audience a wider sense of the world.

Continuity in space means that audience members have a good sense of a video's environment, and where characters are. One easy way to establish continuity in space is to begin a sequence with wide shots before cutting in closer to introduce the characters and action. This principle applies throughout a video. Any time a major environmental change occurs, the editor should take a moment to make sure the audience knows where they are. Continuity in time ensures that the audience can follow what is happening, especially between cuts. The most common way to maintain time continuity is to *match the action*, a technique discussed later in this chapter. Time continuity is also affected by light. Our perception of time is intrinsically related to the time of day and how it affects the quality of light. Cutting from a golden hour shot with dramatic shadows to a midday shot with flat light will break continuity for viewers and tell them that a sequence is manufactured.

In "Combing Valparaiso's Hills," continuity played a key role in sculpting the final video. The editor's rough cut bounces spatially from one location to the next: sometimes at the top of the hill, sometimes at the bottom, then back to the middle, with the time of day changing all the while. During the second pass, special attention was paid to continuity. Shots with similar location and lighting were grouped together and ordered. Although the footage was filmed over a week's time within very separate geographical locations in the city, the final version gives the impression of a smooth, seamless journey down the hill in a single day.

Aether Industries / Texas Weather Balloon Photo/.5sec

Rough Cut: Combing Valparaiso's Hills

The very first rough cut for Combing Valparaiso's Hills. Shot on the HERO3+ in 2013.

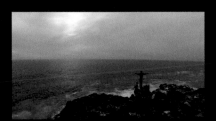

https://vimeo.com/
109965620

Director: Abe Kislevitz Producer: Yara Khakbaz
Crew: Caleb Farro, Kyle Camerer Editor: Gabriel Noguez

Final Cut: Combing Valparaiso's Hills

Aaron Chase, Brian Lopes, and Chris Van Dine get lost in a maze of colorful urban streets in this ode to Valparaiso, Chile. This is the final cut. Shot on the HERO3+ in 2013.

Director: Abe Kislevitz Producer: Yara Khakbaz
Crew: Caleb Farro, Kyle Camerer Editor: Gabriel Noguez

https://www.youtube.com/
watch?v=cN-YTcSnE6c

The Cut

By far the editor's greatest tool is the ability to cut, thereby breaking continuity of space and time. This tool should not be taken lightly. Ideally, every cut is purposeful: it serves some function that relates locally to its particular sequence, or globally to the overall structure of the edit.

There are plenty of reasons *not* to cut. Novice editors are often beholden to the idea that faster, more frequent cutting equals more excitement in video and thus badass editing. While this might be true in some contexts, it should never be a guiding principle. If a shot is crucial and best tells the story, the editor should have confidence in that shot, letting it breathe until the natural action within is complete. On the other hand, editors often try to include too much, especially if they've grown attached to what they've shot. It's better to let go of mediocre shots and repeated beats, using only the best imagery to tell the story, than to cram everything on the timeline simply because you filmed it.

When is a cut motivated and useful? When it shows the action better from a different angle, changes time or location to advance the story, removes nonessential or uninteresting footage to speed things up, shows something that is referenced or implied in the shot before (as in a cutaway), or conincides with major music cues. Music cues—including huge hits; changes in mood, tempo, or instrumentation; beginnings and ends of verses, choruses, and bridges—can serve as natural cutting points, especially in montages. The cut can also serve subtler, more artistic functions, such as juxtaposing two seemingly unrelated images to imply meaning or metaphor between them.

Bradford Schmidt / Hawaii ⚭ Handheld 📷 Photo/.5sec

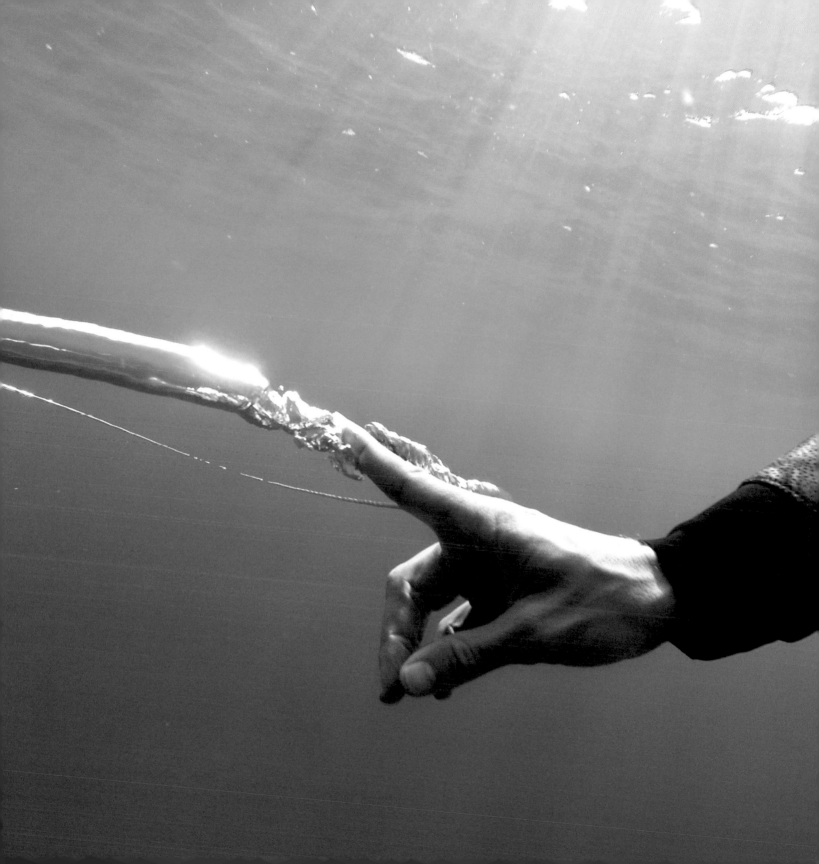

Action Cut

The *action cut* (traditionally called *match on action*) takes advantage of two different angles of the same action by cutting between them. Continuity between angles is maintained by the action of the subject and the setting itself. The added perspective lends depth to an otherwise straight-forward POV sequence.

Action cuts can occur before, during, or at the end of the action. For extreme sports, things happen so fast that it's best to overlap time and action between cuts, or even repeat the same action. This maintains continuity and extends the moment so the audience can fully enjoy it.

Good coverage while shooting will ensure the most flexibility with action cutting. The video "Skiing Cliff Jump with Jamie Pierre" is a useful example. Jamie Pierre rigged himself with multiple cameras on his chest, backpack, ski poles, and skis before dropping a massive cliff. The multitude of angles inspired the edit's silly over-the-top style and allowed us to action cut liberally to the music. It also helped to elongate Jamie's air time by replaying the cliff jump from multiple angles.

Skiing Cliff Jump with Jamie Pierre

Witness world-record holding extreme skier Jamie Pierre cliff huck from an unbelievable elevation. Shot on the HD HERO in 2011.

https://www.youtube.com/watch?v=f-oyjdZD-lY

Filmer: Jamie Pierre
Editor: Brandon Thompson

Match Cut

Action cuts are actually a specific form of the more general idea of *match cutting*. As its name implies, a match cut "matches" similarities between two shots. Match cuts create a flow that keeps the viewer engaged in the video even when cutting between very different times and locations. The similarities between shots may be subtle and only perceived on a subconscious level, giving the masterful match cut a surreal or hypnotic feel.

The filmstrip above shows frame grabs from a sequence in the HERO3 launch video, a product reel that relies heavily on match cutting to create a seamless interweaving of images. The sequence starting at 2:50 illustrates some of the most common elements for match cutting:

- **Composition:** POV arms diving to POV arms swimming underwater.

- **Motion:** Forward motion from bike wheel to running POV.

- **Texture:** Water spray to snow spray.

- **Color:** Underwater blue POV hands to underwater blue wave.

- **Wipe:** Water's surface wipes frame between POV diving shots.

The wipe is a special form of match cutting in which movement across the frame or obstruction of the lens is matched between shots. We use them often due to the interactive nature of GoPro. We fondly call them *portals*. Also, it's good to note that most editing programs include a cross-dissolve function. Bad cross dissolves are one of the hallmarks of novice editing. They work best when used to fuse shots that are already match cut; otherwise, it's best to avoid using them.

GoPro HERO3: Almost as Epic as the HERO3+

Athletes and adventurers from around the world come together for some never-before-seen moments in this product release reel for the HERO3 in 2012.

Directors: Nicholas Woodman, Bradford Schmidt
Producer: Yara Khakbaz Crew: GoPro Media
Editors: Abe Kislevitz, Jordan Miller, Sam Lazarus

https://www.youtube.com/watch?v=A3PDXmYoF5U

Jump Cut

With the *jump cut,* the same perspective is retained from shot to shot but the action jumps in time. A smooth jump cut will keep the difference between shots relatively minimal. Usually, the subject changes position while the background stays the same, or vice versa. GoPro mounted shots are especially easy to jump cut, as the mounting apparatus (helmet, bike frame, surfboard, what have you) provides a stable foreground against which both the subject and environment can change without disorienting the audience. This can be a good way to transition into new locations or incorporate shots from different locations into the same action sequence.

The primary use of jump cutting is to compress time. This is handy when a certain section unfolds too slowly or when shortening a sequence to hit a musical cue later on the timeline. As with all cuts, you can use a masterful jump cut to convey an idea. You can see a good use of this in the "'Misdirected Man,' by Hip Hatchet" video featured here. The final jump cut, made poignantly on the last pluck of strings, signals the video's end and takes the viewer back to the porch where it all began. The cut literally and symbolically "brings the viewer home," which is what his song is all about. In this case, a simple editing technique becomes poetry.

"Misdirected Man" by Hip Hatchet

Hip Hatchet (Philippe Bronchtein) plays a heartfelt acoustic version of "Misdirected Man," a song about home and what love means. Shot on the HERO3 in 2013.

https://www.youtube.com/watch?v=TFKyEyoCL54

Filmer: Jordan Miller
Editor: Gabriel Noguez

Rolex 24 at Daytona Teaser

The 50th anniversary of the Rolex 24 at Daytona showcases the world's best drivers competing for 24 hours on the 3.56-mile course. Shot on the HD HERO2 in 2012.

https://www.youtube.com/watch?v=KNf_wILZU04

Filmer: Patrick Barrett
Editor: Sam "The General" Lazarus

Smash Cut

The whole purpose of *smash cutting* is to draw attention to the cut. In this sense, it is the exact opposite of match cutting. The smash cut takes advantage of contrasting imagery, action, or sound to startle the audience. Smash cuts have many uses. They can serve a structural purpose, abruptly transitioning the video from one sequence to another. They can be used to emphasize the difference between two environments, such as shown in "Rolex 24 at Daytona Teaser," where abrupt shifts between tranquil scenery and roaring POV racing footage intensify the action. Smash cuts can also be used metaphorically, to underscore an idea that is present inside the story.

Cutaway and Crosscutting

A *cutaway* does just what it says: cuts away to another shot to show something implied or referenced in the first. In interviews, characters often discuss ideas or actions for which you have footage. A popular technique is to cut away from the interviewee to show what he or she is talking about as the interview audio carries on underneath.

Crosscutting is cutting from a shot or sequence to show a parallel shot or sequence. This is useful when you want to connect multiple ideas or stories simultaneously. In the featured video, the sequence starting at 2:30 shows aspiring surf grommet Lily Richards's interview with Roxy surfer Kelia Moniz. The edit crosscuts between the interview and sequences of both girls surfing and enjoying the water. Paired with the music and voiceover, these crosscuts symbolize Lily's dream, conveying to the audience her desire to grow up and be a cool pro surfer, just like Kelia.

Dreams with Kelia Moniz

Join Roxy surfer Kelia Moniz on a longboard session at the beautiful Waikiki Beach. Listen in as she shares her dreams and aspirations with lil' grommet surfer Lily Richards. Shot on the HD HERO in 2011.

Director: Bradford Schmidt Crew: Pete Hodgson, Atilla Jobbagyi
Editor: Brandon Thompson

https://www.youtube.com/watch?v=CSJPZ_DQooo

Time Manipulation

The manipulation of time is inherent in most forms of storytelling. In filmmaking, this manipulation is upfront and quite literal, and thus can be an extremely effective tool to use. Slow motion, fast motion, reverse motion, and speed ramping are all tools that editors can use to enhance a story. As with any editing technique, the use of time manipulation should be wise and deliberate.

Slow Motion

High frame rates are a mainstay for GoPro. Along with the wide lens, slow motion provided by the camera's high frame rates make the vast majority of POV footage watchable. You can use slow motion to highlight a particular trick or action, control pacing, elongate a video's climax, smooth out or reinforce changes in music tempo or quality, create time for text overlay or voiceover, stabilize shaky footage, and more. And, of course, there is the aesthetic. *Everything* looks good in slow motion.

Slow motion tends to work with certain activities more than others. The normal, fast motion of moto and auto footage is part of what makes racing videos so exciting. Here, you should generally avoid slow motion, except for key moments when things happen too fast, such as in collisions or crashes. The inherently slow pace of human flight makes slow motion unnecessary, although launches, landings, and intricate aerial maneuvers are good exceptions. Slower motion shines with bike, snow, surf, wake, skateboard, and just about any other sport where trick sequences play a major role.

Another great use for slow motion is footage stabilization. You can greatly smooth out shaky handheld, pole, drone, or POV footage by dropping the speed. The trade-off is a decrease in pacing, which may or may not be appropriate to the sequence you are cutting. In general, footage speed should match the music tempo and intensity, as well as the video's pacing.

Ski Flying with Anders Jacobsen

Ski jump training with Anders Jacobsen in Lillehammer, Norway. Shot on the HERO3+ in 2013.

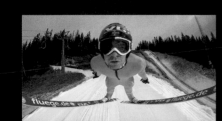

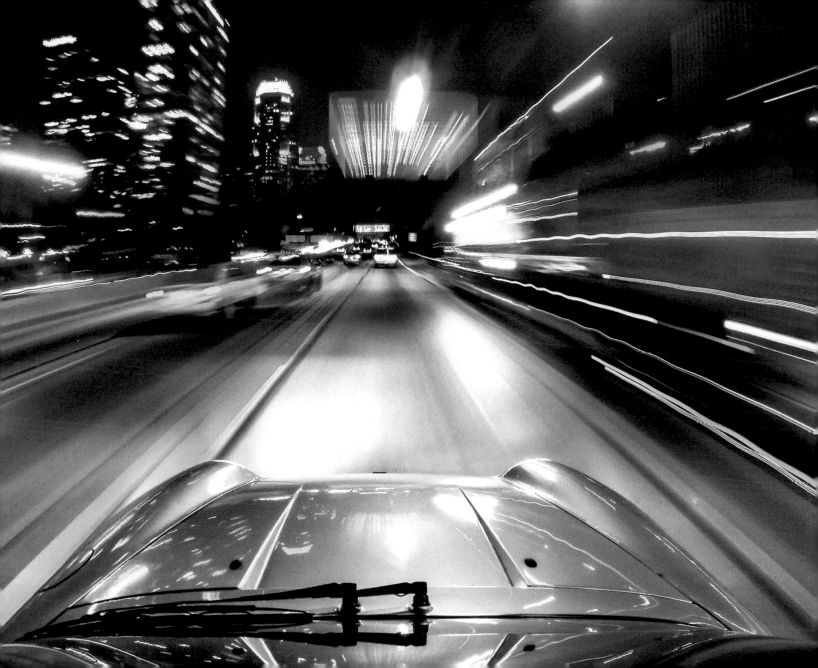

Motion Interpolation

Downconverting footage from capture frame rate to a lower playback frame rate, such as 24, 25, or 30 fps, will give you the maximum amount of slow motion for any clip inside a project. Trying to slow a clip beyond this point will cause the editing program to duplicate frames to occupy the extra space created. The duplicated frames cause visual "stairstepping," which looks awful. Using a motion interpolation program such as GoPro Studio's Flux allows you to drastically slow footage by calculating motion vectors of individual pixels between frames to create new, intermediate frames. This can result in a much slower effect that can simulate the slow motion produced by high-speed cameras of 1000 fps or more. Motion interpolation programs inevitably produce artifacting and warping, even more so the greater the distance between pixels in subsequent frames. You can find many tricks and tutorials online, but in general, shoot in 60 fps or above and avoid fast motion and complicated foregrounds/backgrounds to get the best results.

Speed Ramping

Speed ramping occurs when the speed of footage accelerates or decelerates, often unnoticed by the audience. It is best to understand speed ramping as a function before implementing it as a style. For POV footage especially, we often hide speed ramps in launches and landings of a jump to slow down time in the air and emphasize the athlete's weightless performance. When implemented correctly, speed ramping flows with the story rather than calling attention to itself in an obvious way. When used stylistically, speed ramping dramatically accelerates the audience into a climactic moment instead of just cutting to it. The change in speed is often rapid and paired with sound effects or big beats and rising/falling pitches in the music. Transitionally, a speed ramp to fast speed with a little bit of motion blur can "portal" or wipe from one setting to the next. Most editing programs have variable speed control built into them, so ramping can be as easy as keyframing a starting and ending speed. In the "Kelly F*cking Slater" video in this section, the editor displays functional and stylistic speed ramps. Slater's handheld camera was shaky at times, but the editor combined an epic track, text, and speed ramps into and out of slow motion to extract a great moment.

Kelly F*cking Slater

Kelly Slater, 11-time ASP World Champion, joins the GoPro team.
Shot on the HD HERO2 in 2012.

https://www.youtube.com/
watch?v=fjoF55NAo_c

Filmer: Kelly Slater
Editor: Sam "The General" Lazarus

Fast Motion

Just as slow time captures something we couldn't quite catch with our eyes at real speed, fast time reveals aspects of the world we wouldn't see otherwise. The most notable use of sped-up footage is to compress time, as in the example video of Ravi Fernando, "The Rubik Juggler." Even though Ravi's feat is amazing, it's doubtful the audience would sit through five-and-a-half minutes to see it. For POV or moving shots, accelerating footage works well with upbeat or fast music. Often, we use a little motion blur and a vignette to give the audience a sense of warping through time.

Reverse Motion

Reverse motion is a tricky technique to use well, as it calls attention to editing. Find the right place for a reverse, however, and the results can be very rewarding. The final shot in the featured video "Surfing with Mikey Bruneau" uses reverse time to great comical effect. Most often, reverse time is used functionally as opposed to stylistically. More than once, we have salvaged an important reveal in an establishing introduction where the smoothest part of a drone shot was the pull-back instead of the push-in. We simply reversed the footage, and voilà. In the same way, a reversed sunset time-lapse can give you the sunrise you didn't capture, or vice versa. Just be mindful of unnatural movements such as people walking backwards, objects defying gravity, and the like.

The Rubik Juggler

Ravi Fernando takes solving Rubik's Cubes to the next level!
Shot on the HD HERO2 in 2013.

Filmer: Ravi Fernando
Editor: Wes Nobles

https://www.youtube.com/
watch?v=bVTDgAUU_Ww

Surfing with Mikey Bruneau

Mikey Bruneau and his GoPro camera surf, bike, and fly in less than a minute.
Shot on the HD HERO in 2010.

Filmer: Mikey Bruneau
Editor: Mario Callejas

https://www.youtube.com/
watch?v=ix7aqvaE8FY

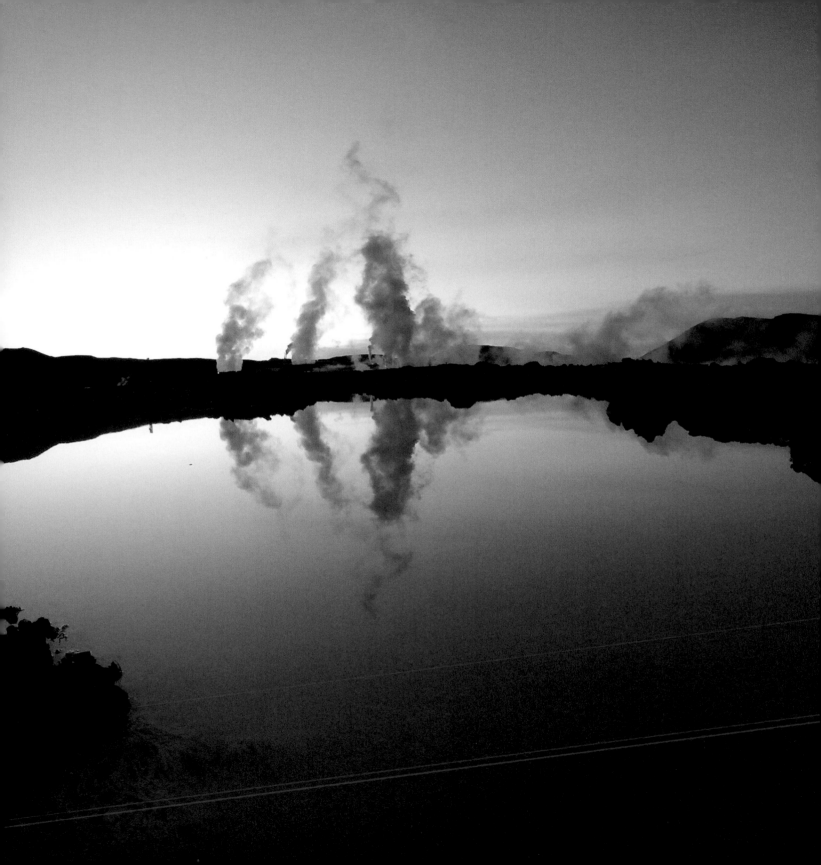

Time-lapses

Time-lapses on the editing timeline generally serve three functions: establishing, pacing, and passage of time. They are often seen in the beginning of a video or particular sequence, where they introduce an environment. They can be introduced at critical points in the edit to control a story's pacing. Finally, time-lapses convey time's passage and can be used to emphasize the amount of time between one event and another. The HD HERO2 reel, featured here, uses time-lapses to establish environments, both at the beginning and throughout the edit inside individual sequences.

GoPro Studio does an excellent job of processing time-lapses. The program gives users the option of downscaling photo time-lapses or leaving them at full resolution. Full size time-lapses are data heavy and require more rendering, but the extra resolution gives editors additional options. They can crop in to choose a frame, or even perform virtual camera movements such as pans and zooms. These movements can add a cinematic feel to an otherwise static or lackluster time-lapse. It's good to note that subtlety is key to techniques like these. A little bit of virtual camera movement goes a long way.

In low light conditions, photo time-lapses may require additional work in post-production. We use the denoiser in DaVinci Resolve or After Effects if noise is an issue. Because the camera is taking exposure readings at interval, flickering can sometimes be a problem In variable light conditions. We recommend using a deflickering plug-in to smooth out problem time-lapses.

Zak Shelhamer / Blue Lagoon, Iceland Tripod Photo/.5sec

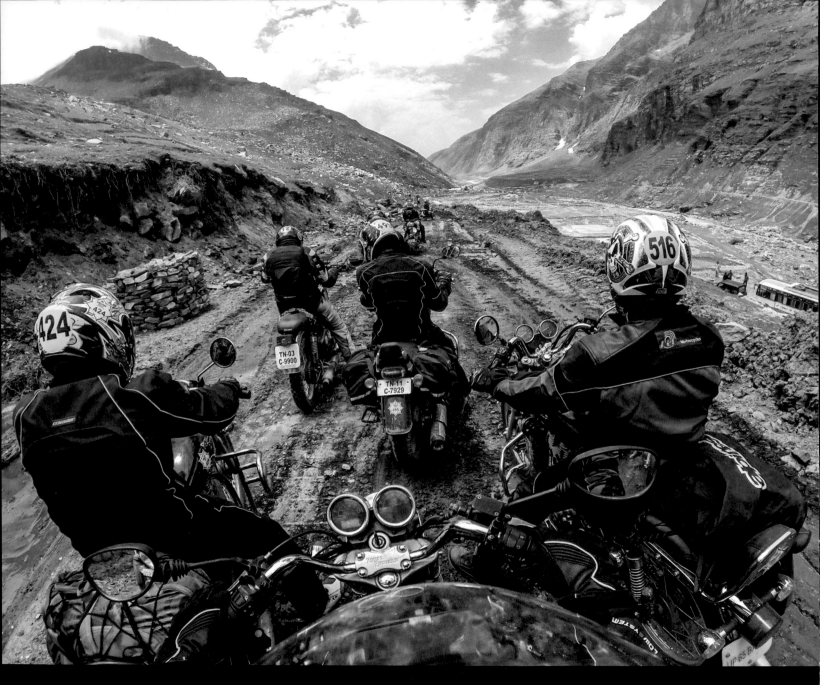

Ketan Kundargi / Khardung La, India Top Helmet Photo/.5sec

Interviews and Voiceover

Proper use of interview audio, sound bytes, and voiceover starts during the selects stage and influences the structure of the paper cut. Interview audio tracks are often very long. A good workflow is to import these tracks directly into your editor, create a new timeline, and listen through the newly imported audio, trimming the audio track so only those clips pertaining to the story remain. Most editing programs have a marker function that allows you to mark and label these newly selected clips so you can find them later.

A raw audio track will almost always need adjustment for pacing. Depending on the inherent speed of your edit, you will find people speaking slower or faster than you want to cut. Space out the line delivery to slow things down, or trim dead air in between sentences to speed things up.

We all tend to speak in a stuttered or roundabout manner. Filler words—uh, like, and you know—all sound natural in real life and when a character is onscreen. In voiceover, however, fillers tend to stand out, making the speaker seem more inarticulate than he or she may be. Chopping out the filler words ensures that the audience focuses on what's really important: the meaning of the words and accompanying imagery. Also, in interviews, ideas are often expressed circuitously and out of order. Don't be afraid to cut and reorder phrases if you are confident that doing so stays true to the character and what he or she meant to convey.

Interview audio and voiceover require quite a bit of audience attention. Be aware of how the audio is interacting with the images. If it feels too chaotic or busy, the action is probably too intense and the voiceover should be placed elsewhere. Otherwise, the audience will not be able to digest important information or beats in the story. Frequently, the rough cut has too much audio laid over the images and the second pass whittles these down to only the essential words. Once you start cutting a lot of interviews and voiceover, you will develop a sense of rhythm, of how the words and cuts can work together.

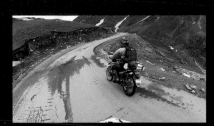

Himalayan 4,500 km Adventure

A story of a motocross racer who takes his less than experienced father on an incredible journey through the Himalayas. Shot on the HD HERO2 in 2012.

Filmer: Adam Riemann
Editor: Kyle Camerer

https://www.youtube.com/watch?v=Ui27fwRvfUU

The Second Pass

When you get to the *second pass,* you've finished the rough cut and are *deep* in the woods. You're probably a little cross-eyed and you've listened to the same music track so many times you could hum it in your sleep. Now is a good time to take a break. Step outside. The second pass stage requires objectivity. You'll review your structure and story flow, both by yourself and, more importantly, with others. Decide which beats work and which don't. Re-evaluate the music and start thinking about increasingly subtle dynamics, such as how the action, story, music, and cutting speed affect the edit's pace.

Peer Review

Most videos are passion projects. More than likely, you will spend long hours by yourself cutting, tweaking, and watching your edit over and over again. Sometimes it's easy to forget that your edit needs an audience—that your own vision, while important, matters only as much as it can be conveyed to others. This, after all, is the purpose of video, and perhaps of art itself.

Before you screen, make sure the story is complete and you aren't missing beats. The video should be watchable, but not perfect. Don't worry about seamless transitions or color. The review is about structure and communicating an idea with your story, not about little details that will be polished later.

Find someone you trust—someone who is familiar with the filmmaking process. Ideally this trusted person has created videos and understands what makes a good story. Once that person has seen the cut, you can ask questions such as:

- Do you know who the characters are and what they want?

- Do the sequences and beats lead to a climax?

- Is the ending earned?

- Does it feel as if the character has overcome something or learned something?

Now brace yourself. Remember: You are not your film. Your film should be personal, yes, but don't take responses to it personally. At the end of the day, if the audience hasn't realized something essential, then the artist isn't doing their job correctly. No amount of convincing the audience in person is going to make a video any better. Our advice is, be confident but open. What you will receive are only comments and suggestions. You know your film best.

Ryan Cheney / Bolinas, California ✉ Static Photo/.5sec

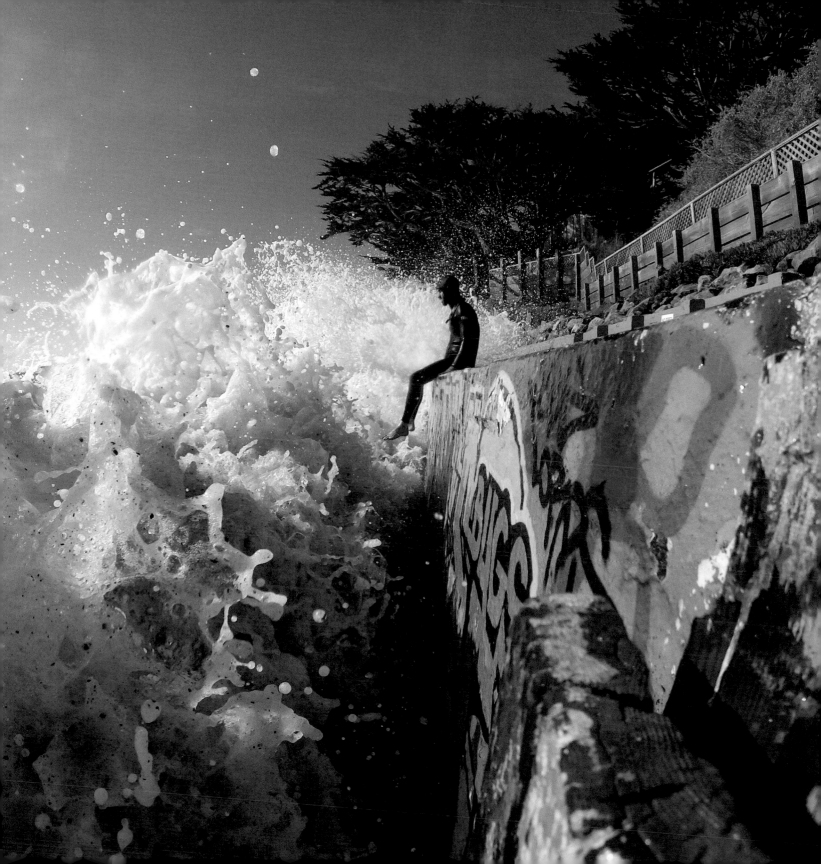

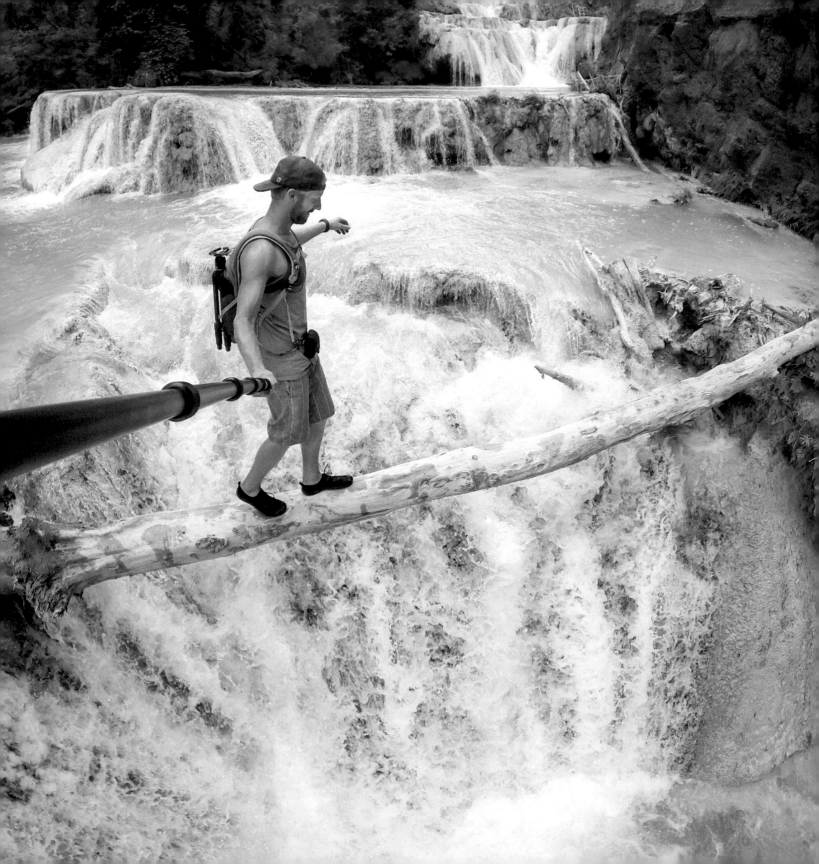

Pacing

The inherent intensity at any given point in a video is referred to as *pacing*. Many things contribute to pacing: frequency of cuts, the speed and intensity of action within the frame, music tempo and instrumentation, and much more.

In general, the pacing of a video should be smooth, increasing and decreasing gradually. Abrupt changes in pacing draw attention to the editor's work. Perhaps more importantly, the pacing should directly follow the story. As the characters encounter obstacles and tension mounts progressively through each beat, the pace of the video should gradually increase, until pacing reaches a maximum right before or during the climax. Of course, not every video rises directly in tension from beginning to climax. Rapid or discontinuous cuts, aggressive music, speed ramping, and other tools used to accelerate pacing have the side effect of fatiguing the audience. Over time, this can desensitize them to the very tension such tools are meant to create. This is why it is useful to stairstep the pacing somewhat, slowing down now and again to let the audience breathe before continuing onward and upward. In a story, these stairsteps often coincide with your beats.

The "Monster Energy Supercross Highlights" video featured in this section offers a phenomenal example of how acceleration in cutting speed affects the pacing of a sequence. The video opens with slow wide shots and the cuts quicken with the music and action. The cutting speed stairsteps once or twice before the final ascent. The video ends at the point of maximum tension, both musically and on the timeline, as the cuts are almost too fast for the eye to follow. The video is an event teaser, but the same principles apply to building toward beats and an eventual climax inside a story.

Once you've finished your first rough cut, rewatch the video with only pacing in mind. Keep some paper handy and note where the video feels slow and where it feels rushed. Are there places where you think the audience might be confused, overwhelmed, or on the verge of losing interest? If so, rework the problem sections and watch the video again.

Travis Burke Photography / Havasupai, Arizona Pole Photo/.5sec

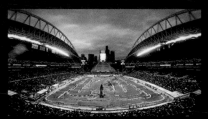

Monster Energy Supercross Highlights

GoPro presents the best HD HERO videoclips from the Supercross 2011 season.

Filmers: GoPro Media
Editor: Abe Kislevitz

https://www.youtube.com/
watch?v=Z2fejJhCt6Y

Music Redux

A common editing practice is to choose temporary tracks during the rough cut stage that may not be perfect, but still work emotionally and tonally. This is so the editor can start cutting the video without getting bogged down by music selection. Once the rough cut is finished, the editor can swap out temp tracks and start thinking more about how the music interacts with the images and affects the pacing and flow of a story.

Pacing and music are intimately related. As you adjust an edit for pacing and music during the second pass stage, you will start to see sections where the music stands out or feels out of sync with the video. There may be a number of reasons for this: the song is too fast or slow for the edit's action or cutting speed, the music volume is too high or low, music may not be necessary for the given sequence, or the music may be emotionally over-the-top for a given beat. A common pitfall is to use music too heavy handedly, hitting the audience over the head with an orchestral hammer when all they need is a minimal arrangement to tease out an emotion already inherent in the story.

Even at this stage, it's not too late to try something different. Used properly, music can breathe life into otherwise formulaic genres. The "Hangtown AMA Motocross" teaser in this section was initially edited to bagpipe music to be silly—but it created an idea association that stuck. You can't deny that dozens of motocross riders revving and slamming into each other as they jockey for position resembles something of a slowmo battle sequence straight out of *Braveheart*.

Lyrics can be tricky. The appropriateness of lyrics in music is dependent on narrative purpose. If the lyrics give insight into the characters, then by all means use the song. If they don't, then the music will probably just distract the audience from the story and characters. The "Sturgis: 110th Anniversary of Harley-Davidson" video featured here contains a poignant lyrical moment at 1:50, which provides emotional insight into one of the characters. The close-up of Chad Kagy's face shows that he is tired and hungover. The lyrics emphasize this bittersweet beat, and help convey the idea that Chad is homesick and lonely on the last leg to Sturgis.

http://youtu.be/
71PLvj2FzTM

Hangtown AMA Motocross

Motocross madmen battle it out at the first stop of this year's much anticipated Lucas Oil Motocross Championship. Be prepared for dirt, mud, oil, broken bones, revving engines, quivering throttles, and...bagpipes? Shot on the HD HERO in 2010.

Filmer and Editor: Bradford Schmidt

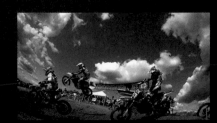

Sometimes you'll find that the music you chose in the paper cut stage isn't working for the story that has developed over the editing process. Perhaps the song is right for one beat but not another. Adding additional music tracks can help ensure that each beat of a story has the correct emotional tone. In "Danny MacAskill's Imaginate," the editor originally cut the entire piece to the brooding Lorn track featured at the end of the video. It felt too dark. During peer review, we temped in Saint-Saëns' *Aquarium* movement from *The Carnival of the Animals* and everyone gasped. We were all desperate to feel the magic of Danny's imagination. The piece was recut with a more evocative track for the beginning, with Lorn coming in after Danny falls off the bike, to introduce the consequence beat.

The marriage of music and images is one of the most important—and difficult—decisions the editor will face. You'll know when you've chosen the right track. The imagery and rhythm of the music flow together. The emotion emanating from each story beat is emphasized, but not forced, by the accompanying songs. Overall, the music should feel appropriate to the action, cutting speed, and emotion contained in each sequence.

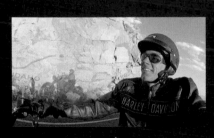

Sturgis: 110th Anniversary of Harley-Davidson

GoPro athletes Chad Kagy, Brian Lopes, Aaron Chase, Eric Jackson, and friends set out from Seattle, Washington, and make their way to Sturgis, South Dakota, on a 1400-mile cross-country journey on Harley-Davidson motorcycles. Shot on the HD HERO2 in 2012.

Director & Editor: Wes Nobles Producer: Aaron Huffman

https://www.youtube.com/
watch?v=_5ZPKY_Bp1I

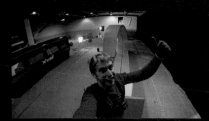

Danny MacAskill's Imaginate

Journey into the mind of Danny MacAskill as he plays on giant toys from his childhood imagination. Shot on the HERO3 in 2013.

Director & Editor: Kyle Camerer
Producer: Aaron Huffman

http://www.youtube.com/
watch?v=TB9edUeygUM

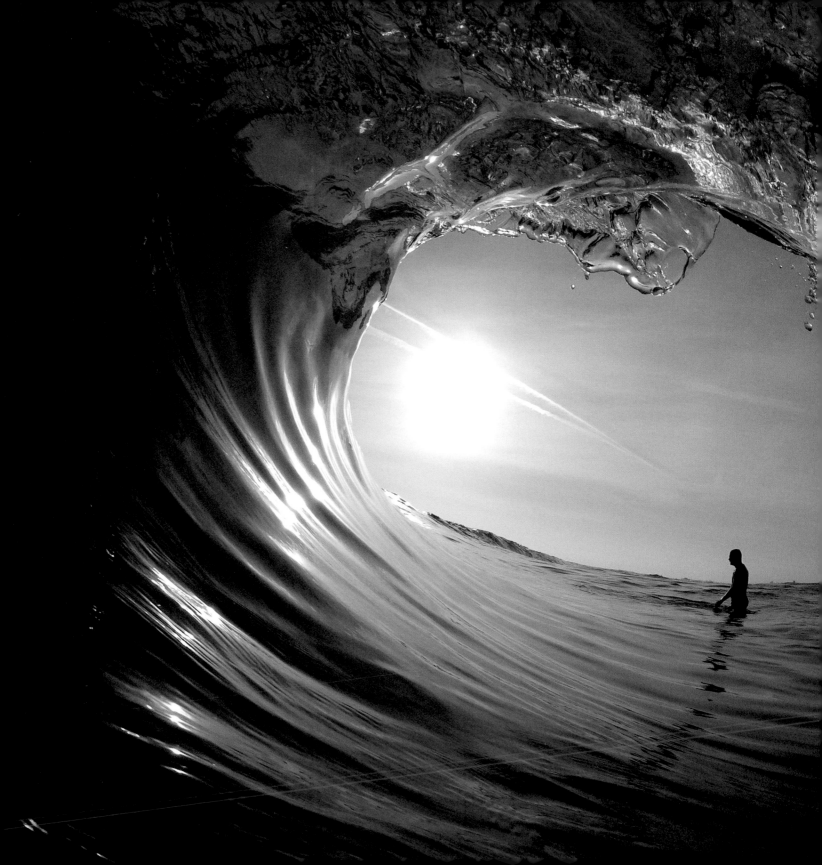

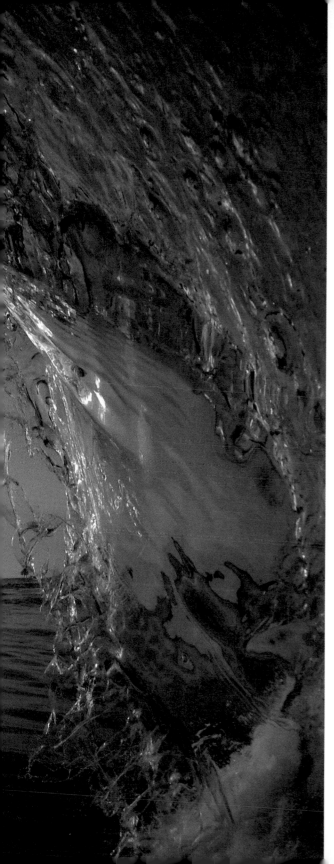

Final Pass

So you've listened to enough critique. You've wandered down a few rabbit holes and come out again. You've got a standout character. You've got music that flows. The story makes sense and everyone loves it. You've locked down a solid structure and finalized all the beats necessary to earn a climactic ending and a cathartic resolution.

Watch the edit a few more times. Feel out and massage each cut. Trim a few frames here, a few frames there. Be certain each shot is the best one for that particular sequence. Tighten it all up. This is your last chance to make the edit sing.

Because now...it's time to polish.

This can be hard. When you're impatient to release your video into the world, it takes a lot of discipline to buckle down and spend time working on what may seem like trivial details—things like color, sound, titles, and stretching. But these aspects aren't trivial. All these things add polish to a video and can be pivotal storytelling tools.

Spencer Rowe / Newport Beach, California Handheld Burst

Cropping and Stretching

Placing 4:3 aspect ratio footage on a 16:9 timeline will result in black bars on either side of the video. In the GoPro workflow, we usually leave the footage in this state until the final pass stage of an edit. During the earlier stages of editing, an editor's time is best spent on building the story rather than waiting around for image transformations to render.

The editor has two options for dealing with 4:3 footage: dynamic stretching or cropping. If you don't want to lose any pixels or important information at the top or bottom of the frame, dynamic stretching is the best option. In the media department, we generally employ a little bit of both cropping and stretching to gain a good balanced image.

Dynamic stretching first pulls the footage horizontally so it fills the 16:9 frame, then stretches the sides to retain proper proportions in the center. The stretch is usually applied more at the left and right sides of the image, where it is less likely to be noticed. In essence, the editor chooses a "protected" vertical area, stretching pixels inside the area less and those outside more. The area can be moved side to side and the width adjusted so that the best possible stretch is obtained. GoPro Studio offers dynamic stretching for GoPro clips. Andy's Elastic Aspect is another useful program that functions as a plug-in for editing software.

Cropping, on the other hand, enlarges the footage until the black bars disappear. In one sense, this defeats the purpose of shooting in 4:3 in the first place, as you lose those extra pixels you gained. However, it gives leeway in choosing the frame. You can slide the footage up or down to find the best part of the image, cropping out too much sky at the top, or cropping out the ground and mounting apparatus at the bottom of the frame. This principle extends to any image with greater resolution than the resolution setting of your timeline. You can use a good crop to focus audience attention on a particular object or area of the image, or get closer to a character's face to convey emotion in an interview. The editor can also keyframe image scaling and movement to create virtual pans and zooms over time. This can give otherwise static shots a dynamic and cinematic feel.

4:3 on 16:9 Timeline

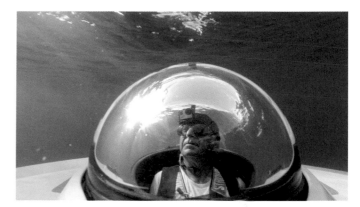

Cropped

Non-Dynamic Stretching

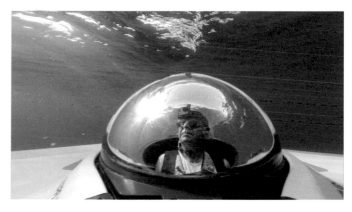

Dynamic Stretching

Graham Hawkes / Hawaii Adhesive Mount 1440p48

Sound

Editors have a tendency to focus so much on the visual that they overlook an equally crucial aspect of video: sound. Good audio can feel as real and visceral as any combination of imagery. It fully immerses an audience in the onscreen environment and helps them identify with a character by conveying that character's aural experience.

The time for working on sound is usually right after the editor has locked the visual cut. In this stage of editing, you focus on mixing raw camera audio, voiceover, and music levels; applying audio filters; and even adding sound effects to make the action onscreen more impactful.

Proper mixing of sound is crucial to making sure the audience understands the story. The viewer should be able to watch the video from start to finish without having to adjust the volume. If you find the volume varying too much within a certain clip, most editing programs have a pen tool for adjusting volume over time. Human speech should take precedence in the mix. While characters are speaking, adjust music and any other audio so the audience doesn't have to struggle to understand what is being said. Music levels can vary throughout an edit, depending on how integral the music is to what is happening onscreen. In quieter sections of a video, consider adding subtle background or ambient noise to keep the mix from feeling empty. The "Red Bull F1 Showrun" video featured here uses mixing as a stylistic and narrative tool, by juxtaposing ambient audio of quiet city streets with the roaring of F1 engines.

Many editing applications have filters to impact the way an audio track sounds. Using a hi-pass, low-pass, or bandpass filter can reduce the amplitude of undesired audio frequencies inside a clip, such as wind noise, traffic noise, or camera impacts. Reverb is another useful filter. It simulates the echoing of sound in larger spaces, and has many uses stylistic uses.

https://www.youtube.com/
watch?v=YffOSqT_TMY

Red Bull F1 Showrun Copenhagen
with David Coulthard

The people of Copenhagen get stoked hearing a roaring Formula One car up around the bend. This is one sight they did not expect to see! Shot on the HD HERO2 in 2012.

Filmers; Alex Hoerner, Christoph Hoerner Editor: Alex Hoerner

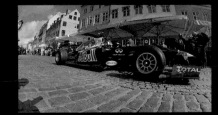

Often, the camera isn't in the best position to capture the best possible audio. Hollywood studios employ massive sound departments to create and mix all the sound effects in their movies. Why not take a page out of their book? You can record your own sound effects or find them online. There are many websites that act as open source audio archives. When using sound effects from these sites, make sure that you obtain permission from their owners, or that they are licensed for use in the public domain.

Motion Stabilization

Camera shake isn't always bad. Shakiness in perspective is a hallmark attribute of POV footage. Shake contributes to the authenticity and realism of what is happening onscreen. A fine line exists, however, beyond which too much shake will fatigue or even disorient the viewer.

Motion stabilizers have become a standard feature in many editing and visual effects programs. Motion stabilization works by analyzing the overall motion of an image and then compensating by cropping in and moving the entire image in the direction opposite the camera shake. These features work best when the shakiness is relatively minimal. They cannot correct for those times when the image itself becomes deformed by motion, such as with rolling shutter caused by high-frequency vibration.

Applying motion stabilization is time-consuming, so you should only use it to salvage shots that are crucial to sequences or a story. You won't want to apply it to every single clip on the timeline. There are easier, more efficient ways to get smooth video. It all starts in shooting. Using the appropriate mounts while filming does wonders, as does capturing multiple takes. Over the years, we've counted many YouTube comments debating whether GoPro uses secret in-camera stabilizers or overboard motion stabilization in videos. Not necessary. We simply mount cameras properly, shoot loads of footage, and then choose the best, shake-free clips for our videos.

Filming at high frame rates is another stabilization technique. It gives you the option to slow down footage, thus decreasing how shaky the video feels for the audience. Isolated shakes and jars can even be hidden in plain sight, so to speak, if they are paired with hits and beats in the music. This can add style and energy to an edit, although as a technique it's best used in moderation.

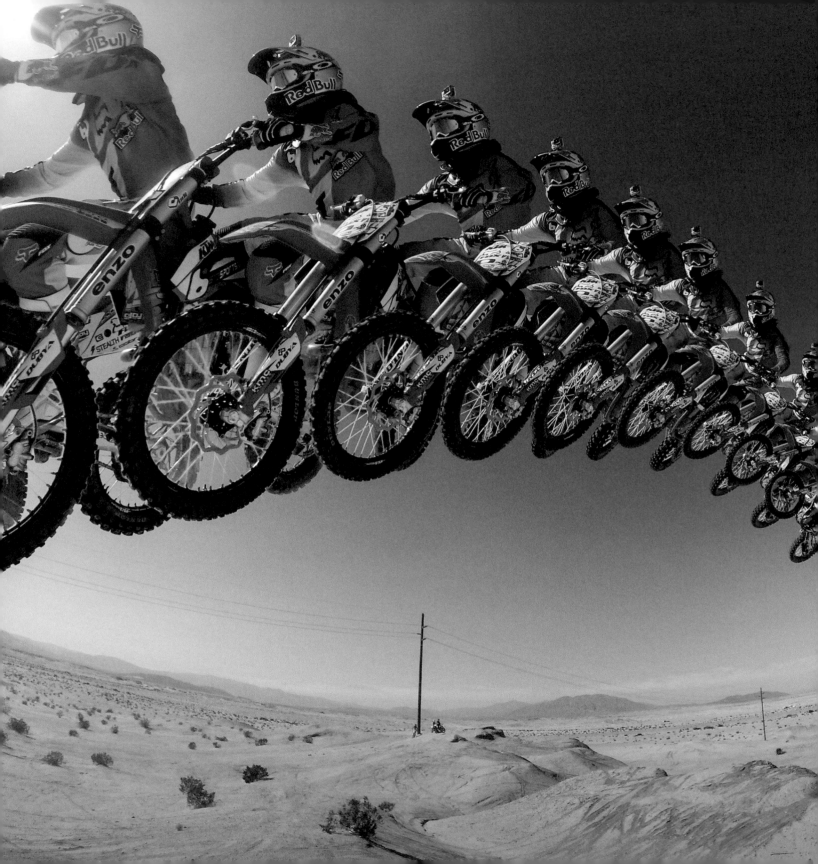

Graphics

In filmmaking, *graphics* refer to any text or effect overlaid on a video, or even used within it as a standalone sequence. Like all aspects of good video, graphics are used best when they blend naturally with the other elements of the edit and serve to create or enhance a story. For both text and graphics, After Effects is the program of choice for GoPro's media department.

Text is most often used to title a video, introduce characters, or explain to the audience something that cannot be conveyed otherwise (usually because the footage doesn't exist). We often deal with user-generated content where the shooter captured the middle part of the story and climax, but didn't get any introductory or ending footage. The easiest way to create context or a resolution for these pieces is to overlay a little paragraph of text that introduces the characters or explains the results of their story, as the situation requires.

Placement is crucial. In general, graphics should not obscure important actions taking place onscreen. A good understanding of alpha layers and the compositing modes used in your editing program will help you seamlessly integrate graphics over video images. Music and sound do wonders to integrate graphics as well, especially if they are cued to the effects taking place. The hardest thing with graphics is making them feel organic, so they do not draw the audience out of the video experience. There is a certain elegance in simplicity, and the best graphics are designed according to this principle. The featured video "Mind the Gap with Jesper Tjäder" uses simple text overlays, blurs, and a subtle keyframing of After Effect's Optics Compensation (a lens correction plug-in) to enhance the story without overshadowing it.

Graphics can quickly turn into the most time-consuming part of an edit, so it's best to plan ahead and know the particular effect you want to create. You can find hundreds of tutorials online that will walk you through creating almost any imaginable effect. Once you master a few effects, you'll find yourself combining them to produce novel effects. Experimentation is key. You'd be surprised how far you can get by just fiddling with something until it looks cool.

Wes Nobles, Ronnie Renner / Ocotillo Wells, California Tripod Burst

Mind the Gap with Jesper Tjäder

Jesper Tjäder sends a line that wasn't intended to be hit, a massive gap from one jump to another at the Nine Knights competition. Shot on the HERO3+ in 2014.

Filmer: Jesper Tjäder
Editor: Matt Cook

https://www.youtube.com/watch?v=0DioVNaipVI

227

Color Correction

Many videos are filmed over a number of days in different locations and lighting conditions, but the footage is edited together to present a story in which sequences take place in the same time and space. Audience members can be very aware of how the quality of light determines time and location, especially when differing clips are placed side by side. The primary job of the color corrector is to balance images so that differences in exposure and color don't break continuity for the audience.

Most editing programs have color correction modules for adjusting your images. At GoPro, we often use DaVinci Resolve, which offers a powerful free version available for anyone to download. It's a standalone application available for Windows or Mac. Color correction is a deep science, but the basics are easy to learn. You can achieve phenomenal results by adjusting two simple aspects of an image.

The first aspect is contrast. Adding contrast increases the range of brightness in an image by darkening the shadows and lightening the highlights. While working with contrast, we recommend using a waveform to make sure you don't push the shadows or highlights too far, resulting in clipping and a loss of definition.

The second aspect of an image to adjust is color balance. This refers to adjusting the overall hue of the image. Shots filmed at sunset can be overly red or orange. Overcast shots are often a little blue. Water scatters red light, so anything filmed at more than a few feet underwater will be bluish-green. Color balancing all of these shots can make them look more natural, and is done by adding opposing colors into the image. Many color correction applications have a dropper tool that adjusts color balance automatically.

As you work with color, you'll get an idea for its many uses. We often use subtle vignettes to focus the viewer's eye on what is important in frame. You can use color stylistically to create a tone, look, and feel for a video. In the "Our Orangutan Brethren" video described in Chapter 6, we wanted to convey to the audience the effects of palm oil production on the orangutan habitat. The section of jungle we filmed was destroyed over a year before we got there, but had since turned green with small plant growth. Using masks and selective color in DaVinci Resolve, we were able to recreate what the area looked like right after it had been slashed and burned.

Bradford Schmidt / Sumatra, Indonesia Tripod Photo/2sec

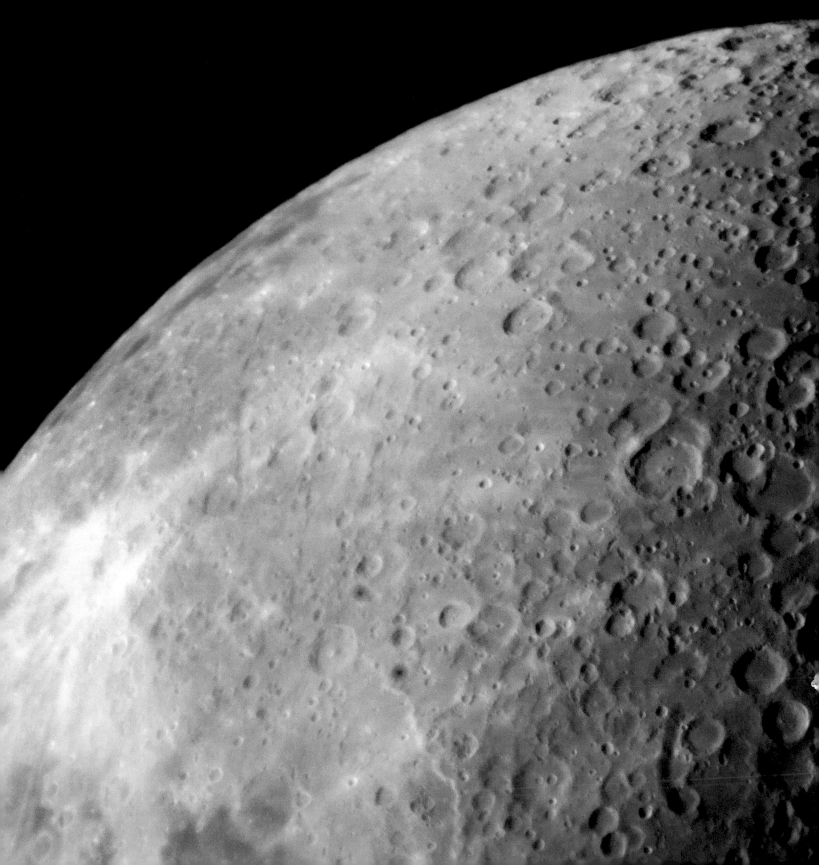

Editing and post-production in general are all about working within constraints—the availability of footage, music, time limits, and so on. Your storytelling will always be limited in some sense. Learning to embrace limitations can make you more creative as an artist and push your work to new levels.

The unique combination of light, sound, and language in video makes for infinite possibilities in storytelling. The techniques presented in this chapter are best practices that, when employed correctly, create stories. They can turn a day of shooting into a polished edit, a mountain of raw footage into a concise and well-told tale, and an aimless montage into a powerful and immersive experience that carries meaning for more than just the individual creator.

These techniques are only guiding principles. They are a base, a frame of reference from which experienced artists can strike out in entirely new directions... bending the rules, breaking them, and inventing new rules of their own.

Wes Nobles / Daly City, California GoPro + Telescope Photo/.5sec

Story Analysis

GOOD STORYTELLING INVITES THE AUDIENCE to take part. It involves them. It asks them to be invested—to be emotionally wrapped up in the story. How does this happen? The filmmaker presents a problem or puzzle that the characters and the viewers themselves must solve: $a + b + c = ?$

How involved viewers become depends on how artfully they are led toward the conclusion. If the answer is just on the tip of their tongue when it is finally revealed, then you've won them over. If the answer is too obvious or too opaque, then don't count on the audience sticking around for the conclusion.

This makes the moment when you let your story out into the world a daunting one. As the creator, you are not there to modulate the viewer's experience: why a certain shot is shaky or poorly framed, why a particular cut was made, or why the narrative feels vague or confusing. The story now stands on its own. Once your art has been released to the audience, it is now theirs. Their interpretation and understanding are as true as your own.

The filmmaker controls how the audience responds to the video through the various tools at his or her disposal. Proper planning, mounting, shooting, editing, and all the tools presented so far in this book are part of the filmmaker's arsenal. In this chapter, we present examples of how GoPro has used all these tools to tell complete stories. Whether or not you think these are great stories, the process of analysis is important to storytelling.

Justin Jenny / Huntington Gorge, Vermont ☕ Tripod 📷 30sec Exposure, ISO 800

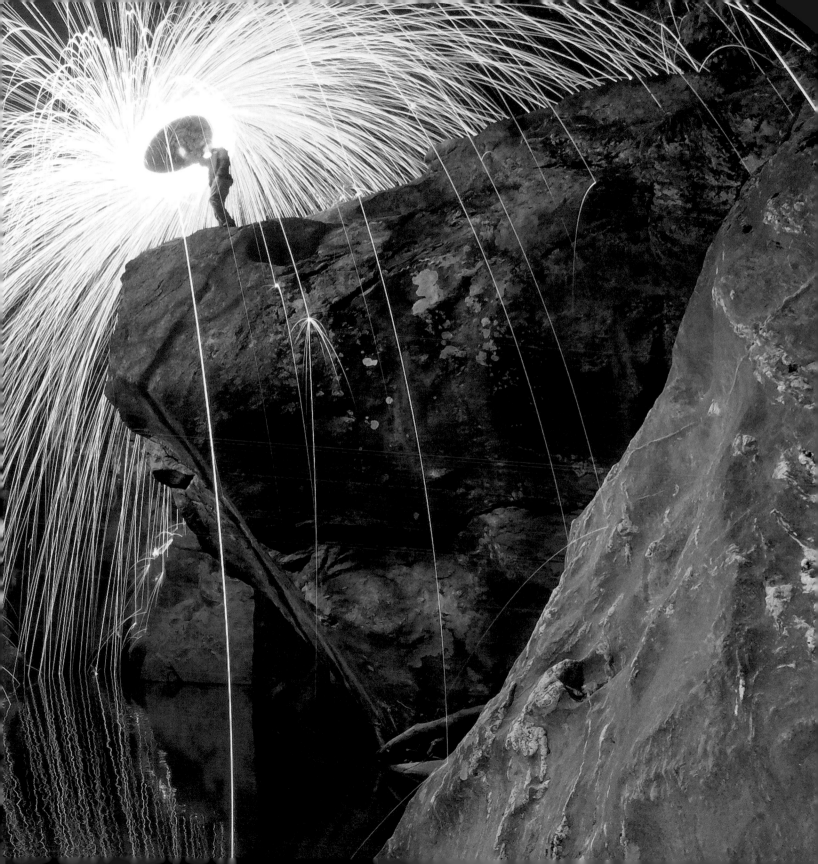

The Moment

Not every project needs to be a big story piece. We often handle content from users who may not have had a sprawling, epic story in mind while shooting. These GoPro edits tend to be short pieces, in which the filmer has captured something that is spectacular, unusual, funny, touching, or virtuosic. At GoPro's office, we define videos like these as *moments*.

Moments can consist of one-take shots or several shots cut together. They are short and sweet. Each shot is impactful and every second matters. A moment can go on as long as the audience's attention is held, but the most natural length seems to be between one and two minutes long. Ending the video at the point of maximum engagement leaves the audience hungry for more.

Moments, like any story, have a *beginning, middle,* and *end* structure. The jellyfish video featured here was shot by one of our users. Production artist Tyler Johnson edited the moment and, in the rough cut phase, nailed the beginning and middle beats. However, the video ended while the girl was still swimming through the jellies. It was beautiful and flowed well, but the moment didn't feel complete because nothing else really *happened*. Tyler went back into the footage for the second pass and found the clip where the girl reached out and held one of the jellyfish. The human connection to that magical world gave the moment completion and was the perfect ending beat.

Jeb Corliss / Jellyfish Lake, Palau Handheld Photo/.5sec


Lost in Jellyfish Lake

Nana Trongratanawong is surrounded by millions of golden jellyfish during a freedive at Jellyfish Lake, Palau. Shot on the HERO3 in 2013.

https://www.youtube.com/watch?v=Fv7j_KSanEk

Filmer: Nana Trongratanawong
Editor: Tyler Johnson

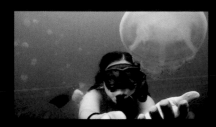


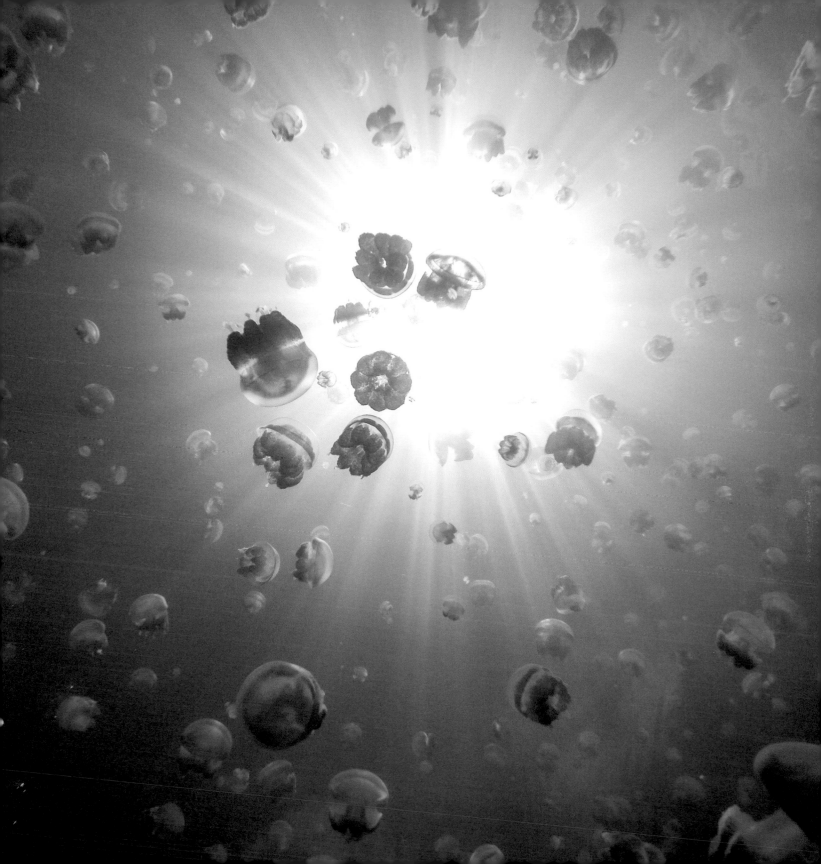

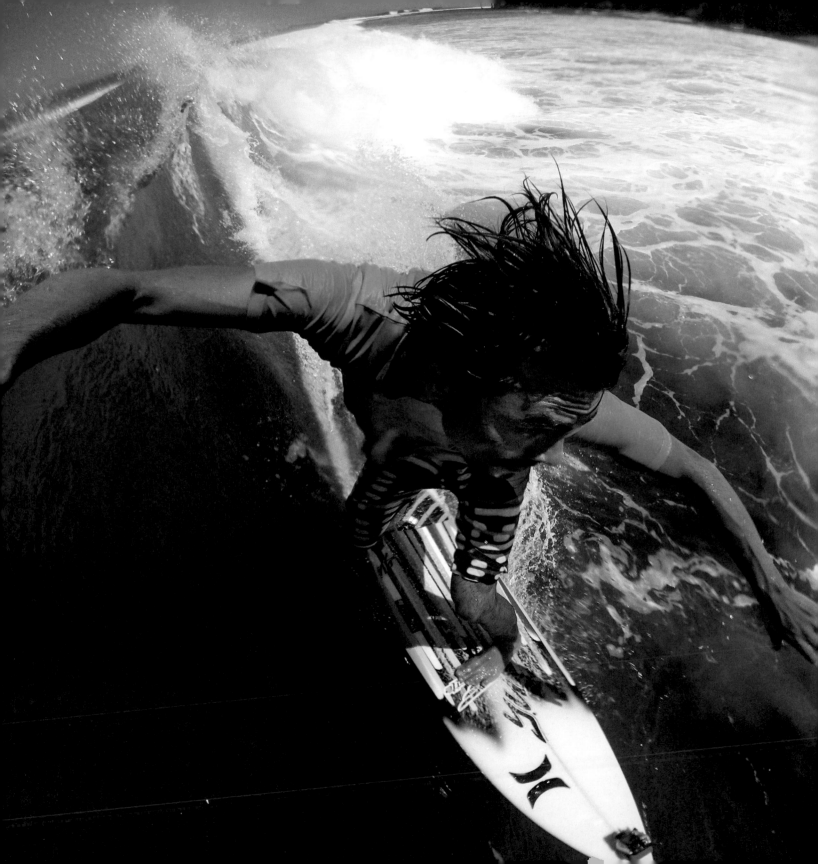

The Montage

In all of GoPro's product release reels, from the HD HERO2 to the HERO4, story takes a backseat to the powerful synthesis of action, music, controlled pacing, and smooth transitions. The *montage* hypnotizes the viewer with a seemingly unending stream of images. Rather than presenting a single story, a number of adventures are woven together to tell a larger story of human achievement and experience. And while the video may feel structureless, it's not. A basic structure introduces the characters and environments so that the audience never feels lost and one moment flows smoothly into the next.

For a product release montage, editors tend to group shots into several different categories.

- Introductory shots introduce the characters and their environments.

- Gear-up shots show the characters getting ready, whether they are literally putting on gear or traveling toward their environmental obstacle.

- Action shots show the characters conquering inherent obstacles or danger.

- Reaction shots capture the characters in moments of genuine reaction to their triumph. These tend to be smiles, celebrations, and expressions of gratitude toward life or nature. Reactions form crucial interludes between action sequences. They give the video a sense of continual reprise or return to center and work well as the video's resolution.

Perhaps the most challenging aspect of the montage is pacing. Both music and cutting speed control the edit's pace, with cutting speed increasing as the music builds toward each climax. Individual shots and action cut sequences should be long enough that the audience fully understands where they are and what they are watching, yet short enough that the momentum isn't slowed down. Here, discontinuity in time and space serves as an asset, causing the audience to constantly anticipate what's next. The relentless crosscuts keep the viewer from ascribing too much importance to any one sequence, instead producing a greater sense of awe at the mind-boggling scope of human endeavor.

Marlon Gerber / Sumatra, Indonesia 3-Way Extension Arm Photo/.5sec

Hero3+ Black Edition: Smaller, lighter, mightier still.

This is the HERO3+ product release reel created by the media team at GoPro in 2013.

Directors: Nicholas Woodman, Bradford Schmidt
Producer: Yara Khakbaz Editors: Jordan Miller, Abe Kislevitz

https://www.youtube.com/
watch?v=3wbvpOIIBQA

Character Study

At times—by charisma, antagonism, or sheer outrageousness—a character will eclipse traditional dramatic structure and carry a piece on his or her own. There are no hard lines here. Often, an in-depth exploration will reveal within the character those tensions and obstacles necessary for dramatic structure. Many story pieces are also great character pieces, and vice versa.

The "Leah Dawson 'Slow Down'" video is a magical character piece. Dawson shot the surfing sequences during her travels and recorded the song on her rooftop at home. Structurally, Leah's song both implies an obstacle (the pace of modern life) and offers a solution (slow down) for the audience to think about.

Another of our favorite character studies is "See You Tomorrow." Kelly Slater is arguably one of the best athletes in the world, and a somewhat mystical character. The kickball game shows Slater's childlike curiosity and excitement for the small meaningful moments in life. It also symbolizes another game that has been a part of Slater's life for many years: the ASP World Tour. He's an 11-time world-champion surfer, currently besting athletes half his age, who weren't even born when he won his first world title. Slater grins at the ageless turtle and is seemingly ageless himself, a better athlete than ever at 40 years old. The end line "See you tomorrow," represents what Slater is innocently telling the audience. No matter who's the world champ this year, he'll be back.

All of this may seem subtle—and it is. But viewers can only take away what is poured into a piece. Any piece of art retains inherent meaning from the amount of thought and emotion put into it by the creator. An audience may not always consciously recognize it, but they feel it.

Shane Dorian, Kelly Slater / South Pacific 3-Way Extension Arm Photo/.5sec

Leah Dawson "Slow Down"

Leah Dawson believes that if we empower our viewers with positive content, the world will be a happier, healthier place. We couldn't agree more. Shot on the HD HERO2 in 2011.

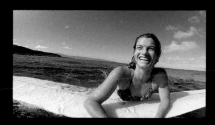

https://www.youtube.com/watch?v=O5FayNvJrqU

Filmer: Jordan Miller
Editor: Jordan Miller

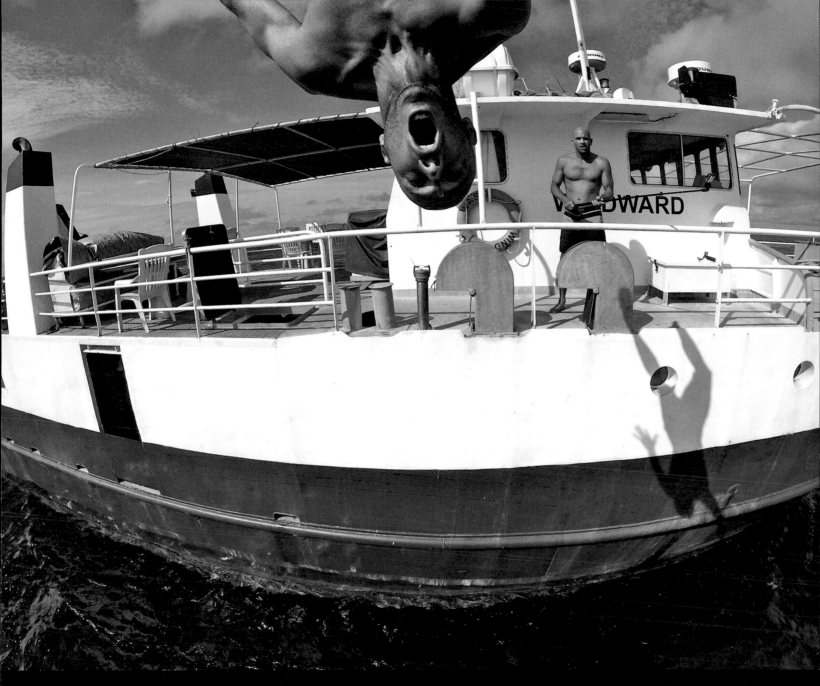

Kelly Slater Presents: See You Tomorrow

Kickball, anyone? Kelly Slater takes us beyond the waves and shares a more intimate portrait of the daily life of the world's greatest surfer. Shot on the HD HERO2 in 2012.

Filmer: Kelly Slater
Editor: Sam "The General" Lazarus

https://www.youtube.com/watch?v=cou3-IGFnQU

Power Intro

The *power intro* is a unique way to create and motivate a story. It creates a frame where the action of the edit can take place and gives that action structure. Here, GoPro Senior Production Artist Abe Kislevitz uses a *Mission Impossible*–style intro to present the obstacle of capturing epic photos for the HD HERO2 product release. The intro is flashy and polished, and, most importantly, it informs the action for the rest of the edit.

Post-production additions such as graphics can reshape videos entirely. There is an industry saying that is often uttered on productions when something goes wrong: "We'll fix it in post." The power intro takes this saying quite literally. We use this structure often at GoPro: It's a fun way to give depth and add story to a run-of-the-mill action sports montage. It can also be used to link together footage from different characters or locations, as can be seen in the Travel Montage structure presented later in this chapter.

The power intro provides the perfect opportunity to experiment with visual effects. For the beginner, designing and sustaining quality graphics over a short intro is easier than doing so for an entire edit. Kislevitz did all the visual effects work for the featured video "Mt. Hood Snow Photo Expedition" in After Effects and then augmented it with a number of other techniques, including sound effects, voiceover, music cueing, and audio filters. Extra touches like these do wonders to integrate graphics into a video and make them feel believable for the audience.

Tom Wallisch / Mount Hood, Oregon 3-Way Extension Arm Photo/.5sec

Mt. Hood Snow Photo Expedition

Three of the raddest snow athletes, Tom Wallisch, Tim Humphreys, and Tucker Perkins, team up with GoPro to capture the most cutting-edge POV photography. Shot on the HD HERO2 in 2011.

https://www.youtube.com/watch?v=ce488XpZsE4

Director and Editor: Abe Kislevitz Producer: Yara Khakbaz
Crew: Mario Callejas, Kris Jamieson

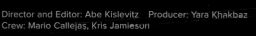

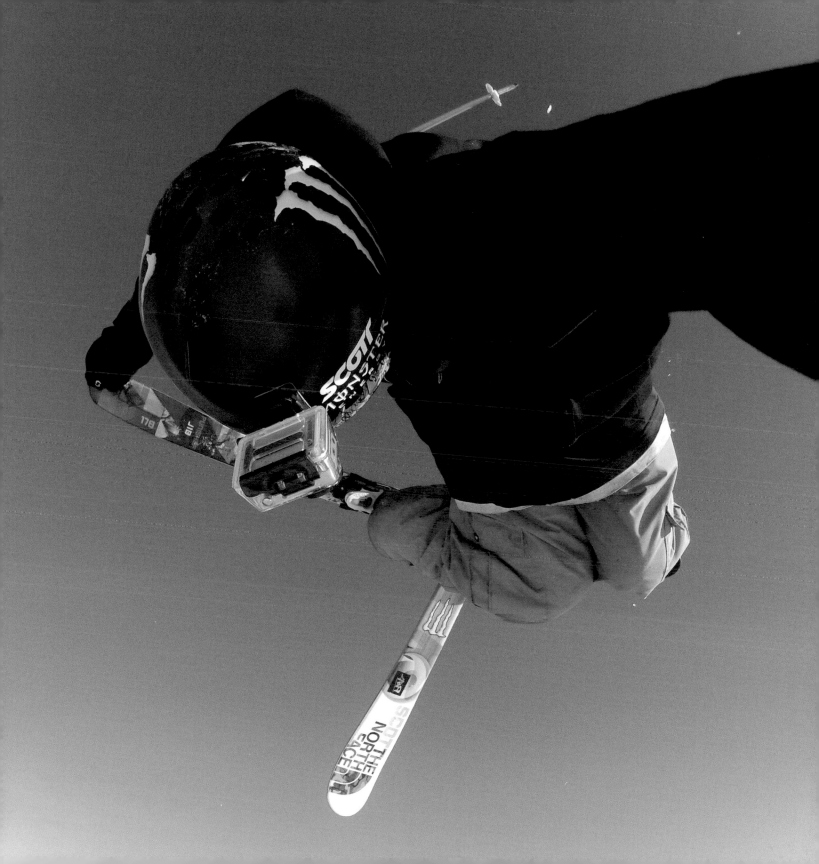

Baptism By Fire – Vegas To Reno
With Nick Woodman

Nicholas Woodman competes in the 2013 General Tire Vegas to Reno
desert race. 24 hours and 540 miles of the longest offroad race in America.
Getting there (or not) is all the fun. Shot on the HERO3+ in 2013

Director: James Kirkham Producer: Jaci Pastore
Crew: Rod Rojas Editor: Patrick Barrett

https://www.youtube.com/
watch?v=5MYmeWHxtJg

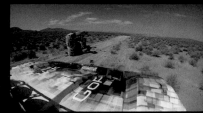

The Race

By its very nature, a race story has the structure built in. In this section, we feature two races with GoPro CEO Nicholas Woodman. The "Nick Woodman at Laguna Seca" video is straightforward POV coverage. The actual race was 20 or 30 laps long, but the editor selected and combined the most exciting parts to make the race feel like one or two seamless laps.

Stories in this genre often center around the character of the racer, whose great obstacle is to win the race. But what happens when the racer doesn't finish, or even loses? This is when storycrafting gets interesting because the story must be about something other than winning.

The "Baptism By Fire - Vegas To Reno With Nick Woodman" video is a great example of how to combine or rearrange certain sections of a race to create a better narrative flow, while remaining true to the spirit of a piece. Production artist Pat Barrett's rough cut was properly sequential. Pit stop 1 arrived, then pit stop 2, and so forth, each with an interaction and insight into Nick and Dave, the two characters. In the second pass, we took more liberties, rearranging the character interactions and pit stops. These character interactions, rather than any particular mile marker or pit stop, became the beats of the story. The memorable exchange about paying to take a shit—and Dave's maniacal laughter—actually occurred early in the race. But moving it to right after the final breakdown and Nick's perilous wounding earns the moment and connects the two characters. While the narrative may not be 100% chronologically accurate, it's right on target emotionally. When we showed Nick the edit months later, he couldn't recall that anything was out of place chronologically. Emotional truths can trump chronological facts, even to the characters who experienced them.

Nicholas Woodman / Vegas to Reno, Nevada　 Pole Extension　 Photo/.5sec

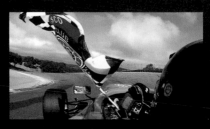

Nick Woodman at Laguna Seca

GoPro CEO Nick Woodman battles around Mazda Raceway Laguna Seca during an SCCA Regional race weekend in his Formula 1000. Shot on the HD HERO2 in 2012.

Filmer: Nicholas Woodman
Editor: James Kirkham

https://www.youtube.com/
watch?v=xU3q43audxY

Athlete Sections

In 2010, GoPro was still a small company that most people had never heard of. We showed up at the Post Office Bike Jam in Aptos, California, and rigged up anyone who would wear our funny-looking little camera. Our equipment elicited skeptical looks from the crowd: long poles rigged with prototype 3D housings, experimental seatpost and bike frame mounts, and an extended gnar-whal off the front of Aaron Chase's helmet. The results paid off, though. Afterwards the athletes watched incredulously and laughed at the new perspectives we'd captured.

We include this video as a nod to the classic action sports formula we grew up watching. Story-wise, not much directorial planning is needed for a video like this. Shooters capture plenty of coverage, while the editor introduces the characters individually and gives them their own action sequences. We tried to equally distribute the sequences with the best tricks and angles to keep viewers invested just when they might be on the verge of tuning out. The face shots and funny moments with the athletes break the action-induced hypnosis and give the viewer a second to breathe between sequences.

Overall, the combination of never-before-seen shots and a catchy music track made the "2010 Post Office Bike Jam" video a benchmark for GoPro and the first of our videos to hit one million views.

2010 Post Office Bike Jam

Each year after Sea Otter, the world's best freestyle riders gather at a jump park outside the U.S. Post Office in Aptos, California. Shot on the HD HERO in 2010.

https://www.youtube.com/watch?v=4aJzYioSDi4

Filmers: Bradford Schmidt, Justin Fierro, Steve Borgic
Editor: Brandon Thompson

Shaun White's Birth of a Board

Check out the life cycle of Shaun White's Burton snowboard, all the way from the factory in Burlington, Vermont, to the slopes of Northstar in Lake Tahoe, California. Shot on the HERO3 in 2012.

https://www.youtube.com/watch?v=NAG52cfSh2Y

Filmers: Hart Houston, Abe Kislevitz
Editor: Hart Houston

Bookends

Bookends refer to beginning and ending a video with the same or similar shot—a useful technique in dramatic storytelling. Probably the most common use of bookends features a character returning to the physical location where the story began. For the viewers, this can be especially satisfying if they feel like they've traveled somewhere and learned something before returning "home" again.

The original inspiration for the "Shaun White's Birth of a Board" video came from the opening titles of the film *Lord of War*, when the audience follows a bullet from its manufacturing process until it's fired from a gun in a war. Our video follows a snowboard from its origin as a tree in the forest to a finished product that White rides. We were having a hard time finding a natural ending in the editing room when it hit us: bookend it where we started! We called White and asked him to take a run and lean the board up against a tree to mirror the opening shot. Sometimes reshooting during the rough cut stage can give you the missing piece that pulls the puzzle of an edit together.

The Intermission

The *intermission* is particularly useful in breaking up action footage. Music and action cutting have a tendency to put viewers in a kind of trance. An intermission can break the trance and command attention. You can use an intermission in various ways, including communicating character insight, introducing music transitions, juxtaposing environments, or giving consequence to an action (such as a crash). An abrupt or discontinuous intermission can also serve a thematic purpose. By shedding light on previously presented characters, you can often dispel viewers' preconceived notions.

During the rough cut of the "Alana and Monyca Surfing Hawaii" video, we felt the piece was becoming just another action montage. During production, Alana Blanchard and Monyca Byrne-Wickey wore chest-mounted cameras for hours while shopping around town. The editor dug back into the raws to find funny moments of the girls singing and shopping. He cut those together in a staccato intermission that broke up the montage and gave the audience a glimpse into the day-to-day life of two model surfer girls.

Alana and Monyca Surfing Hawaii

Alana Blanchard and Monyca Byrne-Wickey show us what a ton of fun in Hawaii looks like. Shot on the HD HERO2 in 2011.

Filmers: Bradford Schmidt, Travis Pynn
Editor: Sam "The General" Lazarus

https://www.youtube.com/
watch?v=PaahUogxMow

Travel Montage

What do you do when you have a lot of footage from a lot of different places? One of the simplest ways to use everything in a cohesive manner is to give the audience a tour. Keeping characters constant while cutting to different times and locations maintains continuity and lets the audience feel as if they are traveling alongside them.

Creating a framework and thread that the audience can follow helps the sequences work together. The "Jamie Sterling Big Wave World Champion 2011" video uses graphics and geography to link many disparate locations around the world. Each section could potentially be a short little web episode on its own, but the editor uses a framework to tie them all together. The video "A Year with Andy Mac" employs a slide motif and Andy Macdonald's constant chatting to move through the adventure. This video showcases a great use of teasers to hook the audience and features a nice bookend. We begin and end at Bucky Lasek's Backyard Bowl, with Macdonald giving us a positive message and hope for a new year. Intuitively, this conveys one of the most rewarding things about traveling: eventually you return home. You return to the same place, but you are not the same person. The experience has transformed you.

Rhys Lawrey / Dunhuang, China Handheld Photo/2sec

A Year with Andy Mac

Take a trip around the world with Andy Macdonald as he skates through Colorado, California, Denmark, India, and South Africa. Shot on the HD HERO in 2011.

https://www.youtube.com/watch?v=qHaSxkmUDtY

Filmer: Andy Mac
Editor: Davis Paul

Jamie Sterling Big Wave World Champion 2011

Chase monster waves with Jamie Sterling on an epic international journey that culminates in his 2011 Big Wave World Championship. Get your trunks, board, and passport out and join him. Shot on the HD HERO.

https://www.youtube.com/watch?v=Z1RlihA8Xq0

Filmer: Jamie Sterling
Editor: Brandon Thompson

The Journey

The *journey* is a classic adventure film structure. It is like a travel montage, but with a more clearly defined beginning and end, fewer locations, and a major emphasis on storytelling. GoPro is a real asset for filming these projects: the camera's unobtrusive nature and long recording time allow adventurers to film interactions in a more intimate and authentic way.

A mountain biking piece such as "Lost in Peru" is an especially natural fit for this structure. The piece was an orphan edit for a while: gigs upon gigs of unorganized footage passed around to various editors who tried to create a narrative flow. Finally, we decided to start at the top of the mountain and journey toward the bottom, structuring the theme and lessons learned along the way.

The introductory beat is the arrival in Cuzco and establishes the characters. We didn't have many over-the-top, death-defying feats in the footage, so we grouped together all the steep, dark, cloudy shots and anything featuring ruins or cliffs. Because this was filmed over weeks on multiple mountains, we let the rocky paths and some color correction pull the disparate locations together. When Ali Goulet and Aaron Chase talk about the consequences of a fall, the trail starts to feel dangerous and threatening—enough to make viewers lean forward in their seats. This made the mountain itself the obstacle.

The middle beat, starting at 2:20, comes as the mountain's grade flattens out. Though it may seem like a random intermission, the mini-store beat is essential because it shows the first awkward engagement between the main characters and the local people. When you're first traveling abroad,

Rough Cut: Lost in Peru

This is one of the original rough cuts for GoPro's "Lost in Peru" edit. Shot on the HD HERO in 2011.

https://vimeo.com/
109965647

Filmers: Aaron Chase, Chris Van Dine, Ali Goulet
Editor: GoPro Media

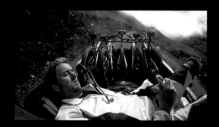

Final Cut: Lost in Peru

Join Ali Goulet, Chris Van Dine, and Aaron Chase as they explore a foreign land on an epic trip around Peru. Shot on the HD HERO in 2011.

https://www.youtube.com/
watch?v=qoYTDv85fDA

Filmers: Aaron Chase, Chris Van Dine, Ali Goulet
Editor: Davis Paul

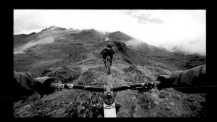

the environment and indigenous people can feel intimidating and scary. But when you've established a connection, you quickly realize that the world is a good-hearted place filled with curious people just like yourself. As the characters connect with the local children onscreen, the clouds lift and the sun comes out. The trail is now friendly and welcoming. If the edit started off with this footage, the story would not have felt emotionally progressive for the audience. The new structure shows the characters learning something about themselves and the culture—which should be the true purpose of the journey, not just shredding some new line.

The subsequent climax has been earned and sums up literally what was only hinted at before. At a local school, the characters are able to give back in their small way to the people and culture, empowering those who have empowered them. The difference between the rough and final cuts is huge. The audience members probably won't grasp all the beats on the first viewing, but they'll feel the change in narrative flow. That's the beauty of structure and story. Make every second and every shot count in the stories you tell.

The Sequel

Once you shoot successfully in a location, you'll find yourself wanting to return there. This can create new challenges for the storyteller. How do you tell a story with the same characters, action, and location without repeating yourself?

The "Still Lost in Peru" video features Chris Van Dine, Aaron Chase, and Ali Goulet returning to Peru with friends for another biking trek. The edit presented difficulties due to the similarity of the content. The first rough cut was a 15-minute montage containing basically the same journey as the original Peru edit, including another final beat with the same children at the same school. For the second pass, the editor dove back into the raw footage and found a conflict between two of the main characters. This became the new obstacle. We reworked the major beats and began the sequel where the original story left off. This allowed the original theme to grow, from foreigners learning inside a new culture in the original video, to traveling friends working together and learning from each other in the sequel.

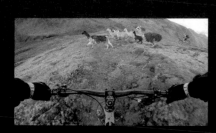

Still Lost in Peru

Aaron Chase gets lost in Peru again with Chris Van Dine, Ali Goulet, Katie Holden, and Rich Van Every. Shot on the HERO3+ in 2014.

Filmers: Aaron Chase, Chris Van Dine, Ali Goulet, Katie Holden, Rich Van Every
Editor: Justin Whiting

https://www.youtube.com/
watch?v=HG1jJCU1SLA

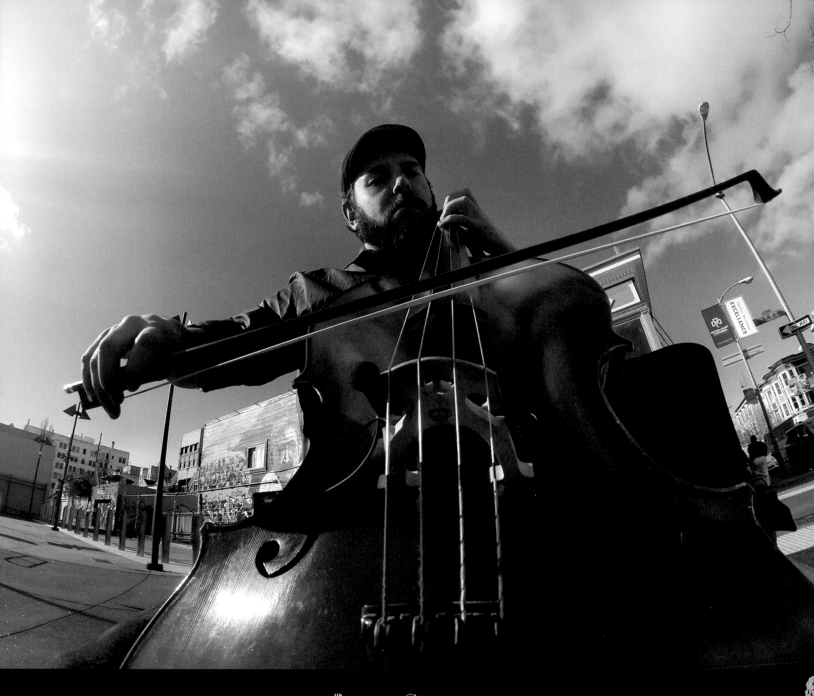

Charly Akert, The Family Crest / San Francisco, California 🎸 Jaws Mount 📷 Photo/.5sec

Music Video

One reason music works so well with narrative is that well-crafted songs and stories have many similarities. They both contain well-defined sections that give them structure. They are paced so that they rise in tension. They introduce ideas or themes that are often revisited or expanded upon later. And songs and stories can elicit powerful emotion in an audience.

"The Family Crest" walks through a modern band's typical day as the band members generate enthusiasm for a newly released album. It was a great collaboration because both GoPro and The Family Crest were born in the San Francisco Bay Area, which is the video's location. The band's label, Tender Loving Empire, has longtime been a musical collaborator with GoPro's media department. We also used an instrumental version of the song featured in this video for our HERO3+ product reel.

In the video, the song's structure gives natural boundaries to each sequence. The first verse introduces us to the band and various environments. The first chorus coincides with the band playing in its practice space. In the second verse, the band takes photos and creates flyers. The second chorus hits as the band takes to the streets, playing live shows and distributing flyers for an upcoming performance. A quick bridge reminds us where we've been and where we're headed. The last and most triumphant chorus drops as the band plays its album release show on stage at the Great American Music Hall. The whole edit has built toward this moment. The music plays for a little longer as a series of recaps reminds us of the journey we have been on. Then, the images cut out as the last chorus ends.

The music video is a format that many of us have seen since childhood. It's a popular genre, simply because it works so well. And while a lot can be gained from a strictly "action cut" music piece, we believe that the best and most memorable music videos have story and structure built into them.

The Family Crest

Journey from the streets of San Francisco to the famed walls of the Great American Music Hall with orchestral rock band The Family Crest. Shot on the HERO3+ in 2014.

Director: Jordan Miller Producer: Jaci Pastore
Crew: Evan Arnold Editor: Gabriel Noguez

https://www.youtube.com/watch?v=NJI-TGP3Hr8

The Surreal

The "Director's Cut - Shark Riders" video was originally a product release video for the HD HERO2's flat lens dive housing. We spent a lot of time formulating the building blocks of the story on-site. Each night, we logged footage to see what worked and what didn't. Then we discussed which beats we wanted to film the next day.

The first few days were spent listening to Healey and Mancino, and we noted their similarities and differences. From our conversations, a few common themes emerged: their tendency to seek spiritual experiences inside of nature, their fearlessness and fascination with predatory underwater animals, and their lack of trust in other human beings. Overall, we saw a story about two people who had an easier time connecting with nature than with other humans.

The Bahamian locations provided ample imagery, with sunken planes and ships that were great subtext for the two characters—one a bird, the other a fish, both moving through the story trying to connect with each other.

The introduction dives into the underwater world as both Healey and Mancino explore the surreal depths alone. They abruptly meet amidst shallow wreckage and part ways distrustfully. The shipwreck footage starting at 2:40 shows a spooky visual embodiment of the internal fear both independent characters need to overcome in order to make a connection. The surreal sequences, including Healey's happy place in the pool and Mancino's chase with the fake shark head, project their idealized worlds to extremes within an already dream-like reality. The two characters finally connect by riding a tiger shark, thus bringing together their mutual need to connect with each other through nature. The final shot bookends the introduction with an ascension back into the sky, calling attention to the existential question "What is real and what is a dream?"

For this video, post-production was scheduled for a week, which was a little optimistic. The surreal version ended up being a little too heady for a product release video, so we cut a simplified version and released the director's cut eight months later. If you look closely at Healey's pool scene, you can see both of this book's authors, one floating on an inflatable mattress, the other wearing a cowboy hat and deftly cleaning the pool with a long-handled skimmer.

Director's Cut – Shark Riders

The director's cut dives deeper into the world of a bird and a fish, Roberta Mancino and Mark Healey, respectively. This story was collaboratively created in the Bahamas over five days, capturing more than 150 hours of footage. Shot on the HD HERO2 in 2012.

https://www.youtube.com/watch?v=bj5ufMLKYhk

Director: Bradford Schmidt Producers: Yara Khakbaz, Whitney McGraw
Crew: Travis Pynn, Andy and Emma Casagrande Editor: Brandon Thompson

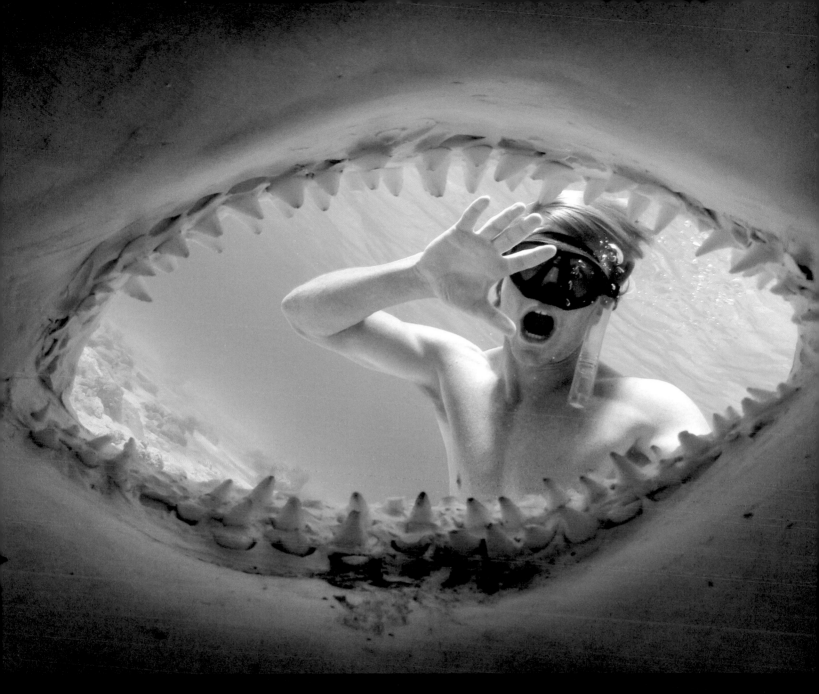

Mark Healey / Grand Bahama Island, Bahamas Shark Mouth Photo/.5sec

The End Is the Beginning

Concerning the rough cut, editor Gabriel Noguez said it best: "Your first draft should show your boldest ideas." His rough cut of "Combing Valparaiso's Hills" did just this. The opening scene boldly introduced Chris Van Dine, and his raw conversation with Aaron Chase lent gravity to the forthcoming feat and worked as an incredible hook. As a filmmaker, it's good to note that one of the best ways to make your audience root for the protagonist is to have another character tell the protagonist they can't do something. Such a side character, who challenges or empowers the protagonist, is often called a *foil*.

Nevertheless, that rough cut stumped us for weeks. We had a badass soundtrack, loads of footage, and nearly three minutes of introduction. So, what next? The raw moment between Van Dine and Chase worked great as an introduction, but the truth is that it was the only real climax or resolution in the footage. We tried making the plaza at the bottom of the hill the climax, and while the connection with the local culture was nice, it always felt flat for a climactic moment. So we decided to keep the climax and resolution where it was and make *the ending the beginning*. It was a fun little nod to Tarantino or *Memento,* giving the whole edit a cyclical, samsaric feel. The last scene ends right where the introduction began. You get back to the top of the hill, the music drops, and you find yourself exactly where you started.

Combing Valparaiso's Hills

Aaron Chase, Brian Lopes, and Chris Van Dine get lost in a maze of colorful urban streets. This is an ode to Valparaiso, Chile. Shot on the HERO3+ in 2013.

https://www.youtube.com/
watch?v=cN-YTcSnE6c

Director: Abe Kislevitz Producer: Yara Khakbaz
Crew: Caleb Farro, Kyle Camerer Editor: Gabriel Noguez

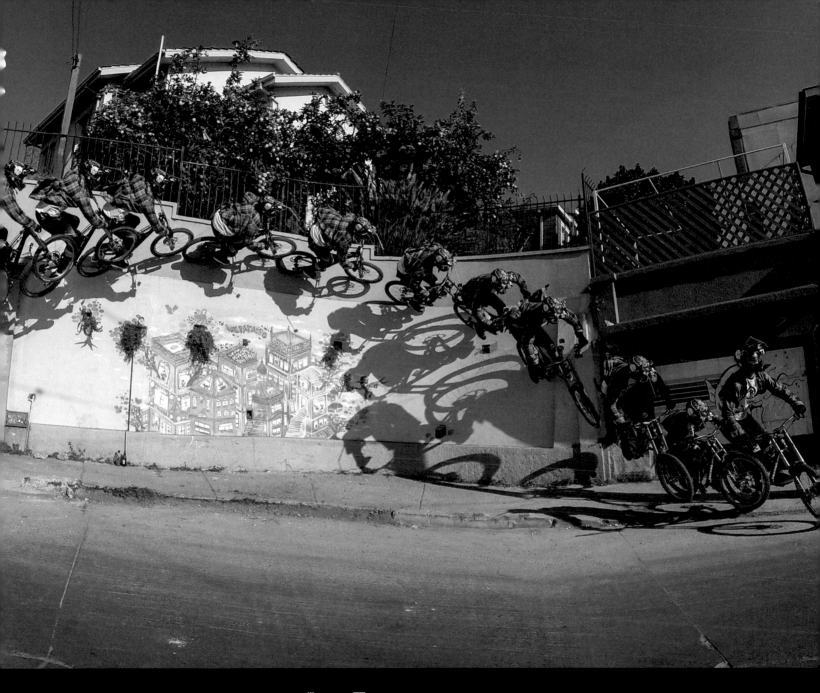

The Inner Conflict

Falling into the default mode of action sports cutting is easy while editing GoPro footage. Pick a cool song, throw in some face shots for the intro, line up your action sequences, and just cut cut cut to the beat. But sometimes when you're focused on reproducing what feels familiar, you miss a chance to tell a unique story. Gavin Beschen's story was one we didn't want to let slip past us.

From the time we spent with Beschen and from watching the footage he sent us, a few things stood out. Though he was from San Clemente, he seemed to have put that chapter of his life behind him. Clearly, he'd moved to Hawaii to get away from the madness of California and his past there. He also seemed to have a special fondness for growing things, including trees and plants. He was creating a green utopia in his own backyard. Finally, he was raising a family and cared about them very much.

A story began to emerge. We started to see Beschen as a gardener, a man who had put the past behind him, gotten a piece of land, settled down, and worked on creating a world to grow things in. One of the things he was growing was his little girl, Marley, nurturing her but also protecting her from the outside world. It was a beautiful story, with deeper undertones concerning time, age, and what it might mean to bring a child into the world.

A common way to use music is to create tension with a brooding song and then bring on the more evocative, soaring tracks as the tension resolves. For this edit, we tried something a little different. We paired three music tracks with the three main "characters." A "dark side" version of Beschen, representing his past, is paired with a song from Black Moth Super Rainbow. A "light side" version of Gavin, the gardener, plays the ukulele. His daughter, Marley, is paired with the Magnificat, the Song of Mary. When the three characters finally collide in the edit's climax, their individual songs come together, creating a strange harmony. This technique manifests musically what the story tells us literally and emotionally.

Gavin Beschen, Pete Hodgson / Oahu, Hawaii Tail Extension Photo/.5sec

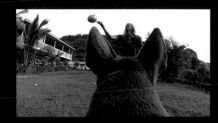

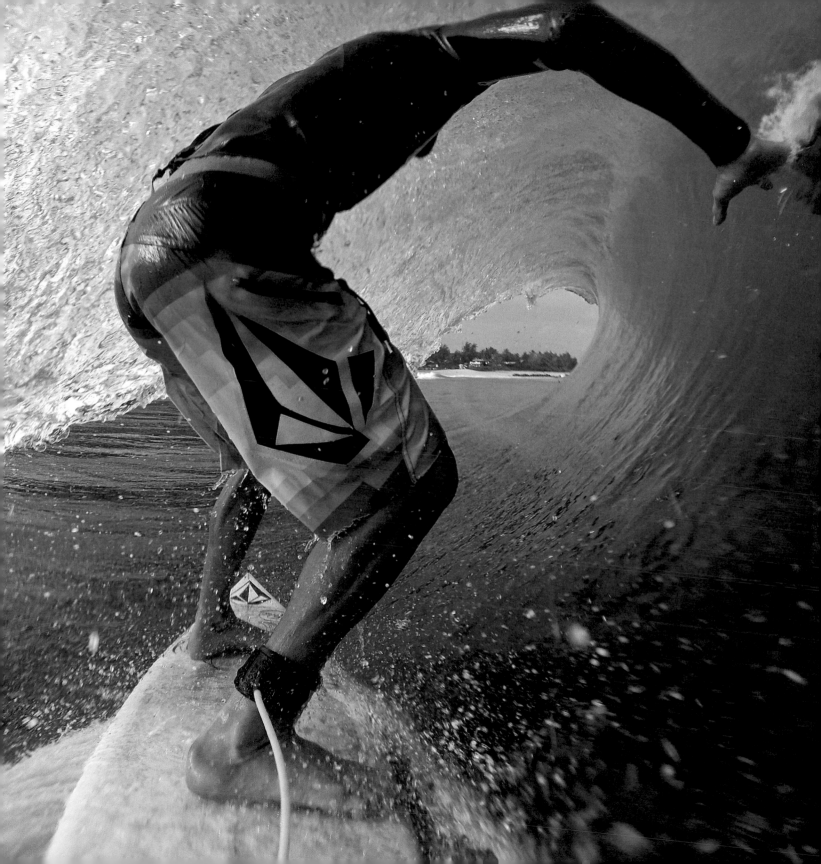

The Cause

Films and documentaries involving *causes* can be tricky. The filmmaker wants to paint an urgent picture about the problem, but the audience will turn away if that picture becomes too bleak or preachy. You have to inspire the audience to reassess their own lives or take action, without making them feel guilty or descend into despair. Most importantly, you have to make the audience care.

The opening scene from "Lions - The New Endangered Species?" was our first encounter with the naturalist Kevin Richardson and two lions, Meg and Amy. We decided that involving the crew showed the sense of wonder and danger they experienced as it actually happened. Richardson's easy interaction with the lions tended to lull the audience into a state of bliss. Using the crew as a foil not only reminds us how lethal and dangerous lions are to humans, but it also opens a door to talking about the reverse: just how dangerous humans are to lions.

Once we introduced Richardson and planted the seed of the cause at 2:45, the hyenas came along, offering a kind of humorous left hook that gave the audience a break from the lion exposition. Richardson's voiceover and intimate knowledge of the hyenas as individuals personalizes them and sets the tone for the final section. The crew members in cages bring the audience back to reality and the attack on the vehicle highlights the danger.

The final section begins with the story of the lions Meg and Amy. Shots of Richardson interacting and face-rubbing with the lions give the impression that they are more like his daughters than wild animals. We are tactfully tugging at the viewers' heartstrings, getting the audience to recognize the lions as individuals like us, before reintroducing the cause.

Naturally, the interviewer asks Richardson about his kids and the future, and this leads us back to the root of the problem and the reason for the video. It's the same seed planted ten minutes earlier in the edit. Now, after our journey with Richardson, the problem is really beginning to bloom and make sense to the audience. The final sequence gives us the visual and metaphorical representation of his utopia: walking with his daughters Meg and Amy in the sunset grass without cages or bars. This challenges the viewers to assess their own impact on the natural world, and hopefully moves them toward supporting Richardson's cause.

Lions – The New Endangered Species?

The GoPro production crew journeys to Africa to explore the danger and beauty of Kevin Richardson's passions for lions and their future. Shot on the HERO3+ in 2013.

https://www.youtube.com/watch?v=MNCzSfv4hX8

Director: Bradford Schmidt Producer: Yara Khakbaz
Crew: Mike Pfau, Andy Casagrande, Mark Healey Editor: Sam "The General" Lazarus

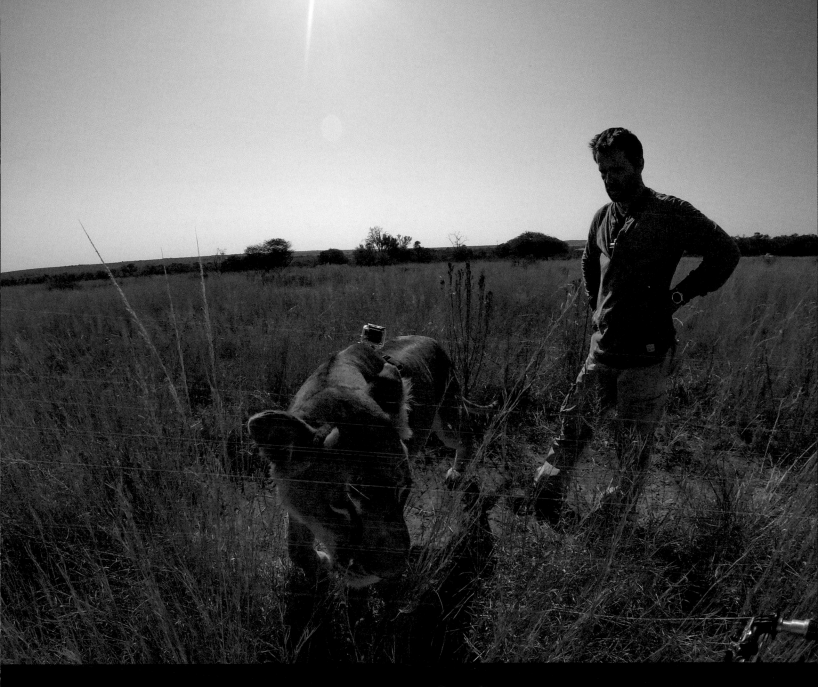

The Romantic Comedy

"The Cape Griffons" video featured here became a *romantic comedy* only after several revisions, because its intended structure as a Cause didn't quite work. The editor tried various ways to personalize the vulture Persey and the species' plight, but nothing really worked structurally. After two rough cuts, we finally figured out that the story wasn't about the birds—it was about Kerri Wolter and Walter Neser. We wanted to know them as a couple as much as we did the vultures themselves. So the intended side story became the main story. As often happens when you crack the code of a story, the rest just fell into place.

The opening foreshadows Walter releasing a bird over an epic vista. The bird is paired with Kerri's narration of her first fearful experience flying with Walter. After the introduction, the duo travels around the wilds of Africa saving birds. The interviewer asks where they met and Walter gives a general response before Kerri diverts the conversation to bird exposition. All her information about the individuals finding mates and being parents are subtle inferences to the evolution of Kerri and Walter's relationship.

The interviewer hesitantly asks again where they met. They awkwardly tell the story, both interrupting each other to recount their different perspectives. This creates the tension that carries the audience through the rest of the piece. Like any love story, the main question is: will the couple stay together?

Power usually switches from one person to the other in a relationship, so we tried to be selective in editing to create a verbal jousting match. Kerri jabs at Walter about stalking her to come paragliding. Walter's knowing grin tells her how much he thought she would appreciate it. Kerri responds with how ridiculous he seemed. Walter reasons with her logically and wins. Kerri takes the power back by interrupting about stalking again and they laugh it off. Kerri finally admits how scared she really was, and we hear the sincerity in her voice after they lift off. Walter knowingly grins because this takeoff parallels the start of their amazing relationship. In this sense, they both win the joust. In the end, all they can agree on is that they don't agree on anything.

The Cape Griffons

Kerri Wolter and Walter Neser are a South African couple saving a species, one bird at a time. Shot on the HERO3+ in 2013.

https://www.youtube.com/watch?v=ZZoPR_1itGM

Director: Bradford Schmidt Producer: Yara Khakbaz
Crew: Mike Pfau, Andy Casagrande Editor: Sam "The General" Lazarus

The Spirit Quest

GoPro's HERO4 launch campaign was a departure from all previous product launches because we consciously omitted action sports. Instead, we chose to focus on the adventures of individuals within human culture and nature. This made the building blocks of the stories and the conflicts within a little more nuanced. The "Descent into the Lava of Marum" video was a standout among the HERO4 launch stories because the conflict combined GoPro's usual action sports "human versus nature" tension with a deeper "human versus self" conflict.

The opening of the story confidently begins with a failure. The protagonist, Geoff Mackley, and his partner, Brad Ambrose, attempt to descend into an active volcano. Halfway down, weather rolls in, and the audience becomes aware of how perilous the journey is, on account of the acid rain and the difficult rappel down. Showing the audience the consequences of failure in the opening allows the editor to then relax and take his time in establishing all the characters afterwards. Exposition on the characters and their mission is given at the basecamp while they wait for the weather to clear. The audience is willing to wait with the characters because they are now invested in seeing what is inside the volcano as well. Creating that expectation allows the filmmaker to elongate the tension.

The sun finally shines through, and the crew descends again. Geoff gets entangled in rappelling equipment halfway down, reminding the audience of the difficulty again while also developing our character as he pushes on in spite of adversity. This is all part of the "human versus nature" conflict, but when Geoff reaches the inner sanctum of the volcano, the audience begins to wonder "Why is he doing this?" The "human versus self" conflict is then interwoven with voice-over, and Geoff contemplates his own individual existence and how it connects to life on our planet. Director and editor Mike Pfau only found this final beat after the rough cut, when he went through his interviews with Geoff again, and linked all the pieces together in the second pass.

It can often be useful to keep in mind the rich history of human storytelling when drawing inspiration for a piece. One of the stories we had in mind while cutting Geoff's climatic epiphany was the biblical account of Moses and the burning bush. At the edge of the roiling lava lake, Geoff forces his tearful eyes open to stare into the face of God, perhaps to find the meaning for his own existence and the connection between life and death.

Descent into the Lava of Marum

Geoff Mackley and Brad Ambrose journey to the center of Marum Volcano in Fiji to behold one of the world's only active lava lakes. Shot on the HERO4 in 2014.

Director & Editor: Mike Pfau
Producer: Cort Muller Crew: Trenton Pasic

https://www.youtube.com/watch?v=toxDDERtvOY

The Meta-Story

The unexpected can be quite refreshing. Probably the last thing anyone is expecting when they sit down to watch a YouTube skiing video is a sincere contemplation on the meaning of life. From an editor's perspective, finding a story inside a lot of random clips can feel as difficult and nebulous as teasing meaning from the great, multiform complexity of our own human experience. Such was the Ryan Price piece: He had been shooting for years with the camera and produced gigabytes of footage that seemed to require more than just a freeskiing montage.

We explored a number of different frames or motifs trying to structure this edit. One option included a wild introduction set 200 years in the future with the viewers being analyzed by a sentient GoPro computer and placed inside a Ryan Price avatar on a spiritual mountain-climbing-skiing quest. The video employed tons of graphics and After Effects work in the process. It was silly, and the wild ideas were distracting us from what was supposed to be an earnest story. The simple school frame we eventually choose, using chalk writing on black title cards, was instantly relatable and got the story moving quickly.

The edit is a twist on the traditional search for meaning or enlightenment, which often ends quite literally with an archetypal mountaintop. Here, the journey is envisioned not as a climb up the mountain, but a descent down. Anticipation for the answer to the question mounts as Price and his friends ski through varying terrain. The philosophy and physics sequences give the viewers examples of the innumerable ways humans interpret their reality and imbue it with meaning. The tension mounts until at last the climax, when the frame of the pop quiz breaks down inside the ice cave. Here, the narrator attempts to give us an answer to life's ultimate question, beyond philosophical abstractions or mathematical formulas. The ice cave realization informs the last montage of the edit, then gives the characters and audience a reason to climb the mountain again, live life, and discover their own meaning inside of it.

This edit in particular was a breakthrough in experimentation. Over the years, one of our mottos at GoPro has been: try to do something new with each and every video, even if it is only one thing. Difficult projects like this give you the chance to expand your horizons rather than resorting to the familiar or formulaic. The effort may work, it may not. But just by trying you have pushed your own limits and will grow as a creative artist.

Ryan Price – A Skier's Search for Meaning

School is back in session as the first flakes of winter begin to fall. But what does it all mean, anyway? Ryan Price, Devin Price, and Mike Cullen take us straight to the heart of the matter. Shot on the HD HERO in 2011.

https://www.youtube.com/watch?v=FfUJ3in8RDc

Filmers: Ryan Price, Devin Price, Mike Cullen
Editor: Brandon Thompson

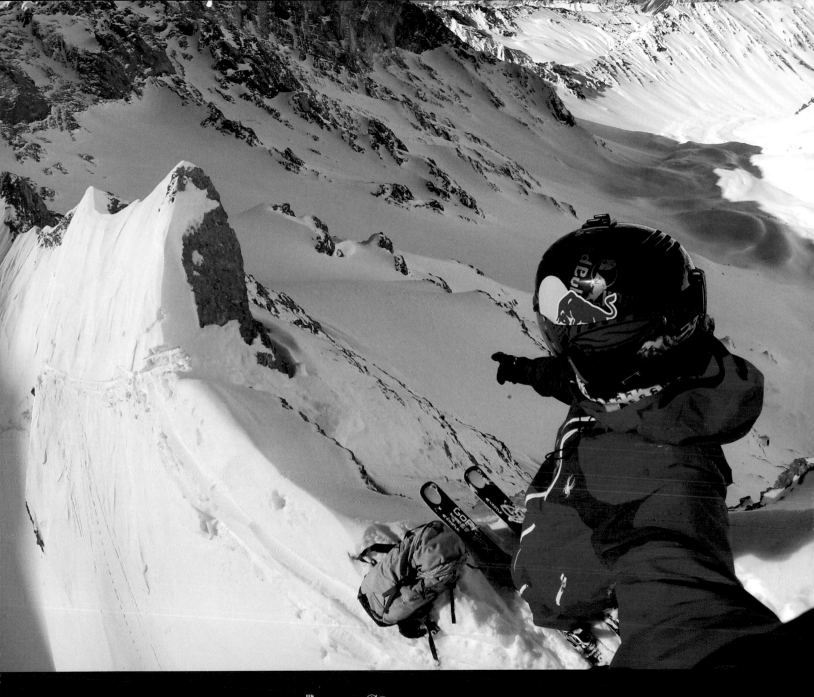

Chris Davenport / The Andes, Chile Handheld Photo/.5sec

Short Feature

In feature-length films, structure is traditionally broken down into three acts. Each act can weave and twist and turn in all kinds of wild and interesting ways. Theories about three-act structures are debated endlessly, but all viewpoints support milestones, landmarks, and beats to retain the audience's attention and help navigate their way.

Every feature story needs a protagonist and an antagonist or conflict. As described in Chapter 5, we generally have the essence of both in our videos. Fortunately for the "Our Orangutan Brethren" video, we had an actual physical representation of our antagonist: the deforested wasteland. This physical antagonist allowed us to form a classical three-act structure in this short film.

The following list outlines how a classical three-act structure can function.

Act One

- **Characters and settings are introduced and the film's theme is stated:** The introduction is where the audience finds out the protagonist, Peter, is likable and worth caring about. Peter carries the orangutan deep into their forest while telling a fond story about Waikiki, one of his first released apes. Waikiki injures Peter but later asks for forgiveness by putting his arm around Peter as if to say, "Hey, we are still friends." This is the theme of the story that will grow in the viewers' minds, unbeknownst to them, until the very end.

- **The obstacle, problem, threat, or antagonist is introduced:** Peter explains that time is short, orangutans are at the brink of extinction, and every individual counts. Peter even looks at his watch as if to confirm that time is running out. It's good to note: we didn't stumble upon this shot until digging back into the selects after the rough cut. Every frame counts in telling the story, and those details are so subtly important.

- **The "B" love story is introduced:** Betty and Suri's mother and daughter relationship is the B love story. Usually the B love story empowers the protagonist to rise and conquer the final obstacle and bring about the climax of the story. In this case, Betty, the mother, lets go of her daughter, Suri, during the final climactic release.

Act Two

- **Fulfilling the promise of the premise:** The second act starts with the protagonist entering into a new world: Peter brings the orangutans into the forest for their training. This gives the audience exactly what was promised by the title, thumbnail, and description. The audience chose to watch a video called "Our Orangutan Brethren" with an image of an orangutan carrying a GoPro in the jungle. Give the audience what they came to see.

- **Reaching the false summit or midpoint:** The midpoint is when the story ascends to an understanding or small climax and everything seems to be wonderful. In the story, Suri is actually ascending a tree into the sunlight. Peter informs the audience that orangutans and humans are genetically similar. The story has arrived at a wonderful peak, but this is just the false summit that occurs right before everything comes crashing down. Suri drops the stick, and the audience fears that all hope may be lost.

- **All hope is lost:** This is the turning point of the film when the protagonist has reached the lowest point. The audience learns that our human consumption of palm oil is destroying habitat and causing orangutan extinction. Our irresponsible human actions serve as the antagonist embodied in the wasteland. This beat occurs right before the climax of the story.

- **Rise to the climax:** The protagonist rises up and conquers. Typically, the rise is empowered by the B love story. Visually, we are actually climbing a rise here, and Peter's entire team is running together. Peter is repeating, "Every individual counts at the moment." The metal box slides open, and Suri is set free.

Act Three

- **Resolution:** The theme of the story is complete as the audience connects all the dots. Humans have been hurting the orangutans. Peter is putting his arm around the whole species as if to say, "Hey, we are still friends." Betty's smile and humming lullaby complete the B love story—subtle but emotionally important. The last image of the rising orangutan is a powerful message for hope.

Our Orangutan Brethren

What we do for orangutans, we do for ourselves. Peter Pratje reveals how we, as individuals, can help prevent their imminent extinction. Shot on the HERO3+ in 2013.

Director: Bradford Schmidt Producer: Yara Khakbaz
Crew: Jordan Miller Editor: Mario Callejas

https://www.youtube.com/
watch?v=oir_PSJpbAA

Share Your World

EVERYONE HAS PASSIONS AND INTERESTS that ultimately lead to experiences to share and stories to tell. We hope this book inspires you to pursue your own passions in life and to share your stories with the world.

GoPro would not be where it is today without our enthusiastic users who continually capture incredible life experiences and share them with others online. While we're proud of the content we produce at GoPro, the truth is it's our users who are GoPro's most powerful and influential content creators. Just visit GoPro's Facebook page or Instagram feed: You'll quickly lose yourself looking at photos and videos from inspired people around the world who participate in every conceivable activity captured from every imaginable angle. GoPro has become an uplifting expression of peoples' passion for life.

Nick Woodman said it best: "GoPro is helping the world visually communicate in a new and engaging way, and that can only be a good thing."

Dean Carriere / Mount Everest Handheld Photo/.5sec

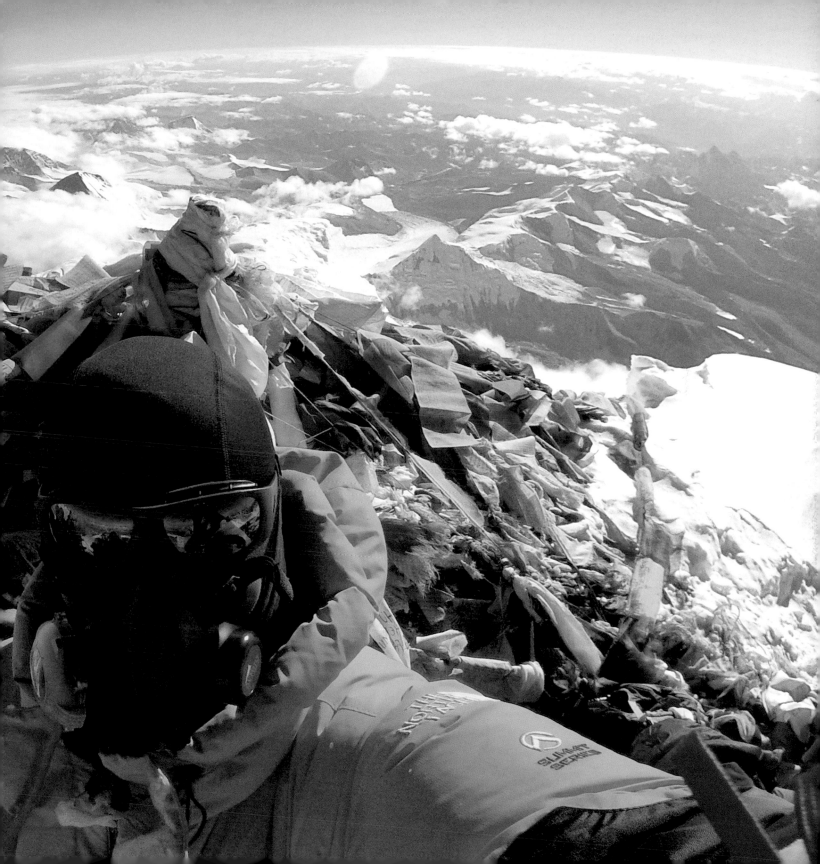

GoPro App

The GoPro App allows you to use your smartphone or tablet as a live video remote control. It's great for framing shots and changing resolutions and frame rates on the fly. Now that GoPros can capture in so many different FOVs and feature so many optional advanced controls, the GoPro App has become an invaluable tool for our media department. The GoPro App streamlines camera setup and shot confirmation leads to overall better content since you can now spend more time experimenting with new shots.

The GoPro App also makes it easy to playback and copy photos and video over Wi-Fi from your GoPro to your smartphone or tablet. This greatly simplifies sharing your favorite moments to Facebook, Instagram, Twitter, and more without needing to wait to connect to a computer. There's something so fulfilling about immediately sharing an awesome experience with friends and family. Consider sharing photos and short clips of your adventures as teasers for any longer form edits you might want to publish once you get home. The GoPro App also has a feature called HiLight Tag, which allows users to mark key moments inside a video while recording. In addition, the GoPro App links directly to GoPro's Photo and Video of the Day. These showcase innovative content and can be a great way to generate new ideas for your next project.

In GoPro's media department, we use the GoPro App most often to preview shots and compose our frame as well as to control the camera remotely. We've used it countless times to change FOV or frame rate from a distance after mounting the camera. The camera is often out of reach, so it's convenient and efficient to have the GoPro App on hand for last-minute tweaks.

Over time, the GoPro App will expand to include editing tools and additional content management features to further simplify the process of capturing, managing, sharing, and enjoying your GoPro content.

Alana Blanchard / Oahu, Hawaii 3-Way Extension Arm Photo/.5sec

GoPro App: Control. View. Share.

Alana Blanchard, Lakey Peterson, and Camille Brady test out the new GoPro App features during a surf trip in the Mentawai Islands of Indonesia. Shot on the HERO3+ in 2013.

Director: Jordan Miller Producer: Yara Khakbaz
Crew: Bradford Schmidt, Adam Instone Editors: Ryan Truettner, Abe Kislevitz

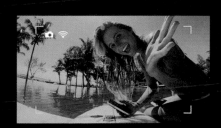

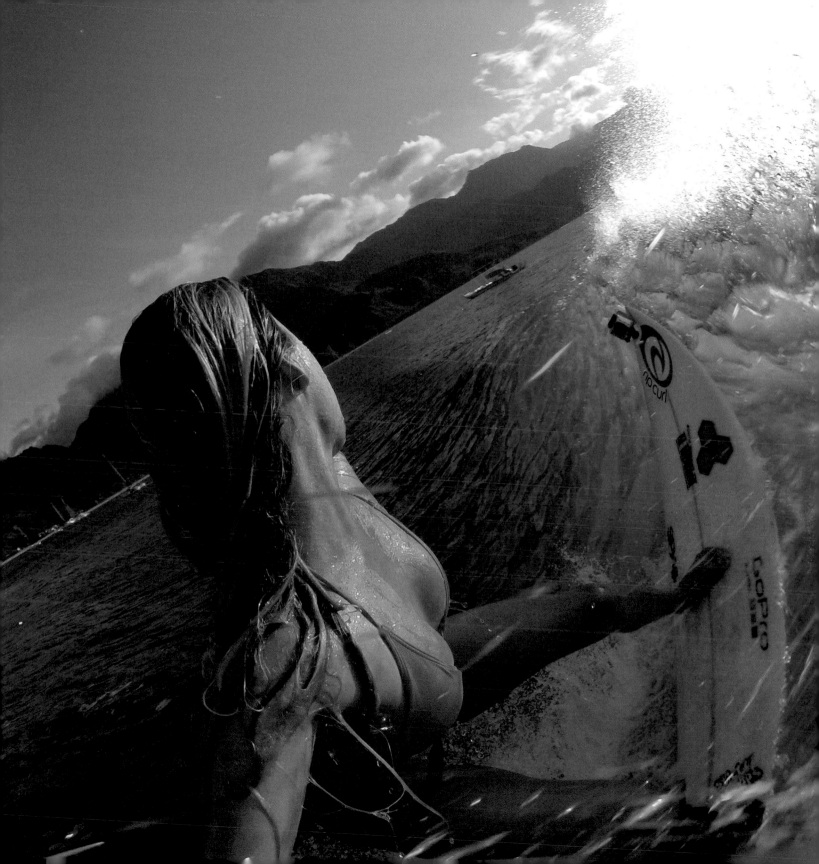

GoPro Studio and Edit Templates

GoPro Studio is GoPro's free desktop editing application. It features a broad range of tools including Flux, a powerful slow motion and speed ramping tool, and Edit Templates, templatized versions of some of GoPro's best originally produced and user generated content.

Our users frequently ask us how they can learn to edit videos like they see on the GoPro Channel. Edit Templates represent the beginning of our solution, whereby our users can make their favorite GoPro videos their own by replacing our clips with theirs. We've already selected the music, set the edit points, and done most of the work to fast-track our users to a great edit.

Our hope is that over time our new users will become more comfortable and courageous with their editing and Edit Templates represent a solid way for them to get started and understand the mechanics of editing. Even for advanced users, Edit Templates make it easy to quickly pull together compelling content to share.

Hippie Bus Adventure

GoPro Sr. Production Artist Jordan Miller and his lady friend Caro_Bou take you on a pop-top VW adventure. This video is the basis for the GoPro Hippie Bus Adventure template. Shot on the HERO3 in 2012.

https://www.youtube.com/watch?v=D-OF9LzClbU

Filmers: Jordan Miller, Caroline Emerson
Editor: Jordan Miller

GoPro Studio 2.0 – Shibby Stylee

This video was filmed in Hawaii and features flipping, diving, hiking, camping, and surfing. It was created with the Hippie Bus Adventure template and was Grand Prize Winner of the GoPro Studio 2.0 contest.

https://www.youtube.com/watch?v=0XtQmYJ65eg

Filmer: Andrew Agcaoili
Editor: Andrew Agcaoili with GoPro Studio

Image Quality and Exporting

Image quality is one of the first things a viewer will notice about your video. Using the proper workflow, you can take GoPro footage from the camera to fully edited video with very little, if any, loss in image quality. You can do a number of things to maintain quality: keep the camera's firmware updated; use the correct settings during the transcoding, editing, and exporting stages of video creation; and avoid overly aggressive color correction or zooming of footage while editing.

If you've worked in an intermediate codec, we recommend compressing your video before uploading it to the web. You can compress the video in your editing program as you export or using third-party software such as Apple Compressor or Sorenson Squeeze. Choosing the right bit rate for video compression is all about compromise. In general, a higher bit rate means a higher quality video. But it also means that the video will take longer to upload and stream. For HD video played over the web, the range of 10 to 30 Mbps (megabits per second) is considered to be a good compromise.

YouTube, Vimeo, and other video services provide upload guidelines with recommended settings. Knowing a little bit about the specifics of compression ensures that your video quality remains high:

- **Resolution:** Use the same resolution as that recommended for the intended playback device. 1920×1080 is a good bet, although YouTube now accepts resolutions as high as 4K.

- **File format:** This refers to the container that holds together the video and audio components of a video. For web, this is usually MP4.

- **Video codec:** This setting is where you specify the compression on the largest part of your file, the video stream. It is usually set to H.264.

- **Audio codec:** You can usually leave this the same as GoPro's standard audio compression, which is AAC.

- **Bit rate:** This refers to the amount of video information (measured in bits) transferred per second. For HD, always use a variable bit rate centered around 10 to 30 Mbps.

Uploading video for Instagram requires additional considerations. Instagram video has a square aspect ratio with a resolution of 640 x 640 pixels. We recommend editing on a 1080p timeline (don't forget the 15 second time limit), and then compressing the video to a bit rate of around 1 to 2 Mbps on export. The file size should be under 10 MB. Email the video to yourself and then use the Instagram app to upload the video. The app will scale your 1080p video to the proper resolution and apply a square crop. Be sure to choose a good crop so that all the essential action is visible.

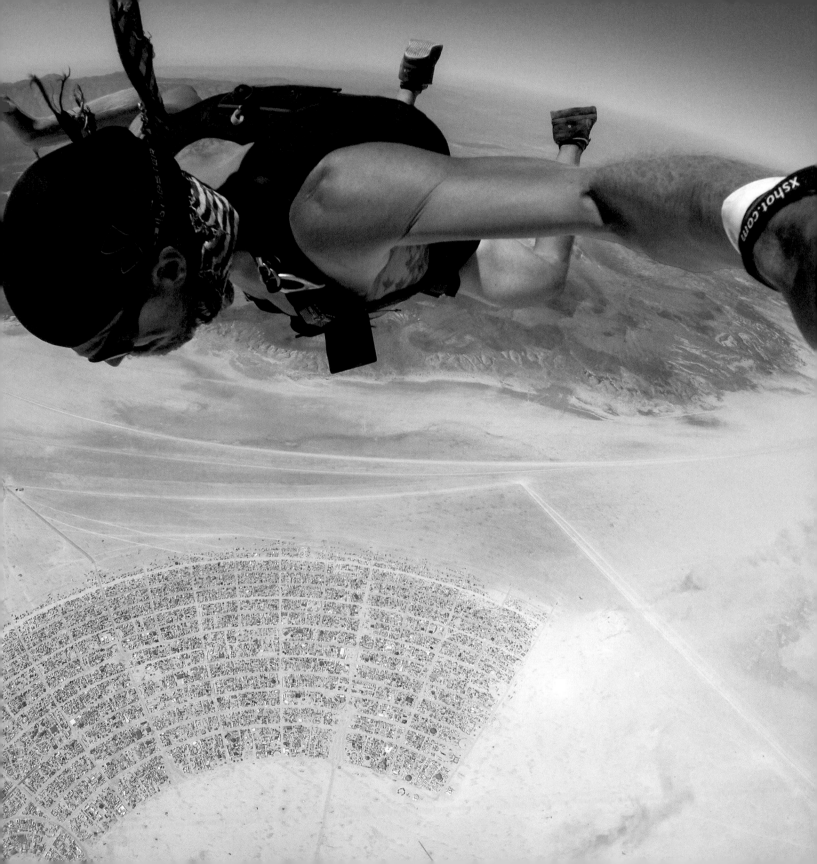

Forums for Sharing

Online social networks are still a relatively new consumer phenomenon, and it's no coincidence that GoPro has become a movement of its own during this same period. There would be no Facebook without photos, and no YouTube without videos... and perhaps no GoPro without Facebook, YouTube, and the like. GoPro and online social platforms have developed a symbiotic relationship, each benefiting mutually from the strengths of the other.

In the early days, we were surprised to see our users tag their shared photos and videos with GoPro's name. Users were so enthusiastic about self-capturing and watching footage of themselves doing what they loved most in life that they developed a strong emotional connection with the product and brand that enabled them to do so. GoPro became less about the product and more about the content and the emotions that the product enabled. GoPro's ability to connect with its users and fans on an emotional level is a big part of why its brand is so strong.

GoPro shares its content and engages with its users and fans on most relevant social and content distribution platforms, including: YouTube, Vimeo, Instagram, Facebook, Twitter and more.

- **YouTube:** GoPro's channel has published over 900 videos and has attracted more than 2.4 million subscribers. In 2014, YouTube named GoPro the #1 Brand Channel on its channel leaderboards on account of the viewership and and engaging nature of its content. To date, the channel has garnered over 600 million views.

 www.youtube.com/GoPro

- **Instagram:** GoPro's account has over 3.2 million followers with over 1,200 photo and video posts. The feed is considered one of the most engaged brands on the platform. GoPro received a Shorty Award for Best Instagram account in 2014.

 www.instagram.com/GoPro

- **Facebook:** GoPro's page has amassed over 8 million fans. In 2014, GoPro earned an award for Best Facebook Page at the Shorty Awards.

 www.facebook.com/GoPro

In the following sections, we touch base with individuals who we've seen use these platforms to great effect.

Neil Amonson / Black Rock Desert, Nevada ▼ Handheld ⏱📷 Photo/.5sec

YouTube: Abe Kislevitz

In early 2009, Nick Woodman was searching for GoPro customer videos on YouTube and stumbled upon a bunch of GoPro ski videos produced by a USC college student named Abe Kislevitz. Abe's videos were the first user generated videos that expanded Nick's mind of what a GoPro was capable of. Nick reached out to Abe through his YouTube account and asked him if he'd like to shoot the launch film for the soon-to-be-released HD HERO. We flew Abe and a couple of his USC Ski Team buddies up to Mt. Hood, Oregon to film "The Ski Movie." Abe did such a good job that Nick invited him to come work at GoPro after graduation. Fortunately, Abe accepted and now helps lead media production as a Senior Production Artist. Abe also maintains a personal YouTube account that has nearly 40,000 subscribers and 10 million views.

How can YouTube users optimize their subscribers and view counts?

A big part of it is consistently posting videos for a long time. If you have a history of good content, subscribers will look forward to your next project. Another thing is to find a niche, a look and style that is your own, and stay consistent to that. Focus on image quality, content, story...something that's going to give your videos an edge over everyone else. Lastly, be interactive and engaged with your community, so they feel like you have something to offer every time you release a video. One thing I'll often do with each video is try a new effect or technique in After Effects. Everyone always asks about it and wants to learn how to do it, so the dialogue around the video becomes interactive.

How can a new GoPro user and content creator get noticed?

At GoPro we always notice the creators who are consistently posting amazing content. I always tell people to stick to it and really hone their skills as an artist, videographer, and editor, and people will pick up on it naturally. That's how I got noticed and hired. When I'm hiring someone at GoPro, it's solely based on the portfolio and examples of work because, ultimately, that will tell me if someone is really and truly passionate about what they're doing. When you find a job that's truly in line with your passions, you'll wake up excited to go to work and push yourself every day.

Abe Kislevitz / Laax, Switzerland 3-Way Extension Arm Photo/.5sec

USC Ski & Snowboard — The Weekend

Join the USC Ski & Snowboard team on the slopes of Mammoth for another year in paradise!

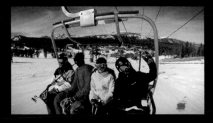

http://www.youtube.com/
watch?v=Jj2fjQHzXDM

Director and Editor: Abe Kislevitz
Crew: Caleb Farro, Chris Farro, Matt Cook, USC Ski & Snowboard Team

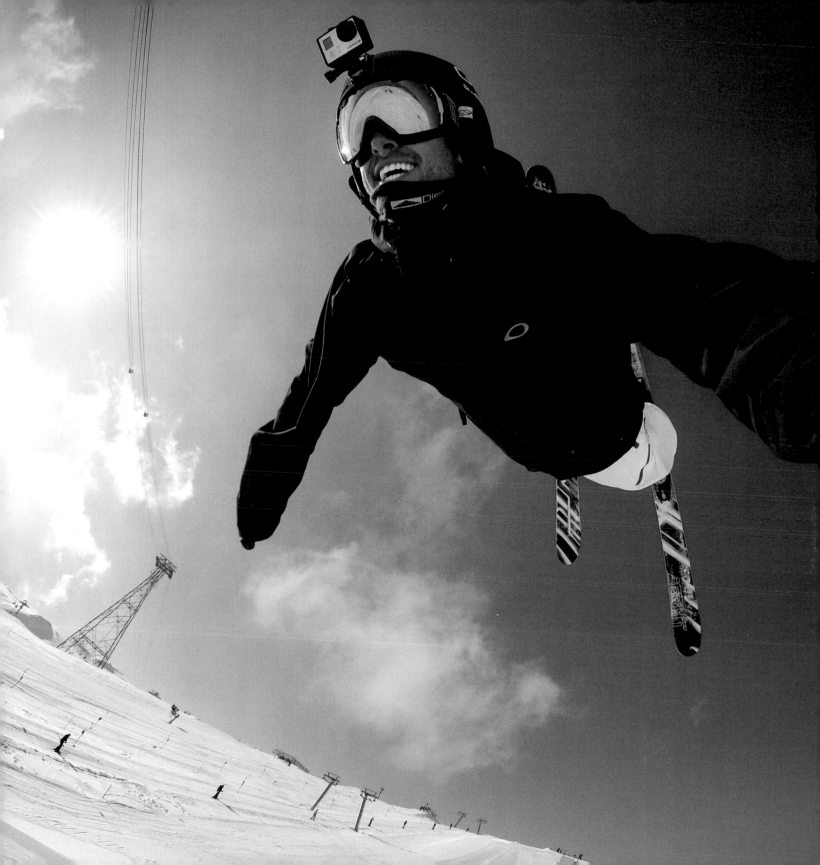

Instagram: Zak Shelhamer

Photographer and former pro snowboarder Zak Shelhamer has been passionate about photography since his dad first introduced him to the household darkroom as a kid. Shelhamer and his friend Eric Willett were featured in GoPro's first "Snowboard Movie." Since then, he has seen his passions for adventure and photography come together in a lead production artist position at GoPro, and on Instagram, where he has more than 170,000 followers.

What is photography to you?

Being a photographer isn't about knowing how to set up lights, or knowing what an f-stop is. These are tools, sure. But I believe photography is all about creating emotion through a picture.

What's your strategy for Instagram?

First, post your photos at noon, Pacific Standard Time. That way you get the people at lunch break on the West Coast, people just getting off work on the East Coast, and anyone who isn't in bed yet in Europe. Second, post consistently. Post along a schedule so people can expect to see new content from you regularly. Third, engage with your followers by commenting on their photos and answering any questions. As far as workflow, I use the GoPro App to send the photo to my phone. Then I'll use Snapseed to do a basic color pass before bringing it into Instagram. I used to take a lot more photos with my iPhone or DSLR, but these days 95% of my Instagrams are GoPro.

What is the best part about Instagram and why is it important in your life?

When you join Instagram, your first followers will be your immediate circle of close friends. Once that circle grows as people beyond your friends recognize your hard work, it's really gratifying. When Instagram was first taking off several years ago, I was contacted by them because they liked my photos. I got featured on Instagram's suggested user page and I suddenly jumped from a couple hundred followers to 50,000 followers in a few months. I was getting thousands of likes and comments from people I didn't know, which was validating. So that's the first stage, recognition, but then comes the pressure. You've earned followers' attention and trust and you don't want to disappoint them. The good thing is that 99% of the recognition, likes, and comments are positive. Listen to that feedback, translate it, and weave it into your work. It's crucial for growing as an artist.

Zak Shelhamer / Hawaii ᛦ Handheld 🕐📷 Photo/.5sec

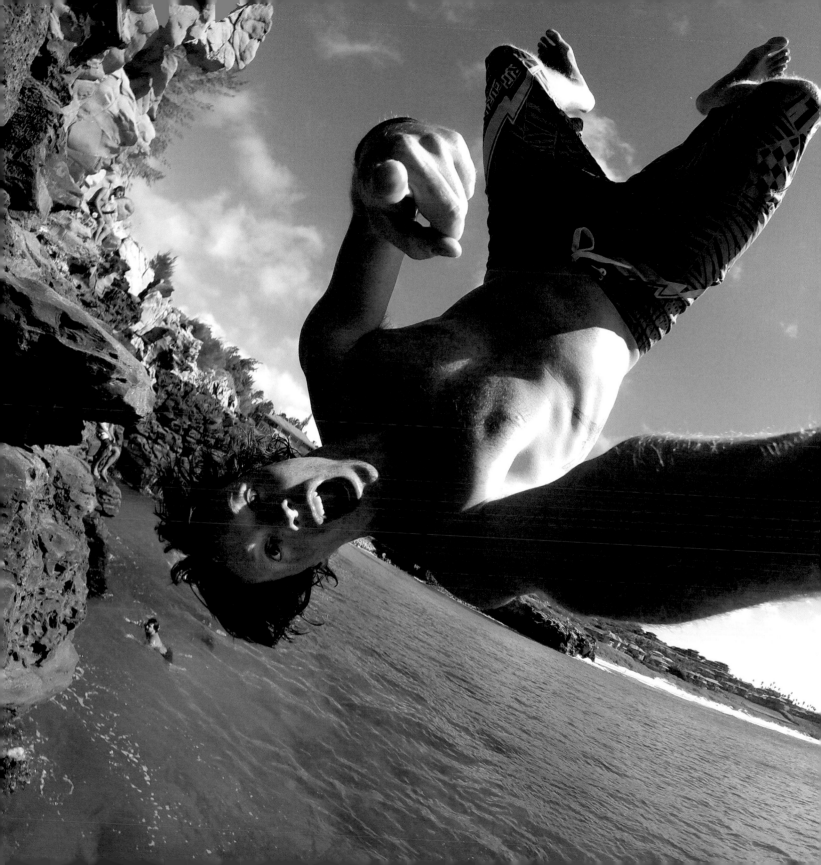

Facebook: GoPro Bomb Squad

In the summer of 2010, Neil Amonson and Marshall Miller were in Switzerland capturing their BASE jumps with a couple of GoPros and dreaming about doing exactly that for the rest of their lives. Thus, the GoPro Bomb Squad was born. They later picked up two other members, Jesse Hall and JT Holmes. Today, the four travel the world BASE jumping, skydiving, speedflying, paragliding, and wingsuit flying. The GoPro Bomb Squad's Facebook page has been a pivotal tool in the group's development and their profession.

Describe the growth of your Facebook page.

Our first 100 fans were all our friends, when we started the page. But soon, we jumped to 1,000 fans when we posted from the Teva Mountain Games in Vail, Colorado. When you're at 100 you can't even imagine having 1,000 fans. Every time GoPro shared one of our photos, we'd jump another thousand. So half a year later we had 90,000 fans. Now we're nearing 150,000.

What's your strategy for Facebook posts?

Being good at social media is much harder than people think. You have to generate a lot of content, and you have to keep up with it, over and over and over. You can't just put a cool picture up and then not do anything for a month. In the beginning, we tried to do one post a week. Now we try to post once every day, or at least three to four times a week. We try to be approachable and interactive. But most importantly, we have a high quality standard. We do a ton of jumps, but if we don't feel like we've captured "the moment," then we don't share it. Every jump, we're very mindful of where the camera is and what it's capturing. Bottom line: You have to be creative on the shots, and make them new and fresh.

How does Facebook fit into your group as a business?

Our business as the GoPro Bomb Squad is so socially based it makes us feel a little vulnerable, but it's probably not going anywhere. GoPro was our first sponsor and our title sponsor, then we picked up ten other sponsors largely because of GoPro's backing and our presence on social networks like Facebook. When production companies or TV shows are hiring, they quickly go to our Facebook page—it gives us such credibility as a business.

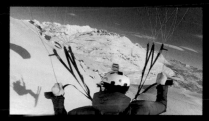

GoPro Bomb Squad: Alaskan Speed Flying

When the GoPro Bomb Squad take a road trip in Alaska, you can be sure shenanigans will ensue. Shot on the HD HERO2 in 2012.

http://www.youtube.com/
watch?v=tVE7ug4jJaw

Filmers: GoPro Bomb Squad
Editor: Trenton Pasic

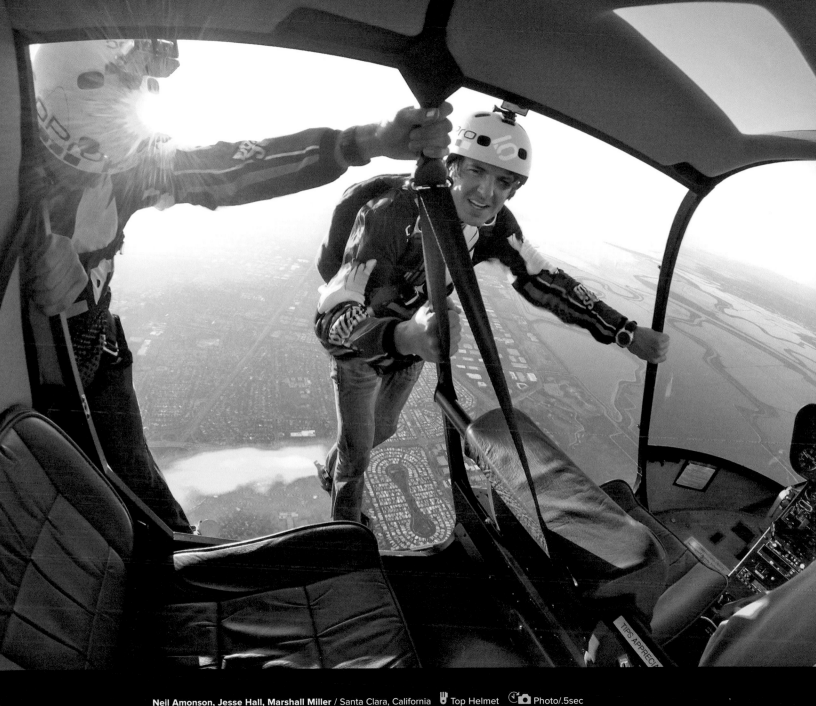

Neil Amonson, Jesse Hall, Marshall Miller / Santa Clara, California 🎩 Top Helmet 📷 Photo/.5sec

Viral Videos

A video that goes *viral* quickly gains a huge number of views and shares. When content is so newsworthy, exciting, or meaningful to a massive number of people, they cannot help but share it with everyone they know—whether online or in everyday life. Ad agencies try to duplicate it. PR machines try to induce it. But true virality is not an exact science. You know a viral video when you see it, but it's nearly impossible to conjure one out of thin air. At GoPro, a number of our videos have gone viral, from Mike Montgomery's uncut slopestyle run in the early days to the more recent and meteoric "Fireman Saves Kitten."

Some subjects naturally attract big audiences on YouTube and tend to be shared often. For some inexplicable reason, cats are often at the top of this list. After you watch "Fireman Saves Kitten," take a moment to view the original video ("The Rescue" by fireman Cory Kalanick, which is linked in the online description). This is the original video that GoPro production artist Tyler Johnson found one day. At over 500,000 views, the original video had done pretty well at the time, so Tyler decided to try to acquire the content for the GoPro channel. From the original video, it wasn't immediately apparent that a quality moment could be crafted from the footage.

Once the raw video arrived, Tyler spent the better part of several weeks really crafting the story—selecting the best shots, sound designing the breathing and sirens for the intro, recording radio voiceover, and selecting music. The content was there, but he needed to bring out the story in editing to make it really shine. The result is a short and sweet little story that is emotional, meaningful, and extremely shareable for a wide audience...as evident from the 24 million views it has received since.

Videos don't have to be short to be viral or shareable. We believe the main reason most viral videos tend to be short is because longer, more engaging videos are so much more difficult to create. The longer a video is, the more difficult it becomes to maintain audience attention through careful structuring of story. Viewers quickly start to tune out if they are not receiving new information, or if the video lacks a larger structure. However, a well-structured and well-paced video creates an immersive experience in which the casual viewer—the one who only planned to watch a 30-second Internet video—may end up sticking around for 5, 10, 15 minutes, or longer.

Fireman Saves Kitten

Fireman Cory Kalanick rescues an unconscious kitten from a burning house filled with smoke. Shot on the HERO3 in 2013.. The original video, "The Rescue," can be found at: http://goo.gl/Eyv8Y.

http://www.youtube.com/
watch?v=CjB_oVeq8Lo

Filmer: Cory Kalanick
Editor: Tyler Johnson

Another one of GoPro's most viral videos is also about cats, but this one is nearly 15 minutes long. "Lions - The New Endangered Species?" made everyone at GoPro realize the true value of great storytelling. The edit took months to cut, and during that time some folks at GoPro headquarters suggested chopping the video into three episodes. They feared that nobody would stick around for 15 minutes to watch an entire short film on YouTube. But we insisted, and so the piece stayed whole.

Before releasing the 15-minute story, we released the 60-second "Lion Hug" clip a couple of months before. The clip gave the audience the most sensational footage of Kevin Richardson and his lions in the span of one minute. This short video did well, quickly rising to 2.5 million views in the first few weeks before plateauing. When we finally released our 15-minute lion story, it didn't perform as well in the first month. But then it kept growing. And growing. And growing. Over the next six months, the 15-minute long "Lions - The New Endangered Species?" started to eclipse even our product launch videos. Viewership is still growing at 22 million views, while "Lion Hug" is hovering at 3.5 million.

This case study of the "Lion Hug" and "Lions - The New Endangered Species?" really shows that virality is about unique content *and* great storytelling. If a filmmaker can combine both, the potential for views and shares increases exponentially.

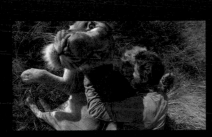

Lion Hug

The Lion Whisperer, aka Kevin Richardson, has a good morning greeting with his pride of furry friends. This video was published before the 15-minute "Lions - The New Endangered Species?" Shot on the HERO3+ in 2013.

Filmer: Kevin Richardson
Editor: Sam "The General" Lazarus

https://www.youtube.com/watch?v=ZRd3Irukxu8

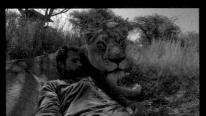

Lions – The New Endangered Species?

The GoPro production crew journeys to Africa to explore the danger and beauty of Kevin Richardson's passion for lions and their future. Unique content and great storytelling are both factors in viral videos.

Director: Bradford Schmidt Producer: Yara Khakbaz
Crew: Mike Pfau, Andy Casagrande, Mark Healey
Editor: Sam "The General" Lazarus

https://www.youtube.com/watch?v=MNCzSfv4hX8

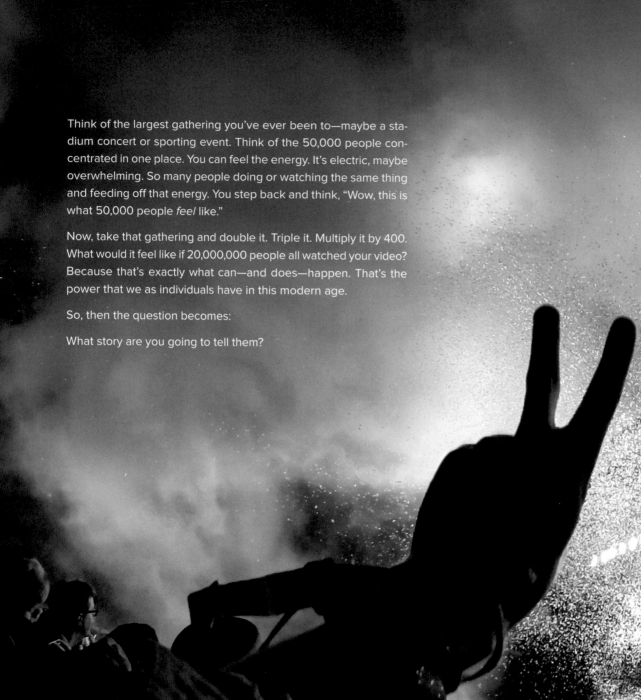

Think of the largest gathering you've ever been to—maybe a stadium concert or sporting event. Think of the 50,000 people concentrated in one place. You can feel the energy. It's electric, maybe overwhelming. So many people doing or watching the same thing and feeding off that energy. You step back and think, "Wow, this is what 50,000 people *feel* like."

Now, take that gathering and double it. Triple it. Multiply it by 400. What would it feel like if 20,000,000 people all watched your video? Because that's exactly what can—and does—happen. That's the power that we as individuals have in this modern age.

So, then the question becomes:

What story are you going to tell them?

Jordan Miller / California Mouth Mount Photo/.5sec

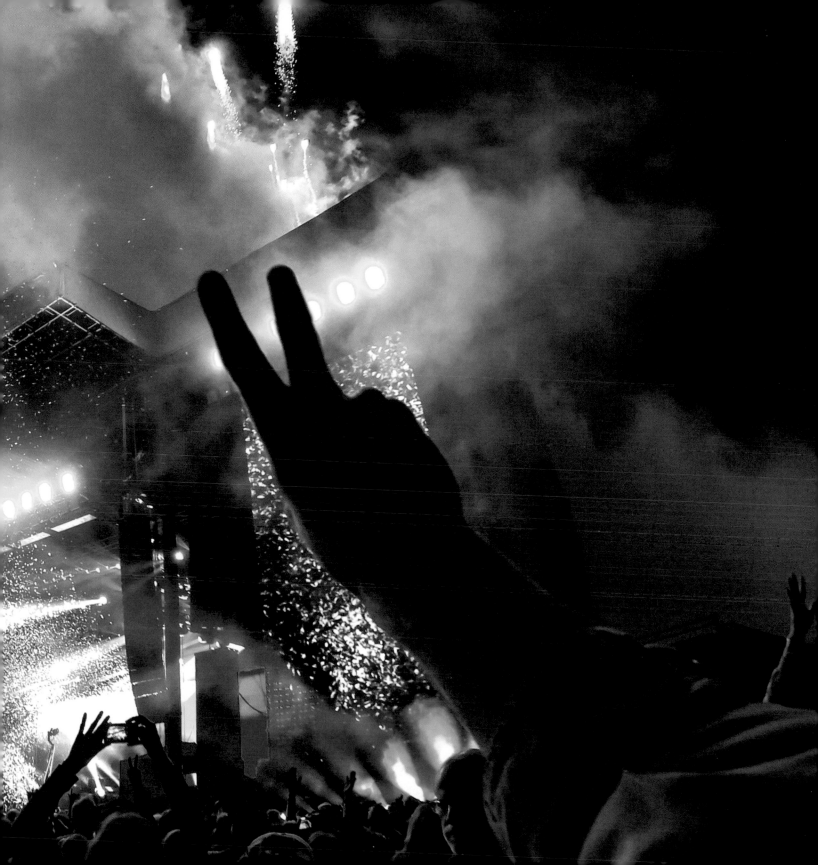

Videos Reference

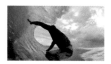

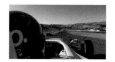

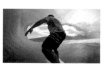

Chapter 2: Mounts

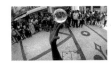

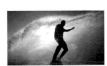

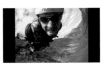

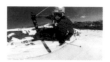

Chapter 4: Capturing a Story

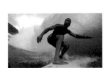

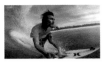

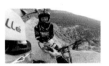

Chapter 5: Art of Editing

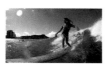

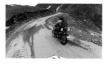

Chapter 6: Story Analysis

Red Bull F1 Showrun
Copenhagen with
David Coulthard 224

Mind the Gap with
Jesper Tjäder 227

Lost in Jellyfish Lake
234

Hero3+ Black Edition:
Smaller, lighter, mightier
still. 237

Leah Dawson
"Slow Down" 238

Kelly Slater Presents:
See You Tomorrow 239

Mt. Hood Snow Photo
Expedition 240

Baptism By Fire –
Vegas To Reno With
Nick Woodman 242

Nick Woodman at
Laguna Seca 243

2010 Post Office
Bike Jam 244

Shaun White's
Birth of a Board 244

Alana and Monyca
Surfing Hawaii 245

A Year with Andy Mac
246

Jamie Sterling Big Wave
World Champion 2011 246

Rough Cut: Lost in Peru
248

Final Cut: Lost in Peru
248

Still Lost in Peru 249

The Family Crest 251

Director's Cut –
Shark Riders 252

Combing Valparaiso's
Hills 254

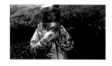

Chapter 7: Share Your World

Index